NEW YORK CITY MUSEUMS

A ROSS GUIDE

NEW YORK CITY MUSEUMS

A ROSS GUIDE

MUSEUMS • HISTORIC HOUSES •

ART GALLERIES • LIBRARIES •

AND OTHER SPECIAL PLACES OPEN TO

THE PUBLIC IN THE NEW YORK

METROPOLITAN AREA

BY BETTY ROSS

AMERICANA PRESS • Washington, D.C.

For Sinclair and Allan,
future museum-goers

All information in this book was accurate at the time of
publication but museum and art gallery hours are subject to
change without notice.

917.471
R73

Library of Congress Cataloging-in-Publication Data

Ross, Betty.
 New York City museums : a Ross guide : museums, historic
houses, art galleries, libraries, and special places open to the
public in the New York metropolitan area / by Betty Ross.
 p. cm.
Includes bibliographical references and index.
ISBN 0–9616144–2–0 (pbk.)
1. Museums—New York (N.Y.)—Guide-books.
2. Historic buildings—New York (N.Y.)—Guide-books.
3. Art museums—New York (N.Y.)—Guide-books.
4. New York (N.Y.)—Description—1981—Guide-books.
I. Title.
AM13.N5R67 1991 91–70942
917.47'10443—dc CIP

Printed in the United States of America

Cover: Gracie Mansion, front door; courtesy the Gracie
Mansion Conservancy.

ACKNOWLEDGEMENTS

This book could not have been produced without the help of many friends and colleagues.

Special thanks are due to Nancy Donner and Dina Alcure of the New-York Historical Society; Pat Hildebrand of the Old Merchant's House; Herb Kurz and Laura Mogil of the American Museum of Natural History; Arthur Lindo of the Cooper-Hewitt Museum; David Reese of Gracie Mansion; Dana Rogers of the Museum of Television and Radio; Heidi Rosenau of the Solomon R. Guggenheim Museum; Suzanne Stirn of the Abigail Adams Smith Museum, and Manny Strumpf and Carol Solano of the National Park Service, and the many other curators and public information officers who provided information, read the manuscript, and double-checked facts.

I appreciate also the contributions of Kay Corinth, Karen Levy, Diana Linden, Jan Aaron, Pamela Ivinski, and Jennifer Carlson of the Museum of Modern Art, as well as the comments and suggestions of Jean Baer, Diane Conklin, Charles Parkhurst, and Gail Ross.

And I would like to add a final word of appreciation and thanks to Harriet Ripinsky and Linda Ripinsky for supervising the production of the book; my editor, Vicki Venker Johnson for her ever-cheerful and invaluable assistance, and my family—especially my husband, Richard Mullens—for their understanding and support.

CONTENTS

PREFACE

This book provides comprehensive coverage of sixty museums, historic houses, and other special places open to the public in the New York metropolitan area. Although the focus is primarily on New York City, all five boroughs are represented.

The book is designed for both residents and visitors. Each chapter highlights attractions that should not be missed if your time is limited, and points out what can be seen when browsing at a leisurely pace.

Like our companion volume about museums in Washington, D.C., the book includes biographies and historical backgrounds, indepth reports on museum collections, anecdotes, and information on hours, admission fees, museum shops, restaurants, libraries, handicapped facilities, and public transportation. Listings of a hundred and twenty-two art galleries and thirty-seven museums and historic houses available for private functions are also included.

A twenty-two-block-long section of Fifth Avenue, stretching from Eighty-second Street to Hundred and Fourth Street, has been dubbed Museum Mile in honor of the large number of cultural institutions clustered there. But other parts of Manhattan, as well as the Bronx, Brooklyn, Queens, and Staten Island, are also worth exploring.

This book features some of the lesser-known attractions, in addition to the familiar stars. Such unique places as the Edgar Allan Poe Cottage, the Old Merchant's House, and the Morris-Jumel Mansion are treasures waiting to be discovered. And even avid museumgoers may have missed some of New York's newest attractions, such as the Ellis Island Immigration Museum, the Center for African Art, the Lower East Side Tenement Museum, and Richmondtown Restoration. The quality and diversity of New York's museums and historic houses are truly impressive. The museums are cross-referenced, and, as the Checklist of Special Collections indicates, there is something here for everyone.

Every effort has been made to ensure the accuracy of this book. Each entry was carefully researched, and museum officials read the manuscript and double-checked facts. Museums are constantly changing, dynamic institutions. As a result, exhibits are often moved, works of art are loaned to other museums, placed in storage temporarily, or removed for study or conservation.

In addition, museum schedules are sometimes altered. So try to call in advance to be sure a museum is open at the time you plan to visit.

Whether you are interested in art, history, science, or ethnic and cultural traditions, I hope this guide will help to open new doors for you, finding new places to explore, while adding to your enjoyment of old favorites. And I hope you will share my enthusiasm for New York's wonderful museums, historic houses, and other special places open to the public.

Betty Ross
Washington, D.C.
February 1991

INTRODUCTION

New York, long known as America's center of fashion and finance, is also one of the most important cultural centers in the world, with a history dating back more than two hundred years. Cultural institutions were being established here when, in other parts of the country, most people could barely read and write.

In 1790, the Society of St. Tammany at City Hall established a museum that flourished until the group shifted its focus from culture to politics.

The American Academy of the Fine Arts was established in 1802. Two years later, New York's oldest museum and the first historical society in the United States—the New-York Historical Society—was founded. And, in 1825, a group of artists organized the New-York Drawing Association, which later became the National Academy of Design.

Early in the nineteenth century, Americans, aware of the country's cultural deficiencies, considered patronage of the arts virtually a civic responsibility. Then, as now, the arts were also viewed sometimes as a means of acquiring social status. As a case in point, consider the story of Eliza Jumel.

In the early 1800s, New York was scandalized when Stephen Jumel, a wealthy merchant, married his mistress, Eliza Bowen. The grande dames of Old New York, knowing of her rather shady past, refused to accept the new Mrs. Jumel, so the couple sailed for Paris, where they found favor with Napoleon and his court.

In addition to buying high-style French furnishings for her New York home—which is profiled in this book—Eliza Jumel began building an art collection. By the time her husband, fearing financial ruin because of her extravagance, sent her back to New York in 1816, Eliza had acquired nearly a hundred old master paintings.

She decorated her home in the latest French style—including a bed that formerly belonged to Napoleon—and hung her paintings, hoping to cut a swathe in society, at last. She even arranged to show her collection at the American Academy of the Fine Arts in 1817. Unfortunately, however, even such symbols of culture and refinement as paintings by—or attributed to—Rubens, Van Dyck, Murillo, Tintoretto, and other well-known artists could not open doors for Eliza. And, in 1821, when the paintings no longer served her purpose, they were sold at auction.

As the nineteenth century progressed, New Yorkers and other Americans became interested in natural history, as well as art.

The same men whose fathers and grandfathers brought home Canaletto and Guardi views of Italy as souvenirs of a Grand Tour of Europe filled their homes with minerals and fossils, as well as paintings and prints. When Phineas T. Barnum opened his famous American Museum at the corner of Broadway and Ann Street in 1841, one of the main attractions was the natural history collection formerly displayed at Charles Willson Peale's Philadelphia museum.

And when the New-York Historical Society's vast accumulation of natural history specimens threatened to

overshadow the group's historical collections, the scientific collection was donated to the newly established Lyceum of Natural History.

Interest in archaeology was also widespread, as Pompeii began to yield more and more evidence of an earlier civilization. The first object donated to the Metropolitan Museum of Art after it was established in 1870 was a Roman sarcophagus unearthed during an archaeological expedition.

Two of the earliest and most important American collectors were Luman Reed and Thomas Jefferson Bryan, both of New York City. Reed believed in supporting contemporary American artists and, during the 1830s, was a major patron of Thomas Cole, Asher B. Durand, William Sidney Mount, and George W. Flagg. Once a week, he opened the art gallery in his home to the public, a gesture that provided one of the few opportunities at that time for artists and others to view original works of art.

Bryan, who assembled an important collection of European paintings while living abroad for nineteen years, opened the Bryan Gallery of Christian Art in 1852. Despite its title, the gallery contained old master paintings, genre scenes, portraits, and mythological subjects, in addition to religious art. Bryan moved his collection to the Cooper Union for the Advancement of Science and Art when it opened in 1859. Five years later, the collection was installed at the New-York Historical Society, where both the Reed and Bryan collections can be seen today.

Other great New York collectors followed the pioneering Reed and Bryan. Many, such as Henry Clay Frick, Archer M. Huntington, J. Pierpont Morgan, Gertrude Vanderbilt Whitney, Solomon R. Guggenheim, and Nelson Rockefeller, started with a small, private collection that eventually became a great public bequest.

Financial success and art patronage were often closely linked. Building a great collection is only the beginning, however. Finding suitable quarters to display the treasures is equally important, and today's visitors to the Frick Collection, the Pierpont Morgan Library, the Hispanic Society of America, the Jacques Marchais Center of Tibetan Art, and the Solomon R. Guggenheim Museum, to name just a few, can see how some enthusiasts chose to showcase their collections.

New York continues to fulfill its historic role as an exciting site for museums and art galleries. As the museum world grapples with such issues as deaccessioning, fundraising, and operating in difficult economic times, there are bright signs on the horizon. The remodeling and expansion plans of such diverse institutions as the Museum of Broadcasting, the Solomon R. Guggenheim Museum, and the Jewish Museum mark the vitality of New York museums in the 1990s.

From a handful of small institutions in the 1800s, New York has grown to encompass some of the major cultural organizations of our time. Along the way, they have served to educate, enlighten, entertain, and enrich the lives of millions of people throughout the world.

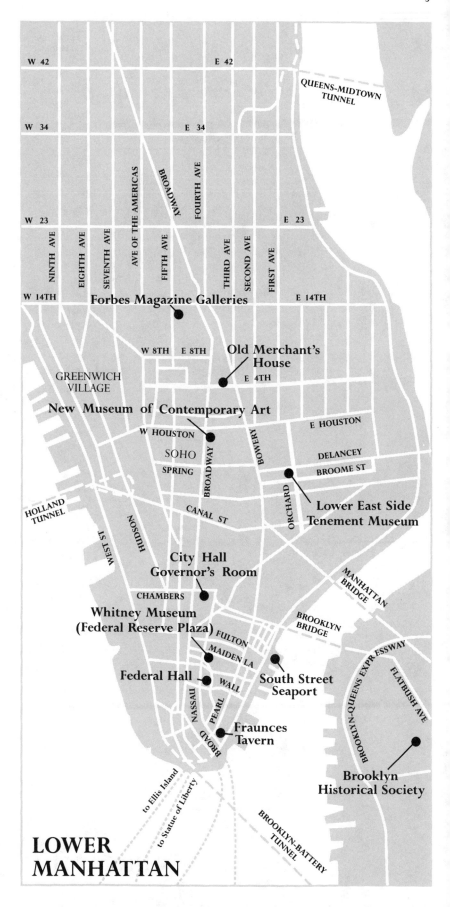

LOWER MANHATTAN

W 42 E 42

QUEENS-MIDTOWN TUNNEL

W 34 E 34

AVE OF THE AMERICAS

BROADWAY

FOURTH AVE

W 23 E 23

NINTH AVE

EIGHTH AVE

SEVENTH AVE

FIFTH AVE

THIRD AVE

SECOND AVE

FIRST AVE

W 14TH **Forbes Magazine Galleries** E 14TH

W 8TH E 8TH **Old Merchant's House**

GREENWICH VILLAGE

E 4TH

New Museum of Contemporary Art

W HOUSTON E HOUSTON

SOHO

SPRING

BROADWAY

BOWERY

DELANCEY

BROOME ST

ORCHARD

Lower East Side Tenement Museum

HOLLAND TUNNEL

CANAL ST

WEST ST

HUDSON

City Hall Governor's Room

CHAMBERS

MANHATTAN BRIDGE

BROOKLYN BRIDGE

Whitney Museum (Federal Reserve Plaza)

FULTON

MAIDEN LA

Federal Hall

WALL

South Street Seaport

BROOKLYN-QUEENS EXPRESSWAY

FLATBUSH AVE

NASSAU

PEARL

Fraunces Tavern

BROAD

Brooklyn Historical Society

to Ellis Island

to Statue of Liberty

BROOKLYN-BATTERY TUNNEL

Hudson River

LINCOLN TUNNEL

WEST SIDE HWY

JAVITS CONVENTION CENTER

ELEVENTH AVE

TENTH AVE

NINTH AVE

EIGHTH AVE

MADISON SQ GARDEN

SEVENTH AVE

W 34

AVE OF THE AMERICAS

BROADWAY

EMPIRE STATE BLDG

W 14

W 23

E 23

FIFTH AVE

E 34

E 36

UNION SQ PARK

MADISON AVE

Theodore Roosevelt Birthplace

PARK AVE SOUTH

Pierpont Morgan Library

E 14

E 20

LEXINGTON AVE

THIRD AVE

SECOND AVE

FIRST AVE

STUYVESANT TOWN

FDR DRIVE

East River

MURRAY HILL

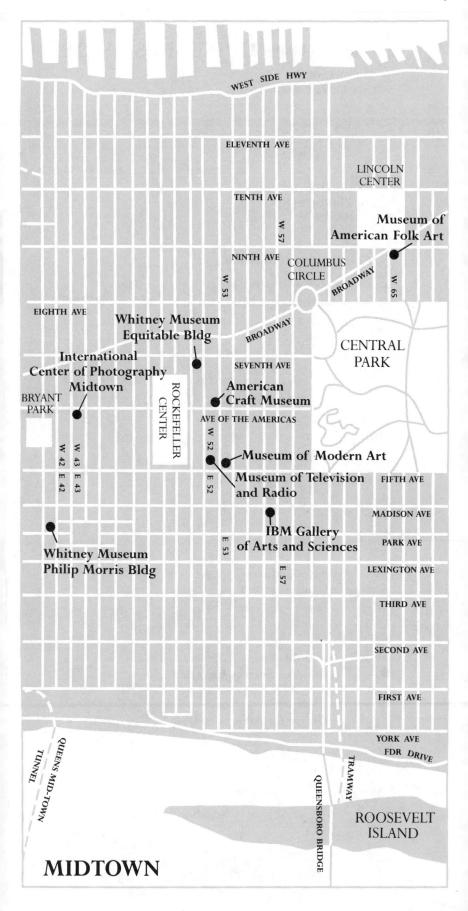

MIDTOWN

8

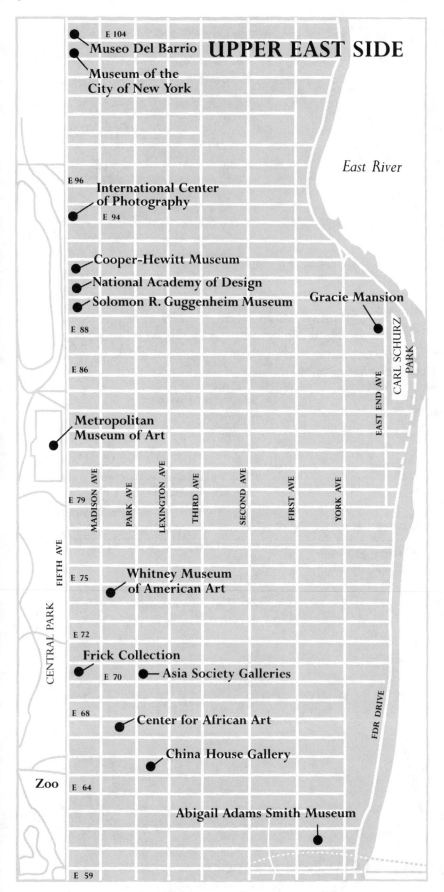

E 104
Museo Del Barrio UPPER EAST SIDE
Museum of the
City of New York

East River

E 96
International Center
of Photography
E 94

Cooper-Hewitt Museum
National Academy of Design
Solomon R. Guggenheim Museum Gracie Mansion

E 88

E 86 CARL SCHURZ PARK

Metropolitan
Museum of Art

MADISON AVE LEXINGTON AVE THIRD AVE SECOND AVE FIRST AVE YORK AVE

EAST END AVE

PARK AVE

E 79

FIFTH AVE

E 75 Whitney Museum
of American Art

CENTRAL PARK

E 72

Frick Collection
E 70 ●— Asia Society Galleries

E 68
Center for African Art

China House Gallery

FDR DRIVE

Zoo E 64

Abigail Adams Smith Museum

E 59

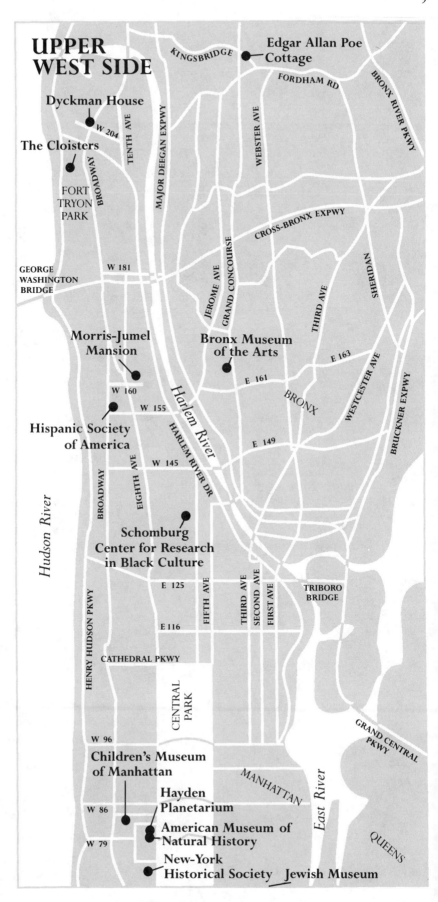

UPPER WEST SIDE

Edgar Allan Poe Cottage

KINGSBRIDGE

FORDHAM RD

BRONX RIVER PKWY

Dyckman House

W 204

TENTH AVE

WEBSTER AVE

MAJOR DEEGAN EXPWY

The Cloisters

BROADWAY

FORT TRYON PARK

CROSS-BRONX EXPWY

JEROME AVE

GRAND CONCOURSE

THIRD AVE

SHERIDAN

GEORGE WASHINGTON BRIDGE

W 181

Morris-Jumel Mansion

W 160

Bronx Museum of the Arts

E 163

E 161

BRONX

WESTCESTER AVE

BRUCKNER EXPWY

Harlem River

W 155

Hispanic Society of America

HARLEM RIVER DR

E 149

W 145

EIGHTH AVE

BROADWAY

Hudson River

Schomburg Center for Research in Black Culture

E 125

FIFTH AVE

THIRD AVE

SECOND AVE

FIRST AVE

TRIBORO BRIDGE

HENRY HUDSON PKWY

E 116

CATHEDRAL PKWY

CENTRAL PARK

GRAND CENTRAL PKWY

W 96

Children's Museum of Manhattan

MANHATTAN

East River

Hayden Planetarium

W 86

QUEENS

American Museum of Natural History

W 79

New-York Historical Society Jewish Museum

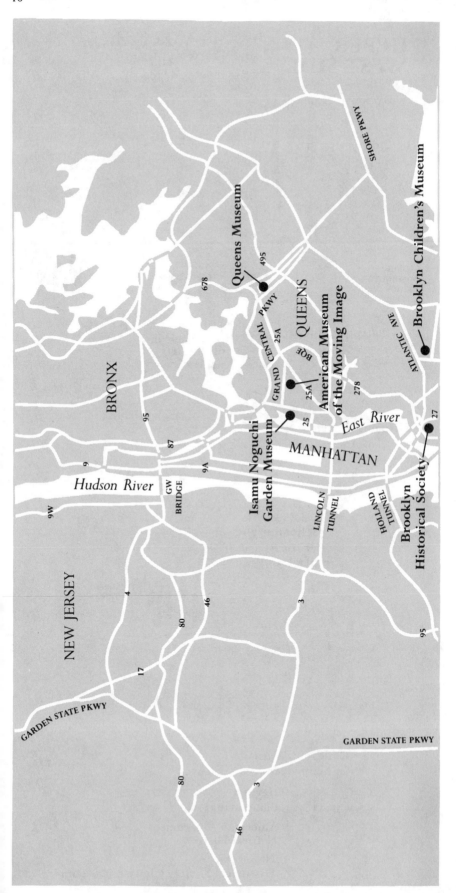

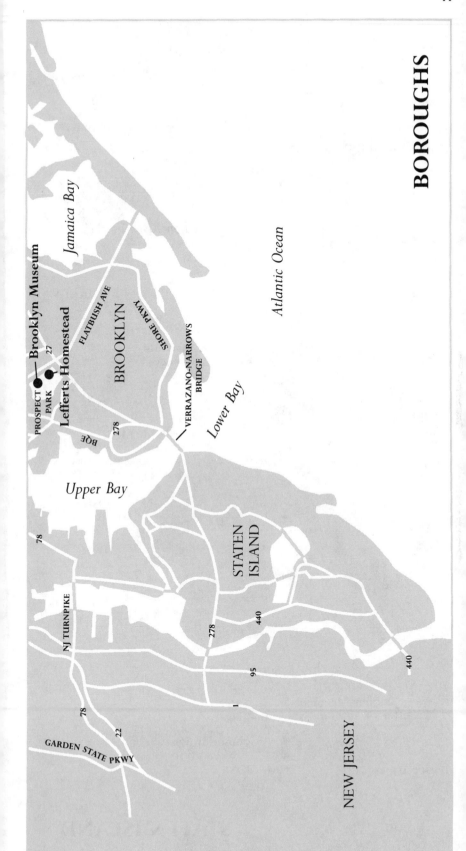

BOROUGHS

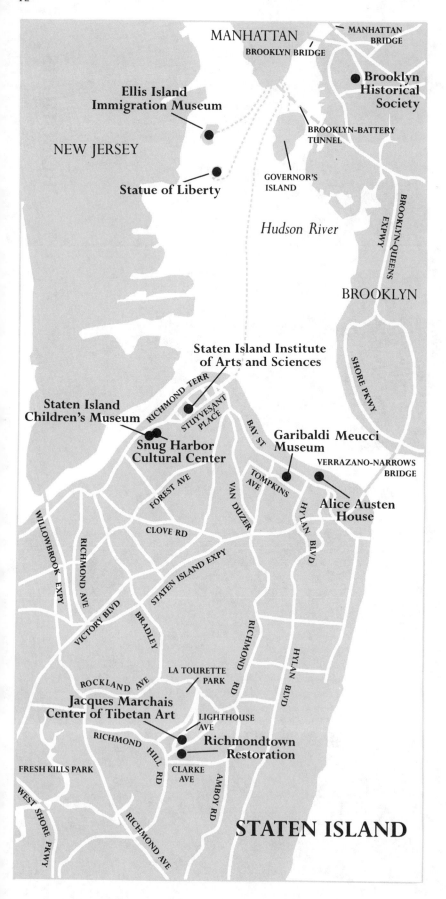

MANHATTAN

MANHATTAN BRIDGE

BROOKLYN BRIDGE

Brooklyn Historical Society

Ellis Island Immigration Museum

BROOKLYN-BATTERY TUNNEL

NEW JERSEY

GOVERNOR'S ISLAND

Statue of Liberty

Hudson River

BROOKLYN-QUEENS EXPWY

BROOKLYN

Staten Island Institute of Arts and Sciences

SHORE PKWY

RICHMOND TERR

Staten Island Children's Museum

STUYVESANT PLACE

BAY ST

Garibaldi Meucci Museum

Snug Harbor Cultural Center

VERRAZANO-NARROWS BRIDGE

FOREST AVE

VAN DUZER

TOMPKINS AVE

HYLAN BLVD

Alice Austen House

WILLOWBROOK EXPY

CLOVE RD

STATEN ISLAND EXPY

RICHMOND AVE

VICTORY BLVD

BRADLEY

RICHMOND RD

HYLAN BLVD

ROCKLAND AVE

LA TOURETTE PARK

Jacques Marchais Center of Tibetan Art

LIGHTHOUSE AVE

RICHMOND HILL RD

Richmondtown Restoration

FRESH KILLS PARK

CLARKE AVE

AMBOY RD

WEST SHORE PKWY

RICHMOND AVE

STATEN ISLAND

NEW YORK CITY MUSEUMS

The Old Merchant's House

ELLIS ISLAND
LIBERTY ISLAND
LOWER MANHATTAN
GREENWICH VILLAGE
AND SOHO

ELLIS ISLAND IMMIGRATION MUSEUM

Ellis Island, New York Harbor
New York, N.Y. 10004
212/363–5304
212/363–3204 recorded information
212/269–5755 ferry information

SUBWAY 1, 4, 5, 9, N, and R; then Circle Line ferry.

BUS M1, M6, and M15; then Circle Line ferry.

FERRY Round-trip tickets from Battery Park, $6, adults; $3, children aged 3 to 17; free, children under 3; groups of 25 or more, $5, adults.

HOURS 9 A.M. to 5 P.M. daily, except Christmas Day. Note: The third floor closes at 4:30 P.M., so start there if you arrive late in the afternoon.

ADMISSION Free; donations accepted.

HANDICAPPED FACILITIES Accessible to the disabled.

FOOD SERVICE Available.

GIFT SHOP Books, posters, T-shirts, and gift items typical of immigrants' homelands.

SPECIAL EVENTS Museum talks and films.

SPECIAL FACILITIES William Randolph Hearst Oral History Center, research library, and learning center.

AUTHOR'S CHOICE Faces of America exhibit, first floor
Treasures From Home exhibit, third floor

Few places in this country are as emotionally charged as Ellis Island, where memories of the hardships endured by nineteenth- and early twentieth-century immigrants mingle with pride in their accomplishments. Now that a masterful, $160 million restoration has been completed, Ellis Island provides fascinating insights into the immigrant experience. Anyone whose ancestors came through this "gateway to America"—which includes about half of the population of the United States—will find the visit rewarding, and, indeed, quite moving.

HISTORY
Originally, Ellis Island was merely a barren, three-acre sandbar in New York Harbor. In 1634, for a trunk full of trinkets, the local Indians sold Gull Island, or Oyster Island as it was sometimes called, to the Dutch West India Company, which had established New Amsterdam on Manhattan Island.

Not long afterward, Mynheer Paauw, a large landowner in New Amsterdam, purchased the island. His descendants sold it during the 1700s. Samuel Ellis, a merchant, bought the island during the Revolutionary War, and it remained in the Ellis family until 1808, when it was sold to New York State.

The state ceded Ellis Island to the federal government for ten thousand dollars so that a fort—Fort Gibson—could be built there shortly before the War of 1812. Fort Gibson was operated by the U.S. Army as a training center for new recruits until the end of the Civil War. It was also used to store U.S. Navy arms and ammunition.

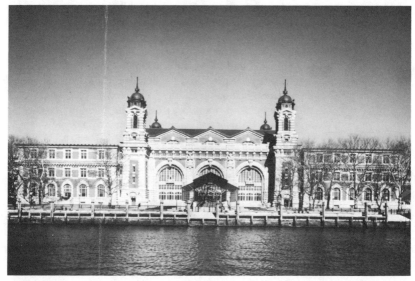

The main building of Ellis Island

Among the other fortified installations built to protect New York was the Southwest Battery, an island fort two hundred feet from the tip of Manhattan. In 1815, the Southwest Battery was renamed Castle Clinton, in honor of DeWitt Clinton, who served as mayor of New York City, senator, and governor of the state. In 1823, the federal government decided it no longer needed Castle Clinton, and gave the property to New York City. Renamed Castle Garden, it opened as an entertainment center the following year.

Castle Garden closed during the mid-nineteenth-century when New York City leased it to New York State to use as a reception center for immigrants. (At that time, individual states were responsible for immigration matters, instead of the federal government.) Castle Garden opened as the New York State Immigration Station in August 1855.

The 1840s and 1850s had seen a flood of immigrants entering the United States, chiefly from Ireland, France, and Germany. The numbers increased dramatically, beginning in 1882–83, as thousands of Eastern and Southern Europeans joined those from Northern and Western Europe, seeking a better life, free of religious or political persecution. Many were Eastern European Jews fleeing the pogroms that followed the murder of Czar Alexander II in 1881. Others came from Italy, Greece, Austria-Hungary, and Poland. The human tidal wave was so enormous that the U.S. Congress decided to place immigration control under the federal government, rather than the individual states.

Eventually, the Castle Garden facilities became cramped and outdated, and a new immigration station was needed. Castle Garden closed in April 1890, after serving as the point of entry for approximately eight-and-a-half-million people. (It was converted into an aquarium, a role it served for nearly half a century until its restoration by the National Park Service in 1946. It now serves as a National Park Service exhibit area and Circle Line ticket office.) While new facilities were being built at Ellis Island, immigrants were processed at Castle Clinton's Barge Office.

At Ellis Island, landfills had increased the size of the original three-acre sandbar to twenty-seven-and-a-half acres, encompassing three connected islands. There were docks, a seawall, and a number of wooden buildings where immigrants were received, examined, and allowed to enter the United States.

Ellis Island opened on January 1, 1892, with many of its buildings still under construction. Approximately 2,250 immigrants were processed the first day. The Ellis Island Immigration Station was finally completed on June 13, 1897. Early the following morning, a disastrous fire of mysterious origin leveled the entire complex. Fortunately, no one was hurt, but all of the immigration records, dating to 1855, were lost. The papers, transferred from Castle Garden, had been stored in the U.S. Navy's abandoned powder magazines.

While Ellis Island was being rebuilt on a larger scale, immigrants were again processed at the Barge Office. Three years and a million-and-a-half dollars later, the Ellis Island Immigration Station reopened for business on December 17, 1900.

Immigrants arriving in first- or second-class accommodations were processed aboard their ships. The great majority, however, traveled in steerage, and were received and examined at Ellis Island.

Processing could take anywhere from three or four hours to several months, depending upon an individual's health, and other factors. Ellis Island was a miniature city, with its own dormitories, kitchen, dining room, laundry, bank, hospital, contagious disease wards, morgue, power house, and railroad ticket office. Births, deaths, and marriages took place here.

The peak years for immigration were between 1892 and 1924. Restrictive laws, immigration quotas, and changing economic conditions at home and abroad gradually reduced the number of immigrants.

During World War I, more than two thousand German sailors who were caught in Allied ports at the outbreak of hostilities, were interned here. At that time, Ellis Island also served as a way station for U.S. Navy personnel, and as a U.S. Army hospital.

Immigration control took place in immigrants' homelands, beginning in 1924, and only those whose papers were not in order or who needed medical treatment were sent to Ellis Island. By 1932, the flood of immigrants had slowed to a trickle, and the island was used as a detention and deportation center, rather than as a gateway to America, for aliens who had entered the U.S. illegally or immigrants who had violated the terms of their admittance. In 1932 alone, approximately twenty thousand deportees left the United States from Ellis Island. Unable to find jobs during the Great Depression,

approximately a hundred and twenty-five thousand more returned to their homelands; only twenty-six thousand entered the country.

The tide was reversed, however, when Adolf Hitler's armies marched across Europe. Between 1933 and 1941, a quarter of a million European refugees passed through Ellis Island, including leading artists, writers, musicians, and scientists.

During World War II, part of Ellis Island was used as a Coast Guard station. In the last phase of its history, from 1941 until the famed landmark was closed in November 1954, it served as a detention center for enemy aliens. During the preceding sixty-two years, from 1892 to 1954, approximately sixteen million people entered the United States through Ellis Island.

Unable to sell the island and its buildings, the federal government declared it a national park in 1956. President Lyndon B. Johnson added it to the Statue of Liberty National Monument by presidential proclamation in 1965. It was opened to the public for limited seasonal visits in 1976, and, in 1982, the Secretary of the Interior appointed former Chrysler Corporation chairman Lee Iacocca to head a committee which would raise funds for restoration. The island was closed to the public in 1984, so that restoration work could begin.

The architectural firms of Beyer Blinder Belle and Notter, Finegold and Alexander carried out what Paul Goldberger, architecture critic of *The New York Times* has called "the most elaborate and expensive restoration of a public building in the United States . . . done with dignity and imagination."

Ellis Island reopened to the public September 10, 1990.

THE BUILDING

Near the ferry dock, the main reception building, an imposing Beaux-Arts structure of brick and limestone embellished with four hundred-foot domed towers, was designed by Boring & Tilton and opened in 1900.

Upon arrival, immigrants entered the reception room, where they were urged to check their luggage. Many refused, however, and insisted on keeping their belongings with them throughout the lengthy examinations that followed. An exhibit of baggage, with trunks and carpetbags piled one on top of another, recalls the room's original purpose.

Next, immigrants climbed the stairs to the cavernous, high-ceilinged registry room or "great hall." Doctors were stationed at the top of the stairs to spot those who were short of breath or had other physical problems. Excluding unhealthy or undesirable immigrants was as important as welcoming the able-bodied. A chalk mark on the back of an immigrant's clothing was used to identify those who appeared to have a medical problem—for example, an "E" for eyes, "H" for heart, or "X" for suspected mental disorders.

Inspectors standing at high desks near the front of the room questioned immigrants about their occupations, destinations, and the like. Medical examinations—for some the most upsetting part of the whole procedure—came next. Doctors often used a buttonhook to keep immigrants' eyelids open when checking for trachoma, a highly contagious disease.

Examination rooms and dormitories were located off the balcony above the registry room. The Stairs of Separation led from the registry room to the first floor. For some, it was a

short walk down those steps to the detention rooms and possible deportation. For others, the stairs led to the New York ferry, the railroad ticket office, and entry into America. Nearby, the Kissing Post was the scene of emotional reunions with friends and family, many of whom had been separated for years.

FIRST FLOOR **THE PEOPLING OF AMERICA**
Exhibits in the former baggage room stress the statistical aspects of immigration history. You learn, for example, that over sixty million people have come to the United States since 1600.

A novel exhibit shows some of the ethnic words that have entered the American vocabulary, including raccoon, poppycock, cabana, schmaltz, and butte, which are derived from the Powhatan Indian, Dutch, Spanish, Yiddish/German, and French languages respectively.

A computerized display enables you to view the names of those who have contributed to the American Immigrant Wall of Honor, a fundraising project designed to commemorate some two hundred thousand immigrants.

Don't miss the Faces of America exhibit, a unique photographic display which shows portraits of Americans from one direction, and the American flag from another.

SECOND FLOOR **REGISTRY ROOM**
Although this hundred-and-sixty-foot-long room is empty now, except for a few inspectors' desks and several rows of hard, wooden benches, you can imagine what it was like in its heyday. And you can almost sense the conflicting emotions of fear, apprehension, and relief experienced by those who spent hours sitting on those benches, looking at the high, arched ceiling, and waiting for their fate to be determined. Display cases on the balcony above contain early photographs of the room.

THROUGH AMERICA'S GATE
Exhibits, using original clothing, tools, and documents, describe immigration processing, step-by-step, in rooms that were originally used as legal hearing rooms, witness waiting rooms, detention quarters, and staff offices. Excerpts from approximately six hundred oral history interviews with immigrants and former staff members enliven the displays.

Arrival procedures, medical diagnosis and care, legal inspection, money exchange, railroad ticketing, mental testing, food service, and social services available to immigrants are among the subjects included.

One of the most interesting exhibits shows how officials tested the intelligence of semi-literate and illiterate immigrants. People with limited schooling, and some who had never held a pencil in their lives were asked to draw a diamond, with widely varying results. In visual comparison tests, immigrants were asked to match drawings of leaves, and to put together small blocks on which faces with different expressions were depicted.

Single women were not allowed to leave Ellis Island with any man who was not related to them, including a fiancé, so marriages often took place on the island.

PEAK IMMIGRATION YEARS

Exhibits on the opposite end of the second floor include a wall of immigrant passports, steamship posters, and a large photograph of market day in Strij, Galicia, in 1905. The picture graphically re-creates a turn-of-the-century village, complete with horse-drawn carts and clusters of gossiping, shawl-draped women.

Orphan children whose mothers were killed in a Russian massacre, October 1900

Between 1880 and 1924, the peak period for immigration, over twenty-six million people entered the United States. Many were fleeing from the Ukraine, where, as described here, twelve hundred pogroms took place in 1918–19.

TREASURES FROM HOME

THIRD FLOOR

Treasures From Home is a fascinating potpourri of items loaned or donated to the National Park Service by families of immigrants.

Display cases filled with the belongings of specific families from Yugoslavia, Turkey, Italy, Denmark, and Switzerland help to personalize history. Other exhibits show many of the objects considered too precious to leave behind—prayer books and bibles, family documents, a sewing machine, embroidered dresses, handmade linens, a long-stemmed pipe, a box camera, an accordion, a samovar, a spinning wheel, crockery and copper pots, and even a coconut from West Guyana as a reminder of home.

A glance at the homelands listed on a wall of photographic portraits is a reminder that immigrants came to America from every corner of the globe.

ELLIS ISLAND CHRONICLES

Exhibits detail the history of Ellis Island from a three-acre, uninhabited sandbar to a twenty-seven-and-a-half-acre complex of brick and stone buildings.

Highlights include a series of scale models showing how the island looked in 1854, when the War Department began building Fort Gibson, and in 1897, when the size of the island was doubled with landfill, to the 1940s.

RESTORING A LANDMARK

Photographs show various phases of the restoration work that transformed Ellis Island from an abandoned wasteland into a museum that re-creates an important aspect of American immigration history.

SILENT VOICES

Rusty metal cabinets and a grime-encrusted, broken piano are a few of the objects here that show how Ellis Island looked after it was closed in 1954. Black-and-white photographs of vacant, dilapidated buildings on the island tell a poignant story of abandonment and decay.

DORMITORY ROOM

Continue along the balcony above the registry room to see a typical dormitory room of the early 1900s. From 1900 to 1908, there were two long, narrow rooms on either side of the balcony, used as men's and women's dormitories, which could accommodate three hundred people. In 1924, single beds with mattresses replaced the canvas bunks, and families were assigned to private rooms.

STATUE OF LIBERTY

American Museum of Immigration
Liberty Island, New York Harbor
New York, N.Y. 10004
212/363–8828
212/269–5755 ferry information

SUBWAY	1, 4, 5, 9, N, and R; then Circle Line ferry.
BUS	M1, M6, and M15; then Circle Line ferry.
FERRY	Round-trip tickets from Battery Park, $6, adults; $3, children aged 3 to 17; free, children under 3; groups of 25 or more, $5, adults.
HOURS	9 A.M. to 6 P.M. daily, June, July, and August; 9 A.M. to 4 P.M. daily, Labor Day through Memorial Day.
ADMISSION	Free; donations accepted.
HANDICAPPED FACILITIES	Immigration exhibit accessible to the disabled. Statue of Liberty accessible only to observation level.
FOOD SERVICE	Available.
SPECIAL EVENTS	Concerts.
AUTHOR'S CHOICE	Statue of Liberty exhibit Exhibit of immigrants' clothing and artifacts

> "Give me your tired, your poor,
> Your huddled masses yearning to breathe free,
> The wretched refuse of your teeming shore.
> Send these, the homeless, tempest-tost to me,
> I lift my lamp beside the golden door!"
> Emma Lazarus

Visitors from all parts of the world are drawn to this icon of American freedom, whose purpose was described so well by Emma Lazarus. The exhibits on Liberty Island document our roots as a nation of immigrants. Equally impressive are the spectacular views of the New York skyline from various levels surrounding the 151-foot-high statue.

HISTORY
Originally, Liberty Island was known as Bedloe's Island. During 1746–47, it was owned by Archibald Kennedy, who spent his summers here. The island served as a quarantine station during smallpox epidemics in the period before the Revolutionary War.

The United States government acquired the property and established Fort Leonard Wood here from 1808 to 1812, in honor of a hero of the War of 1812. It was later used as a Civil War recruitment camp and an ordnance depot. In 1877, the government gave the property to the Liberty project.

The twelve-acre Liberty Island Park is now administered by the U.S. Department of the Interior, National Park Service.

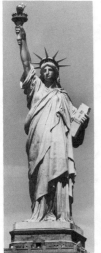

The Statue of Liberty

STATUE OF LIBERTY

French historian Edouard de Laboulaye proposed the monument in 1865 to mark America's 100th anniversary as a nation and to emphasize the French-American alliance during the Revolutionary War.

In 1871, Frederic Auguste Bartholdi, a classical sculptor who won the commission for the statue, visited America to promote the concept. During that trip, he kept a diary in which Bedloe's Island was mentioned as a possible setting for the statue. Bartholdi's inspiration for his work was the *Colossus* of Rhodes, a gigantic statue of the sun god that dominated the harbor of Rhodes and was one of the seven wonders of the ancient world. In developing the design for *Liberty Enlightening the World*, he is thought to have drawn upon such diverse sources as his mother's face, the Freemasons, and ancient Roman coins.

Bartholdi began by making a forty-nine-inch-high model of the statue in clay. This was enlarged repeatedly in plaster until there were three hundred full-sized sections. During the repoussé process, copper sheets only three thirty-seconds of an inch thick are hammered into shape against wooden forms that match the contour of the plaster casts. They are bound together by iron bands and joined to the framework.

The massive figure presented structural problems which were solved by engineer Alexandre Gustave Eiffel, who later built the Eiffel Tower in Paris. Eiffel devised a way to make the statue strong enough to withstand gusty winds, yet flexible enough to expand and contract with fluctuating temperatures. He built an interior framework of wrought iron that was attached to the copper skin with flexible iron bars.

The people of France presented the Statue of Liberty to the Minister of the United States on July 4, 1884. The statue was shipped to the United States in 214 cases aboard a French ship in May 1885 and was dedicated by President Grover Cleveland in October 1886. The dedication ceremonies, attended by representatives of both countries, included fireworks and the ceremonial unveiling of Liberty's face.

The statue and its pedestal were built without government funds and required extensive fundraising in the United States and abroad. In France, public lotteries and displays of the head and the torch at large expositions helped to raise $400,000 for construction of the statue. Fundraising for the pedestal began in the United States in 1871, and the cornerstone was laid in 1884. Construction was halted, however, because of lack of funds.

Joseph Pulitzer, publisher of the *New York World*, came to the rescue with editorials and cartoons in a campaign that benefited both the pedestal project and his financially strapped newspaper. By August 1885, Pulitzer had raised $100,000, chiefly in small donations, and had boosted his paper's circulation as well.

The pedestal of the statue was designed by Richard Morris Hunt of rusticated blocks of Stony Creek granite and concrete. He envisioned the shields around the base emblazoned with the coats of arms of the then-forty states. The pedestal was originally set on a base enclosed by the star-shaped bastions of the old fort but it was altered to accommodate the immigration exhibit.

"The New Colossus," a poem by Emma Lazarus, was

inscribed on a tablet in the pedestal in 1903. The floodlights at the base were added in 1916 and the statue became a national monument in 1924. It was repaired and strengthened in 1937 and again in 1986.

Liberty weighs 225 tons and stands 151 feet tall on an eighty-nine-foot pedestal. The torch, which extends 305 feet above sea level, shines through leaded glass, illuminated by nineteen lamps with a total of thirteen thousand watts. The statue's scale is truly monumental: the lady's waist measures thirty-five feet around, her mouth is thirty-five feet wide, and her index finger is eight feet long.

Stairways and a glass-enclosed elevator ascend to the top of the pedestal. From there, a twenty-two-story spiral staircase goes to the crown. Because of the great popularity of this attraction, there is sometimes a two- or three-hour wait to climb to the crown.

STATUE OF LIBERTY EXHIBIT

Exhibits document the evolution of the statue, from 1865, when it was first suggested by Laboulaye, through its dedication twenty-one years later, to its twentieth-century role as a symbol of hope for immigrants, and its recent restoration.

In addition to the historical displays, there are exhibits that include replicas of the statue in French and Irish crystal, and folk art replicas of the famous statue. Also here are a full-size replica of Liberty's face, created in copper repoussé especially for the exhibit; an original bust of Laboulaye by Bartholdi, and Laboulaye's three-volume *History of the United States*.

Over a thousand postcards of the Statue of Liberty, including some turn-of-the-century scenes, embellish two eight-by-ten-foot murals by Brooklyn artist Eugenia Balcells. The postcards were collected for thirty-five years by Michael Forster of Farmville, North Carolina, who donated them to the National Park Service, sponsor of the Liberty exhibit.

IMMIGRATION EXHIBIT

These galleries, opened in 1972, document the history of American immigration. The exhibit is presented chronologically and by nationality, beginning with Native Americans who emigrated from Asia approximately twenty thousand years before the European colonists, and ending with current refugees. Photographs, maps, charts, murals, statuary, documents, dioramas, and audio-visual displays help to tell the story. One of the most interesting displays includes the clothing and other artifacts some immigrants brought with them to America.

Between 1820 and 1870, millions of immigrants arrived in America, with ships docking in New York harbor almost daily. The displays indicate that some were fleeing religious persecution, famine, or wars. Others were seeking better economic conditions or simply the adventure of life in a new country.

None found the streets paved with gold but many achieved great success in the fields of government, science, engineering, industry, art, music, and the theater. And all, seeking freedom and opportunity, helped to create the rich mosaic of the United States.

CITY HALL
THE GOVERNOR'S
ROOM

Broadway and Murray Street
New York, N. Y. 10007
212/566-5459

SUBWAY 2, 3, 4, 5, 6, N, and R.

BUS M1, M6, M15, M101, and M102.

HOURS 10 A.M. to 4 P.M. Monday through Friday.

TOURS May be arranged in advance by calling the City Council office, 212/566-5250.

ADMISSION Free.

HANDICAPPED Accessible through the side entrance; elevator.
FACILITIES

MUSEUM Related items may be purchased at CityBooks, 61 Chambers
SHOP Street.

AUTHOR'S George Washington's writing desk
CHOICE

The Governor's Room in City Hall is actually three rooms— not one. Designed originally for the use of New York's governor during his visits to the city, it has evolved into a grand reception space and a municipal art gallery, containing a desk used by George Washington and some fine period furniture and paintings.

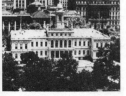

City Hall

HISTORY
In 1802, architects Joseph François Mangin and John McComb won a competition to design New York's City Hall. Although they were both named winners, McComb alone was appointed supervising architect and his name was engraved on the cornerstone without that of his partner on the project.

Construction of City Hall began in 1803. Not until 1810– 11 did plans begin to take shape for the room eventually set aside for the governor. It was to be a large room, fifty-two by twenty feet, in the center front of the second story. Pilasters on the walls and a decorative frieze encircling the room hint at its elegance and importance. A special chamber for the use of the governor was not mentioned until 1813, however.

State and city funds for furnishing the room were appropriated in 1814. That year, the Common Council paid cabinetmaker Charles Christian $1,144 for twenty-four mahogany chairs (at $21 each), two seven-foot sofas (at $90 each), two dining tables for $60, and two antique writing tables ($200 each). (In those days, "antique" referred to style, rather than age.) The walls were painted green; ornately swagged crimson and gold draperies were hung, and rich Turkish carpets were installed by 1816.

When the city needed a place to display a newly acquired

bust of DeWitt Clinton by Henri Consieu, officials realized that the Governor's Room was too small for the growing municipal art collection that was housed there. To meet the need for additional space, the comptroller's office, a small room to the west, was connected to the Governor's Room in 1832. The east room, originally used by the judges of the Supreme Court, was added in 1848–49.

Throughout the 1840s, city officials were apparently quite interested in decorating and maintaining the Governor's Room. In 1844, the Committee on Public Offices and Repairs recommended painting the room and reupholstering the furniture. They also acquired some property associated with George Washington, including a handsome mahogany desk stored at the Bellevue almshouse on which Washington wrote his first message to the Continental Congress in 1789.

In 1847, several armchairs were moved from the Aldermanic Chamber to the Governor's Room. Made by the noted French-born cabinetmaker, Charles Honoré Lannuier, the chairs were originally designed for the Common Council chamber.

The Governor's Room had to be cleaned and painted again as a result of an 1858 fire at City Hall that began when sparks from a fireworks display ignited. The fireworks had been set off to celebrate the laying of the Atlantic cable. The room was renovated and repainted periodically throughout the remainder of the nineteenth century. It was completely redecorated by the firm of Pottier and Stymus in 1884–85, and electricity was installed in 1899. A 1905 redecoration by the Bernstein and Bernstein Company provoked a storm of controversy because of the design, workmanship, and expense. Among other changes, five elaborate silver, gilt, and crystal chandeliers were installed and the walls were painted Pompeiian red.

Mrs. Russell Sage, a critic of the redecoration, arranged for the Russell Sage Foundation to fund a 1907–09 restoration of the Governor's Room, under the direction of architect Grosvenor Atterbury. A *New York Daily Tribune* account pronounced the restored room "perhaps the finest in a public building in the country." Atterbury's goal was to return the room as closely as possible to its original state. Although various nineteenth-century alterations had destroyed most of the original woodwork, he succeeded in following the spirit, if not the letter, of the original plan. With the exception of the paint and draperies, the room that visitors see today is the 1907 restored version.

Atterbury was called upon again in 1936 to supervise a three-year restoration project that included repainting the room, reupholstering the furniture, and installing new draperies. The paintings and furniture were removed when World War II threatened, and, in 1941–42, the city's Office of Civil Defense moved desks and file cabinets into the elegant rooms. After the war, various civic bodies reportedly coveted the space, but, fortunately, the Governor's Room was restored to its original function as a municipal museum in 1947. It has been refurbished several times since then, most recently in 1983. The Art Commission of the City of New York is responsible for documenting and caring for the historic objects here.

In addition to focusing attention on the city's history and to

displaying portraits of New York's most prominent citizens, the Governor's Room has traditionally been the scene of momentous events, both happy and sad. Among those honored here were General Lafayette during his triumphal tour of America in 1824–25; ex-President Martin Van Buren in 1841; Sam Houston, a leader in Texas's fight for independence from Mexico, in 1855, and, more recently, visiting kings, queens, prime ministers and presidents, as well as governors. Events as varied as the city's official welcome to the Japanese Embassy in 1860 and the viewing of Horace Greeley's body in 1872 have taken place within these historic walls.

At the head of the staircase, not far from the Governor's Room, Abraham Lincoln's body lay in state in April 1865. Approximately 120,000 grieving New Yorkers paid their last respects here.

On happier occasions, ticker-tape parades in honor of visiting celebrities generally begin at City Hall and proceed up Broadway.

THE BUILDING

This is New York's third City Hall. The first Dutch *Stadt-huys* was located in a former tavern on Pearl Street in 1653. The second City Hall, erected by the English during the eighteenth century, stood at the corner of Wall and Broad Streets, where Federal Hall National Memorial is located today.

The present City Hall, surrounded by a leafy park, combines French Renaissance ornamentation with Federalist form. Its two wings balance a central portico. The five arched windows of the Governor's Room can be seen directly above the portico.

To save money, the building was constructed of marble on the south, or downtown, side, and less expensive brownstone was used on the north or uptown side. Budget-conscious officials reasoned that, since nobody lived north of Chambers Street, the brownstone would not be noticed. In 1956, the entire façade was replaced with Alabama limestone.

A statue of George Washington stands in the main lobby. It is a bronze replica of the statue of Washington by Jean Antoine Houdon in the state capitol building in Richmond, Virginia. The mayor's office is in the west wing on this floor, and the president of the City Council has an office in the east wing.

An impressive curved double staircase of marble and wrought iron leads to the second floor. The City Council chambers and the Board of Estimate are located here, in the east and west wings respectively.

CENTRAL ROOM

In addition to portraits of noted Americans, the three-room governor's suite contains changing exhibits relating to George Washington. Visitors might see, for example, a remnant of the Washington Inaugural flag of 1789, the American flag that flew over Lafayette's grave in Paris, or items relating to the centennial of Washington's inauguration.

The writing table Washington used at Federal Hall in 1789 stands in the center of the room. John Trumbull's portraits of Washington and George Clinton, the first governor of New York, hang above the white marble fireplaces at opposite ends of the room. Trumbull's portraits of Alexander Hamilton and

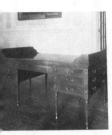

George Washington's writing desk

John Jay, America's first secretary of Foreign Affairs, are also here.

Trumbull, the son of the governor of Connecticut, studied painting with Benjamin West in London and Paris after fighting in the War of Independence. When he returned to America in 1816, his work focused on the heroes and events of the Revolutionary War era.

Red damask draperies with red-and-white striped swags hang at the windows both here and in the adjoining East Room. The sofas are covered in the same striped fabric.

The two long sofas in this room were made by Charles Christian in 1814. A close examination of the chairs in all three rooms reveals certain minor differences. Some have backs measuring eighteen inches across and others have nineteen-inch backs. It is believed that some of the chairs were made for the Governor's Room by Charles Christian, and the others, crafted by Lannuier for the Common Council Chamber, were moved to the room in 1847.

WEST ROOM

A handsome Sheraton mahogany gateleg table and chairs stand in the center of the room. An 1827 portrait of DeWitt Clinton by George Catlin hangs above the mantelpiece. Catlin was a Philadelphia portrait painter who is remembered today for his books and paintings about American Indians.

In addition to portraits of former New York mayors, several presidential portraits by John Vanderlyn are worth noting. His *James Monroe*, *Andrew Jackson*, and *Zachary Taylor* are here. Vanderlyn's portrait of George Washington hangs in the House of Representatives Chamber in Washington, D.C.

EAST ROOM

An antique rose medallion punch bowl stands in the center of the Sheraton mahogany banquet table.

The walls are lined with paintings of some of New York's most illustrious citizens. They range from a 1620 portrait of Henry Hudson by Paul Van Somer and a Trumbull portrait of Governor Peter Stuyvesant to a Vanderlyn portrait of Governor Joseph Christopher Yates and Rembrandt Peale's 1848 painting of James Kent, Chief Justice of the New York Supreme Court. Notice Samuel F. B. Morse's 1828 painting of Christopher Columbus. Morse, inventor of the electric telegraph, was also one of the best early American portrait painters.

John Wesley Jarvis's portrait of Oliver Hazard Perry, commander on Lake Erie in 1812–13, and Thomas Sully's painting of naval hero Stephen Decatur, hang above a pair of Empire desks. These are presumably the "antique writing tables" ordered from Charles Christian in 1814.

FEDERAL HALL

26 Wall Street
New York, N.Y. 10005
212/264-8711

SUBWAY	2, 3, 4, 5, J, and M.
BUS	M1, M6, and M15.
HOURS	9 A.M. to 5 P.M. Monday through Friday. Closed holidays, except Washington's Birthday and July 4.
TOURS	Group tours available by appointment.
ADMISSION	Free.
HANDICAPPED FACILITIES	Accessible to the disabled at 15 Pine Street.
MUSEUM SHOP	Books, postcards, posters, slides, and souvenirs relating to early American history.
SPECIAL EVENTS	Educational programs, seminars, historical celebrations, and film showings. Musical programs in the rotunda Wednesdays at 12:30 P.M.
AUTHOR'S CHOICE	Suit worn by George Washington at his presidential inauguration

Some of the most momentous events in New York history took place on this site, including the inauguration of the first president of the United States and actions leading to the establishment of freedom of the press, the repeal of the Stamp Act, and ratification of the Constitution and the Bill of Rights.

HISTORY

In 1699, Abraham de Peyster donated land near Broadway at the corner of Wall and Nassau Streets for the first English City Hall, which replaced Nieuw Amsterdam's *Stadt-huys* at 71 Pearl Street. Four years later, the municipal government, including the law courts and a debtor's prison, moved into what was then a three-story, red brick, Georgian building.

In 1735, John Peter Zenger, a printer and publisher of the *New York Weekly Journal*, printed strong criticisms of William Cosby, the royal governor. The Governor's Council ordered that issues of the newspaper containing the words to some anti-Cosby songs be burned in the middle of Wall Street. Zenger, accused of "seditious libel," was imprisoned at City Hall for nine months awaiting trial. When Chief Justice James DeLancey, the presiding judge and a friend of Cosby, disbarred Zenger's lawyers, the *Weekly Journal*'s backers arranged for Andrew Hamilton, a distinguished Philadelphia attorney, to plead his case. Hamilton argued that Zenger had printed the truth and that truthful criticism of a government was not seditious libel. Zenger was acquitted, and the principle of freedom of the press, first expressed here, was established fifty-six years later in the Bill of Rights.

The Stamp Act, passed by the English Parliament in 1765 to help pay for British troops in the American colonies, was extremely unpopular with New Yorkers. Special stamps, costing between two pence and ten pounds each, were supposed to be attached to a long list of items, including newspapers, playing cards, and legal documents. New York officials petitioned King George III and Parliament to repeal the act, and a Committee of Correspondence was formed to communicate with other colonies. In October 1765, twenty-seven delegates, representing nine of the thirteen colonies, met at City Hall in the "Stamp Act Congress." The Declaration of Rights and Grievances that resulted from their nineteen-day session stated that Americans had the same rights as Englishmen and could not be taxed without their consent. The following year, a series of mass meetings, a boycott of British goods, and a concerted effort to buy American-made products led to the repeal of the Stamp Act.

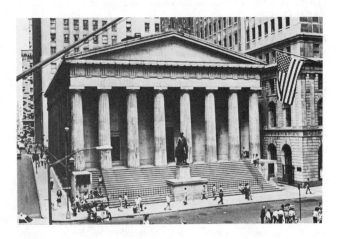

Federal Hall

When the British occupied New York during the Revolutionary War, from 1776 to 1783, City Hall became their headquarters and the Provincial Congress met in White Plains.

The most important events on this site began in January 1785 when the Congress assembled in City Hall. At that time, each of the thirteen states had one vote, despite differences in size and population, and each considered itself independent.

Two years later, when the constitutional convention met in Philadelphia to devise a new form of American government, New Yorkers played a prominent role in developing a constitution to replace the earlier Articles of Confederation. To combat some of the arguments against the proposed document, Alexander Hamilton and John Jay of New York, with Virginian James Madison, wrote a series of eighty-five articles that were published in New York newspapers and reprinted throughout the country. These *Federalist* papers expounded political theory and helped to shape public opinion in favor of the new constitution.

In 1788, New York was designated the capital of the United States and City Hall—renovated under the supervision of Pierre Charles L'Enfant, who later planned Washington, D.C.—was renamed Federal Hall. On March 4, 1789, the Senate and the House of Representatives met for the first time in separate wings of the building. And on April 30, 1789, George Washington, standing on a second floor balcony of

Federal Hall, took the oath of office as the first president of the United States.

Even though all but two states had ratified the Constitution, many Americans feared that the new government might be too powerful. They realized that the Constitution did not include any protection for personal liberties. Therefore, when the House of Representatives met in Federal Hall in June 1789, Madison proposed a number of Constitutional amendments. Twelve amendments passed both the House and the Senate and were submitted to the states for approval that September. Ten of the twelve—known as the Bill of Rights—were ratified by December 1791. They guarantee freedom of the press, speech, and religion, as well as many other individual rights.

Federal Hall continued to be the focal point of political and legal events in New York until the early nineteenth century. After the federal government moved, first to Philadelphia in 1790 and then to Washington, D.C. in 1800, the city government began to outgrow its space in Federal Hall. By 1812, a new, larger city hall had been built and the crumbling old Georgian building, still called Federal Hall, was sold for salvage for $425.

The present building, originally designed as a U.S. Customs House, was completed in 1842. Twenty years later, the Customs House became one of six subtreasuries included in the Independent Treasury System. After subtreasuries were abolished in 1920, the building was used by a number of governmental agencies. At various times, the steps on the Wall Street side, in the shadow of George Washington's statue, have been the site of war bond rallies, patriotic celebrations, and press conferences. The building was declared a national historic site in 1939 and was designated a national memorial, administered by the National Park Service of the U.S. Department of the Interior, in 1955.

THE BUILDING

Designed by Ithiel Town and Alexander Jackson Davis and completed in 1842, this building of Westchester marble is considered to be one of the finest examples of Greek Revival architecture in America. The classical pediment and the eight Doric columns at each end of the structure are reminiscent of the Parthenon, the temple to the goddess Athena in Athens.

(Greek Revival architecture was popular in this country from approximately 1820 to 1850, partly because it made a political statement, harking back to ancient Greek ideals of beauty, simplicity, and democracy.)

A bronze statue of George Washington by John Quincy Adams Ward, erected in 1883, stands in front of the building.

Inside, there are permanent exhibits relating to early New York and American history in the rotunda and nearby galleries. Temporary exhibitions are mounted on the second floor.

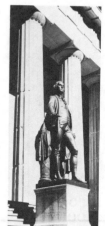

George Washington
by John Quincy Adams Ward

ROTUNDA

FIRST FLOOR

Sixteen Corinthian columns of Westchester marble encircle the spacious, marble-floored rotunda.

Several exhibits are devoted to the architecture of the present building and the two that formerly stood on this site. Some of the important political events that have occurred at Federal Hall are also described.

Notice the inaugural stand that also serves as a rostrum for

public programs. It incorporates a piece of the balcony railing from the original Federal Hall.

Two vaults, originally used to store money, recall earlier periods in the building's history. In one, barrels filled with goods such as zinc, ink powder, and bolts of cloth, recall the Customs House days. Ship captains brought their cargo lists here and paid the duties assessed by customs officers while their ships were anchored in the East River.

The other vault shows the work done by clerks of the subtreasury in the late nineteenth century, including checking for counterfeit money and counting and sorting bills and coins.

GEORGE WASHINGTON ROOM

This room adjoining the rotunda contains some of the most important objects in the museum. Here, for example, are the plain brown suit, manufactured in Connecticut, that Washington wore for his inauguration. Choosing simple, American-made clothing sent an important political message to citizens in the post-revolutionary era.

Also here is the large, leather-covered Bible Washington borrowed from St. John's Masonic Lodge in New York to use in taking the oath of office. President George Bush used this Bible in 1989 during ceremonies marking the bicentennial of Washington's inauguration.

Among exhibits to note is a diorama of the first inaugural parade that proceeded from Washington's home on Cherry Street near the Brooklyn Bridge to Federal Hall.

WEST GALLERY

An eight-minute orientation video, "Journey to Federal Hall," is shown regularly. It describes the events leading to the establishment of the first government under the Constitution at Federal Hall.

Scale models depict the three buildings that have stood on this site—the eighteenth-century City Hall and Federal Hall and the present, mid-nineteenth-century Federal Hall.

EAST GALLERY

"A Promise of Permanency," an exhibit on the Constitution, has been installed by the IBM Corporation. By touching a computer screen, you can learn how the Constitution was developed and the role it has played in the history of the United States.

SECOND FLOOR

Galleries on the second floor showcase temporary exhibits, often presented by the National Park Service in cooperation with other organizations. Historic Hudson Valley, founded by John D. Rockefeller, Jr., in 1951 to preserve America's Hudson River heritage, is particularly concerned with the history and architecture of Federal Hall.

Other exhibition topics range from the work of Alexander J. Davis, a prominent nineteenth-century architect, to New York City politics and history.

In "The Constitution Works" program, educational programs for school groups are developed to increase students' awareness and understanding of the Constitution. Students visit Federal Hall and take part in a hypothetical scenario involving a Constitutional issue.

FRAUNCES TAVERN MUSEUM

54 Pearl Street
New York, N.Y. 10004
212/425–1778

SUBWAY	1, 4, 5, E, N, and R.
BUS	M1, M6, and M15.
HOURS	10 A.M. to 4 P.M. Monday through Friday year round; Noon to 5 P.M. Sunday, October through May. Closed Saturdays and major holidays. Open for Washington's Birthday and Fourth of July.
TOURS	Group tours available.
ADMISSION	Suggested contribution $2.50, adults; $1, students, senior citizens, and children under 12 accompanied by an adult. Free admission on Thursday. Fraunces Tavern Museum Associates, Friends of Fraunces Tavern, George Washington Fellows, and members of the Sons of the Revolution in the State of New York, free.
FOOD SERVICE	Restaurant on the first floor.
MUSEUM SHOP	Books, postcards, gift and souvenir items.
SPECIAL EVENTS	Thursday lunchtime lecture series and Sunday afternoon entertainment programs.
MEMBERSHIP	Fraunces Tavern Museum Associates, from $20.
AUTHOR'S CHOICE	The Long Room

Dwarfed by the nearby glass-and-concrete skyscrapers in the heart of New York's financial district, this brick building at the corner of Dock (now Pearl) and Broad Streets was a center of political and commercial activity during the Revolutionary War period. George Washington bade an emotional farewell to his officers here in 1783. The building also served as the first headquarters for the executive branch of the government.

There is a restaurant on the first floor, as well as a museum with two period rooms, and a series of changing exhibitions devoted to American history and culture on the second and third floors.

HISTORY

This three-and-a-half story house was originally built in 1719 as a family home for Stephen Delancey and his wife, Anne, the daughter of Stephanus Van Cortlandt. The Delanceys may have lived here between 1719 and 1722. Afterward, the building was used as office and warehouse space. For a short time in the 1730s, an English actor rented the house and Henry Holt, a dancing teacher, held classes here from 1730 to 1740.

In 1762, Samuel Fraunces, a native of the West Indies, purchased the building for two thousand pounds and opened the Queen's Head Tavern. In those days, a tavern was more

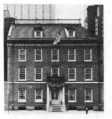

Fraunces Tavern

than simply a place to eat and drink. It was a public gathering place. Ship owners posted details of their ships' arrivals and departures on the tavern wall, and merchants exchanged information and conducted business over a glass of Madeira or punch. Fraunces soon established a reputation for serving excellent food and drink, and the Queen's Head became one of New York's most popular taverns. The New York Chamber of Commerce was founded in the tavern's Long Room in 1768.

Both sides in the Revolutionary War enjoyed the tavern's facilities. In 1774, before the war began, the Sons of Liberty met at the Queen's Head. During the British occupation of New York City from 1776 to 1783, British troops were frequent visitors.

During the Revolutionary War, when British popularity lessened, Fraunces decided that the name of his tavern—originally selected in honor of Queen Charlotte, the wife of King George III—was inappropriate. The tavern was generally referred to as Fraunces's tavern, after its owner. Fraunces was sometimes called "Black Sam," but the 1790 federal census listed him as "free, white, head of household."

In 1785, Fraunces sold the tavern building and retired to rural New Jersey. When George Washington was elected president four years later, he invited Fraunces to be his steward in the Executive Mansion. Within a year, Washington fired Fraunces for spending too much money on food and for serving good food and wine to the servants. Good stewards must have been in short supply, however, because Fraunces was rehired soon afterward. He remained as chief of Washington's household until June 1794.

When Fraunces retired from tavernkeeping in 1785, he leased the building to the government and then sold it to George Powers, a Brooklyn butcher who continued the federal government's lease. John Jay, the first secretary of Foreign Affairs (later the Department of State) was headquartered there for three years. Jay and his six-member staff negotiated treaties with Prussia in 1785 and Morocco in 1786 and engaged in discussions with Spain over American shipping rights here. The building also housed the Treasury Department and the War Department under Henry Knox.

After 1788, ownership of the building changed frequently. It was used as an inn, a hotel, and a meeting place. In 1876, the Society of the Sons of the Revolution in the State of New York was founded here. In 1904, that organization purchased the tavern.

The following year, William Mersereau, one of the first architects to specialize in historic preservation, was hired to restore the tavern building. Fraunces Tavern Museum, the eighth oldest museum in New York City, opened to the public in 1907. It also serves as headquarters for the Sons of the Revolution in the State of New York.

In 1976, the building next door at 58 Pearl Street was renovated to house the Davis Center for American History.

Fraunces Tavern has been designated a New York City landmark. Its entire block is included in the National Register of Historic Places.

VISITOR ORIENTATION EXHIBITION
An introductory exhibit near the museum shop includes reproductions of photographs, paintings, and period artifacts

that interpret the history of Fraunces Tavern and its role in the social, political, and economic life of New York City.

The display focuses on biographical information about Samuel Fraunces, proprietor of the tavern from 1762 to 1785, and the various uses of the building, from a private residence to a merchant's warehouse, a city tavern, a government office, and finally a museum.

THE LONG ROOM

This re-creation of an early tavern is based on extensive research of inventories and estates of eighteenth-century tavernkeepers. The standing bar, tavern tables, Windsor chairs, brass candlesticks, and eighteenth-century wine glasses were typical furnishings. White clay pipes and tobacco were available from the tavernkeeper.

The Long Room

You can visualize the scene here December 4, 1783, when the officers who had served with Washington during the Revolutionary War stood listening attentively as he bade them farewell.

The week before, on November 25, 1783, British troops had left New York after a seven-year occupation. Following a parade down Broad Street, Fraunces Tavern was the scene of New York Governor George Clinton's Evacuation Day celebration. Among those attending were Washington, New York Mayor James Duane, and the French Ambassador. The celebrants consumed 133 bottles of Madeira, wine, and beer, drinking thirteen toasts that saluted Louse XVI, Gustav II of Sweden, Lafayette, and the French Army and Navy, among others. The final toast was "let this day be a lesson to princes."

CLINTON ROOM

This room is named in honor of George Clinton, the first American-born governor of New York.

Furnishings include an early nineteenth-century dining table and chairs with pale green upholstery that may have come from Duncan Phyfe's workshop nearby on Fulton Street. The table is set for dessert, and blue-and-white Chinese export porcelain can be seen on the sideboard.

The scenic wallpaper is particularly noteworthy. It was manufactured in 1838 by Jean Zuber in Alsace. Scenes of the American Revolution were hand printed with woodblocks over an earlier scenic design. Post-revolutionary patriotic fervor produced an amusing anachronism. Lord Cornwallis's 1781 surrender at Yorktown was printed over a view of the Hudson River valley in the 1820s. Zuber scenic wallpaper can also be seen in the Diplomatic Reception Room of the White House in Washington, D.C.

CHANGING EXHIBITIONS

The museum mounts a series of changing exhibitions devoted to the study and interpretation of early American history and culture.

LOWER EAST SIDE TENEMENT MUSEUM

97 Orchard Street
New York, N.Y. 10002
212/431–0233

SUBWAY	B, D, F, and Q.
BUS	M15.
HOURS	11 A.M. to 4 P.M. Tuesday through Friday; 10 A.M. to 3 P.M. Sunday.
TOURS	Every Sunday; hours vary. Call for current schedule.
ADMISSION	$1, suggested donation. From $5 to $12 for walking tours and dramatizations, with discounts for senior citizens and children.
MEMBERSHIP	From $20.

The Lower East Side Tenement Museum

The six-story tenement at 97 Orchard Street, unoccupied since 1935, now houses the nation's first living history museum dedicated to urban immigrant life. Photographic displays, oral histories, exhibitions, walking tours, lectures, and dramas vividly re-create the world of America's immigrants.

Visiting the fledgling museum and strolling the surrounding streets transports you to another era. Here, tenements still predominate in one of the few New York neighborhoods to escape demolition by developers. The neighborhood remains a magnet for new arrivals. Gone are the twenty-five thousand pushcarts that clogged the narrow streets when immigrants called the Lower East Side home. But bargains still abound on counters and racks in front of the area's many discount stores.

HISTORY

The Lower East Side Tenement Museum was founded in 1984 by Ruth J. Abram to preserve and interpret the life of the diverse ethnic groups who lived in this part of New York between 1863 and 1935.

The museum operated out of the historic Eldridge Street Synagogue until 1987, when it moved to 97 Orchard Street. A capital campaign is currently underway to enable museum officials to purchase and renovate the property.

New York's first tenements—defined as five- to six-story buildings squeezed onto twenty-five-by-sixty-eight-foot lots—were built in the 1830s as cheap housing for immigrants. Within a few years, they also appeared in such cities as Philadelphia, Chicago, Boston, and Newark.

The brick building at 97 Orchard Street was described as one of the worst types of tenements, where as many as twenty people crowded into cramped, three-room apartments without indoor plumbing. It was probably constructed in 1863 by Lucas Glockner. In 1919, a new owner, Moses Helpern, installed four first-floor stores. In 1935, he sealed off the residential floors because stricter housing codes would have required expensive renovations.

Steps lead to the entrance and the two storefronts on the

first floor. Here are the museum offices and a vest-pocket size theater where actors interpret oral histories. Eighteen historians around the nation have reconstructed the composite stories of six typical tenement households, whose experiences will form the basis for a living history museum here.

Originally, there were twenty three-room apartments, four to a floor, with a ten-by-twelve-foot living room and two tiny bedrooms. Each apartment had a coal stove, concrete tub for bathing children (adults went to the public baths), laundry, and dishwashing. The tubs, when covered with planks, served as tables during meal times. There were no running water, indoor toilets, or fire escapes. Outhouses were in the backyard. Fires and outbreaks of serious disease were common.

Residents lived in a murky world. Back windows often faced other buildings, side windows looked out on air shafts, and gas lamps provided light in the stuffy rooms. In the sweltering summer months, families slept on the roofs and fire escapes.

With some residents taking in sewing and tailoring, and others going out to work long hours, there was probably round-the-clock activity, which meant little privacy or serenity. One former tenant at 97 Orchard left evidence of his tailoring craft. A note scribbled on the wall reads "Pants made to order, $1.50." Residents also took in boarders to make ends meet.

In 1867, New York State enacted the first tenement house law. It required fire escapes and outdoor toilets but no provision was made for enforcement. In 1901, another law called for the installation of running water and two indoor toilets for every four apartments, as well as a window on an interior wall to provide more light and ventilation.

The narrow closets built for the toilets took space away from the apartments and made them even more cramped than before. Life remained basically the same as in the 1800s, except for an occasional change of paint and wallpaper.

Immigrants faced the added burdens of learning new trades and a new language. Despite the hardships, thousands survived, built prosperous lives, and eventually moved away from the Lower East Side. Their memories have also survived and stand as an inspiration, not only to the newest immigrants who still flock to this area, but to all who must overcome severe obstacles.

THE MUSEUM

The museum evokes the experiences of six ethnic groups, showing how free Blacks, Irish, Germans, Chinese, East European Jews, and Italians struggled to survive.

In addition to walking tours of the area, "Family Matters: An Immigrant Memoir," an oral history of a Lower East Side Jewish family, presented in the museum's theater, aids in re-creating the immigrants' world.

THE PEDDLER'S PACK WALKING TOUR

An actor-tour guide retraces the footsteps of the Scheinbergs, a real family who lived nearby on Eldridge Street around 1910, who were typical turn-of-the-century immigrants.

Tour highlights include P.S. 42 on Hester Street, where immigrant children were "Americanized"; the corner of Orchard and Hester Streets, location of a market and the

scene, in 1910, of a revolt by the Mothers High-Priced League, which won lower prices. Here, too, was the corner where contractors chose work crews.

At 16 Orchard Street, Jewish stars embedded in the building indicate that it was a "kosher place." A building topped by an odd-looking cupola at Canal and Orchard was Yarmulovsky's Bank. Founded for immigrants in 1893, its closing caused a panic in 1910.

The years have taken their toll on the immigrants' once-familiar places. The former Landsmanschaft (aid association) at 5 Ludlow Street is now an Italian funeral parlor; on East Broadway, the famous Garden Café where revolutionaries congregated and drank endless glasses of tea is now a Chinese restaurant, and the elaborate white structure nearby that was once the Yiddish Silent Cinema is now an electronics store. (For theater, the immigrants went to Second Avenue to see the great Yiddish actor, Boris Tomashevsky.) Another East Broadway building that housed the *Jewish Daily Forward*, a radical Yiddish newspaper, is now a Chinese Bible society.

Trains still leave the subway station on East Broadway for Coney Island, one of the immigrants' favorite haunts. But the fare—formerly a nickel until 3:30 P.M. and a dime for the remainder of the day—is now considerably higher.

Seward Park is another tour stop. It was built to keep youngsters away from the pushcart-filled streets, but a host of Parks Department restrictions defeated that purpose. The Seward Park branch of the New York Public Library, which once had thousands of Yiddish and Russian books, continues to serve the community.

Also on East Broadway, the Educational Alliance, founded over a hundred years ago, offers immigrants English language instruction and social studies; on Henry Street, St. Theresa's Catholic Church, built in 1841, was converted to a Presbyterian church in 1963, while the Rabbi Jacob Joseph School, "the Harvard of Yeshivas," still gives classes at 12 Henry Street.

SOUTH STREET SEAPORT MUSEUM

**16 Fulton Street, at South Street
New York, N.Y. 10038
212/669–9430
212/669–9424 recorded information**

SUBWAY	2, 3, 4, 5, A, C, J, and M.
BUS	M15.
HOURS	10 A.M. to 5 P.M. daily October through April; 10 A.M. to 6 P.M. daily May through September.
TOURS	Group tours by reservation; call 212/669–9405. Call 212/669–9400 for school groups.
ADMISSION	$6, adults; $3, children, aged 4 to 12; $5, seniors over 65; $4, students with I.D.; free, members. Tickets available until one hour before closing at the Pier 16 ticket booth and the Museum Visitors' Center.
HANDICAPPED FACILITIES	No access to historic ships.
FOOD FACILITIES	Food and beverages available in Cannon's Walk Block, Fulton Market Building, Pier 17 Pavilion, and Schermerhorn Row.
MUSEUM SHOPS	Books, navigational charts, posters, nautical gifts, jewelry, toys, and souvenirs.
SPECIAL EVENTS	Films, workshops, craft demonstrations, walking tours.
MEMBERSHIP	From $25.
AUTHOR'S CHOICE	*Peking*, moored at Pier 16

The South Street Seaport Museum preserves a slice of New York and maritime history, re-creating the era when clipper ships and, later, steamships were the mainstay of American commerce. Activities aboard ships in the Seaport Harbor and in several buildings on shore give visitors a taste of life in nineteenth-century New York.

HISTORY

A hundred years ago, the area around the South Street Seaport was the hub of New York's flourishing maritime trade. So many vessels disgorged their cargoes at docks along the East River that South Street was known as the "street of ships." Sea captains and their crews rubbed elbows with merchants, tradesmen, and immigrants in the district's many bars, brothels, and boardinghouses. As the shipping industry declined during the twentieth century, the seaport lost its vitality and importance.

In an effort to preserve a vital element of New York history, the seaport area's nineteenth-century buildings—dwarfed by the nearby skyscrapers of the financial district—were restored as a living museum and opened to the public.

The Seaport covers an area of several blocks along Front,

Fulton, and South Streets. In addition to the historic aspects, a variety of boutiques, shops, and restaurants add to the ambiance and enjoyment of a visit here.

SEEING THE SEAPORT

The Visitors' Center, located on Fulton Street in Schermerhorn Row, should be your first stop. After purchasing your tickets, browse through the exhibits and pick up a brochure with a map of the eleven-block historic district. If time is limited, concentrate on the *Peking* and one or two other sites.

Tickets are required to visit the *Ambrose*, the *Peking*, and the *Wavertree*, as well as the Museum Gallery, the Children's Center, and the A.A. Low Building, Norway Galleries.

Here is a brief rundown of attractions:

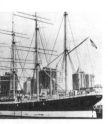

The Peking

- **Pier 16** Tickets to exhibits, historic ships, and tours, as well as Seaport Line harbor cruises and schooner *Pioneer* sailings.
- **Peking** A four-masted, 347-foot bark that is the second largest sailing ship in existence today. Tours and talks scheduled daily, every hour from 10 A.M. to 4 P.M.
- **Wavertree** A three-masted tall ship, launched in England in 1885 and currently being restored to sail again.
- **Major General William H. Hart** A steam ferry, built in 1925, that originally carried commuters to and from Manhattan.
- **Lettie G. Howard** A clipper-bowed Gloucester fishing schooner, also under restoration.
- **W.O. Decker** A small, 1930 wooden tugboat, available for private charter.
- **Pioneer,** a 105-year-old, two-masted schooner offering two- or three-hour excursions in New York Harbor.

NOTE: The *William H. Hart*, *Lettie G. Howard*, and *W.O. Decker* can be viewed from the dock but are closed to the public. Separate tickets are required for the *Pioneer*.

- **Maritime Crafts Center** Carvers, painters, and craftsmen at work on ship models, carvings, and figureheads.
- **The Pilothouse** Originally part of a 1923 New York Central tugboat.
- **Pier 17 Pavilion** Three floors of boutiques, shops, and restaurants. Good view of the Brooklyn Bridge from the balcony.
- **Fulton Fish Market** Largest wholesale fish market in the country.
- **Fulton Market Building** Food markets, restaurants, shops, and cafés in a structure that recalls the 1883 market building. Small Craft Collection of wooden boats displayed in the top-floor Museum Club.
- **Front Street Shops** Galleries and shops in nineteenth- and twentieth-century buildings that line both sides of the street.
- **Cannon's Walk Block** An assortment of shops, restaurants, outdoor cafés, and a theater housed in a block of nineteenth- and twentieth-century buildings.
- **Waterfront Photographer** Changing exhibits of photographs relating to the seaport.
- **Book and Chart Store** Books, navigational charts, and posters.
- **Curiosity Shop** Nautical gifts and jewelry.

- **Bowne & Co., Stationers** A nineteenth-century printing shop.
- **Museum Gallery** Changing exhibits relating to New York City and maritime history.
- **Melville Library** Open by appointment.
- **Schermerhorn Row** Early nineteenth-century buildings built by Peter Schermerhorn on speculation, housing restaurants, a pub, and specialty stores, as well as the Museum Visitors' Center.
- **Museum Shop** Toys, kites, ship models, and souvenirs of the seaport.
- **Children's Center** Exhibits, workshops, and special programs.
- **A.A. Low Building, Norway Galleries** Changing exhibits on New York's maritime history in the former countinghouse of a China trader.
- **Boat Building Shop** Craftsmen restoring boats, such as a pilot's gig and a single-masted sandbagger.
- ***Titanic* Memorial Lighthouse** A memorial to the victims of the 1912 *Titanic* disaster, located across from One Seaport Plaza on Fulton Street between Water and Pearl Streets.

FORBES MAGAZINE GALLERIES

62 Fifth Avenue
New York, N.Y. 10011
212/206–5549

SUBWAY	1, 2, 3, 4, 5, 6, B, D, F, L, N, Q, R, and S.
BUS	M2, M3, M5, M6, and M14.
HOURS	10 A.M. to 4 P.M. Tuesday, Wednesday, Friday, and Saturday. Guided group tours by advance appointment only on Thursday. Closed Sunday, Monday, and legal holidays.
TOURS	Guided tours for groups of 10–30 people by advance reservation.
ADMISSION	Free. Children under 16 must be accompanied by an adult, with no more than four children per adult.
SALES DESK	Catalogs of exhibitions and books relating to the collections available at the reception desk.
AUTHOR'S CHOICE	Imperial Easter eggs by Fabergé

Tucked away on the ground floor of the Forbes Building is an eclectic collection of objets d'art, toys, fine art, and presidential memorabilia. The collection, assembled by the late publisher Malcolm Forbes and his sons, includes one of the world's greatest collections of the work of Peter Carl Fabergé, master jeweler and goldsmith in Imperial Russia. (Only Britain's Queen Elizabeth II has a larger Fabergé collection.) In addition, there are thousands of toy soldiers and over five hundred antique toy boats.

HISTORY

The late Malcolm Forbes, publisher of the biweekly business magazine founded by his father, B.C. Forbes, in 1917, was the catalyst for the Forbes Magazine Collection. It is one of the oldest corporate collections in the country and among the few that can be seen by the general public. The whimsical collection reflects the diverse interests of Malcolm Forbes and his sons, Malcolm, Jr., Robert, Christopher, and Timothy.

Forbes began collecting seriously in 1937 during his freshman year at Princeton University, when he bought a brief note written by Abraham Lincoln. Paying for it required eighteen months of his allowance. Forbes's autograph collection had begun earlier when, as a young boy, he collected the signatures of celebrities with whom his father corresponded.

The work of Fabergé came to Forbes's attention in the early 1960s, with the purchase of a gold cigarette case for his wife. For nearly twenty years, the Fabergé collection was displayed in the lobby of the Forbes Building. In order to exhibit additional objects from the magazine's collection, the design firm of Purpura & Kisner and architect John Blatteau converted the ground floor into 8,000 square feet of exhibition space.

A curatorial department was established in the early 1970s to catalog the collection and supervise its conservation and exhibition. The galleries opened in 1986.

THE BUILDING

The building on Fifth Avenue at the corner of Twelfth Street was designed by Carrère and Hastings, architects of the New York Public Library and the Frick Museum, with Shreve & Lamb, who later designed the Empire State Building. They received the American Institute of Architects' silver medal for new buildings completed in 1925.

The Forbes Building, home of the Forbes Magazine Galleries

Originally commissioned by the MacMillan Publishing Company, the office building replaced two single family homes—a handsome Greek Revival structure dating from about 1840 at 62 Fifth Avenue and an Italianate mansion once owned by financier Thomas Fortune Ryan at 60 Fifth.

Construction of the building was supervised by Harold MacMillan, who later left the family publishing business and became prime minister of England.

In the early 1960s, the Forbes magazine company acquired this granite building and the brownstone next door, becoming the office building's second occupant. After extensive renovations, the staff moved into their new quarters in 1967, the fiftieth anniversary year of the magazine that has been dubbed "the capitalist tool."

SHIPS AHOY: A CENTURY OF TOY BOATS

The entrance to this gallery is dominated by a series of eight ground glass panels taken from Jean Dupas's mural, *History of Navigation*, that originally graced the grand salon of the *Normandie*, the flagship of the French Line.

Malcolm Forbes's love of the sea is reflected in the hundreds of boats on display, ranging from rowboats and speed boats to river boats and warships, by all the major toy manufacturers.

Forbes has said that, in his childhood, "Toy boats in the family were more prized than electric trains or other playthings." The *André*, the largest boat in the collection, was purchased in Paris at the toy store, Nain Jaune, and is driven by a steam-powered diesel engine. These toy boats of tin and cast-iron were designed to be played with, unlike others which are models of actual ships.

One of the most interesting exhibits is devoted to the series of five model yachts owned by Forbes from 1955 until his death in 1990. Called the *Highlander* in honor of his Scottish ancestry, the first craft was a 72-foot Canadian boat that had seen service in World War II. Next was a 98-foot, steel-hulled yacht, built in 1957 and designed for corporate entertaining. The most recent *Highlander*, commissioned in 1985, is 151 feet long, with five guest staterooms, six salons, fourteen heads, and six rooms for the crew. Manned by a captain with a crew of fourteen, it carries a helicopter on board, as well as two tenders and two five-speed motorcycles.

ON PARADE

Everyone who has ever played with toy soldiers or thrilled to martial music will enjoy these miniature figures arranged in dioramas and vignettes depicting military and ceremonial processions. Forbes began his collection of military miniatures

in the 1960s when he purchased a set of World War I doughboys at an auction. The forces now number more than 100,000, including a large brigade of troops housed at the Museum of Military Miniatures at Palais Mendoub in Tangier, Morocco.

The collection traces the development of toy soldiers from two-dimensional metal "flats" to full round figures. Examples of all major manufacturers—Heinrichsen, Aloys Ochel, Heyde, Elastolin, and Lineol of Germany; Mignot and Lucotte of France; William Britain of the United Kingdom, and Barclay and Manoil of the United States—are included. They date from approximately 1870 to the 1950s.

Among the historical figures and events depicted are Caesar and Cleopatra in a Roman processional; the sacking of Troy; George Washington reviewing his troops, and the 1889 coronation of Menelik I, emperor of Ethiopia.

Nearby, uniformed soldiers from all corners of the globe are massed in an imaginary castle setting. You can see miniature Greek Evzones, English Horse Guards, Zulu warriors, and Royal Marines stationed on parapets and marching with military precision.

Balancing the military scenes is a "Home Farm," a vignette in keeping with England's anti-militaristic mood of the 1920s. The miniature figures even include a village idiot, among the rarest of figures. Nearby, a wagon train overtaken by Indians is shown against a photomural of the Sangre de Cristo Mountains surrounding Forbes's Trinchera Ranch in Colorado.

A reproduction of the Pyramid of the Sun in Tenochtitlan in Mexico City stands in the center of the room, complete with tiny Aztec warriors in feathers and jaguar skins.

Other exhibits illustrate "The Land of Counterpane," a poem by Robert Louis Stevenson. As you leave this gallery, notice artist Andrew Wyeth's drawings of Revolutionary War soldiers that illustrate a "thank you" note he wrote for a gift of military miniatures.

THE TROPHY ROOM: THE MORTALITY OF IMMORTALITY

Malcolm Forbes provided an apt description of this gallery:

"Every object you see here bears an inscription that marked a moment that was of great moment to Gone getters and doers. These varying milestone markers, so meaningful to lives past, were acquired in flea markets, at auctions and other emporiums of the ephemeral."

"This trophy room is a moving reminder that all things and all of us are all too soon 'over and out.' "

Over two hundred once-significant events are recaptured here, including the prize for the best pen of White Leghorn chickens at the Northamptonshire Egg Laying Trials in 1929–30.

PRESIDENTIAL PAPERS

A selection of personal letters and documents relating to American presidents—culled from more than 2,500 items included in Forbes's multimillion-dollar collection—is on view. The varied exhibits range from an authorized copy of Abraham Lincoln's Emancipation Proclamation to an early land survey by George Washington, and a rare, complete set of signatures of all the signers of the Declaration of Independence.

Here, too, is Paul Revere's expense account for one of his rides from Boston to New York to alert citizens to the British threat in 1774. His expenses, approved by John Hancock, totaled fourteen pounds and two shillings!

In addition to the historic letters, manuscripts, and pictures, there are other presidential souvenirs. Notice particularly the bottle of 1787 Château Lafitte wine purchased in France by Thomas Jefferson and the opera glasses used by Abraham Lincoln April 14, 1865, the night he was assassinated.

FABERGÉ

The collection comprises more than three hundred objets d'art by Fabergé. Twelve elaborately decorated Easter eggs are included, making this the largest collection in the world of Imperial Easter eggs.

Near the entrance to the gallery is a music box, crafted of silver in the shape of a paddle-wheel steamer, that plays "God Save the Czar" and "Sailing Down the Volga."

Peter Carl Fabergé became the head of his father's St. Petersburg jewelry firm in 1870 at the age of twenty-four. At the height of Fabergé's career as jeweler by appointment to Czar Alexander III and Nicholas II, he supervised a staff of approximately five hundred craftsmen who specialized in gold and silversmithing, enameling, and cutting and polishing precious stones.

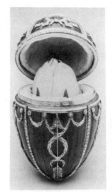

Although Eastern Europeans had a long tradition of giving elaborately decorated Easter eggs, Fabergé was among the first to make them as objets d'art. It is thought that fifty-four Imperial Easter eggs were commissioned by the last two czars of Russia from 1885 to 1916. Forty-five are known to exist today. Of those, twelve are the stars of the *Forbes Magazine* collection.

The first egg Fabergé made for the Danish-born Czarina Marie Feodorovna, seen here, was an Easter gift from her husband, Czar Alexander III, in 1885. Perhaps inspired by an eighteenth-century Easter egg in the Royal Danish collection, the gold, enamel, and ruby egg has a removable yolk and opens to reveal a hen.

The Imperial Rosebud egg by Fabergé

After Alexander's death in 1894, his son, Czar Nicholas II, continued the tradition, giving Easter eggs to both his mother and his wife, Alexandra. The Imperial Rosebud Egg, which was lost for many years, was the first one Alexandra received as an Easter surprise in 1895. When it is opened, the red enameled egg reveals a yellow enameled rosebud inside, crowned with a tiny portrait of Czar Nicholas II.

The Chanticleer Egg of two-color gold, enamel, and pearls, contains as a surprise a chanticleer that crows and flaps its wings on the hour. It was a gift from Czar Nicholas II to his mother, Dowager Empress Marie Feodorovna, in 1903.

Painted miniatures, automated birds, and jewelled flowers were among the imaginative surprises Fabergé included in his Imperial Easter eggs. Only two of the surviving eggs were designed with religious connotations. One, exhibited here, is the Resurrection Egg presented to Czarina Marie Feodorovna by Czar Alexander III in 1889. It is crafted of rock crystal, gold, enamel, diamonds, and pearls.

The Coronation Egg of 1897, containing a tiny gold, bejewelled coronation coach; the Fifteenth Anniversary Egg of

1911, decorated with miniature portraits of the Imperial family and scenes of the major events of their reign, and the Dowager Empress's Cross of St. George Egg of 1916, the only Imperial Egg to leave Russia in the possession of its original owner, are among the most luxurious and ingenious Fabergé creations.

The Fabergé eggs are tangible reminders of an extravagant life-style that ended disastrously for the Romanov dynasty with the Russian Revolution in 1917. The Fabergé workshops created other objets d'art besides Easter eggs. Note, for example, a tiny nephrite watering can embellished with diamonds, and a miniature basket of lilies of the valley. In the Fabergé workshops, such mundane objects as picture frames, boxes, and cigarette cases, displayed here, became works of art.

A few preparatory drawings can be seen, including the designs for an iridescent glass Tiffany vase with serpent mounts; the Imperial presentation tray of Czar Nicholas II and Czarina Alexandra Feodorovna, and a vase and finial design created for Prince Chakrabongse of Siam.

A rock crystal polar bear and an automated rhinoceros in the exhibition are typical of Fabergé's skill as a creator of naturalistic animal figures. Queen Alexandra of Great Britain, sister of Dowager Empress Marie Feodorovna, assembled the world's largest collection of these miniature animals, which are now owned by Queen Elizabeth II.

FINE ART

The collection numbers more than three thousand works of art, ranging from paintings by Peter Paul Rubens, Sir Joshua Reynolds, Thomas Gainsborough, Pierre-Auguste Renoir, and Vincent van Gogh to George Bellows and contemporary Western artist James Bama.

There are also a few subcollections devoted to works by French nineteenth-century military artists, British Victorian artists, Orientalists, kinetic artists, twentieth-century American realists, and twentieth-century photographers.

One of the most unusual pieces in the collection is Wendell Castle's illusionist sculpture of gloves and a key case on an eighteenth-century-style table, carved from a single block of wood.

NEW MUSEUM OF CONTEMPORARY ART

583 Broadway
New York, N.Y. 10012
212/219–1222
212/219–1355 recorded information

SUBWAY	6, AA, C, E, F, N, and RR.
BUS	M1, M5, and M6.
HOURS	Noon to 6 P.M. Wednesday, Thursday, and Sunday; Noon to 8 P.M. Friday and Saturday. Closed Monday and Tuesday.
TOURS	Group tours by reservation Noon to 5 P.M. Wednesday, 10 A.M. to 5 P.M. Thursday, and Noon to 6 P.M. Friday and Saturday.
ADMISSION	Suggested contribution $3.50, adults; $2.50, artists, students, and senior citizens; members and children under 12, free.
HANDICAPPED FACILITIES	Limited.
MUSEUM SHOP	Art books and exhibition catalogs.
SPECIAL EVENTS	Lectures, performances, and symposia related to contemporary art.
SPECIAL FACILITIES	Artists' monographs, exhibition catalogs, art books, and periodicals available in the Soho Center Library, a free, non-lending resource center open weekdays. Appointments suggested.
MEMBERSHIP	From $45.

If you want to see the work of the most innovative contemporary artists and learn about the lastest trends in art, the New Museum of Contemporary Art is the place to go. Some of the works on view may shock you. Some may make you wonder "Is that art?" But if you leave with new insights and a heightened perception of contemporary art, the museum will have achieved its goal.

HISTORY
Director Marcia Tucker founded the museum in 1977 to provide a noncommercial forum for contemporary art. Located for the first year in a small office in the Fine Arts Building on Hudson Street, the museum moved to the Graduate Center of the New School for Social Research in 1978. Despite cramped quarters, museum officials won high marks for exhibitions and catalogs designed to increase public awareness of contemporary art.

Since 1983, the museum's home has been in the renovated, historic Astor Building on Broadway between Prince and Houston Streets in Soho. Its high ceilings and flexible space provide an impressive backdrop for the museum's wide variety of presentations. These include installations, performance art,

and videos, as well as prints, drawings, paintings, and sculpture.

In addition to presenting programs that shed light on specific exhibitions, the museum offers lectures and panel discussions devoted to aesthetic, social, and political issues relating to contemporary art.

The unique High School Art Criticism Program, offered by the museum's education department, features a semester-long series of discussions with artists and critics, writing projects, and museum, studio, and gallery visits.

Unlike most similar institutions, the New Museum functions on the principle of consensus, with all decisions and responsibility handled democratically. Any member of the staff may present ideas for exhibitions or programs, which are then developed by staff teams whose members include representatives from all departments.

Because of their unique role in the art world, the museum and its director have received many awards. These include a 1988 Certificate of Achievement from the Municipal Art Society of New York "for more than a decade of unceasing commitment to seeking out challenging contemporary works on the cutting edge of American art" and the Skowhegan School of Painting and Sculpture's 1988 Award for Lifetime Service to the Arts to Director Marcia Tucker.

SEMI-PERMANENT COLLECTION

By definition, a museum of contemporary art must focus on current art. In order to fulfill its mission, the New Museum established a Semi-Permanent Collection that provides support for artists through the purchase and exhibition of their work. The collection also supplements the museum's temporary exhibitions.

Art works are acquired through gifts and museum purchases. To be included in the Semi-Permanent Collection, a work of art must be less than ten years old. It cannot be retained by the museum for more than ten years.

Artists whose works have been in the Semi-Permanent Collection through the years include Andres Serrano, Hollis Sigler, Julian Schnabel, Jenny Holzer, Robert Colescott, and Sherrie Levine.

EXHIBITIONS

Recent exhibitions have included "Impresario: Malcolm McLaren and the British New Wave"; "Christian Boltanski: Lessons of Darkness"; "Strange Attractors: Signs of Chaos," and shows devoted to the works of Robert Colescott and Nancy Spero. There have also been installations by Ann Hamilton and Kathryn Clark, Felix Gonzales-Torres, the collaborative group General Idea, Ted Victoria, Margaret Harrison, Guillaume Bijl, and Christian Marclay.

A view of "Strange Attractors: Signs of Chaos"

An example of the New Museum's innovative approach to art is Linda Montano's program, "Seven Years of Living Art," based on the teachings of the Yoga Chakras. From 1984 to 1991, Montano spent one day each month seated in the Mercer Street window, discussing art and life with museum visitors.

OLD MERCHANT'S HOUSE

29 East Fourth Street
New York, N.Y. 10003
212/777–1089

SUBWAY	6, A, B, C, D, E, F, K, and RR.
BUS	M1, M5, M6, and M102.
HOURS	1 to 4 P.M. Sunday. Closed during August.
TOURS	Group tours by appointment.
ADMISSION	$2, adults; $1, senior citizens and students; members and children under 12 with adults, free.
SPECIAL EVENTS	Walking tours and lectures.
AUTHOR'S CHOICE	Double parlors on the first floor Period clothing displayed on the second floor

The Old Merchant's House—one of Manhattan's best-kept secrets—is the sole survivor of a once fashionable residential neighborhood that is now commercial. Occupied by the same affluent, middle-class family for nearly a century, it is virtually a time capsule of the nineteenth century, interesting both for its social history and its architecture.

HISTORY

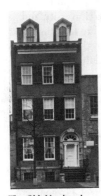

The Old Merchant's House

In the 1820s, with New York City beginning its growth uptown, the farmland around Washington Square was divided into residential lots. The neighborhood soon attracted wealthy merchants, such as John Jacob Astor, who lived nearby on Lafayette Place's Colonnade Row. Until Gramercy Park became popular in the 1850s and 1860s, the area around Washington Square was considered to be New York's most fashionable "uptown" address.

In 1832, Joseph Brewster, a hatter and real estate speculator, built both this red brick, Ionic-columned house and its twin next door. Three years later, Seabury Tredwell, a successful hardware merchant, purchased the house for $18,000. The Tredwell family—Eliza, Seabury, and their five daughters—moved uptown from Dey Street and lived here until the youngest daughter, Gertrude, died in 1933.

The Tredwells watched the world go from candlelight to electricity, from horse-drawn carriages to automobiles, and from the era of stern Victorian fathers to the days and bathtub-gin nights of bobbed-hair flappers.

As with many historic houses, a romantic legend hovers over the Old Merchant's House. It is said that Seabury Tredwell, who was the nephew of the first Episcopal Bishop of Connecticut, forbade Gertrude to marry the young doctor she loved because he was a Catholic. Gertrude eventually died a spinster at the age of ninety-three. Another legend says that Gertrude was the model for Catherine Sloper, the heroine in

Henry James's novel, *Washington Square*. Like Gertrude, Catherine had an unhappy love affair. And descriptions of the Slopers' house in the book bear a striking resemblance to the Tredwells' Fourth Street home.

The Tredwells were a conservative family, not given to following all the latest fashions. Seabury Tredwell was one of the last men in New York to wear his hair in an eighteenth-century-style queue.

Research has indicated that the interior of the house had only five coats of paint in more than a hundred years—most of them varying shades of off-white. In 1867, two years after her husband died, Mrs. Tredwell turned the back parlor into a dining room and added Victorian-style draperies and carpeting to the Greek Revival interior. Three distinct periods are reflected in the furnishings: Federal, with pieces purchased at the time of the Tredwells' 1820 marriage; Greek Revival pieces acquired when Tredwell retired from the hardware business and moved his family into a larger house, and some Victorian furnishings installed during Eliza's 1867 redecoration.

In addition to their reluctance to change the decor, the Tredwells managed to save virtually everything they ever owned, from theater programs, straight pins, and needlework to Eliza's trousseau gowns. Through the years, Gertrude kept everything "as Papa would have wanted it."

After Gertrude's death, George Chapman, a grandnephew of Mrs. Tredwell, saved the house from being auctioned and opened it as a museum in 1936. He understood how unusual it is to find a totally authentic house with period furnishings, owned by the same family for ninety-eight years. After Chapman's death in 1958, a private, nonprofit foundation continued to operate the museum, but both the building and the neighborhood were deteriorioating, and funds were limited.

The house has survived a series of crises, including possible deterioriation and collapse in the mid–1960s. Joseph Roberto, an architect affiliated with nearby New York University, and his interior designer wife, Carol, volunteered to lead the restoration effort and a fundraising campaign that raised nearly $400,000. With the aid of the Decorators Club and major fabric and rug manufacturers, structural repairs were made and the shabby interiors were restored to their former elegance.

Publicity in the *New York Times* helped to call attention to the significance of the house, and, as a result, grants were received from the Fund for the City of New York and the New York State Historic Fund, among others. Fundraising is a continuing problem but the Old Merchant's House is still standing today, an authentic, sturdy reminder of a bygone era.

THE HOUSE

Architecturally, the house is typical of the transitional period between Federal and Greek Revival styles. The front door, for example, includes a Federal fanlight above Ionic columns that draw their inspiration from Greek sources.

A handsome pair of iron baluster urns stands in front of the marble-framed entrance.

Instead of hiring an architect, it is believed that Joseph Brewster used local carpenters to carry out one of the designs of Minard Lafever, the author of *The Young Builder's General Instructor*, published in 1829. Lafever is credited with

popularizing the Greek Revival style of architecture, which flourished from approximately 1820 to 1850.

A 4,000-gallon cistern in the garden provided water for the Tredwells before the Croton Reservoir was built in 1842. Earlier, water had to be brought from a well at Broadway and Bleecker Street.

A display of nineteenth- and early twentieth-century New York street scenes in the entrance hall re-creates the period of the Tredwells. Notice the 1866 photograph of Lafayette Place at Great Jones Street, which shows the once-elegant, tree-lined streets of the neighborhood. **GROUND FLOOR**

FAMILY ROOM

This room to the left of the entrance hall provided a cozy setting for family meals and for the Tredwell girls' homework sessions. The eight-foot ceiling made the room easier to heat than the bedrooms which have eleven-foot ceilings, and the parlors where the ceilings are thirteen feet high. Because water has leaked into the room through the fireplace wall, the bricks are exposed now, so that visitors can see details of the house's construction.

The Delft urns on the marble mantel provide a subtle contrast to the pale peach walls. (This is the only room in the house whose walls are not off-white.) A portrait of Joseph Brewster hangs above the fireplace. In 1851, Brewster helped to finance the clipper ship, *Challenge*. The day before the vessel sailed on its maiden voyage, Brewster went aboard to check on the cargo. Knocked unconscious in a fall on the ship, he died soon afterward.

KITCHEN

The Tredwells needed several servants to maintain their home. An 1855 census indicated that three of the four servant girls they employed that year had come from Ireland and one had emigrated from England.

An iron stove stands in the fireplace, where cooking was originally done over an open fire. A beehive oven, used for baking bread, and a soapstone sink with a hand-operated pump are special features of this spacious kitchen. Notice the collection of stoneware crocks from New York and Connecticut, a tin footwarmer, and a pie safe with perforated tin doors.

The brass lacemaker's lamp was an ingenious nineteenth-century device imported from London. A tin reflector intensified the light produced by two candles placed in spring-powered fittings.

Extra leaves for the dining room table were stored in the kitchen. When fully extended, the mahogany dining table could seat fourteen.

ENTRANCE HALL

FIRST FLOOR

The walls of the entrance foyer have been painted to simulate marble. This *faux marbre* technique was a fashionable treatment for walls and floors during the nineteenth century.

The carved mahogany newel post on the staircase is original.

FRONT PARLOR

In keeping with the Greek Revival theories of harmony and classical symmetry, both the front and back parlors are identical in size and architectural details. A false door was even cut into a wall in the front parlor to balance a door in the back parlor. Both rooms have the original egg-and-dart ceiling molding. The gold-veined black marble for the fireplaces was quarried in Belgium and Italy.

The sliding doors connecting the two rooms are made of the original pine with a mahogany veneer; the doorknobs are silverplated. An unusual architectural note is the pair of columns with hand-carved Ionic columns that frame the doorway.

A portrait of a rather stern-faced Seabury Tredwell hangs over a black horsehair sofa. Over the piano at the other end of the same wall is a painting of his wife, depicted with a book in her hand and a frilly bonnet on her head. The rosewood square-case piano was manufactured in the 1840s by the New York firm of Nunns & Fischer. It also has one organ pedal and its bellows are concealed underneath.

The crimson and gold carpet was originally woven in France; its geometric pattern is based on a Pompeiian ceiling tile. The heavy red damask draperies with an upside-down pineapple design are a Scalamandré reproduction of the original fabric.

The red damask-covered American Empire sofa with carved eagle legs, crafted around 1815, may have come from Duncan Phyfe's workshop nearby on Fulton Street. The center table with ball-and-claw feet and the six mahogany side chairs are similar to furniture illustrated in the 1835 catalog of Joseph Meeks, another well-known New York cabinetmaker whose shop was at 14 Vesey Street.

The white walls and gold-framed pier mirror between the windows help to brighten the room.

BACK PARLOR (DINING ROOM)

Originally used as a twin parlor, this became a formal dining room used occasionally in later years. The patterned crimson and gold carpet and the red damask draperies match those in the front parlor.

The mahogany dining table and chairs, the two marble-topped pier tables on either side of the fireplace, the sideboard, and the mirror at the far end of the room are all American Empire pieces, dating from approximately 1830 to 1845. The chandeliers in both parlors were originally lit with gas and were converted to electricity in 1936.

TEA ROOM

This room, originally an open porch with a small balcony overlooking the garden, was enclosed and converted into a pantry or service area in the 1850s. It was later called a "tea room" by George Chapman, which is how it is displayed today. It is furnished with a Federal mahogany *demilune* breakfast table, ca. 1820, and four Gothic Revival caned side chairs of wood painted to look like rosewood, dating from approximately 1865.

BEDROOM

Three of the Tredwell children shared this spacious, high-ceilinged bedroom. The canopied child's bed, made in 1815, is the oldest one in the house. The elaborate draperies on the mahogany four-poster bed are period reproductions inspired by the original draperies of 1867, which were still hanging, although threadbare, in the 1960s.

Most of the American Empire furniture in this room dates from approximately 1825 to 1845. The dressing table, ca. 1845, boasts lyre-shaped front legs—a decorative motif often favored by Duncan Phyfe and other nineteenth-century cabinetmakers.

Period gowns and accessories are displayed in a glass-enclosed case in the small hallway connecting the two bedrooms. Notice the Empire-style, embroidered white muslin gown that was made in 1815, five years before Eliza Tredwell's marriage.

MASTER BEDROOM

It is believed that Gertrude Tredwell was born and died in the canopied four-poster bed in this room. The furnishings include Federal tiger maple cane-seated side chairs, part of a set of twelve that were made in New York in 1825, as well as a Boston rocker, and an unusual armoire with side doors that conceal bookshelves.

A teal blue satin gown is the focal point of a small display in the closet. The dress, found in one of the seventeen trunks in the attic, contained an unexpected treasure. Museum officials discovered a theater program in a pocket of the dress, where one of the Tredwell ladies tucked it more than a hundred years ago. Laura Keene, who starred that evening at the Laura Keene Theatre, was also the leading lady in *Our American Cousin* at Ford's Theatre in Washington, April 14, 1865, the night President Lincoln was assassinated.

STUDY

A mahogany Gothic Revival secretary desk made in 1835, with Gothic-arched glazed doors, satinwood interiors, and ivory knobs, dominates this small room next to the master bedroom. The room may have served a variety of functions through the years, as a small nursery, a sitting room, a sewing room, a dressing room, or Seabury Tredwell's study.

Among the family papers found here is Tredwell's will, written before his death in 1865. He left an estate of $120,000, with $10,000 going to each of his children, except one of his sons—considered an "unstable" businessman—who received $4,000 in trust for his daughter.

The Theodore Roosevelt Birthplace

MURRAY HILL
AND MIDTOWN

PIERPONT MORGAN LIBRARY

**29 East 36th Street
New York, N.Y. 10016
212/685–0008**

SUBWAY	6.
BUS	M1, M2, M3, M4, M5, and M34.
HOURS	10:30 A.M. to 5 P.M. Tuesday through Saturday; 1 to 5 P.M. Sunday.
TOURS	2:30 P.M. Tuesday and Thursday, tours of period rooms; 2:30 P.M. Wednesday and Friday, tours of the main exhibition.
ADMISSION	Suggested contribution $3, adults; $1, students and senior citizens.
HANDICAPPED FACILITIES	Wheelchair available for visitors. All exhibition space is on one level, except for eight small steps at the entrance and leading to the historic rooms.
MUSEUM SHOP	Books, cards, facsimiles, posters, and other gift items, including Mr. Morgan's own special blend of tea.
SPECIAL EVENTS	Recorded slide lecture on the current exhibition shown daily at 12:15 P.M. weekdays and 1:15 P.M. Sunday.
MEMBERSHIP	From $35.
AUTHOR'S CHOICE	First edition printing of the Declaration of Independence, East Room Gutenberg Bible, East Room Life mask of George Washington

The marble-lined Pierpont Morgan Library, with its collection of books, manuscripts, prints, and drawings, is one of the world's most respected museums and research centers. Its rich interiors retain an aura of intimacy, much as in J. Pierpont Morgan's day.

The Pierpont Morgan Library

HISTORY

J. Pierpont Morgan, who was born in 1837, was one of America's most renowned financiers. He started his collection when he was fourteen years old with an autograph from President Millard Fillmore; as a teenager in school in Europe, he collected pieces of stained glass from cathedrals and churches. The presidential signature is still in the collection, together with hundreds of letters and documents of the first thirty-four presidents.

Morgan's father, Junius, was also a collector and among his possessions was a letter from George Washington describing his dreams for the new nation. The letter is in the library today, in addition to other Washington memorabilia.

Although well-educated and wealthy, Morgan was not an art expert and was frequently advised in his collecting by his nephew, Junius Morgan, a connoisseur of literary material, and by his cataloger, Belle da Costa Greene. However, the final

decision always rested with Morgan, who believed in his own abilities to recognize quality.

Not until 1890, when his father was killed in a carriage accident on the Riviera, however, did Morgan begin to buy seriously and on a grand scale. During the final decade of the nineteenth century, he bought such tresures as a 1455 Gutenberg Bible on vellum; a 1459 Mainz Psalter; the ninth-century Lindau Gospels with its extraordinary jewelled binding; the four Shakespeare Folios, as well as the original autograph manuscripts of Keats's *Endymion*, Dickens's *A Christmas Carol*, and the manuscripts Lord Byron had presented to his mistress, Countess Guiccioli.

Eventually, Morgan began acquiring entire libraries from other collectors. Thus he acquired the Duke of Hamilton's famous Golden Gospels, a French manuscript, *Apocalypse*, that had belonged to the Duc de Berry, and a collection of 270 Rembrandt etchings. The collection continued to grow with purchases of books, mezzotints, first editions of his favorite French and English authors, and great quantities of letters, including those of British kings and queens.

When Morgan died in 1913, his library was widely acclaimed as the finest private collection in the United States. In his will, Morgan specified that his collection should be permanently available for the education and pleasure of the American public. In 1924, believing that the library had become too significant to be privately held, J.P. Morgan, Jr., transferred it to a board of trustees, with an endowment to provide maintenance. Soon afterward, it was incorporated as a public reference library by a special act of the legislature of New York State.

J.P. Morgan, Jr., continued the collection with the assistance of Belle da Costa Greene, library director for some forty years. One of the younger Morgan's significant additions was the famous thirteenth-century *Old Testament Illustrations*, a volume that had once been in the library of Shah Abbas the Great, King of Persia.

Acquisitions made by the library today are guided by the Fellows of the Pierpont Morgan Library, who also oversee grant-aid and publications. A recent library triumph was the purchase of the magnificently illustrated *Book of Hours* created for Catherine of Cleves, acknowledged to be one of the most beautiful and important books in the history of Western manuscript illumination.

THE BUILDING

In 1902, Morgan recognized that he needed a permanent home for his extensive collection, which was then maintained at various locations. He commissioned McKim, Mead & White to design a building on land adjoining his residence. McKim undertook the job himself, designing the structure in the style of a Renaissance palazzo built of fitted marble blocks in classic Greek fashion. McKim drew his inspiration from the Nymphaeum in the Villa Giulia in Rome, which was built for Pope Julius III in 1554. The neo-Italianate building was completed in 1906.

The present library building blends McKim's structure with the annex next door, which is the former home of J.P. Morgan, Jr. The annex, a Renaissance-style brownstone building, was commissioned in 1928 and designed by Benjamin Wistar

Morris. Visitors enter through the annex on Thirty-sixth Street, off Madison Avenue.

Library officials plan to renovate the annex and join the two sections with a glass-enclosed courtyard. This expansion will preserve the intimate scale of the museum while adding needed exhibition space, an education center, and offices.

EXHIBITIONS

A portrait of library director Belle da Costa Greene by Paul-César Helleu hangs in the entry hall; a plaque dedicated to her is in the gift shop. John Singer Sargent's portrait of Mrs. J.P. Morgan, Jr., is in the hall, on the stair landing. Mrs. Morgan loved flowers and added many horticultural books to the library.

Cases in the corridor leading to the shop and the period rooms hold manuscripts, literary works, and art objects.

Although accredited students and scholars may use the library for research purposes, only a small portion of the collection is on public view in a series of continuing temporary exhibitions.

The library regularly presents important international exhibitions that dovetail with its own holdings. As an example, "Words of Blood, Images of Fire," attempted to shed light on the French Revolution through showing the drawings of Jacques-Louis David and other artists. Other recent exhibitions have been devoted to the drawings and watercolors of Maurice Sendak and to German drawings from 1780 to 1850.

PERIOD ROOMS

The two period rooms adjoin the area that was originally the main entrance. Murals by Harry Siddons Mowbray cover the domed ceiling, above an ornate marble floor that is patterned after the Villa Pia flooring in the Vatican. Mowbray, formerly the acting head of the American Academy in Rome, also painted the murals in the East Room and in the elevator hall of the annex.

EAST ROOM

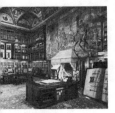

The East Room

Floor-to-ceiling bookcases displaying some of the library's vast collection are focal points. State-of-the-art fire detection and air control systems preserve these treasures, which are among the most valuable in the world.

The library is particularly renowned for its one thousand medieval and Renaissance manuscripts, dating from the fifth to the sixteenth centuries; its tens of thousands of letters and hundreds of autograph manuscripts. Here are books that date from the inception of printing, including the work of William Caxton, England's first printer. One of the most important collections of early children's books in the United States is also here.

Highlights of the library's bindings collection—considered to be the most comprehensive such collection in America—are bejewelled and metalwork bindings and a gold-tooled presentation binding made for Queen Elizabeth I in London in 1573. More than nine thousand drawings and prints include works by Dürer, Michelangelo, Rembrandt, Rubens, and Watteau, among others. The library's collection of music manuscripts is noted for its breadth and depth and includes

autograph scores by Bach, Mozart, Beethoven, and Stravinsky. The Gilbert and Sullivan archive is the most extensive found anywhere.

Among the printed works on permanent display in the East Room's glass-enclosed cases are the Gutenberg Bible and one of twenty-two original printings of the Declaration of Independence. The art objects in this room include a rare bronze *Running Eros* from the second or third century B.C. and a sixteenth-century Flemish tapestry that hangs above the massive fireplace.

Mowbray murals cover the richly patterned coved ceiling. Portraits of female muses alternate with those of leaders and teachers of Western civilization. Twelve spandrels sport zodiac symbols and the Roman deities who governed them.

Two "lucky" stars, placed above the entrance so that Morgan could walk under them, are set apart from other decorations. They coincide with two important dates in Morgan's life: his birth, April 17, 1837, and his second, long-lasting marriage to Frances Louisa Tracy, May 31, 1865.

WEST ROOM

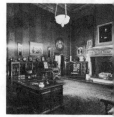

This room with its red brocade walls, Italian Renaissance carved wood ceiling, and fifteenth-century stained-glass windows was originally Morgan's study, with McKim-designed furniture, handsome paintings, and other art objects. It was here that Morgan met with other bankers to stem the financial panic of 1907 and ultimately preserve the banks' solvency. Here, too, he entertained celebrities in the arts and other fields.

The West Room

Low wooden bookcases house more of the library's valuable collection. The fifteenth-century marble fireplace is attributed to the studio of Desiderio da Settignano.

THEODORE ROOSEVELT BIRTHPLACE

28 East 20th Street
New York, N.Y. 10003
212/260–1616

SUBWAY	6, N, and R.
BUS	M1, M2, M3, M5, M6, and M7.
HOURS	9 A.M. to 5 P.M. Wednesday through Sunday. Closed Monday, Tuesday, holidays, and Wednesday following Monday holidays.
TOURS	9 A.M. to 3:30 P.M.
ADMISSION	$1, adults; children under 17 and senior citizens over 62, free.
SALES DESK	Books, postcards, color transparencies.
SPECIAL EVENTS	Concerts, lectures, and regularly scheduled films.
AUTHOR'S CHOICE	Child's red velvet chair used by Theodore Roosevelt.

This reconstructed brownstone recalls the era of horseless carriages and horsehair sofas when Theodore Roosevelt, twenty-sixth president of the United States, was a boy. An energetic, multitalented man, Roosevelt was a rancher, naturalist, conservationist, explorer, public official, the author of over thirty books, and the winner of the Nobel Peace Prize.

Roosevelt spent his first fourteen years in the house that originally occupied this site. His life is encapsulated in the displays and memorabilia on view in two museum exhibit areas and five Victorian period rooms.

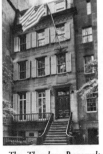

The Theodore Roosevelt Birthplace

HISTORY

The first Roosevelt to settle in America was Claus Martenszen Van Rosenvelt, who emigrated to the Dutch colony of New Amsterdam, now New York City, in the 1640s. His descendants have played a prominent role in the commercial and social life of the city ever since.

In the mid-nineteenth century, Cornelius Van Schaack Roosevelt purchased both number 26 and number 28 East Twentieth Street—then a quiet, tree-lined street in Gramercy Park, New York's most fashionable residential area—as wedding gifts for his two sons, Theodore, Sr., and Robert. Theodore and his bride, Martha Bulloch, moved into number 28 in 1854. Theodore, Jr., the second of their four children, was born in 1858. The Roosevelts lived in the house until the fall of 1872, when they set out on a yearlong European tour. Immediately upon their return, the family moved into a new house at 6 West Fifty-seventh Street.

"Teedie" Roosevelt was a sickly child who suffered from asthma. To help him build up his body and improve his health, his father built a gymnasium on the back porch of the house.

Young Roosevelt exercised daily and eventually overcame his asthmatic problems. He also developed an interest in natural history and, after learning taxidermy, started the "Roosevelt Museum of Natural History" in his home.

The frailty of Roosevelt's childhood is in marked contrast to the vigor of his adult life. An exponent of the "strenuous life," T.R. as he was called, was a hunter, fisher, and explorer. He discovered the source of a river in Brazil and led the Rough Riders in Cuba during the Spanish-American War.

In 1880, he married Alice Hathaway Lee, who died February 14, 1884, soon after the birth of their daughter, Alice (later Alice Roosevelt Longworth). Roosevelt's mother died of typhoid fever the same day as his wife. To assuage his grief, Roosevelt bought two cattle ranches in the Dakota Territory and lived the rugged outdoor life of a rancher and cowboy. During this period, he also wrote two books—a biography of Senator Thomas Hart Benton of Missouri and *The Winning of the West*.

Roosevelt returned to New York in 1886. He ran for mayor at the request of Republican leaders and was badly defeated. In December 1886, he married Edith Kermit Carow, a childhood friend.

At the age of twenty-three, Roosevelt was elected to the New York State legislature. This was the first in a long list of public offices he held, including U.S. Civil Service commissioner, police commissioner of New York City, assistant secretary of the U.S. Navy, and governor of New York.

In 1900, William McKinley was elected president of the United States, with Roosevelt as his vice-president. McKinley's assassination six months after assuming office propelled Roosevelt into the White House. He was elected to a full term as president in 1904. During his second term, Roosevelt became the first American to win the Nobel Peace Prize as a result of his efforts to negotiate an end to the Russo-Japanese War. He ran for president again on the "Bull Moose" ticket and was defeated in 1912.

Roosevelt survived an assassination attempt in 1912, and, because his heavy coat and a fifty-page speech in a pocket blunted the effect of the bullet, he managed to give a ninety-minute speech immediately afterward.

When Roosevelt died at his home in Oyster Bay, New York, January 6, 1919, Vice-President Thomas R. Marshall remarked that "Death had to take him sleeping, for if Roosevelt had been awake, there would have been a fight."

THE BUILDING

The original three-story house on this site, a typical New York brownstone, was built in 1848. A fourth floor was added to the house in 1865.

By the turn of the century, residential properties in the neighborhood, including the former Roosevelt home, were being converted into commercial establishments. In 1916, the house was torn down and a two-story commercial building was erected on the site. After Roosevelt's death, a group of prominent New York women decided to purchase the site, raze the commercial building, and reconstruct Theodore Roosevelt's boyhood home as a memorial. Museum galleries and other facilities were built on the adjoining lot, where Robert Roosevelt's home once stood.

The reconstructed birthplace opened to the public in 1923, and, in 1963, the Theodore Roosevelt Association donated it to the National Park Service, which now maintains it as a national historic site.

TOURING THE HOUSE

Leon Marcotte, a leading New York interior designer, redecorated the Roosevelt home in 1865, and the period rooms recall the years between then and 1872. Roosevelt's two sisters and his wife provided detailed information about the color schemes and the furnishings. Approximately forty percent of the furnishings were in the original house. Family members donated another twenty percent, and the remainder are period pieces.

FIRST FLOOR ## MUSEUM

This room to the right of the entrance contains scores of glass-enclosed display cases filled with personal belongings, pictures, and documents relating to the Roosevelt family.

You can see the wedding clothes worn by President Roosevelt's parents; a miniature tea set with lace-edged napkins in silver rings that Roosevelt's mother gave to Edith Kermit Carow, the childhood friend he later married, and copies of some of his writings. In addition to social, literary, and political essays, Roosevelt wrote books on history, biography, and natural science. The uniform T.R. wore as a Rough Rider during the Spanish-American War and his book of cavalry drill regulations are here. Other exhibits recall his political campaigns and his years as president.

During her seven years as First Lady, an aide said that Edith Roosevelt "never made a single mistake." She supervised a major remodeling and redecoration of the White House, replacing the Victorian furnishings with neoclassical ones in keeping with the period of the house. The mansion was officially named the White House during T.R.'s administration.

One of the pictures displayed in the museum shows Roosevelt's family leaving the Executive Mansion at the end of his term. When she saw that photograph, Roosevelt's daughter Alice commented that "We look as if we are being expelled from the Garden of Eden."

SECOND FLOOR ## LIBRARY

This was the family living room during the Roosevelt era. The richly patterned wallpaper and crimson carpet provide a colorful backdrop for the black horsehair furniture. The Roosevelt children complained that the horsehair chairs scratched their bare legs when they sat on them. As a result, young Theodore was given the miniature red velvet chair seen here.

Two obelisks on the mantel are souvenirs of a family trip to Egypt. Roosevelt recalled that this comfortable room was filled with "tables, chairs, and bookcases of gloomy respectability" during his childhood.

The original gas lamp hangs here, with a different pattern etched into each panel of the shade, thanks to a lithopane process perfected in Germany in the 1830s. A clock that belonged to the Roosevelt family stands on the mantel.

DINING ROOM

Running the width of the house, this room is furnished in Gothic Revival style, with chairs covered in the then-popular black horsehair.

On the sideboard, the rose-patterned dishes with green borders recall the origins of the Roosevelt family name. In Dutch, Roosevelt means "field of roses."

PARLOR

With a sparkling crystal chandelier and rococo revival furniture upholstered in pale blue damask, it is easy to understand why Roosevelt recalled the parlor as "a room of much splendor . . . open for general use only on Sunday evening or on rare occasions when there were parties." He thought the cut-glass prisms of the chandelier possessed "peculiar magnificence."

LION ROOM

This exhibit area focuses on Theodore Roosevelt's prowess as a hunter. A stuffed lion is the focal point of the room.

Other exhibits illustrate the story of Roosevelt and "teddy bears." On a hunting trip in Mississippi in November 1902, the president and his guides tracked down a bear and surrounded it. Roosevelt refused to shoot the animal, even though one of the guides urged him to do so to win a hunting trophy. Soon afterward, cartoonist Clifford Berryman drew a cartoon based on Roosevelt's kindness to the bear. When a store owner in Brooklyn saw the cartoon, he obtained the president's permission to make toy bears, labeled "Teddy's Bear," to sell in his shop.

THIRD FLOOR

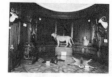

The lion room

NURSERY

The crib, sleigh bed, dresser, and child's chair in this room originally belonged to the Roosevelts. A portrait of T.R.'s Aunt Anna hangs over the mantel. The scenic wallpaper is a reproduction of a period paper.

Steps under the window lead to the porch where a gymnasium was originally set up for the ailing young "Teedie." The Roosevelt children climbed through the window to the gym.

MASTER BEDROOM

The satinwood and rosewood furniture in this room was designed for the master bedroom by Leon Marcotte in 1865. The bed, dresser, secretary, and washstand were later used in the home of Theodore Roosevelt's sister, Corinne.

A portrait of Roosevelt's mother hangs over the mantel. Martha Bulloch Roosevelt is remembered as a gracious, Southern lady who was a member of a prominent Georgia family.

The master bedroom

64

AMERICAN CRAFT MUSEUM

40 West 53rd Street
New York, N.Y. 10019
212/956–3535

SUBWAY	1, B, D, E, F, N, Q, and R.
BUS	M2, M3, M4, M5, M6, M7, M27, M28, M30, and M32.
HOURS	10 A.M. to 8 P.M. Tuesday; 10 A.M. to 5 P.M. Wednesday through Sunday.
TOURS	6 P.M. and 7 P.M. Tuesday; 11 A.M. and Noon Saturday.
ADMISSION	$3.50, adults; $1.50, senior citizens over 65 and students with I.D.; children under 12 and members, free.
HANDICAPPED FACILITIES	Accessible to the disabled. Wheelchair and elevator accessible.
SALES DESK	Exhibition catalogs, postcards, *American Craft Magazine*.
SPECIAL EVENTS	Tuesday evening lectures and weekend artist demonstrations.
MEMBERSHIP	From $40.

"A good life is found only where the creative spirit abounds, where people are free to experiment and create new ideas within themselves."

Aileen Osborn Webb

Anyone who appreciates handmade, rather than mass-produced, objects, will enjoy this museum devoted to twentieth-century crafts. Objects made from clay, fiber, glass, metal, plastic, or wood, are traditionally considered "crafts." Here, however, functional objects have been raised to the level of fine art.

HISTORY
The American Craft Museum was established by the American Craft Council in 1956. The council, and through it the museum, traces its history back to the efforts of Aileen Osborn Webb, who championed the cause of the American craft movement for fifty years. A wealthy Putnam County socialite, Mrs. Webb was also a talented potter, watercolorist, enamelist, and woodcarver. Through her efforts, a small crafts cooperative in Putnam County grew into a national nonprofit membership organization, the American Craft Council, which was founded in 1943.

During the Depression, in the 1930s, Mrs. Webb established a cooperative association to help county residents earn money by selling their handiworks. In 1939, she formed a new association, the Handcraft League of Craftsmen, and, the following year, opened America House, a crafts shop at Madison Avenue and East Fifty-fourth Street in New York City. The League merged with Anne Morgan's American Handcraft Council in 1942 to become the American

Craftsmen's Cooperative Council. In addition to helping craft workers sell their products, the new group established an educational arm, staged craft exhibitions, and began to publish a magazine, *Craft Horizons*.

In 1955, Mrs. Webb purchased a brownstone at 29 West Fifty-third Street, west of the Museum of Modern Art, to house the offices, library, and exhibition gallery of the American Craft Council. The following year, the gallery opened as the Museum of Contemporary Craft. It soon achieved recognition for presenting such first-of-their-kind exhibitions as "Louis Comfort Tiffany," "Woven Forms," and the first museum retrospective of the work of ceramic artist Peter Voulkos.

The museum moved into larger quarters in a renovated brownstone at 44 West Fifty-third Street in 1979, where it continued its program of pioneering exhibitions. The name was changed to the American Craft Museum, to better reflect its emphasis on the history and current state of contemporary craft in this country. Several years later, the museum opened temporary satellite exhibition space at the headquarters of the International Paper Company on West Forty-fifth Street, where its shows ventured into such state-of-the-art areas of craftsmanship as "The Robot Exhibit."

By October 1986, the museum had moved to its present home at 40 West Fifty-third Street, where the four-level space features a soaring staircase-atrium and adjacent intimate galleries. The museum now has four times the exhibition space it had before, which enables it to present major exhibitions as well as combinations of smaller shows.

THE BUILDING

When it opened in its new building in 1976, the American Craft Museum represented a new concept in museums. Tucked in the northeast wing of a Kevin Roche John Dinkeloo and Associates office tower on West Fifty-third Street, across from the Museum of Modern Art and next to the Donnell Library, it was considered to be the first condominium museum in the country.

The museum has its own entrance, independent of the main tower, while its extensive glass façade, seventy-two feet long and twenty-one feet high, permits a clear view of the lobby gallery and the forty-foot-high stairway-atrium. In addition to the exhibition galleries, the condominium houses museum offices.

Fox & Fowle, who also designed the previous museum space, have created flexible gallery spaces in which contemporary crafts—from the smallest brooch to the most monumental tapestry—can be displayed. The stairway-atrium connects all the gallery levels, including the lower level "Eventspace," which is used for special events and education programs, as well as exhibitions and other activities.

THE COLLECTION

The museum collects, conserves, exhibits, interprets, and documents twentieth-century crafts. It also focuses on such related disciplines as architecture, design, the decorative arts, fashion, painting, and sculpture.

Major artists of the post–World War II period are included in a growing permanent collection. Although all craft media

Bowl *by Ruth Duckworth, 1978*

Bittersweet XIV, *a quilt by Nancy Crow, 1981*

are represented, the collection is strongest in ceramics and fiber art. The recent donation of the Dreyfus Corporation collection of masterpieces from the fiber art revolution of the 1960s augments the earlier Johnson Wax collection of work in all media by leading postwar artists.

Among the 123 objects in the Johnson gift are the handsome *Halfplate* by Erik Gronburg, in stoneware with lusters and glazes; *Tikal* by Anni Albers, an intricately woven cotton square, presumably inspired by centuries-old Mayan culture; a beautiful handblown glass vase by Mark Peiser, and Stanley Lechtzin's electroformed, silver gilt pendant embellished with amethyst and fresh-water pearls.

Selections from the permanent collection are on view in changing exhibitions. They may also be seen from time to time at other museums through loans or in such traveling exhibitions as "Craft Today: USA," which was the first exhibition to bring contemporary American crafts to the Soviet Union, East Germany, Czechoslovakia, and Poland.

Temporary exhibitions range from major retrospectives of such artists as maverick turn-of-the-century potter George Ohr and revolutionary fiber artist Lenore Tawney to shows appealing to multicultural audiences. These include "Who'd a Thought It: Improvisation in African-American Quiltmaking" and "Fragile Blossoms, Enduring Earth: The Japanese Influence on American Ceramics."

In addition, the museum organizes exhibitions that reflect current issues in craft and related art forms, such as the annual series, "Explorations," which features emerging and mid-career artists in small simultaneous exhibitions. "Crafts of the Bauhaus" typifies the thematic group exhibitions that contribute to the knowledge and scholarly documentation of the early and mid-twentieth century, enabling today's art forms to be understood in an historical context.

IBM GALLERY OF SCIENCE AND ART

590 Madison Avenue
New York, N.Y. 10022
212/745–3500
212/745–6100 recorded information

SUBWAY	4 and 5.
BUS	M1, M2, M3, M4, M57, and M30.
HOURS	11 A.M. to 6 P.M. Tuesday through Saturday.
TOURS	Group tours by reservation. Call 212/745–5214.
ADMISSION	Free.
HANDICAPPED FACILITIES	Accessible to the elderly and disabled.
FOOD SERVICE	Food kiosk in atrium.
SPECIAL EVENTS	Free talks and films relating to current exhibitions.
SPECIAL FACILITIES	196-seat auditorium.

A visit to the IBM Gallery of Science and Art proves that the IBM Corporation is involved in much more than computer technology. As the gallery's name implies, the company is both a supporter of the arts and a pioneer in scientific research.

HISTORY

IBM's involvement with the arts began in the 1930s when its founder and chairman Thomas J. Watson, Sr., decided to purchase art works from each of the seventy-nine countries where IBM was then doing business. In 1986 alone, over $17 million was earmarked for the arts worldwide for purchases and for corporate sponsorship of museum exhibitions.

The gallery opened in late 1983 with selections from the Museum of American Folk Art and the Phillips Collection in Washington, D.C. Since then, in keeping with its policy of bringing exhibitions to New York that would not otherwise be seen there, gallery presentations have covered a wide variety of topics.

Exhibitions have focused on such diverse subjects as newly excavated artifacts from Pompeii, the art of Northwest Coast Indians, the prints of Japanese woodblock artist Ando Hiroshige, eighteenth- to twentieth-century paintings from the Rhode Island School of Design's museum, contemporary architecture, and contemporary Swedish design. Works from the IBM Corporation's art collection have also been exhibited.

The gallery's showing of selections from Winterthur Museum in early 1990 was the largest and most important exhibition of early American decorative arts from the Winterthur Museum ever to be shown in New York City.

Scientific exhibitions have been devoted, among others, to computers and art, space photography, microscopy, the nature of light and vision, and Sir Isaac Newton's contributions to physics.

THE BUILDING

IBM's New York headquarters, a forty-two-story, granite and glass building designed by Edward Larrabee Barnes, opened in 1983. Barnes provided twelve-foot ceilings, constant levels of temperature and humidity, and a system of flexible lighting and partitions in the exhibition area.

You enter the IBM Gallery on Madison Avenue at Fifty-sixth Street, through an atrium filled with plants and forty-foot-high stands of bamboo. Temporary exhibitions are housed on the lower level of the building. Science exhibits are located in the Fifty-seventh Street lobby and on the mezzanine.

The gallery is built on a raised computer floor so that cables can be strung anywhere within the space to provide electrical power for exhibitions.

THINK: INNOVATION AT IBM

Opened in 1989, this permanent exhibit celebrates contemporary advances in basic scientific research, as well as innovative uses of technology in education.

It also calls attention to IBM's motto, "Think," which expresses Thomas J. Watson, Sr.'s belief that "To think is to achieve." As the founder of IBM, Watson stressed the need for employees to have the environment, tools, education, and freedom to create.

The exhibition focuses on the pioneering work of various IBM scientists, including Daniel Grischkowsky, who developed a technique for creating ultra-short laser light pulses lasting only a fraction of a second; K. Alex Muller and J. Georg Bednorz, who have created high temperature superconductors; Gerd Binnig and Heinrich Rohrer, who invented the scanning tunneling microscope, and mathematician Benoit Mandelbrot, who introduced fractal geometry, a new way of looking at the complex shapes of nature.

MUSEUM OF AMERICAN FOLK ART

Eva and Morris Feld Gallery

Two Lincoln Square
New York, N.Y. 10023
212/977–7298

SUBWAY	1, 2, 3, 9, A, B, C, and D.
BUS	M5, M7, M10, M30, M66, and M104.
HOURS	9 A.M. to 9 P.M. daily.
TOURS	Group tours by reservation. Call 212/595–9533.
ADMISSION	Free.
HANDICAPPED FACILITIES	Accessible to the disabled.
MUSEUM SHOP	Adjacent to museum (212/496–2966) and 62 West 50th Street (212/247–5611). Handmade crafts and objects; books and catalogs related to American folk art.
SPECIAL EVENTS	Lectures, gallery tours, courses, symposia, workshops, quilt competitions.
SPECIAL FACILITIES	Research library open by appointment.
MEMBERSHIP	From $35.
AUTHOR'S CHOICE	*Girl in Red Dress with Cat and Dog* by Ammi Phillips St. Tammany weathervane Archangel Gabriel weathervane "Bird of Paradise" quilt

The Museum of American Folk Art, the only national urban institution of its kind, celebrates the creativity and diversity of America's folk artists. While the museum's new building is under construction, changing exhibitions, including selections from the permanent collection, are shown in this satellite museum on Columbus Avenue between Sixty-fifth and Sixty-sixth Streets, across from Lincoln Center.

HISTORY

The museum was founded in 1961 by a small group of serious collectors dedicated to collecting, preserving, and exhibiting naive works of art that depict America's cultural heritage. Originally located at 49 West Fifty-third Street, the museum moved to Columbus Avenue and Sixty-sixth Street in 1989.

In 1972, New York City granted Two Lincoln Square Associates the right to add 63,000 square feet to its building, provided the additional space included an arcade for public use.

When the resulting arcade did not fulfill the city's mandate

for the plaza, arrangements were made to open a branch of the Museum of American Folk Art there. The museum, which had been without a permanent exhibition home for two-and-a-half years, agreed to provide exhibitions and other programs, as well as public space, in exchange for a ninety-year lease, rent-free. The museum will return to West Fifty-third Street in several years, when its permanent headquarters are completed. The Lincoln Square gallery will remain a branch museum.

THE BUILDING

Clifford LaFontaine Inc. designed the Eva and Morris Feld Gallery at Lincoln Square, in association with Superstructures Architects/Engineers. The museum opened in April 1989.

Because parts of the existing plaza were open to the sky, the architects virtually constructed a "building within a building." The walls, windows, roof, and skylights had to be built within the dimensions of the plaza, close to the existing walls and ceilings.

St. Tammany
weathervane, mid-19th century

Installing an independent heating and air conditioning system between the museum and the base building, as well as controlled temperature, humidity, and lighting systems, were additional challenges. To solve the problem of too much natural light from the large areas of clear glass along Columbus Avenue—which affected the controlled lighting of museum objects—the architects designed a ceiling that slopes to form a "throat" at the intersection of the gallery's two axes.

You enter the museum through a garden court where weathervanes and carousel animals from the permanent collection are exhibited on a rotating basis. The mid-nineteenth-century, nine-foot-high *St. Tammany* weathervane of molded and painted copper is the focal point of the atrium.

Exhibitions are housed in three street level galleries radiating from the atrium.

THE COLLECTION

Defining the term "folk art" is difficult. Recognizing that it is subject to debate, museum curator Elizabeth V. Warren has stated that "The artists were *mostly* self-taught; *many* of them came from a crafts tradition; *most* of the work is handmade; *some* of it is utilitarian; and *some* aesthetic criteria, admittedly subjective, should be applied in judging folk art, as it is in all forms of art."

The permanent collection ranges from the eighteenth century to the present and includes paintings, furniture, textiles, sculpture, and three-dimensional objects, both functional and decorative. Selections are shown on a rotating basis.

Girl in Red Dress With Cat and Dog
by Ammi Phillips, 1834–36

Highlights include *Girl in Red Dress with Cat and Dog*, painted by Ammi Phillips in Amenia, New York, 1834–36, which is one of the museum's masterpieces; an 1833 portrait of Eliza Gordon Brooks, executed in watercolor and gold metallic paint on paper by Ruth Whittier Shute and Dr. Samuel Addison Shute, and a charming picture of General Washington on horseback by an unknown artist who worked in southeastern Pennsylvania around 1810.

A gate in the form of an American flag (with its field of stars reversed) is one of the most unusual objects in the collection. It was made in Jefferson County, New York, around 1876.

Weathervanes were a popular subject for folk artists and the museum boasts a number of fine examples, including *St. Tammany*, who welcomes guests in the atrium, and others depicting the Archangel Gabriel, a sea serpent, and an eagle with a shield. You can also see the shop signs and carousel animals that provided additional outlets for the creativity of folk artists. The "Animal Carnival" collection of contemporary New Mexican carvings shows how the folk tradition has continued to the present time.

An 1830–40 Pennsylvania corner cupboard painted to resemble the grain of wood; a hanging candle box from the Connecticut River Valley featuring geometric designs that were carved around 1790–1810, and an early nineteenth-century worktable of painted tiger maple are a few of the treasures to be found here.

The museum's interest in textiles is reflected in its sponsorship of annual quilt competitions, courses in quilting, and one of the finest collections in the country of quilts, counterpanes, coverlets, samplers, and hooked and braided rugs.

Look for the striking "Bird of Paradise" quilt and the Friendship Album quilt created by the sewing society of a church in Elizabeth Port, New Jersey, in 1852. Other highlights include the William and Dede Wigton Collection of Pennsylvania and Ohio Amish Quilts, the David Pottinger Collection of Indiana Amish Quilts, and the Margaret Cavigga Collection of crazy quilts.

TEMPORARY EXHIBITIONS

The museum mounts several temporary exhibitions each year. Recent exhibitions have focused on newly discovered folk sculptures, carved fish decoys, and the paintings of M. W. Hopkins and Noah North. Museum officials organized "Access to Art: Bringing Folk Art Closer," as a traveling exhibition designed to introduce folk art to blind and visually impaired visitors.

MUSEUM OF MODERN ART

11 West 53rd Street
New York, N.Y. 10019
212/708–9480

SUBWAY E and F.

BUS M1, M2, M3, M4, and M5.

HOURS 11 A.M. to 6 P.M. Friday through Tuesday; 11 A.M. to 9 P.M. Thursday. Closed Wednesday.

TOURS 12:30 P.M. and 3 P.M. daily, and 5:30 P.M. and 7 P.M. Thursday, gallery talks. Group visits, including foreign-language tours, by appointment. Call 212/708–9685. Sculpture touch tour for the visually impaired by advance appointment. Call 212/708–9795.

ADMISSION $7, adults; $4, students and senior citizens; museum members and children under 16 accompanied by an adult, free. Voluntary contributions 5 P.M. to 9 P.M. Thursday.

HANDICAPPED FACILITIES Accessible to the disabled. Wheelchairs and amplifying headphones available for use in the theaters. Sign-language interpreted lectures, 7 P.M. third Thursday of each month.

FOOD SERVICE Garden Café, ground floor; Members Dining Room overlooking the Sculpture Garden open to nonmembers as space permits.

MUSEUM SHOPS MoMA Book Store, ground floor: catalogs, art books, posters, and stationery. MoMA Design Store, across the street at 44 West 53rd Street: modern design objects for home and office. MoMA Store in Grand Central Station, Lexington Avenue and 42nd Street: select items from both stores.

SPECIAL EVENTS Lectures, seminars, modern art courses, Brown Bag Lunchtime Lectures. Saturday morning parent and child workshops, family hours, and family film series. Free concerts Friday and Saturday evenings every July and August in the Sculpture Garden.

SPECIAL FACILITIES Abby Aldrich Rockefeller Sculpture Garden.

RESEARCH FACILITIES Museum Library, 212/708–9433; Study Centers in Architecture and Design, Drawings, Film, Photography, and Prints, 212/708-9400, open by appointment. Teaching Information Center in the Edward John Noble Education Center, 212/708–9864.

MEMBERSHIP From $60.

AUTHOR'S CHOICE Abby Aldrich Rockefeller Sculpture Garden
Les Demoiselles d'Avignon by Pablo Picasso
Water Lilies by Claude Monet
The City Rises by Umberto Boccioni

The Museum of Modern Art—MoMA—houses the world's foremost collection of twentieth-century art. Beginning with

only eight prints and one drawing, its collection has grown to include over a hundred thousand paintings, sculptures, drawings, prints, photographs, architectural models and plans, and design objects, as well as some ten thousand films and videotapes. Together, these holdings provide an unrivaled view of the modern masters and movements that have made the period from about 1885 to the present one of the most varied and revolutionary in the entire history of art.

HISTORY

The Museum of Modern Art opened its doors on November 7, 1929, with an exhibition of works by Paul Cézanne, Paul Gauguin, Georges Seurat, and Vincent van Gogh. Opening to the public just ten days after the stock market crash, the museum was nevertheless an immediate success, proving the public's appetite for modern art. At that time, American museums rarely showed late nineteenth- and early twentieth-century art, and few people collected modern art seriously.

The Museum of Modern Art

The late Alfred H. Barr, Jr., the museum's visionary founding director, conceived of a multidepartmental museum that would encompass not only painting and sculpture, but also photography, film, and design—fields not generally acknowledged as art. Under Barr's leadership, the museum became a stronghold of European and American modernism. A friend of Pablo Picasso, Henri Matisse, and the Surrealists, he acquired their works liberally. His exhibitions, "Cubism and Abstract Art," and "Fantastic Art, Dada, and Surrealism," both mounted in 1936, set the standard for modern art curatorship. Barr's radical and ambitious vision of a museum devoted to the many arts of our time became the Modern's guiding principle.

The museum's Department of Architecture and Design began in 1932 with the pioneering exhibition, "Modern Architecture: International Exhibition," which introduced to America the work of Le Corbusier and the Bauhaus architects Ludwig Mies van der Rohe and Walter Gropius. The controversial "Machine Art" exhibition of 1934 filled the museum with steel springs, ball-bearings, and propeller blades; the department's subsequent judgments on "good design" have influenced the field worldwide.

Photography, first exhibited in 1932, was formally established as its own department in 1940 by Beaumont Newhall, author of what is still considered to be the definitive history of the medium. Photographer Edward Steichen assumed the directorship in 1947 and, in 1955, mounted "The Family of Man," one of the museum's most widely circulated and enduringly popular exhibitions. Under its current director, John Szarkowski, the department has embraced photojournalism and "street photography," including the work of Diane Arbus, Garry Winogrand, and Lee Friedlander.

The museum's Film Department—the first of its kind—was established in 1935 and now houses more than ten thousand works by international film- and videomakers. Its collection ranges from the original negatives and prints of D.W. Griffith's *The Birth of a Nation* to gifts by Stanley Kubrick, Francis Ford Coppola, and other major contemporary filmmakers. In 1979, MoMA received an honorary Academy Award in recognition of its ongoing program of film

preservation and its continuing support of the motion picture as an art form.

From the start, the museum has benefited from a history of enlightened patronage and imaginative leadership. Beginning with its three founders—Lillie P. Bliss, Mrs. Cornelius J. Sullivan, and Mrs. John D. Rockefeller, Jr.—many prominent New Yorkers and leading art world figures have been influential in its development. Among those who have served or continue to serve as trustees, advisors, or benefactors are Mrs. Simon Guggenheim, art dealer Sidney Janis, CBS founder William S. Paley, architect Philip Johnson, and three generations of Rockefellers. Over the past six decades, their support—and that of others like them—has ensured the prosperity of this vital and independent institution.

THE BUILDING

In 1939, the museum opened in its present building, on the site of a Rockefeller town house it had leased since 1932. Designed by Philip Goodwin and Edward Durell Stone, it is one of the first examples of the International Style in America. Among its innovative features were loft-like galleries with movable partitions, track lighting, and white walls, which eventually became standard for displaying art.

Unlike the Beaux Arts palaces that were typical of museums at that time, the Modern's six-story building was located on a busy midtown street with an entrance that was flush with the pavement, making it an integral part of the urban fabric. The distinctive glass-and-steel façade soon became a public symbol of the modern treasures contained within. Despite subsequent remodelings and expansions during the 1950s and 1960s, the original façade remains essentially intact.

The Abby Aldrich Rockefeller Sculpture Garden

In May 1984, the museum completed a major renovation and expansion that doubled its gallery space and added a second theater for films. Designed by Cesar Pelli, dean of the Yale School of Architecture, the centerpiece of the "new" MoMA is a four-story, glass-enclosed Garden Hall. Ascending the escalators through five floors of exhibition space, visitors experience a vista that encompasses masterworks from the collection, the Sculpture Garden, and the midtown skyline.

The Abby Aldrich Rockefeller Sculpture Garden is among New York's most delightful outdoor spaces. Although part of the building's original plan, it was formally designed in 1953 by Philip Johnson and named for one of the museum's founders. Open year round, weather permitting, the garden is an inviting place to stroll among trees, fountains, and reflecting pools, while enjoying such masterpieces of modern sculpture as Picasso's *She-Goat*, Auguste Rodin's *Monument to Balzac*, and Claes Oldenburg's *Geometric Mouse*.

PAINTING AND SCULPTURE

THE COLLECTIONS

The painting and sculpture collection—arrayed on two floors—unfolds like a great story of modern art. Arranged chronologically, the tour begins on the second floor, with masterpieces of Post-Impressionism by Cézanne, Gauguin, and van Gogh, including the latter's *Starry Night* and the recently acquired *Portrait of Joseph Roulin*. Claude Monet's four-panel *Water Lilies* is installed nearby in a contemplative gallery that overlooks the garden.

Just beyond Henri Rousseau's *Sleeping Gypsy*, visitors are confronted by Picasso's *Demoiselles d'Avignon* and other masterpieces of Cubism. Avant-garde paintings by the Russian Constructivists follow, along with the dynamic canvases of the Italian Futurists, Dada's antic "readymades," and the dreamlike works of Surrealism, including Salvador Dali's much-parodied *Persistence of Memory*. Whole galleries are devoted to the work of Picasso, Matisse, Constantin Brancusi, Piet Mondrian, and Joan Mirò.

At the third-floor entrance to the collection, visitors are greeted by the familiar favorite, Andrew Wyeth's *Christina's World*. Matisse's delightful cut-out *The Swimming Pool*—originally created for the artist's dining room—provides a bridge from postwar European art to Abstract Expressionism. The galleries of monumental, color-drenched canvases by Jackson Pollock, Richard Diebenkorn, Mark Rothko, Barnett Newman, and Ad Reinhardt are another MoMA forte.

The final galleries feature a constantly changing display of contemporary work from 1950 to the present by Alice Aycock, Jenny Holzer, Anselm Kiefer, Susan Rothenberg, and Andy Warhol, to name but a few.

PHOTOGRAPHY

The Edward Steichen Photography Center, on the second floor, houses the museum's photography collection, ranging from the earliest daguerreotypes to Polaroids.

The installation proceeds counterclockwise, beginning with Victorian portraiture and continuing with the crystal-clear panoramas of the nineteenth-century landscape photographers W.H. Jackson and Timothy O'Sullivan, and the cityscapes of Edward Steichen, Margaret Bourke-White, and Berenice Abbott. Man Ray's experimental photographs are displayed

alongside images by André Kertész, Henri Cartier-Bresson, Walker Evans, Edward Weston, and Dorothea Lange. Outstanding examples of photojournalism and fashion photography abound, including works by Irving Penn, Weegee, and Richard Avedon.

The entrance gallery is reserved for temporary exhibitions or recent acquisitions.

PRINTS AND ILLUSTRATED BOOKS

The Paul J. Sachs Gallery, on the third floor, exhibits a small fraction of the museum's large and important collection of lithographs, etchings, woodblock prints, and other forms of printed art. Light levels are kept deliberately low to preserve the rotating display of works by Henri Toulouse-Lautrec, Edvard Munch, Paul Klee, Jean Dubuffet, and Jasper Johns, among others.

An introductory gallery, dedicated to former MoMA publications director Monroe Wheeler, functions as a reading room with exhibition catalogs and books about prints.

The Tatyana Grosman Gallery, named in memory of the pioneering fine art publisher, is devoted to installations of works by contemporary printmakers.

DRAWINGS

The third-floor drawings galleries, dedicated to trustee Ronald Lauder, are devoted to one of the world's most significant collections of modern works on paper, including pencil, ink, and charcoal drawings, watercolors, gouaches, and collages.

Twittering Machine by Paul Klee, 1922, Museum of Modern Art purchase

The works displayed include preliminary studies and independent themes, featuring such masterworks as Klee's *Twittering Machine* and Picasso's *Minotaure*. The gallery's flexible design allows the museum to mount either a single exhibition or several shows at one time, arranged according to a particular artist, style, or subject.

ARCHITECTURE AND DESIGN

Visitors ascend to the fourth-floor architecture and design galleries beneath a helicopter, suspended from the ceiling. The works installed at the entrance provide a mini-survey of the collection's highlights: a flaming red Italian sports car, a model of Frank Lloyd Wright's *Fallingwater*, a case containing laboratory beakers, cocktail shakers, and a turntable, and a selection of posters from the museum's vast holdings of graphic arts.

A model of Fallingwater *by Frank Lloyd Wright, Museum of Modern Art Collection*

Inside the Philip Johnson Gallery are models and drawings for buildings by Mies van der Rohe, Richard Neutra, Le Corbusier, Frank Gehry, and others. The surrounding Philip Goodwin Galleries display the finest examples of modern and contemporary furniture and industrial design, beginning with Tiffany Art Nouveau vases and extending to Eames chairs and all manner of household appliances. Among the more mundane objects elevated to high art are Tupperware, hockey masks, and a compact disc.

FILM AND VIDEO

The Roy and Niuta Titus Theaters 1 and 2, on the lower level, are the heart of the film department. As many as four film programs are screened daily, ranging from animated shorts to social documentaries, from foreign features to Hollywood classics.

Recent retrospectives have honored actors Anna Magnani and Charlie Chaplin, directors Vincente Minnelli and Constantin Costa-Gavras, and producers Ed Pressman and Albert Broccoli of *James Bond* fame. Regularly scheduled programs include memorial tributes compiled from the museum's archives and three weekly series showcasing works by independent film- and videomakers.

The theater lobby functions as a gallery for lively exhibitions of film stills and posters.

A recently created video gallery, located on the third floor, provides a permanent home for the museum's growing collection of works by contemporary videomakers.

TEMPORARY EXHIBITIONS

The museum's collections provide an essential background for its active program of exhibitions, ranging from major retrospectives to contemporary installations. Among the highly acclaimed exhibitions MoMA has mounted in recent years are "Vienna 1900: Art, Architecture, and Design;" "Picasso and Braque: Pioneering Cubism;" "Photography Until Now;" retrospectives devoted to Paul Klee, Frank Stella, and Andy Warhol; and surveys of recent French and German cinema.

Two series are devoted to contemporary artists: "Projects," which features frequently changing installations by lesser-known artists, and "Artist's Choice," which presents works from MoMA's collection selected by prominent artists.

MUSEUM OF TELEVISION AND RADIO

25 West 52nd Street
New York, N. Y. 10019
212/752–4690
212/752–7684 screening information

SUBWAY	E and F.
BUS	M1, M2, M3, M4, and M5.
HOURS	Noon to 5 P.M. Wednesday through Saturday; Noon to 8 P.M. Tuesday. Closed Sunday and Monday.
ADMISSION	$4, adults; $3, students, $2, senior citizens and children under 13.
HANDICAPPED FACILITIES	Accessible to the disabled.
MUSEUM SHOP	Catalogs, posters, and T-shirts.
SPECIAL EVENTS	Exhibitions, screening and listening series, and seminars.
SPECIAL FACILITIES	Research library and theater.
AUTHOR'S CHOICE	Historic dramatic programs Classic comedy shows

Increasingly, this museum is being discovered by everyone who either watches or performs on radio or television. It is the first institution of its kind where you can actually watch and listen to early dramatic programs, timeless comedy, and memorable historic events, as well as great sports, arts, and political programming. An hour or two at a console in one of the museum's broadcast study centers can re-create the golden age of radio and the greatest moments of television. From crystal sets to satellite feeds, the history of radio and television unfolds before your eyes.

HISTORY
The late William S. Paley, the founder and chairman of CBS, recognized the need to collect, preserve, and exhibit radio and television programs so that this aspect of contemporary culture would not be lost forever. He founded the museum as a nonprofit institution in 1975, and, with grants from broadcasting networks, corporations, foundations, and individuals, it opened the following year.

Originally, the museum was located at One East Fifty-third Street in a building that once housed the Stork Club. Space that was suitable for a nightclub, however, soon became inadequate for the museum's growing collections.

In 1984, the museum's trustees began to search for a new

home. When a site was selected nearby on West Fifty-second Street, Paley contributed $12 million to purchase the land, and the three major networks, ABC, CBS, and NBC, each pledged $2.5 million. With a goal of $45 million, additional funding came from foundations and individuals associated with radio and television.

They believed that making available an outstanding collection of programs would help to increase public appreciation of the artistic value, social impact, and historic importance of radio and television.

THE BUILDING
Ground was broken for the new building at 25 West Fifty-second Street, between Fifth and Sixth Avenues, in 1988. Designed by John Burgee Architects with architect John Burgee and design consultant Philip Johnson, the seventeen-story structure combines distinguished design with state-of-the-art technology.

The Steven Spielberg Exhibition Gallery and the museum shop are on the first floor. Objects that reflect the history of the industry, such as storyboards, sets, props, and costumes, are showcased in the gallery. A two-hundred-seat theater, used as a screening room for major exhibitions, is on the floor below.

On the second floor, a smaller theater, which seats ninety people, provides an intimate setting for seminars and

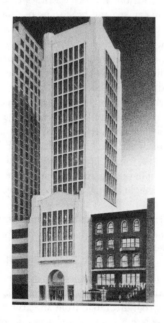

The Museum of Television and Radio

specialized series, and a forty-five-seat screening room is used for symposia and discussion programs.

Rooms with specially designed consoles for viewing and listening to the collection are located on the third floor. A computer-generated card catalog listing radio and television programs available to the public is a special feature of the fourth-floor library.

Temporary exhibitions of photographs, documents, and objects are mounted in galleries on the second and fifth floors. Also on the fifth level are an education room, a television/

radio console room, and a radio listening room, which is the first such space ever created in a museum.

The remainder of the building houses offices, whose rental fees help to offset some of the museum's expenses.

THE COLLECTION

The collection includes radio and television scripts and programs on tape, film, and kinescope. Today, the museum's holdings span seventy years of broadcast history, with cassettes of twenty-five thousand television programs, fifteen thousand radio programs, ten thousand commercials, and twelve hundred original radio scripts.

This is one of the few collections in the world of radio and television programs accessible to the general public.

If you would like to watch or listen to a particular program, you should go first to the library. Check the card catalog to find out what is available and then make an appointment to listen or view the cassette of whichever program interests you. Hour-long appointments are booked on a first come, first served basis.

Next, you will be assigned a console, similar to a carrel in a library, which is large enough to accommodate two people. Earphones are provided for listening.

Name any popular program of the last sixty or seventy years and you can probably find episodes here. From Jack Benny, Fred Allen, Jackie Gleason, and Ernie Kovacs to Lucille Ball and Bill Cosby, you can see and hear some of America's greatest comedic talents.

You can watch great dancers, such as George Balanchine and Fred Astaire, or legendary performers, including Billie Holiday, Duke Ellington, Louis Armstrong, Benny Goodman, Judy Garland, and Frank Sinatra.

Among the earliest radio broadcasts are a speech by Vice-Presidential candidate Franklin D. Roosevelt in 1920, as well as several of his fireside chats from the White House; an eyewitness account of the Hindenburg disaster; Edward R. Murrow's broadcasts from London during World War II; reports of the dropping of the first atomic bomb on Hiroshima, and highlights of the Army-McCarthy hearings during the 1950s.

NBC has contributed 175,000 disc recordings, a collection that represents the entire NBC Radio Network programming from 1927 through 1969.

More recent events, including moon shots, the Senate Watergate hearings, and the assassination of President Kennedy are preserved in the museum's television collection.

The television programs range from an excerpt from a 1936 drama, "Poverty Is Not a Crime," and a rare segment of "The Streets of New York," a 1939 NBC drama, to a 1944 broadcast of Verdi's "Hymn of the Nations" by the NBC Symphony under Arturo Toscanini, the Shakespeare Plays, "Civilization," "Gunsmoke," "The Honeymooners," and "Charlie's Angels."

Programs from Great Britain, Ireland, and West Germany can also be seen.

Each year, the museum staff adds programming to the collection, evaluating programs on the basis of social significance, historical impact, and artistic value.

The museum also has extensive collections of radio and

television commercials, ranging from Jack Benny's early commercials for Jell-O to the latest political campaign spots.

As its founder William S. Paley said, the museum's collection mirrors "the history of our time—everything important that's happened anywhere in the world."

EXHIBITIONS AND SEMINARS
Exhibitions focusing on various aspects of the collection are presented throughout the year. Topics have included the Disney television programs, the Toscanini/NBC Symphony concerts, the CBS documentary series "See It Now," "The Telephone Hour," and the comedy of Sid Caesar.

Seminars conducted by broadcasting professionals, writers, and critics provide an opportunity to examine a variety of subjects, ranging from television news coverage and the relationship of television and politics to behind-the-scenes glimpses of television and radio.

Gracie Mansion

ASIA SOCIETY GALLERIES

725 Park Avenue
New York, N.Y. 10021
212/288–6400

SUBWAY	6.
BUS	M1, M2, M3, M4, M101, and M102.
HOURS	11 A.M. to 6 P.M. Tuesday through Saturday; Noon to 5 P.M. Sunday. Closed Monday and major holidays.
TOURS	12:30 P.M. Tuesday through Saturday. Group tours available by reservation.
ADMISSION	$2, adults; $1, students and senior citizens. Members, free.
HANDICAPPED FACILITIES	Limited wheelchair access.
MUSEUM SHOP	Books, catalogs, postcards, jewelry, and artifacts relating to the art, history, and culture of Asia.
SPECIAL EVENTS	Performances, films, lectures, and special celebrations.
SPECIAL FACILITIES	Lila Acheson Wallace Auditorium available for special events.
MEMBERSHIP	From $50.
AUTHOR'S CHOICE	The Mr. and Mrs. John D. Rockefeller III Collection of Asian Art

Showcasing the art of Asia is only one of many functions performed by the Asia Society. Lectures, performances, and films are an integral part of the society's efforts to promote understanding between Americans and Asians.

HISTORY

The Asia Society was founded in 1956 by John D. Rockefeller III to promote a greater awareness and appreciation in the United States of the peoples of Asia. Through the years, the society has worked to increase America's understanding of Asia's history, culture, and contemporary political events.

The society's programs encompass approximately thirty countries, ranging from China, Korea, Japan, and the Indian subcontinent to Southeast Asia, Australia, and New Zealand. Regional centers have been established in Houston, Los Angeles, Washington, D.C., and Hong Kong.

In addition to housing one of New York's most outstanding small museums, with an active schedule of art exhibitions and publications, the Asia Society provides a forum where distinguished visitors from abroad can exchange views with Americans. In a cross-cultural exchange, programs of traditional and contemporary music and dance, films, and videos give Americans an opportunity to learn about Asian culture.

The Asia Society

THE BUILDING

Architect Philip Johnson designed the society's first permanent home, Asia House, at 112 East Sixty-fourth Street, which opened in 1960.

The society moved to its present location on Park Avenue at Seventieth Street in 1981. The building was designed by architect Edward Larrabee Barnes. His use of red sandstone from Rajasthan, India, (a gift of the Indian government) and the broad vaulted arches provide references to Asian materials and architectural motifs. And the red granite from Oklahoma is a subtle salute to the society's East-West mandate.

A museum shop with one of New York's largest and most impressive selections of books related to Asia is at street level. There are three main galleries: the Mr. and Mrs. John D. Rockefeller III Gallery and the Arthur Ross Gallery on the second floor, and the C.V. Starr Gallery on the ground floor. The Burke Room, which is used chiefly for photography exhibitions, and the 258-seat Lila Acheson Wallace Auditorium are on the lower level.

MR. AND MRS. JOHN D. ROCKEFELLER III COLLECTION

A trip to Japan in 1951 inspired Rockefeller and his wife to begin collecting Asian art. During the next twenty-five years, they traveled extensively throughout Asia, adding to their collection of paintings, sculpture, and porcelains from China, Korea, Japan, and South and Southeast Asia.

In 1963, Rockefeller asked Sherman E. Lee, an Asian art expert who was then director of the Cleveland Museum of Art, to advise him on his purchases. Following his and his wife's own judgment, and with Dr. Lee's advice, Rockefeller wanted to build a small but distinguished collection that would represent the best of Asia's artistic heritage.

Rockefeller insisted that a work of art must "stir and lift" him before he would consider buying it. He wanted the collection to remain small in size and intimate in scale with a high standard of quality. And, to ensure its future growth, he provided an acquisition endowment.

Storage jar, Korea, Yi dynasty, mid-18th century, Asia Society, Mr. and Mrs. John D. Rockefeller III Collection

The Rockefellers' outstanding collection of Asian art includes masterpieces of Buddhist and Hindu religious sculpture and painting from India, Southeast Asia, and other countries; exquisite Chinese, Japanese, and Korean ceramic art, and rare Japanese screen paintings of the Rimpa and Kano schools.

Among the earliest objects in the collection are Indian and Pakistani Buddhas dating from the second or third century. Beautifully crafted figures from Cambodia and Thailand; early ritual vessels and tomb figures from China, and delicate hanging scrolls from Japan are also included.

The objects bequeathed to the society upon Rockefeller's death in 1978 form the core of the society's permanent collection. Selections from the Rockefeller Collection are shown several times throughout the year.

SPECIAL EXHIBITIONS

Listing a few recent exhibitions—"Art from the Himalayan Kingdom of Bhutan, Land of the Thunder Dragon"; "Dreamings: The Art of Aboriginal Australia"; "Traditional

Crafts in Contemporary Korea"; "Faces of Papua New Guinea"; "Paintings of Jakachu: Master Artist of Japan", and "Chinese Cloisonné: The Pierre Uldry Collection"—indicates the diversity of subjects explored by the gallery.

Carefully researched illustrated catalogs accompany each exhibition. The society is noted for the high quality of its exhibitions and the scholarship of its publications.

CENTER FOR AFRICAN ART

54 East 68th Street
New York, N.Y. 10021
212/861–1200

SUBWAY	6.
BUS	M1, M2, M3, and M4.
HOURS	10 A.M. to 5 P.M. Tuesday through Friday; 11 A.M. to 5 P.M. Saturday; Noon to 5 P.M. Sunday. Closed Monday.
TOURS	2 P.M. Sunday. Group tours by appointment.
ADMISSION	Suggested contribution $2.50, adults; $1.50 children, students, and seniors.
MUSEUM SHOP	Exhibition catalogs.
SPECIAL EVENTS	Lecture series.
MEMBERSHIP	From $35.

The Center for African Art

Tucked away in a town house on Sixty-eighth Street is a virtually unknown little gem of a museum. One of the finest small museums in the country, the Center for African Art is noted for the high quality of its exhibitions. And the intimate scale of the galleries—which are usually uncrowded—adds to a visitor's enjoyment.

The museum's shows help to explain the wide appeal of African art and its influence on such modern painters and sculptors as Picasso and Brancusi.

HISTORY
When the Museum of Primitive Art was absorbed by the Metropolitan Museum of Art in 1982, many of its former supporters regretted the loss of that "small and dynamic museum." The group, which included businessmen, African experts, and art collectors, decided to establish a museum that would deal exclusively with African art. (The Museum of Primitive Art had included the art of Oceania and the Americas, as well as Africa.)

With a great African collection permanently installed in the Michael C. Rockefeller Wing of the Metropolitan Museum, the goal of the founders was to continue the education and exhibition policies of the former museum.

The museum moved to its present Sixty-eighth Street location in 1984, after the two adjoining buildings had been connected.

THE BUILDING
The two town houses which are home to the museum were designed in neo-French Renaissance, Beaux Arts style and built in 1900 and 1910.

The first and second floors of both buildings have been converted into five small galleries.

EXHIBITIONS

The museum mounts two exhibitions each year devoted to various aspects of African culture. Scholarly, illustrated catalogs accompany most shows.

Recent exhibitions include "Likeness and Beyond: Portraits From Africa and the World," "Wild Spirits Strong Medicine," and "Yoruba: Nine Centuries of African Art and Thought." The Yoruba exhibition, which was typical of the center's innovative approach, explored the origins of Yoruba art, the relationship between Yoruba art and philosophy, and the development of regional traditions. The fact that the Yoruba show traveled to several major museums after opening here— including the Art Institute of Chicago, the National Museum of African Art, the Cleveland Museum of Art, and the High Museum in Atlanta—is an indication of the Center for African Art's high standards.

EDUCATIONAL PROGRAMS

The museum's education department provides special materials for school groups and organizes workshops to train teachers.

CHINA HOUSE GALLERY

**China Institute in America
125 East 65th Street
New York, N.Y. 10021
212/744–8181**

SUBWAY	6.
BUS	M1, M2, M3, M4, M29, M101, M102.
HOURS	10 A.M. to 5 P.M. Monday through Friday; 11 A.M. to 5 P.M. Saturday; 2 P.M. to 5 P.M. Sunday.
ADMISSION	Free; contributions accepted.
MUSEUM SHOP	Exhibition catalogs, books, and miscellaneous gift items.
SPECIAL EVENTS	Lectures, symposia, films.
SPECIAL FACILITIES	Lunchroom facilities for groups.
MEMBERSHIP	From $50.

China House Gallery presents innovative exhibitions of fine Chinese works of art, as well as educational exhibitions about China and Chinese culture. It is more than an art gallery, however; it is part of the China Institute in America, a nonprofit, nonpolitical organization whose mission is to foster understanding between the American and Chinese people and to assist the Chinese in America.

HISTORY
Founded in 1926 by American and Chinese educators, China Institute is the oldest bicultural institution in the United States devoted to China. Headquartered in an Upper East Side brownstone known as China House, the site was given to the organization in 1945 by the late Henry Luce as a memorial to his father. Luce was born in Shandong province, the son of missionary parents who devoted their lives to promoting friendship and understanding between the East and West.

China House Gallery

ACTIVITIES
China Institute, through China House Gallery and the School of Chinese Studies, organizes lectures, conferences, seminars, symposia, films, and publications devoted to cultural, social, and political topics on both modern and ancient China. Other educational activities include a medical exchange program and tours to China. Tours are also arranged by the gallery to visit American museums with outstanding exhibitions of Chinese art. The institute's Chinese Student/Scholar Services program provides social and educational activities for young Chinese living in New York.

INTERIORS

China House Gallery is located in the two main rooms on the first floor of the brownstone.

The alcoves on the stairway are decorated with original rubbings of the Eastern Han dynasty (2nd century A.D.) stone bas-reliefs from the well-known Wu family shrine near Jiaxiang in Shandong province. They depict the early cultural heroes of ancient China, both historical and mythological.

A classroom and a handsome library, which is used for lectures, meetings, and receptions, are on the second floor.

EXHIBITIONS

China House Gallery has a long tradition of presenting innovative exhibitions of fine Chinese works of art, organized and produced by the gallery in cooperation with scholarly guest curators. Major museums throughout the world, as well as private collectors, lend objects to these shows. In addition, the gallery brings important traveling exhibitions to New York.

China Institute's annual New Year exhibition uses examples of folk art, cultural artifacts, fine arts, and other material to explain various aspects of Chinese civilization. Lunchtime lecture series or day-long symposia often complement these exhibitions.

COOPER-HEWITT MUSEUM

National Museum of Design
Smithsonian Institution
2 East 91st Street
New York, N.Y. 10128
212/860–6868

SUBWAY	4, 5, and 6.
BUS	M1, M2, M3, M4, M18, and M19.
HOURS	10 A.M. to 9 P.M. Tuesday; 10 A.M. to 5 P.M. Wednesday through Saturday; Noon to 5 P.M. Sunday. Closed Monday and major holidays.
TOURS	4 P.M. and 7:30 P.M. Tuesday; 11 A.M. and 2 P.M. Wednesday; 1 P.M. and 3 P.M. Thursday; 2 P.M. Friday; 1 P.M. Saturday. For further information, call 212/860–6862.
ADMISSION	$3, adults; $1.50, senior citizens and students over 12. Free admission Tuesday evenings from 5 to 9 P.M. Cooper-Hewitt and Smithsonian members, free.
HANDICAPPED FACILITIES	Accessible to the disabled.
MUSEUM SHOP	Books, jewelry, and objects relating to museum exhibitions.
SPECIAL EVENTS	Lectures.
SPECIAL FACILITIES	Reference facilities available to designers, researchers, scholars, and students by appointment.
MEMBERSHIP	From $35.
AUTHOR'S CHOICE	Enid A. Haupt Conservatory

Housed in the former home of industrialist Andrew Carnegie, the Smithsonian Institution's Cooper-Hewitt Museum is the only American museum devoted solely to historical and contemporary design. In addition to prints, drawings, ceramics, glass, jewelry, furniture, metalwork, textiles, and wallpapers, the collection includes objects relating to advertising, architecture, fashion, interior and industrial design.

HISTORY
Born in Dunfermline, Scotland, in 1835, Andrew Carnegie emigrated to America when he was thirteen years old. The Carnegie family settled in Allegheny City, Pennsylvania. Starting as a bobbin boy in a cotton factory, Carnegie ultimately amassed a great fortune as the owner of steamship and railway lines, iron, coal, and steel corporations. When he sold these holdings to the then-new U.S. Steel Corporation in 1901, Carnegie became one of the richest men in the world.

In 1898, Carnegie decided to build "the most modest, plainest, and roomiest house in New York." He chose a site at

Fifth Avenue and Ninety-first Street, which was then a bastion of the middle class. With the completion of the Carnegie mansion, however, other wealthy families began to follow his example and upper Fifth Avenue became a fashionable address.

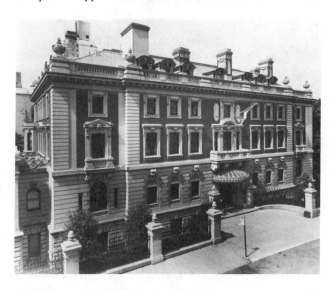

The Cooper-Hewitt Museum

Carnegie, his wife, Louise, their daughter, Margaret, and nineteen servants moved into the mansion in 1901. Few would consider this house either modest or plain. Carnegie believed that, after providing "moderately for his dependents," he was obligated to look after his "needy brethren," and he conducted his philanthropic activities from this house.

During his lifetime, the wealthy industrialist gave $350 million to various educational and social institutions. He donated over $56 million to build more than 2,500 free public libraries throughout the English-speaking world, including about 1,700 libraries in the United States.

Carnegie died in 1919 but his wife continued to live in the house until her death in 1946. With the exception of Carnegie's desk, all of the furnishings were sold at auction, as Mrs. Carnegie wished.

The Cooper-Hewitt Museum was organized in 1897 as part of the Cooper Union School by sisters Amelia, Eleanor, and Sarah Hewitt, the granddaughters of the nineteenth-century inventor and philanthropist, Peter Cooper. Their aim, which has continued to be a guiding principle of the museum, was to provide resources for students and all those interested in studying the decorative arts and design.

All three sisters had a good eye and a collector's instinct for acquiring a wealth of quality drawings, laces, prints, textiles, and decorative objects without the help of advisors. Their emphasis always was on objects, ranging from architectural renderings to wrought iron gates, that would provide source material for those who wished to learn about design and technical skills.

The museum became affiliated with the Smithsonian Institution in 1968 and moved into the former Carnegie mansion in 1972. It became the Smithsonian's National Museum of Design and re-opened to the public in 1976. The move itself was a gargantuan task, involving the packing and moving of hundreds of thousands of objects of every size, in

addition to the largest and most complete decorative arts library in the country.

A two-year graduate study program leading to a Master of Arts degree in the history of the decorative arts is offered by Cooper-Hewitt, in cooperation with the Parsons School of Design/New School for Social Research.

THE BUILDING

The mansion, constructed at a cost of $1.5 million, was designed by the architectural firm of Babb, Cook, and Willard in the Georgian style of an English manor house. There were sixty-four rooms on six levels on a site 230 feet long by 200 feet wide. Boilers and other equipment to keep the mansion functioning were in the basement; kitchen, laundry, and other service rooms were on the ground level; Carnegie offices, a library, and a handsome suite of public rooms were on the first level; family living quarters on the second; guest rooms on the third, and servants' quarters were on the fourth level. Front and back stairs, as well as private elevators, connected the various levels. Carnegie had one of the first Otis elevators installed in a private home.

Carnegie and his wife, an avid gardener, saw the undeveloped tract at Ninety-first Street and Fifth Avenue as a place to have a garden as well as a house. Now as then, lush lawns are neatly manicured, flowers bloom, wisteria climbs a wall, and large trees shade the garden behind a wrought iron fence at the southern end of the house.

The building, both a national and a city landmark, was remodeled as the Smithsonian's New York outpost in the mid–1970s at a cost of $3 million. The architectural firm of Hardy, Holzman, and Pfeiffer Associates won an award for a redesign that carefully preserves the essence of the mansion while accommodating the needs of a museum.

Stained glass windows, warm wood paneling, and ornately carved ceilings help to re-create the Carnegie era. The rooms are now used as exhibition galleries but handsome woodwork and other elegant details recall their original roles.

GREAT HALL

FIRST FLOOR

Visitors enter a marble foyer and step into the great hall, where Scottish oak paneling recalls Carnegie's love for his native land. A three-story pipe organ originally graced the east end of the hall. It provided wake-up music every morning at eight, in addition to after-dinner entertainment.

A view of the foyer and great hall

OFFICE

Carnegie's offices, where he met with those seeking assistance, were at the west end of the hall. A five-room suite, each decorated with a different motif, faced the south and was used to entertain distinguished guests, including presidents and potentates of the arts and industry.

The small, wood-paneled anteroom leading to this gallery was originally a reception room. Notice that the height of the doorway is lower than is customary. Carnegie was a short man, only about five feet, two or three inches tall. It was said that the low doorway meant that his visitors had to bow to him as they entered.

Favorite Carnegie sayings are inscribed near the ceiling

moldings. One reflects his love of books: "Mine own library with volumes that I prize above a dukedom."

MUSIC ROOM
The Louis XVI style music room was accented with French antiques. Its ornamental ceiling incorporates a bagpipe in honor of Carnegie's Scottish heritage.

GARDEN ROOM
The adjacent garden room leading from the entrance hall glows with Tiffany glass panels over the doors.

DINING ROOM
Brocade wallcoverings accented the formal dining room. Mark Twain, Ignace Paderewski, Booker T. Washington, and Madame Curie were among those invited to the Carnegies' dinner parties. Guests were asked to autograph the tablecloth, and their signatures were later embroidered to become a permanent record of their visit.

BREAKFAST ROOM
Large windows overlook the garden. This room adjoins the dining room and leads to the conservatory.

ENID A. HAUPT CONSERVATORY
This skylit, glass-vaulted space filled with ferns, palms, and other plants, links two exhibition galleries. The conservatory was restored with funds contributed by publisher-philanthropist Enid A. Haupt.

EAST GALLERY
This skylit room was originally the Carnegies' picture gallery.

SECOND FLOOR

BILLIARD ROOM
Immediately to your right as you reach the top of the stairs is a rather small, paneled room where Carnegie and his friends played billiards. The room overlooks the stair landing. In the room across the hall, ceiling beams are exposed. The Carnegie mansion was the first one in the United States to have a structural steel frame, similar to the one invented by John Augustus Roebling, builder of the Brooklyn Bridge.

LIBRARY
The family library was next door to the billiard room. Notice the inlaid ceiling and intricately carved teak trim around the doors, designed by Lockwood de Forest of Tiffany and Company.

BEDROOMS
The bedrooms formerly occupied by Mr. and Mrs. Carnegie are at the end of the hall, connected by a dressing room. The woodwork in Mrs. Carnegie's room is particularly noteworthy, with dentil crown molding and carvings over the door and around the fireplace.

Carnegie's bedroom had a northern exposure, overlooking Ninety-first Street and Central Park. Throughout his life, Carnegie slept in the brass bed he had used as a child.

Mrs. Carnegie's bedroom, facing west, overlooked the garden and Central Park.

Originally, guest rooms, a suite for Mrs. Carnegie's sister, Stella Whitfield, a small gymnasium for Carnegie, and a schoolroom for their daughter were located on the third floor. Today, this floor houses the museum's library and the Doris and Henry Dreyfuss Study Center with its separate sections for each of the collections.

THIRD FLOOR

The former servants' quarters now house the Drue Heinze Study Center for Drawings and Prints and the Thomas M. Evans Center for the study of textiles.

FOURTH FLOOR

FACILITIES
During the Carnegie era, sophisticated planning ensured every comfort at all times. There were duplicates of each major piece of machinery to provide backups in case of an equipment failure. An artesian well provided water for drinking and bathing, and a spare generator could be used if there were a power failure. A coal car, loaded at a 250-ton bin, ran along tracks to bring fuel to five boilers. The house had central heating and air-conditioning. Cool breezes wafted through every room from attic fans that sucked in the air and passed it through filters stretched across tanks of cooling water.

THE COLLECTION
The Cooper-Hewitt Museum's permanent collection includes more than 167,000 objects which represent three thousand years of design history from cultures around the world.

The Hewitt sisters originally emphasized the seventeenth, eighteenth, nineteenth, and early twentieth centuries. At that time, Victorian taste was considered vulgar. Recently, the library has been adding materials devoted to formerly neglected periods, including Victorian and contemporary.

PRINTS AND DRAWINGS
A Boucher drawing purchased for two dollars is just one of the remarkable acquisitions made by the Hewitt sisters and included among the fifty thousand drawings in the collection. Considered unique in America, the collection ranges from the fifteenth century to the present and includes both well-known and lesser-known artists. Every subject imaginable is covered, from costumes and theatrical set designs to fashions, jewelry, toys, and playing cards.

Most numerous are the architectural drawings and interior designs. The earliest drawing is a late fifteenth-century Gothic steeple. Among the interesting drawings of the twentieth century are those of Hugh Ferriss, considered a gifted draftsman and seer who foretold the future of our cities in his book, *The Metropolis of Tomorrow*.

The museum's holdings include three hundred Winslow Homer drawings, covering the period from his art student days to his work as a Civil War artist-correspondent for *Harper's Weekly*; fifteen hundred sketches by Frederic Edwin Church, an artist of the Hudson River School, and eighty-four drawings and watercolors by Thomas Moran, famed painter of America's West. In lesser quantity but well represented are the European masters, from Andrea Mantegna in the fifteenth century to Giorgio de Chirico in the twentieth; noted

Impressionists of France and America, the German Expressionists, and the American Realists.

The print department also encompasses cut-paper pictures, Christmas cards, valentines, and other objects that document changing tastes and advances in printing technologies.

TEXTILES

Twenty thousand fabrics span the globe and go back as far as the Han dynasty in the third century B.C. The most superb perhaps are J.P. Morgan's gift to the Hewitt sisters in 1901 of 1,022 pieces, which included rare Coptic, Islamic, French, and Italian textiles, as well as those from the Ming dynasty. One particularly beautiful textile is an intricately woven sixteenth-century embroidered book, or picture cover, in silken and metallic threads embellished with coral beads.

The lace collection includes delicate patterns whose subjects are people, flora, fauna, fans, and mythical beasts.

WALLPAPERS

Among six thousand cataloged wallpapers, forty rollers, screens, woodblocks, and stencils are two hundred papers made in France during the late eighteenth century, including some by Jean Baptiste Reveillon. Widely acknowledged for his inventive and tasteful designs, Reveillon used Roman classical themes, flowers, and Chinoiserie.

There are eighty wallpaper-covered bandboxes from the early 1800s, as well as a trove of papers removed from bandboxes to preserve them. Bandbox coverings were created from scraps of wallpaper. They were also made especially to camouflage cardboard boxes and to advertise wallpaper companies.

An armchair designed by Marcel Breuer, 1925

FURNITURE

Cooper-Hewitt's collection of furniture by British, European, and American master designers includes an unusual chair for an eighteenth-century English gentleman. The chair is designed to be straddled, so that the occupant faces the back, where there are book and arm rests, and candlesticks.

Many bentwood pieces by the German inventor-designer Michael Thonet and graceful pieces in the Italian Art Nouveau style are here, including a fruitwood desk and inlaid chair made by Carlo Zen. The collection also includes an armchair of bent tubular steel and canvas by Marcel Breuer.

WOODWORK

An abundance of rococo objects can be seen among the three hundred pieces of ornamental woodwork.

CERAMICS

Every conceivable kind of ceramics is represented, from ancient earthenware to delicate porcelains, stoneware, and the works of contemporary potters.

GLASS

The five hundred pieces of glass range from the first to the twentieth centuries.

BUTTONS

Two thousand buttons, made of every imaginable material, from bone and precious stones to plastics, are included in the collection.

JEWELRY

Jewelry, too, is among the museum's riches, from ancient to modern pieces, including bracelets, anklets, brooches, and earrings. The vast collection also contains beautiful jewel-encrusted boxes to hold scissors, snuff, and other items.

METALWORK

Both elegant and practical metal objects can be found among the four thousand cataloged pieces. They are crafted in silver, gold, tin, pewter, copper, tole, brass, bronze, iron, and steel.

OTHER COLLECTIONS

Lighting fixtures through the ages; enamels; objets d'art, such as a carved rhinoceros horn cup and cover; carved jades, and lacquered doors are included in the collection. Here, too, are birdcages of every type. Two of the most elaborate are Chinese birdcages embellished with ivory, jade, tortoise shell, silver, agate, coral, porcelain, wood, and feathers.

EXHIBITIONS

In an average year, thirteen special exhibitions are presented, many displaying objects from the permanent collection and each one delving into some aspect of contemporary or historic design.

For example, "L'Art de Vivre: Decorative Arts and Design in France 1789–1989," traced two hundred years of French creativity and was a major cultural event to mark the bicentennial of the French revolution. "Purses, Pockets and Pouches," was an exhibition of textile techniques used to make purses, pockets, portfolios, and pouches from the seventeenth to the twentieth centuries. "American Drawings from Cooper-Hewitt Museum: Training the Hand and Eye," exhibited seventy-five drawings and oil sketches from the museum's extensive collection. The latter exhibit was part of the Smithsonian Institution's Traveling Exhibition Service (SITES) program.

FRICK COLLECTION

1 East 70th Street
New York, N.Y. 10021
212/288–0700

SUBWAY	6.
BUS	M1, M2, M3, M4, M29, and M30.
HOURS	10 A.M. to 6 P.M. Tuesday through Saturday; 1 to 6 P.M. Sunday. Closed Monday and major holidays.
TOURS	11 A.M. slide lecture Tuesday through Friday.
ADMISSION	$3, adults; $1.50, students and senior citizens. Children under 10 not admitted; those under 16 must be accompanied by an adult.
HANDICAPPED FACILITIES	Wheelchair available. Call for reservation.
MUSEUM SHOP	Greeting cards, catalogs, posters, prints, postcards, and publications.
SPECIAL EVENTS	Free concerts and scholarly lectures.
SPECIAL FACILITIES	Art reference library. Admission by special request.
AUTHOR'S CHOICE	*Mistress and Maid* by Vermeer, West Gallery *The Polish Rider* by Rembrandt, West Gallery *Self-Portrait* by Rembrandt, West Gallery *Angel* by Jean Barbet, Garden Court

A visit to the Frick Collection recalls the affluent world of the industrialist, Henry Clay Frick. His superb collection of paintings, sculptures (including one of the world's finest groups of small bronzes), French furniture and porcelains, Limoges enamels, and Oriental rugs spans six centuries. The ambiance of Frick's former home, combined with the quality of the objects on view, makes this one of the nation's leading museums.

HISTORY

Born in western Pennsylvania in 1849, Henry Clay Frick, coke, steel, and railroad magnate, was an art lover from an early age. He started collecting around 1870 and, for over forty years, acquired extraordinary art treasures that span the late thirteenth to late nineteenth centuries and chronicle his changing interests and tastes. He was inspired to build his mansion-gallery after visiting the Wallace Collection in London. Pittsburgh was originally considered as the site, but he decided to build in New York because he feared that Pittsburgh's smoke pollution might damage his art works.

THE BUILDING

Frick's forty-room limestone mansion was begun in 1913 and completed the following year on the site of the former Lenox Library. It was designed in the eighteenth-century French style by Thomas Hastings of Carrère and Hastings, the firm also

The Frick Collection

responsible for the New York Public Library. The mansion was conceived as a spacious showcase for works of art, with ample room for expansion.

The Piccirilli brothers created the harmonious carved exterior reliefs, as well as the carvings on the ceiling of the East Vestibule, originally the entrance, and the elevator lobby to its left. Sir Charles Allom of White, Allom in London created the ground floor interiors, following the elaborate decor of seventeenth- and eighteenth-century mansions in England and France.

One year after Frick's death in 1919, the collection was founded as a public gallery. Frick bequeathed his home and works of art in trust to a board of trustees to establish a public gallery known as the Frick Collection.

In the industrialist's richly diverse bequest were a hundred and thirty-one paintings, in addition to sculptures, furniture, porcelains, rugs, silver, drawings, and prints. Additional works in keeping with those in the collection—primarily paintings and sculptures—have been added by the trustees.

Frick had stipulated that he wanted his collection displayed in the setting he had created for it, and today the art works are exhibited without the rigid classifications of most museum installations. Art objects are displayed according to personal taste, rather than according to specific periods or styles.

Mrs. Frick lived here until her death in 1931. Architect John Russell Pope transformed the mansion into a museum, which opened in December 1935. Pope's alterations included converting the carriage court into a handsome barrel-vaulted, glass-topped interior Garden Court with a fountain and Ionic-coupled columns. Created as a setting for sculpture, the court also holds overflow concertgoers. The graceful Oval Room, East Gallery, and a small assembly room were added at the same time as the court.

Further expansion of the Frick was carried out in 1977 by John Barrington Bayley. A classicist, he built a Versailles-inspired gallery that blends with the original structure and serves as a waiting room when visitors exceed two hundred and fifty, the maximum permitted under fire laws.

The Frick Art Reference Library was established by Helen C. Frick in 1920 in memory of her father. Opened in 1924 in a nearby Hastings-designed building, it was torn down during the enlargement of the galleries. Reopened in 1936 in a Pope-designed building, the library is today one of the richest repositories for research on art, with thousands of books, catalogs, and photographs relating to art, chiefly from the same time span as art in the collection.

THE COLLECTION

Frick began his collection on his first trip abroad with fellow industrialist and friend, Andrew Mellon. Initially interested in works by contemporary French salon painters and the Barbizon School, Frick soon added English portraiture, Old Masters, Spanish, Renaissance, and landscape painters.

Art dealer Joseph Duveen supplied some of Frick's most extraordinary acquisitions—the irresistibly flirtatious Fragonards and Bouchers, lustrous enamels, and bronzes from J.P. Morgan's collection. Frick was also assisted by Roger Fry, a curator of paintings at the Metropolitan Museum of Art. Fry was instrumental in purchasing Frick's earliest French

painting, *Pietà With Donor*, seen in the Boucher Anteroom; Rembrandt's *The Polish Rider*, and the two large Veronese allegories in the West Gallery.

Having collected his most important paintings by 1915, Frick became interested in sculpture. His collection, primarily composed of Renaissance bronzes and other small works, includes a wealth of exceptional Italian pieces that had belonged to the late J. P. Morgan and had been on loan to the Metropolitan Museum. At this time, Frick also collected prints and drawings, enamels, and other art objects.

The quality of the furniture is in keeping with the other works of art. Prized pieces to be seen include those from the workshops of such great French artisans of the seventeenth and eighteenth centuries as André-Charles Boulle, cabinetmaker to Louis XIV; Gilles Joubert, and Roger Lacroix, among others. Exquisitely carved Italian *cassoni* line the walls in the West Gallery. Gobelins, Beauvais, and Savonnerie tapestries cover some upholstered pieces.

Only a small number of the Frick's stunning array of Chinese porcelain vases, jars, bowls, and figurines are on view. The majority were purchased from the Morgan estate, but a hundred and forty-seven blue-and-white pieces from the seventeenth and eighteenth centuries were a gift to the collection from Mr. and Mrs. Childs Frick.

Particularly fine porcelains from the K'ang Hsi (1662–1722) and Ch'ien Lung (1736–95) dynasties, and enameled wares from the Ch'ing Dynasty (1644–1912) are on view. *Famille noir*, *famille rose*, and *famille verte* examples are well represented.

In the galaxy of French pottery and porcelains, the stars are the many Sèvres pieces. English silver is splendidly represented with wine coolers created by William Pitts between 1802 and 1804, and by Paul Storr in 1811–12. Intricately woven Persian and Mughal period rugs turn some Frick floors into eternal gardens.

Prints and drawings are on display for special exhibitions only; a small but extremely fine collection, the artists represented include Corot, Gainsborough, Goya, Ingres, Rembrandt, and Rubens. Some are preliminary drawings for paintings in the collection.

ENTRANCE HALL

A posthumous bust of Henry Clay Frick by Malvina Hoffman and Édouard Manet's 1864 painting, *The Bullfight*, can be seen in the marble-floored entrance hall.

Nearby, at the foot of the marble staircase that once led to family quarters, you can see an Aeolian pipe organ that was installed in 1914. An elaborate arched organ screen above the landing, concealing the Aeolian's pipes, was inspired by Luca della Robbia's *Cantoria* for the Duomo of Florence. It was designed by Eugene W. Mason of Carrère and Hastings.

SOUTH HALL

Three of the approximately thirty-five paintings accepted as original works by Jan Vermeer are owned by the Frick Collection. Vermeer's *Officer and Laughing Girl* and *Girl Interrupted at Her Music* are both in the South Hall.

Also here is François Boucher's portrait of *Madame Boucher*, showing the artist's wife in their fashionably decorated Paris apartment.

The marquetry commode and drop-front secretary, crafted by Jean-Henri Riesener, were made for Queen Marie-Antoinette in the late eighteenth century, possibly for her apartment in the Tuileries.

OCTAGON ROOM

Scholars believe that the two fifteenth-century panels, *The Annunciation*, by Fra Filippo Lippi were originally part of a small altarpiece.

ANTEROOM

Hans Memling's striking *Portrait of a Man*, painted around 1470, is considered to be the Flemish artist's earliest known portrait with a landscape background.

Other Flemish art here includes Jan van Eyck's *Virgin and Child With Saints and Donor*, probably painted around the middle of the fifteenth century, and Pieter Bruegel the Elder's *The Three Soldiers*, which dates from 1568.

Don't miss El Greco's *Purification of the Temple*, a small painting of a subject that was popular during the Counter Reformation in the late-sixteenth and early-seventeenth centuries.

BOUCHER ROOM

The paintings, furniture, and decorations in this room evoke the world of eighteenth-century France. Boucher painted the eight panels, *The Arts and Sciences*, for Madame de Pompadour, a mistress of King Louis XV, in 1752. The compositions, originally designed for chair coverings, show children engaged in a variety of adult occupations, ranging from hunting and fishing to painting and sculpture. The panels were eventually installed as decorative panels in the library at the Château of Crécy. The canvases, together with the four modern overdoors, were formerly in Mrs. Frick's bedroom on the second floor.

Turquoise Sèvres porcelains, such as those seen here, were among Madame de Pompadour's favorite decorative accents. They were produced first at Vincennes and, later, at Sèvres.

A watercolor portrait of Adelaide Childs Frick by Elizabeth Shoumatoff stands on a writing table made by Riesener around 1785–90.

DINING ROOM

Eighteenth-century English portraits gaze down from the walls of this spacious room. Artists represented include Thomas Gainsborough, William Hogarth, John Hoppner, Sir Joshua Reynolds, and George Romney.

The furniture, in the style of Louis XVI, was designed especially for the room by the London firm of White, Allom.

English silver-gilt wine coolers crafted in the early years of the nineteenth century, and Chinese porcelain *famille rose* covered jars and vases are handsome decorative accents.

On the mantel, two cobalt blue Chinese porcelain vases with French gilt-bronze mounts flank an eighteenth-century clock decorated with figures representing the triumph of love over time. The clock was purchased in 1916, three years before Frick's death.

WEST VESTIBULE

In 1775, Boucher painted a quartet of scenes depicting the four seasons for Madame de Pompadour. The irregular shapes indicate that they probably served as overdoors for one of her residences. Four eighteenth-century blue-and-white Chinese porcelain ginger jars stand on a marquetry desk from the workshop of French cabinetmaker André-Charles Boulle.

FRAGONARD ROOM

The light and airy opulence of a late-eighteenth-century Parisian drawing room is the setting for *The Progress of Love*, a series of paintings by Jean-Honoré Fragonard. Four of the canvases—*The Pursuit*, *The Meeting*, *The Lover Crowned*, and *Love Letters*—were commissioned by Madame du Barry, a mistress of Louis XV, for a garden pavilion at her château in Louveciennes. Upon completion, she refused to accept them, so Fragonard installed them in his cousin's house in Grasse, together with two additional large panels, four overdoors, and four panels of hollyhocks. Three of the latter now hang in the Music Room. The series decorated J.P. Morgan's London home before Frick purchased them in 1915.

On the mantel stands a marble bust of the Comtesse du Cayla by Jean-Antoine Houdon. The countess is shown as a bacchante with trailing vine leaves. It was exhibited at the Salon of 1777, the same year it was created, and acquired by Frick in 1916.

Two gilt-bronze tripod tables in this room are worth noting. One boasts an unusual lapis lazuli top, and the other, attributed to Martin Carlin, is decorated with Sèvres porcelain plaques. The Carlin piece is considered to be the finest small porcelain table of the Louis XVI period.

A nineteenth-century copy of a Jean-Henri Riesener side table with parquetry veneer stands near a similar table made by the great French cabinetmaker around 1780–83.

Don't miss the exquisite Sèvres porcelain potpourri vase in the shape of a ship on the center table. Only about a dozen examples of this type of potpourri vase have survived.

LIVING HALL

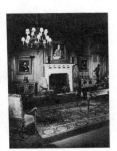

This room typifies Frick's refined tastes, with Old Master paintings, furniture, sculpture, and Oriental porcelains of the highest quality.

Six masterpieces line the walls. Portraits of Sir Thomas More and Thomas Cromwell by Hans Holbein the Younger flank El Greco's *St. Jerome*. On the opposite wall are Giovanni Bellini's masterful *St. Francis in the Desert*, painted in 1480, and two paintings by Titian, *Portrait of a Man in a Red Cap* and *Pietro Aretino*.

The living hall

Most of the furniture here was either made in Boulle's workshop or its style was influenced by him. Boulle was noted for marquetry designs of tortoiseshell and brass.

The Chinese porcelains with *famille noire* and *famille rose* decorations date from the Ch'ing Dynasty, 1644–1912. The Herat floral rug in the center of the room, woven in Persia in the second half of the sixteenth century, is one of the finest in the collection.

LIBRARY

This wood-paneled library reflects Frick's scholarly approach to art, as well as many of his other interests.

The shelves are filled with leatherbound volumes devoted to such artists as Hogarth, Rembrandt, Romney, Turner, and Van Dyck. A history of France shares shelf space with a history of the Carnegie Steel Company. The library includes a five-volume set of Whistler's etchings, Rembrandt's complete works in eight volumes, and books devoted to the history of English and American furniture. In addition to the art books, there are volumes of poetry, and complete sets of books by Charles Dickens, George Eliot, Nathaniel Hawthorne, and other authors.

Studying someone's library often provides fascinating clues to their interests, temperament, and experience. And Frick's library, which provides an insight into the mind of the great financier and collector, is especially noteworthy.

Eighteenth- and nineteenth-century paintings line the walls. There are fine examples of portraits by Thomas Gainsborough, George Romney, Sir Joshua Reynolds, Sir Henry Raeburn, and Sir Thomas Lawrence, as well as an early version of Gilbert Stuart's portrait of George Washington.

The landscapes include John Constable's *Salisbury Cathedral From the Bishop's Garden*, one of his best known compositions; and two paintings by Joseph Mallord William Turner, *Fishing Boats Entering Calais Harbor*, and the lovely *Mortlake Terrace: Early Summer Morning*.

A posthumous portrait of Frick, painted by the Danish-born American artist John C. Johansen in 1964, hangs above the mantel.

Several small bronzes dating from the fifteenth and sixteenth centuries are displayed on tables around the room. Notice the busts of *Marie-Thérèse*, *Queen of France* and *The Grand Dauphin*, after Françoise Girardon, which were probably sculpted in the eighteenth century. Also note an early sixteenth-century Italian sculpture of *David* in the center of the room. It bears certain similarities to the bronze *David* of Donatello.

The London firm of White, Allom designed and executed most of the furniture in the room.

A tall Chinese porcelain vase with a green ground and plum-tree decoration is one of only six examples known to have survived from the Ch'ing Dynasty (1644–1912). Other Ch'ing Dynasty porcelains, decorated with black grounds, are similar to those found in the Living Hall.

NORTH HALL

The paintings here range from Lazzaro Bastiani's sixteenth-century *Adoration of the Magi* to Claude Monet's *Vétheuil in Winter* of 1879. Especially noteworthy is the luminous *Still Life With Plums* by Jean-Baptiste Chardin, the only still life in the collection, which was purchased in 1945.

Comtesse d'Haussonville by Jean Auguste Dominique Ingres hangs above a magnificent eighteenth-century blue marble side table whose top echoes the color of her satin dress. The countess was the granddaughter of the French writer Madame de Staël.

The room is graced by a Jean-Antoine Houdon bust of Armand-Thomas Hue, Marquis de Miromesnil, as well as three fifteenth-century sculptures, crafted by Vecchietta, Andrea del Verrocchio, and Francesco Laurana. The Verrocchio *Bust of a Young Woman* and the Laurana *Beatrice of Aragon*, were bequests of John D. Rockefeller, Jr.

WEST GALLERY

In the late nineteenth century, a picture gallery such as this could be found in many fashionable homes, including the house Frick rented before he built his mansion. Few people, however, would have been able to own the masterpieces collected by Frick.

With the exception of four paintings—Jacob van Ruisdael's *Landscape With a Footbridge*, John Constable's *The White Horse*, Etienne de La Tour's *The Education of the Virgin*, and Rembrandt's *Nicolaes Ruts*—all of the pictures in this room entered the collection during Frick's lifetime.

The stunning assemblage includes two large paintings by Paolo Veronese, *Allegory of Virtue and Vice* and *Allegory of Wisdom and Strength*; Goya's *The Forge*; an elegant Mannerist portrait, *Lodovico Capponi*, by Agnolo Bronzino; *Vincenzo Anastagi* by El Greco; and Turner's *The Harbor of Dieppe*.

Dutch and Flemish art is represented by Rembrandt's *The Polish Rider* and his haunting *Self-Portrait*; two paintings by Frans Hals, *Portrait of an Elderly Man* and *Portrait of a Woman*; a Vermeer, *Mistress and Maid* (the last picture Frick himself bought); Gerard David's *The Deposition*; Meyndert Hobbema's *Village With Water Mill Among Trees*, and Sir Anthony Van Dyck's *Frans Snyders* and *Margareta Snyders*. The two Snyders portraits were reunited for the first time since 1793 when Frick purchased them in 1909.

Near the end of his life, Frick was asked what man's gift he would have wished to inherit, if given the choice. He immediately replied, "Rembrandt's."

Fifteenth- and sixteenth-century sculpture is also displayed here. Don't miss *Samson and Two Philistines*, after Michelangelo, on a table near the entrance to the Enamel Room. Probably sculpted around the middle of the sixteenth century, this is thought to be the finest surviving version of several bronzes that were based on a lost sketch-model by Michelangelo.

With the exception of the modern sofas, all of the furniture in this room is from the period of the Italian Renaissance, mainly from the sixteenth century. Eight carved walnut *cassoni* that served as storage chests are particularly noteworthy. The three Persian rugs were woven in Herat in the seventeenth century.

ENAMEL ROOM

Italian paintings and sculptures of the thirteenth, fourteenth, and fifteenth centuries form a splendid backdrop for a spectacular collection of Limoges enamels. Most of the enamels, which were executed between the early sixteenth and the mid-seventeenth centuries, were purchased from the J.P. Morgan estate in 1916.

The walnut furniture was crafted in France in the sixteenth century, except for the cupboard, which probably came from the Netherlands.

OVAL ROOM

Four monumental portraits—two by Van Dyck and two by Gainsborough—dominate this room, which was created during the 1930s alterations. The space had originally been Frick's office and the north exit from the carriage court.

The Van Dycks hang on either side of *Diana the Huntress* by Houdon. Although several versions of the subject were

produced in bronze and marble, this is one of only five life-size terracottas known to have been executed by Houdon and his workshop.

EAST GALLERY

The paintings in this gallery span the seventeenth to the twentieth centuries. Among the earliest works are Van Dyck's *James, Seventh Earl of Derby, His Lady and Child*, and *Paola Adorno, Marchesa di Brignole Sale*; van Ruisdael's *Quay at Amsterdam*; Aelbert Cuyp's *River Scene*, and Claude Lorrain's *The Sermon on the Mount*.

Twentieth-century works include *The Rehearsal*, a ballet scene by Edgar Degas, and four portraits by James Abbott McNeill Whistler which are hung in each corner of the gallery. Mrs. Frederick R. Leyland, whose portrait Whistler painted with the title *Symphony in Flesh Colour and Pink*, was the wife of a Liverpool shipowner. The Leylands' dining room, transformed by Whistler into the Peacock Room, is now in the Freer Gallery of Art in Washington, D.C.

Other works of art in the room include fifteenth- and sixteenth-century sculptures, and armchairs upholstered in needlepoint dating from the eighteenth and nineteenth centuries.

GARDEN COURT

In this serene setting of fountain, plants, and art works, one sculpture in particular should not be missed. Jean Barbet's *Angel*, cast in bronze in Lyons in 1475, is an outstanding example of late Gothic metal sculpture. Originally, it may have graced the exterior of the Sainte Chapelle in Paris.

Portrait busts dating from the sixteenth and seventeenth centuries are here, as well as a charming eighteenth-century French *Head of a Boy* and *Head of a Girl* depicting Mars and Venus as children.

Two paintings hang here: Corot's *The Boatman of Mortefontaine* and Whistler's *The Ocean*, one of the earliest nineteenth-century paintings to show the influence of Japanese woodcuts. Painted in 1866, both the canvas and the frame bear the artist's butterfly monogram.

GRACIE MANSION

East End Avenue at 88th Street
New York, N.Y. 10128
212/570–4751

SUBWAY 4, 5, and 6.

BUS M104.

TOURS 10 A.M., 11 A.M., 1 P.M., and 2 P.M. Wednesday; school tours Thursday mornings. Reservations required. Special tours by appointment.

ADMISSION $3, adults; $1, senior citizens; students with I.D. and children, free.

HANDICAPPED FACILITIES Accessible to the disabled.

MUSEUM SHOP Postcards, stationery, books, tote bags, and miscellaneous items.

AUTHOR'S CHOICE Handpainted French wallpaper, dining room
Empire style sideboard, dining room
Mahogany table, dining room, Susan E. Wagner wing

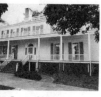

Gracie Mansion

Once the country estate of a wealthy shipping merchant, Gracie Mansion, the home of New York's mayor, is also a ceremonial site and the scene of important meetings and press conferences. The renovated rooms recall the days when the Gracies entertained the leading figures of the eighteenth and early nineteenth centuries but they are also a comfortable setting for presidents, prime ministers, theatrical stars, and other celebrities. The mansion, built about 1799 on the site of a Revolutionary War fort, has been open to the public for tours since the administration of former Mayor Edward I. Koch.

HISTORY

In 1646, this land overlooking the East River at Hell Gate was owned by Sibout Classen, who called his property Horn's Hook after his hometown of Hoorn, Holland. Classen, a carpenter, lived in the village of New Amsterdam and farmed his Hell Gate property.

The next owner of the farm was an Englishman, Barent Resolved Waldron. In 1770, the Waldron family sold part of their land to Jacob Walton of Brooklyn, who built a house for his bride, Polly Cruger, the niece of John Cruger, Jr., a former mayor of New York. As war with Great Britain approached, Walton constructed an underground tunnel from his house to the river as an escape route.

In an effort to protect Manhattan Island during the Revolutionary War, General George Washington turned the Waltons' home into a command post with heavy artillery mounted in the garden. But the Royal Navy sailed down the East River, bombarded the site, destroyed Walton's home, and occupied the land. The Waltons reclaimed their eleven-acre property after the war and sold it for $4,625 in 1798 to Archibald Gracie, a Scottish-born sea merchant. Gracie had a fleet of cargo-carrying ships, which he filled with goods for Dutch and English merchants.

Gracie, his wife, Esther, and their five children lived downtown on Pearl Street. Their summer home was constructed on the foundations of the former Walton home. With a promenade along the river, a beautiful garden, a stable, and a greenhouse on the luxuriant tree-shaded grounds, Gracie mansion was as well appointed as the neighboring Astor, Rhinelander, Cruger, and Schermerhorn estates.

Gracie was active in the civic and commercial life of New York City, serving as president of the New York Insurance Company, vice-president of the New York Chamber of Commerce from 1800 to 1825, and president of the St. Andrew's Society from 1818 to 1823. He was also a member of the board of governors of the Lying-In Hospital.

The Gracies often entertained such distinguished guests as Alexander Hamilton, John Quincy Adams, poet-musician Thomas Moore, and writers James Fenimore Cooper and Washington Irving. Delicacies of the day included oysters from the coves and inlets lining the river, soup made from turtles also found in local waters, and plum cake served from silver baskets. The good life ended when great, irreversible losses to his shipping empire forced Gracie to sell his mansion in 1822 to another merchant-shipper Joseph Foulke. Gracie died in 1829.

Foulke made his fortune principally in the West Indian trade. He and his wife and their nine children occupied the mansion for nearly twenty-seven years. During this time, a road was built that opened Eighty-sixth Street between Eighth Avenue and the East River. The blasting for the road slightly damaged the stables on the grounds, which are no longer in existence. Also at this time, commercial enterprises and housing were springing up nearby.

From 1857 to 1896, the house was home to Noah Wheaton, a builder and hardware merchant, and his family. At one point, money must have been in short supply, for old photographs show the mansion in need of repair amid an overgrown garden. When finances improved, so did the mansion, and, by 1890, the garden was neatly manicured and the house was filled with flamboyant late-Victorian furnishings.

In 1896, the city acquired the mansion and added the surrounding land to East End Park, which is now called Carl Schurz Park, in honor of a former minister to Spain, U.S. senator, and cabinet officer during the Rutherford B. Hayes administration. The mansion deteriorated during the next thirty years, when it was used as a comfort station, ice cream parlor, and storage facility for the Parks Department.

In 1923, largely through the efforts of May King Van Rensselaer, Archibald Gracie's great-granddaughter, the house was refurbished and converted into the Museum of the City of New York. Three years later, the museum outgrew the mansion and moved to its current site at Hundred and Third Street and Fifth Avenue.

In 1942, Parks Commissioner Robert Moses persuaded the city to designate Gracie Mansion as the official home of New York City's mayors. The most significant structural change occurred during Mayor Robert F. Wagner's administration, from 1954 to 1965. Mrs. Wagner, the mother of two young children, believed that her sons could be raised in a more normal environment if official functions were held in a separate area, instead of in the family quarters. The new wing

was completed in 1966 when Mayor John V. Lindsay took office. It was named for Susan E. Wagner, who died in 1964. Lindsay, who served as mayor until 1973, conducted more business at the mansion than the other mayors, who have preferred to work at City Hall.

The Gracie Mansion Conservancy, organized during the administration of Mayor Edward I. Koch, is a nonprofit corporation that preserves, maintains, and enhances the mayor's house. Supported by private donations, this group of professional designers, architects, and engineers oversees the mansion, while the city provides funds for normal maintenance and service.

THE BUILDING

Gracie Mansion, a Federal style frame building, may have been built by Ezra Weeks, the son of cabinetmaker Thomas Weeks, in 1799. Weeks was the chief builder of Alexander Hamilton's country home, the Grange, on Convent Avenue. He also constructed an addition to the country house of Rufus King, the father-in-law of two of Gracie's daughters, in Jamaica, Queens.

The house is painted pale yellow with dark green shutters. A fanlight over the door and graceful chinoiserie balustrades are architectural highlights.

THE INTERIORS

The furnishings and decorative accessories in the mansion span various periods, showcasing the work of New York craftsmen, artists, and artisans. About one-third of the collection is on loan but the conservancy hopes ultimately to have the house furnished with an important permanent collection.

ENTRANCE HALL

When you enter through the Federal fanlight doorway, you step on a floor painted in the nineteenth-century *faux-marbre* style with a compass as a centerpiece. *Faux-marbre* appears again on the baseboards and on the stairs against a background of striped wallpaper.

The unusual five-chair-back settee with its original rush seat was found in the attic of City Hall and was probably made in New York. The tall case clock was made around 1800. A sweeping stairway is a focal point of the entrance hall.

DINING ROOM

The handpainted scenic wallpaper was manufactured in France in 1830. Its scenes of leafy trees and fashionably attired strollers on an outing provide a garden-like setting for the mansion's dining room. Originally ordered for a New York home but never used, the paper remained in storage for more than a hundred years until it was hung at Gracie Mansion.

The handsome Empire sideboard with gilded mounts may have been made for Archibald Gracie, since it was donated to the mansion by his descendants. An astral lamp with a graceful bowl shade and an eagle-topped Federal mirror accent the main furnishings of the room.

PARLOR

Patterned wallpaper and carpet and a painting of New York Harbor in 1839 set the scene for a room that would have been

fashionable in the days of the Gracie Mansion's second tenant, the Foulke family.

The slipper chair with gold mounts is in the French style. Delicate leaves and flower designs decorate the 1830s desk-bookcase. A pair of Duncan Phyfe lyre-back chairs and two eagle-back chairs are placed against the wall. The mansion's original interior shutters hang in this room over windows that opened as French doors to the porch. A portrait over the mantel shows Mrs. Marinus Willett, wife of an early mayor, with her child.

MAYOR'S STUDY
This comfortable, largely contemporary room has the mansion's finest early mantel of carved wood. Period pieces include an early mahogany bookcase and Pembroke end tables. New York street scenes, executed by artist Childe Hassam between 1916 and 1931, accent one wall.

SUSAN E. WAGNER WING
Entrance halls painted to resemble stone lead to the rooms that were added and furnished in period style by interior designer Mark Hampton. The white-accented yellow ballroom can accommodate three hundred guests for receptions and other functions. Premier Zhao Ziyang of the People's Republic of China, Mayor Jacques Chirac of Paris, and President Sandro Pertini of Italy have been entertained in the Wagner wing and Marilyn Horne, Sherill Milnes, Benny Goodman, and Michael Feinstein have performed here in connection with broadcasts of "Live from Gracie Mansion."

SITTING ROOM
The antique mantels in this white-walled room and the room next door were salvaged from old Greenwich Village homes slated for demolition. A 1950s portrait of Susan E. Wagner by Willy Pogany is here, and lithographs of Hudson Valley scenes add a decorative note.

FAMILY DINING ROOM
In the adjoining room with dark red walls, notice the slipper chair near the fireplace and the mahogany Gothic Revival center table, made in 1815. Both pieces date from the Gracie era.

Portraits of Archibald Gracie, Jr., and Elizabeth Wolcott Gracie hang on the walls. The latter portrait was painted by John Trumbull; an unknown artist painted the likeness of Gracie's son.

MUSEUM
Downstairs in the Wagner wing exhibits describe the mansion's history through photographs, sketches, and other artifacts.

SOLOMON R. GUGGENHEIM MUSEUM

1071 Fifth Avenue
New York, N.Y. 10128
212/360–3500
212/360–3513 exhibition information

SUBWAY 4, 5, and 6.

BUS M1, M2, M3, and M4.

HOURS 11 A.M. to 7:45 P.M. Tuesday; 11 A.M. to 4:45 P.M. Wednesday through Sunday.

TOURS 6:30 P.M. Tuesday; 2:30 P.M. Wednesday through Sunday.

ADMISSION $4.50, adults; $2.50, senior citizens and students; children under 7, free. Free 5 P.M. to 7:45 P.M. Tuesday.

HANDICAPPED FACILITIES Accessible to the disabled.

FOOD SERVICE Café on ground floor.

MUSEUM SHOP Books, catalogs, original lithographs, prints, slides, jewelry, posters, and gift items.

SPECIAL EVENTS Lectures, concerts, symposia, films, and multimedia performances.

SPECIAL FACILITIES Aye Simon Reading Room, with international art periodicals, open to members 11 A.M. to 5 P.M. Tuesday through Friday.

MEMBERSHIP From $35.

AUTHOR'S CHOICE *Composition 8* by Vasily Kandinsky
Moulin de la Galette by Pablo Picasso
Paris Society by Max Beckmann

It seems fitting that the Guggenheim Museum building —the home of great modern paintings and sculpture—is itself a work of art. Designed by Frank Lloyd Wright, it has become an icon of the twentieth century.

The Guggenheim has been called "an American museum with a European face," for European artists are well represented, and the collections of its sister museum in Italy, the Peggy Guggenheim Collection, complement those in New York. More than five thousand objects by artists of the late nineteenth and twentieth centuries are included in the collections.

HISTORY

Solomon R. Guggenheim was born in 1861, the fourth of seven brothers whose wealth came from mining interests. Like other tycoons of the day, his art collection began with Old Masters. It developed into a curious potpourri of periods and styles, including fifteenth-century Flemish paintings, American

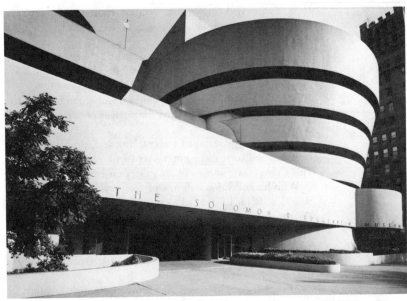

The Solomon R. Guggenheim Museum

landscapes, Audubon prints, and Oriental manuscript illuminations.

During the 1920s, however, the collection developed a new focus. In 1927, Irene Guggenheim commissioned Baroness Hilla Rebay von Ehrenwiesen, a young German artist, to paint her husband's portrait. Hilla Rebay and Guggenheim became friends, and, inspired by her commitment to avant-garde art, he began to collect non-objective painting in Europe and America.

As Guggenheim's artistic advisor, Rebay introduced the collector to Vasily Kandinsky in his studio in Germany. Guggenheim bought several paintings and works on paper, including *Composition 8*, 1923, which formed the core of his growing collection of non-objective art.

During the 1930s, the works of Kandinsky, Fernand Léger, Marc Chagall, Lyonel Feininger, and others of that era turned the walls of the Guggenheims' Plaza Hotel suite into a modern art gallery. From time to time, small public exhibitions of newly acquired works were held.

In 1937, the Solomon R. Guggenheim Foundation was established, specifically to create a museum. Called the Museum of Non-Objective Painting, it opened two years later in rented quarters at 24 East Fifty-fourth Street, with Rebay as its first director. She had definite ideas about how works of art should be displayed, opting for a hushed, meditative atmosphere. According to Thomas Krens, director of the Solomon R. Guggenheim Foundation, Rebay "decorated the gallery walls with pleated gray velour and covered the floors with thick gray carpeting. The plush velvet-upholstered seats, subtle indirect lighting, recorded music by Chopin and Bach, and the odor of incense wafting through the rooms created an atmosphere designed to spiritually enlighten as well as aesthetically entertain."

While Solomon Guggenheim was forming his collection, with its emphasis on non-objective painting, his niece, Peggy Guggenheim was also active in the art world. When she was twenty-three years old, Peggy left the United States for Europe and a life among avant-garde artists and writers. In

1938, she opened Guggenheim Jeune, a commercial art gallery in London, representing such artists as Jean Cocteau, Kandinsky, and Yves Tanguy.

The same year that her uncle opened the Museum of Non-Objective Painting in New York, Peggy decided to establish a museum of modern art in London—a goal that was never fulfilled. She began to acquire paintings and sculptures in Paris for the museum, which formed the nucleus of her private collection.

In 1941, Peggy returned to New York and, the following year, married surrealist painter Max Ernst. She opened Art of This Century, a commercial art gallery on Fifty-seventh Street.

With his collection outgrowing the space on Fifty-fourth Street, in 1943, Guggenheim commissioned Frank Lloyd Wright to design a permanent home for the museum. Land was acquired on Fifth Avenue, between East Eighty-eighth and Eighty-ninth Streets, and, in 1947, the museum moved into the existing six-story mansion at 1071 Fifth Avenue, the site of the present museum.

Also, that year, following her divorce from Max Ernst, Peggy closed her New York art gallery and returned permanently to Europe. Two years later, she purchased the Palazzo Venier dei Leoni on the Grand Canal in Venice, where she opened to the public her collection of Cubist, Surrealist, and European and American abstract painting and sculpture. The Peggy Guggenheim Foundation was established to operate and endow the museum.

Solomon Guggenheim died in 1949 and left the remaining paintings in his personal collection to the museum. Hilla Rebay resigned as director three years later, and was replaced by James Johnson Sweeney, formerly director of the Department of Painting and Sculpture at the Museum of Modern Art.

Under Sweeney's direction, many changes were made, including the manner in which works of art were installed. White walls replaced Rebay's plush, curtained surfaces, and paintings were hung without their customary heavy gold or ornate wooden frames.

Sweeney attempted to fill gaps in the holdings, particularly in the museum's sculpture collection, which was virtually nonexistent. (Rebay was not interested in sculpture because of its "corporeality.") Between 1953 and 1960, the museum's acquisitions included three important Cubist sculptures by Alexander Archipenko; *Maggy* by Raymond Duchamp-Villon; Jean Arp's marble *Growth*; *Twinned Column* by Antoine Pevsner; Miró's ceramic *Portico*, and *Standing Figure* by Henry Moore, which had been commissioned by the Guggenheim.

Broadening the museum's focus, Sweeney added paintings by Abstract Expressionists, Modernists, and Cubists to the once largely non-objective art collection. Chief among these was Paul Cézanne's *Man With Crossed Arms*, formerly known as *The Clockmaker*, which cost the then-enormous sum of $100,000.

In recognition of the shift in its acquisition and exhibition policies, and as a memorial to its founder, the name of the museum was changed to the Solomon R. Guggenheim Museum in 1952.

In 1959—approximately seventeen years after Guggenheim commissioned a new building—the Frank Lloyd Wright-

designed structure opened to the public. The following year, Sweeney resigned and was succeeded, in 1961, by Thomas M. Messer, who guided the museum for the next twenty-seven years.

In 1982, the Guggenheim Foundation decided to expand the museum building, in order to display a larger portion of its holdings, to exhibit large-scale contemporary art, and to accommodate its growing professional staff.

When Messer retired in 1988, he was succeeded by Thomas Krens, formerly director of the Williams College Museum of Art, who supervised the expansion and restoration of the Wright building—a project that required the closing of the museum from May 1990, until the end of 1991.

THE BUILDING

Even before a site was selected, Wright began designing a spiral-shaped building, representing his interpretation of ancient Mesopotamian ziggurats, and reflecting Rebay's wish to build a "temple of non-objective painting." Believing that a museum "should be one extended expansive well proportioned floor space from bottom to top," he designed a curvilinear, poured-concrete ramp that spiraled upward nearly a hundred feet to a glass skylight. A smaller, round structure, known as the monitor building—originally intended as Rebay's residence—was attached to the ramp. The circular motif is repeated in the window grills, terrazzo floors, and exterior pavement, and small bays lining the ramp provide intimate areas for works of art. The lobby, a dramatic circular space, provides a spectacular view of the cantilevered spiral above, topped by its skylit dome.

The rotunda from above with Calder's Red Lily Pads *and Miró's* Portico

In 1948, land at the corner of Fifth Avenue and Eighty-ninth Street was added to the original plot, requiring an alteration of the plans. Three years later, the Guggenheim Foundation acquired the corner lot on Eighty-eighth Street and Fifth Avenue, which, of course, meant still more changes. The revised plans included a twelve-story annex for artists' studios and apartments, designed to serve as a backdrop to the museum building.

During a fifteen-year period, before the building became a reality, Wright prepared approximately seven hundred sketches, six separate sets of working drawings, and two Plexiglas scale models of his design. Construction was deliberately delayed by Guggenheim because of postwar inflation, and, after his death in 1949, it was further postponed, awaiting the museum's new administration.

In 1953, Wright streamlined the structure, and redesigned the entire complex, just as the plans were to be reviewed for the building permit. Throughout this period, he and Sweeney had had countless discussions about the design. They were poles apart on such important issues as the amount of space required for non-exhibition purposes, the color scheme of the galleries, the type of lighting that should be installed, and whether the building should have sloping walls. Sweeney prevailed on most points.

Finally, in 1956, ground was broken for the building, and the museum was relocated to temporary quarters in a town house at 7 East Seventy-second Street. Wright died in April 1959, six months before the museum opened to the public.

The annex he envisioned was completed in 1968, under the direction of William Wesley Peters, Wright's son-in-law and his successor at Taliesin Associated Architects. The 1968 plan—anticipating future expansion—called for a four-story building to be constructed on a foundation that would accommodate a ten-story structure.

The restaurant and bookstore were created on the ground floor in 1974, and the Aye Simon Reading Room, designed by architect Richard Meier, opened off the second ramp in 1978. Space on the fourth floor of the monitor building—formerly the director's office—was converted into the Pioneers of Twentieth-Century Art Gallery in 1980.

The 1990–91 restoration and expansion doubled the exhibition space, with four new galleries opening onto the rotunda spiral, and included construction of a ten-story tower, based on Wright's original design for a twelve-story annex. It also included renovation of the auditorium and the exterior of the building, and modernization of the mechanical systems. The goal was to correct certain physical limitations, while maintaining the integrity of Wright's sculptural masterpiece.

In November 1990, the Solomon R. Guggenheim Museum building was designated a New York City landmark. The first Wright-designed building to receive that distinction, it is the youngest New York building to be granted landmark status.

THE COLLECTIONS

The best way to see the collections is to start at the top ramp and work your way down to the bottom. Wright's design allows visitors strolling down the ramp to see paintings and sculpture from a variety of vantage points.

The museum mounts a series of temporary exhibitions each year, which often include works of art from the permanent collection. Some exhibitions have examined the works of such artists as Francis Bacon, Willem de Kooning, Morris Louis, Kenneth Noland, Mark Rothko, and David Smith. Other shows have been devoted to contemporary artists, such as Jenny Holzer, who was offered a one-person show months before she won the 1990 Venice Biennale. Still other exhibitions focus on aesthetic perspectives or on the modern art of a particular country, such as Italy or the Soviet Union.

Paris Society by Max Beckmann, 1931

Starting with Solomon R. Guggenheim's personal collection, the museum has grown with gifts, purchases, and bequests. In 1948, the museum greatly enhanced its holdings—and added major Expressionist and Surrealist works—by purchasing the entire estate of Karl Nierendorf, a New York dealer who specialized in the works of German artists. His collection of over seven hundred objects included eighteen Kandinskys, a hundred and ten Klees, six Chagalls, and twenty-four Feiningers, as well as Kokoschka's historic *Knight Errant*.

With the Katherine S. Dreier bequest in 1953, the museum acquired twenty-eight works of art, including Brancusi's oak sculpture, *Little French Girl*; an Archipenko bronze; Piet Mondrian's *Composition*, 1929; a Calder string mobile; a 1916 *Still Life* by Juan Gris, and three collages by Kurt Schwitters dating from the 1920s.

In 1965, Justin K. Thannhauser, a leading dealer of Impressionist and modern French painting, placed part of his personal collection of Impressionist, Post-Impressionist, and School of Paris paintings, sculptures, and works on paper on permanent loan. The collection, installed in its own wing, was legally transferred to the Guggenheim Foundation upon Thannhauser's death in 1976. In addition to twenty-seven Picassos dating from 1900 to 1960, Thannhauser's gift included important paintings by Paul Cézanne, Paul Gauguin, Édouard Manet, and Vincent van Gogh, whose artistic accomplishments provide a historical background for the museum's twentieth-century works of art.

Highlights of the Thannhauser collection include Picasso's *Moulin de la Galette*, *Woman Ironing*, and *Woman With Yellow Hair*, a portrait of his mistress, Marie Thérèse Walter; Pissarro's 1867 painting, *The Hermitage at Pontoise*; Cézanne's portrait of *Madame Cézanne*; van Gogh's *Mountains at Saint-Rémy*, and Modigliani's *Young Girl Seated*.

The Peggy Guggenheim Collection was deeded to the Solomon R. Guggenheim Foundation in 1970, with the understanding that it would remain in Venice. Six years later, the Peggy Guggenheim Collection in the Palazzo Venier dei Leoni was listed as an Italian National Monument, and the collection and the palazzo were legally transferred to the Solomon R. Guggenheim Foundation. Peggy Guggenheim died in 1979. The foundation administers both the Solomon R. Guggenheim Museum and the Peggy Guggenheim Collection.

In 1990, the museum added approximately three hundred Minimalist paintings and sculptures of the 1960s and 1970s from the collection of Count Giuseppe Panza di Biumo and his wife, Giovanna. In a combined sale and gift, the museum acquired two hundred and eleven works of art by painters Robert Mangold, Brice Marden, and Robert Ryman, and sculptors Carl Andre, Dan Flavin, Donald Judd, Richard Long, Robert Morris, Bruce Mauman, and Richard Serra.

The Panzas have promised to donate an additional hundred and five works by 1995, together with the land and buildings of their family estate, Villa Litta, in Varese, about thirty miles from Milan, Italy.

INTERNATIONAL CENTER OF PHOTOGRAPHY

1130 Fifth Avenue
New York, N.Y. 10028
212/860–1777

SUBWAY	4, 5, and 6.
BUS	M1, M2, M3, and M4.
HOURS	Noon to 8 P.M. Tuesday; Noon to 5 P.M. Wednesday through Friday; 11 A.M. to 6 P.M. Saturday and Sunday. Closed Monday.
TOURS	Guided tours by advance reservation. Call 212/860–1485.
ADMISSION	$3, adults; $1.50, students; $1, senior citizens. School groups and members, free. No charge 5 to 8 P.M. Tuesday.
HANDICAPPED FACILITIES	Accessible to the disabled.
MUSEUM SHOP	Postcards, videos, and photography books.
SPECIAL EVENTS	Lectures, seminars, and workshops.
MEMBERSHIP	From $40.

INTERNATIONAL CENTER OF PHOTOGRAPHY
MIDTOWN
1133 Avenue of the Americas at 43rd Street
212/768–4680

HOURS	11 A.M. to 6 P.M. Tuesday through Sunday; 11 A.M. to 8 P.M. Thursday. Closed Monday.
ADMISSION	$2, adults; $1, students and senior citizens; members, free. Temporary exhibitions, lectures, education programs, and book store.

The International Center of Photography (ICP) began as one man's attempt to honor the memory and preserve the work of his colleagues. In a relatively short time, however, it has grown into a major institution renowned for the quality and diversity of its exhibitions.

HISTORY
The founding director of the International Center of Photography is Cornell Capa, a Hungarian-born photojournalist, and the brother of war photographer Robert Capa.

Born in Budapest in 1918, Capa became his brother's darkroom assistant while studying in Paris in 1936. While Robert Capa was covering the Spanish Civil War, Cornell, who worked in a photographic studio, spent his evenings developing his brother's pictures, as well as those of Henri

The International Center of Photography

Cartier-Bresson and other photographers. In 1937, Cornell emigrated to the United States. He worked first in the darkroom at Pix, a photographic agency, and then at *Life*. During World War II, he did aerial intelligence photography and public relations for the Air Force. When the war ended, he returned to *Life* as a staff photographer. At that time, his photo essays were devoted mainly to Latin America, England, and American politics.

In May 1954, Robert Capa was killed when he stepped on a land mine in Indochina. That same month, Werner Bischof, Capa's friend and colleague, died in an automobile accident in Peru. Cornell brooded about what would become of the work of these men. He asked, "What happens to a photographer's work after his death, having spent a lifetime 'witnessing' . . . work that cannot get commercial attention, that gets no subsidy for its maintenance and that is not known or celebrated enough to become part of a museum's permanent collection (which is not a solution either, since it accommodates but a tiny fragment of a photographer's life output and does not fulfill the function of an active archive)?"

Cornell Capa, founder of the International Center of Photography

In the 1950s, after doing a story for *Life* about missionaries in Ecuador, he became more aware of the power of humanistic photography and its ability to arouse concern.

In addition to his work as a photojournalist, Capa served as acting president of Magnum, a photographers' cooperative that had been founded in 1947 by Robert Capa, Henri Cartier-Bresson, George Rodger, and David Seymour. Seymour's death in 1956 on assignment in Suez provided an additional stimulus for Capa to try to preserve his fellow photographers' work. He said, "I was as busy as any photojournalist could be, so my effort to save my friends' work had to be an extracurricular activity on nights and weekends. It was expensive and demanding, but I had a personal commitment."

Capa joined with Werner Bischof's widow and David Seymour's sister in establishing a fund in memory of his brother and his two colleagues. In 1966, the fund was expanded into the International Fund for Concerned Photography. A "Concerned Photographer" exhibition at the Riverside Museum in New York in 1967 was one of the first shows to emphasize coherent bodies of work by individual photographers. Capa organized other photography shows at the Riverside Museum, the Metropolitan Museum of Art, and the Jewish Museum and soon began to realize the need for a museum devoted to the works of photojournalists.

After a two-year search for a building, the International Center of Photography opened on Museum Mile, at Fifth Avenue and Ninety-fourth Street, in 1974. In 1989, a midtown branch opened at 1133 Avenue of the Americas at Forty-third Street.

THE BUILDING
Willard Straight, diplomat, financier, and founder of the *New Republic*, was the first occupant of this building in 1915. Straight hired the architectural firm of Delano and Aldrich to design his six-story, red brick neo-Georgian home. An unusual feature of the design is a series of seven windows that resemble portholes just below the roof line.

Later, famed New York hostess Mrs. Harrison Williams lived here.

For approximately twenty years, the building served as the headquarters of the National Audubon Society. When Capa first saw the vacant, dilapidated building, it was priced at $1.4 million—a price later cut in half. The building was purchased and opened to the public November 16, 1974.

A beautifully proportioned circular, marble-floored foyer is the focal point of the first floor. Two exhibition galleries, a screening room, and the museum shop adjoin the foyer. Three additional galleries are on the second floor. The rest of the building is used for offices, classrooms, and darkrooms.

THE COLLECTION

The museum's permanent collection includes more than 12,500 original prints by some of the finest photographers in the world. These are shown on a rotating basis in the Permanent Collection Gallery at both the uptown and midtown locations.

In addition, the archives contain audiotape recordings of lectures, seminars, and interviews with photographers, experts, and visiting artists.

THE EXHIBITIONS

Exhibitions from Europe, Latin America, Asia, and other parts of the world are shown alongside shows curated by the center, and are changed every six weeks. Films and videos are an integral part of the program.

These exhibitions often celebrate the work of individual photographers. The subjects range from nineteenth-century English photographer Henry Peach Robinson to Douglas Kirkland, who photographed stage and film stars of the sixties, seventies, and eighties, to such contemporary photographers as Barbara Kasten, Stephen Frailey, and Cindy Sherman.

EDUCATION

In addition to offering lectures, seminars, and workshops for students, scholars, and photographers, several innovative approaches to education have been developed.

ICP's one-year certificate programs in general studies and in documentary photography and photojournalism draw students from Europe, Asia, and Latin America, as well as the United States. Students spend three terms studying at ICP. In their third term, they are placed in internships with leading photographers or picture agencies, such as Magnum or Black Star.

Another program, devoted to the history, theory, and practice of photography, leads to a Master of Arts degree, in association with New York University.

PORTFOLIO REVIEW

Each year, ICP's Portfolio Review Service helps the museum to keep abreast of new talent and trends in photography. Photographers' portfolios are reviewed and evaluated, by appointment, and recommendations are made concerning the individual photographer's goals and exhibition possibilities.

METROPOLITAN MUSEUM OF ART

Fifth Avenue at 82nd Street
New York, N.Y. 10028
212/879–5500
212/535–7710 recorded information
TTY 879–0421

SUBWAY	4, 5, and 6.
BUS	M1, M2, M3, M4, M18, and M79.
HOURS	9:30 A.M. to 5:15 P.M. Tuesday through Thursday, and Sunday; 9:30 A.M. to 8:45 P.M. Friday and Saturday. Closed Monday, January 1, Thanksgiving, and Christmas.
TOURS	Regular guided tours in English, Japanese, and Spanish. Group tours in French, Italian, Japanese, and Spanish by appointment. Call 212/570–3703.
ADMISSION	$5, adults; $2.50, students and senior citizens.
HANDICAPPED FACILITIES	Wheelchairs at coat check areas; sound augmentation systems available in auditoriums; parking garage. Activities for visually impaired visitors; call 212/535–7710.
FOOD SERVICE	Cafeteria and bar; restaurant reservations, 212/570–3964.
MUSEUM SHOP	Books, jewelry, scarves, ties, posters, glass, note paper, calendars, and three-dimensional reproductions.
SPECIAL EVENTS	Concerts, films, gallery talks, and lectures.
SPECIAL FACILITIES	Grace Rainey Rogers Auditorium. Reference library and print study rooms.
MEMBERSHIP	From $25.
AUTHOR'S CHOICE	American wing Temple of Dendur *Aristotle With the Bust of Homer* by Rembrandt *View of Toledo* by El Greco French Impressionist collection

The Metropolitan Museum of Art

Although New York claims the Metropolitan Museum of Art as its own, it is in fact a world-class institution. One of New York's most popular tourist attractions, it is among the largest museums in the Western hemisphere, and the home of spectacular exhibitions—both temporary and permanent. A walk through the Metropolitan today leads the visitor through a total of nineteen curatorial departments. Each originated with bequests, gifts, and purchases, and grew to become a separate entity.

HISTORY

In Paris in 1866, a group of Americans celebrating the Fourth of July met for dinner. John Jay, grandson of the first chief justice of the U.S. Supreme Court, suggested that New York needed a national institute and gallery of art. At that time, the

city was museum-poor, with only the limited collections of the New-York Historical Society available to the public. Major works of art were in private collections.

When he returned to this country, Jay, as president of the Union League Club, enlisted the support of influential artists and civic leaders. As a result, the Metropolitan Museum of Art was incorporated on April 13, 1870.

The new museum applied to the city for funding the following year. Mayor William Marcy Tweed ("Boss" Tweed) offered to take over the institution but museum officials managed to work out a cooperative arrangement. The city agreed to pay for the buildings and their maintenance, while the trustees retained title to the collections.

The first gift to the new museum was a Roman sarcophagus, which portended the development of a wide archaeological interest. This was soon followed by a collection of European paintings, purchased by public subscription. Next, Louis Palma di Cesnola, the former American consul to Cyprus and an amateur archaeologist who became the museum's first director, sold the trustees his own collection of more than six thousand Cypriot glass, terracotta, and stone objects for $60,000.

In 1887, Catherine Lorillard Wolfe—generally considered to be the richest unmarried woman in the world at that time—left a hundred and forty-three paintings and the museum's first purchase fund. This was used in part to buy a Goya, a Delacroix, a Winslow Homer, and the first important Renoir ever to go to a museum, *Madame Charpentier and Her Children*.

Through the generosity of other patrons, the museum was able to acquire paintings by Rembrandt, Hals, Vermeer, Gainsborough, Van Dyck, and Manet, among others. Although it had been difficult to raise money for the museum initially, by the turn of the century the Metropolitan, heavily supported by Old New York, had become extremely fashionable. Early in this century, the art collections grew as paintings were added by such masters as Tintoretto, Breughel, Ingres, Rubens, Boticelli, Cézanne, and Dürer. The Henry O. Havemeyer family gave approximately two thousand works by Corot, Manet, Degas, El Greco, and others, some of which had been purchased on the advice of Mary Cassatt. Other noted collectors made available paintings by Velázquez, Watteau, Matisse, Picasso, Rubens, Cézanne, Gauguin, van Gogh, Rousseau, and Caravaggio.

Today's statistics are impressive. The museum owns approximately three million works of art covering over five thousand years. More art historians are employed here than in any institution of higher learning. The museum's conservation department is the most sophisticated in the world, with fifty specialists. The Uris Center on the ground floor is the wellspring of educational activities, with its own library, auditorium, and classrooms. It is a major publisher of educational books and films.

All of these activities and services require 2,200 full-time employees and six hundred volunteers.

THE BUILDING

The first collections were shown in two locations—the former Dodsworth's Dancing Academy, 681 Fifth Avenue, and the

Douglas Mansion on West Fourteenth Street—before moving to its present location in the "Deer Park" between Seventy-ninth and Eighty-fourth streets, extending from Fifth Avenue west to the Park Drive. The original Gothic structure designed by Calvert Vaux, who had also designed Central Park, and Jacob Wrey Mould, was opened officially by U.S. President Rutherford B. Hayes on March 30, 1880.

As the museum grew, the building grew accordingly, with several architects adding their talents. Today's mammoth structure supplants entirely the original red brick Vaux and Mould design, so that only its west façade is visible from the Robert Lehman Wing.

The central pavilion was designed by Richard Morris Hunt in 1902; the north and south wings were designed by McKim, Mead, and White in 1911 and 1913. Kevin Roche John Dinkeloo and Associates is responsible for a group of special wings: Robert Lehman in 1975, Sackler in 1978, American in 1980, Michael C. Rockefeller in 1982, and Lila Acheson Wallace in 1987. A comprehensive architectural plan adopted in 1971 also called for the addition of the Henry R. Kravis Wing to house European sculpture and decorative arts from the Renaissance to the beginning of the twentieth century.

FIRST FLOOR

To the right, when you enter from Fifth Avenue, you will find the Egyptian art collection; the Sackler Wing, with the Temple of Dendur; the American Wing, and European sculpture and decorative arts. To the left of the entrance are galleries with Greek and Roman art; primitive art; twentieth-century art; the Petrie Sculpture Garden, and additional European sculpture and decorative arts. Medieval art and the Lehman Wing are in the center of the building.

Exhibitions of the American Wing, European sculpture and decorative arts, Greek and Roman art, and art of the twentieth century continue on the second floor.

EGYPTIAN ART

Egyptian art and the Sackler Wing are located in the northeast corner of the first floor. One of the most comprehensive collections outside of Cairo, the Egyptian collection, which includes some of the museum's oldest objects, is exhibited almost in its entirety. Examples range from the third millenium B.C., the Prehistoric period, to the Byzantine period in the eighth century A.D.

The thousands of pieces—sarcophagi, architectural fragments, jewelry, fabrics, bowls, storage urns, glass, statuettes, and other artifacts—come from several decades of museum excavations, beginning in 1906 when the Department of Egyptian Art was founded. The museum's first curator of Egyptian art, Albert M. Lythgoe, started digging about that time, mostly around Luxor, and continued for twenty years. Many of the digs were funded by Edward S. Harkness, a wealthy philanthropist from Cleveland, who also donated the tomb of Bernebi which graces the first gallery of the area.

In 1920, Herbert Winlock, Lythgoe's assistant and eventual successor, made the amazing discovery of a group of almost perfect models of daily Egyptian life from around 2000 B.C., which are shown in a separate gallery. Other works were made available from the estate of Theodore M. Davis, a millionaire

archaeologist, and from Harkness's gift of Lord Carnarvon's collection.

Walk back toward the American Wing to the Sackler Wing to see the fascinating Temple of Dendur, a mecca for all visitors to the museum and one of its most outstanding acquisitions. The Dendur complex, built around 15 B.C., formerly stood on the west bank of the Nile, fifty miles south of Aswan and six hundred miles south of Cairo.

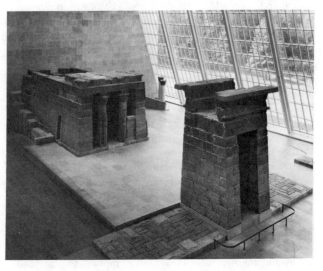

The Temple of Dendur; the Metropolitan Museum of Art, given to the United States by Egypt in 1965, awarded to the Metropolitan Museum of Art in 1967, and installed in the Sackler Wing in 1978

Flooding caused by construction of the Aswan High Dam in 1960 threatened to submerge the Dendur temple and other monuments. In recognition of American contributions to the United Nations Educational, Social, and Cultural Organization (UNESCO) campaign, the Egyptian government gave the temple to the United States government in 1965. It was awarded to the Metropolitan in 1967. The temple and its gateway were rebuilt much as they were on the banks of the Nile and were installed in the Sackler Wing in 1978.

The Sackler Wing is named for the late Dr. Arthur M. Sackler, donor of the Smithsonian Institution's Arthur M. Sackler Gallery of Oriental Art in Washington, D.C.

AMERICAN WING

The two distinct collections of the American Wing— decorative arts, organized in 1934, and paintings and sculpture, formed in 1948—tell a visual story of the history of the United States from the seventeenth century to the early twentieth. Works created after 1916 are part of the Department of Twentieth-Century Art.

One of the world's greatest collections of Americana— paintings, prints, drawings, decorative arts, and architecture— can be found here. There are fine examples of period furniture from the workshops of Samuel McIntire, Duncan Phyfe, and other early cabinetmakers. Especially fascinating is a series of twenty-four rooms with original furnishings, which provides a history of domestic life from 1640 to the early twentieth century, as represented by a Frank Lloyd Wright room of 1912–15.

A valuable aid for visitors, students, and researchers is the Henry R. Luce Center for the Study of American Art. Approximately ten thousand fine art and decorative art

objects, arranged by medium or material, are cataloged and computerized. Information about these objects is available through American Wing Art Research (AWARE).

Adjacent to the galleries on the first floor is a large, restful oasis known as the American Wing Garden Court whose focal point is a gilded bronze *Diana* by Augustus Saint-Gaudens.

ARMS AND ARMOR

The museum has been collecting arms and armor since the early years of the twentieth century and a separate department was established in 1912 with Bashford Dean as curator. Dean was the husband of Mary Alice Dyckman Dean, one of two sisters who donated their family home, Dyckman House, to the city in 1916. Dean's interest in armored fishes, which led him to become a zoologist, progressed eventually to a fascination with historic arms and armor.

The collection is displayed toward the center of the north side of the first floor in ten recently renovated galleries. Included are more than fourteen thousand full suits of armor, helmets, swords, rapiers, shields, pistols, and daggers from Europe, the Near East, Asia, and the Americas.

EUROPEAN SCULPTURE AND DECORATIVE ARTS

The sculpture and decorative arts of Europe cover a major portion of the first floor. The objects on view range from the Renaissance to the early twentieth century, and include sculpture, ceramics, glass, tapestries, textiles, woodwork and furniture, clocks and mathematical instruments, and jewelry and other metalwork.

The collection originated with a gift of eighteenth-century works of art from J.P. Morgan in 1907. This was followed by gifts and bequests of Rodin sculpture from Thomas Fortune Ryan, Sèvres porcelain and furniture from the Kress Foundation, and French royal furniture from William K. Vanderbilt.

Of special interest are a series of period rooms from palaces and great houses. Look for two English neoclassical rooms designed by Robert Adam in the eighteenth century, several eighteenth-century French salons, and a sixteenth-century patio from the castle of Vélez Blanco, Spain. The latter had originally been in the Park Avenue home of George Blumenthal, a former president of the museum.

There are also outstanding examples of Italian Renaissance sculpture, English and French silver, Italian majolica, and porcelains from France and Germany.

A Textile Study Room is available by permission for scholarly research.

ROBERT LEHMAN COLLECTION

Philip Lehman, founder of the investment banking firm of Lehman Brothers, began collecting European decorative arts and Old Master and nineteenth-century French paintings around 1910. He and his son, Robert, formed what was generally considered to be the finest private art collection in the United States.

The collection—a rare assemblage of paintings, drawings, and decorative arts—is displayed in its own small wing on the ground and first floors at the center rear of the building. The seven galleries have been designed to re-create the atmosphere

of the family home in New York City where the art was originally housed.

Italian and Northern European paintings of the fourteenth and fifteenth centuries; seventeenth- and eighteenth-century Dutch and Spanish paintings, and French paintings of the nineteenth and twentieth centuries are showcased in rotating exhibitions. The masterpieces range from a hauntingly beautiful *Annunciation* by Alessandro Botticelli and *Madonna and Child* by Giovanni Bellini to Pierre Renoir's *Young Girl Bathing* and André Derain's *Houses of Parliament at Night*.

Robert Lehman was especially interested in drawings, and the Lehman collection includes some outstanding examples, notably works by Dürer and Rembrandt, and approximately two hundred eighteenth-century Venetian drawings.

JACK AND BELLE LINSKY COLLECTION

The Linskys collected paintings, furniture, bronzes, porcelain, and other artifacts of the most exquisite quality and taste, acquired over a period of forty years. These are shown in special galleries, opened in 1984, on the first floor left center.

Among outstanding works are eighteenth-century French furniture by Boulle and Roentgen, porcelains and figurines by Meissen and Chantilly, and portraits by Fra Bartolomeo, Andrea Del Sarto, and Peter Paul Rubens.

MEDIEVAL ART

The medieval collection stems from a J.P. Morgan, Jr., gift of several thousand examples collected by his father and on loan to the museum.

Ranging from the fourth to the sixteenth century, it includes works from Early Christian, Byzantine, Migration, Romanesque, and Gothic periods. Outstanding examples of stained glass, tapestries, enamels, jewelry, and sculpture are on view in a large area at the center of the first floor.

Many of the museum's greatest examples of medieval sculpture, tapestries, enamels, ivories, paintings, and illuminated manuscripts are displayed at the Cloisters in Fort Tryon Park, which is described elsewhere in this book.

CARROLL AND MILTON PETRIE EUROPEAN SCULPTURE COURT

Opened in 1990, this skylit area is reminiscent of a classical garden, with greenery, chairs, and several large French and Italian marble sculptures dating from the seventeenth to the twentieth century.

Rodin's *The Burghers of Calais* is installed here, as are two figures, *Priaps and Flora*, carved by Pietro Bernini and Gian Lorenzo Bernini in the seventeenth century. The latter formerly stood at the main entrance of Villa Borghese in Rome.

TWENTIETH-CENTURY ART

Interest in art of this century became apparent in 1906, when George Hearn, a New York retailer and a trustee of the Metropolitan, established a fund to acquire examples by living American artists. By 1967, twentieth-century art had become sufficiently important to warrant its own museum department. Although there are many important European works, including Picasso's well-known portrait of Gertrude Stein,

Gertrude Stein by Pablo Picasso; the Metropolitan Museum of Art, bequest of Gertrude Stein, 1946

(which she willed to the Metropolitan), and major paintings by Bonnard, Kandinsky, Matisse, and others, the bulk of the collection is American.

Paintings by the Eight, early modernists, Abstract Expressionists, Color Field painters, and minimalists are handsomely displayed in the Lila Acheson Wallace Wing, which opened in 1987. The collection includes more than eight thousand paintings, works on paper, sculptures, and objects of architecture and design. A selection of Art Nouveau and Art Deco furniture and metalwork is especially noteworthy.

The Iris and B. Gerald Cantor Roof Garden, open seasonally atop the Wallace Wing, is the setting for contemporary sculpture displayed against the spectacular backdrop of the New York skyline.

ART OF AFRICA, THE AMERICAS, AND PACIFIC ISLANDS

Housed in the Michael C. Rockefeller Wing, these galleries at the south end of the first floor are directly to the right of the restaurant entrance.

The wing, opened in 1982, was made possible by Nelson A. Rockefeller, whose son, Michael, was lost while on an expedition to New Guinea. It contains Nelson Rockefeller's own collection, as well as the Metropolitan's primitive art holdings.

The two thousand objects include a large installation of sculpture from Africa and the Pacific Islands. On loan are eighteenth- and nineteenth-century gold pieces from Africa, known as the Barbier-Mueller Collection from Geneva.

Other artifacts include bronze sculpture from Benin and pre-Columbian ceramics, stonework, and gold from Mexico, Central, and South America. North America is represented by Eskimo and American Indian examples.

The Robert Goldwater Library is open to scholars and researchers.

GREEK AND ROMAN ART

Three of the early directors of the museum were archaeologists, which led to the establishment of a Department of Greek and Roman Art in 1909. The collections, housed on the first floor to the left of the Great Hall, date back to the Cypriot, Minoan, and Mycenaean art of pre-Greek Greece, and the pre-Roman art of Italy.

A varied collection has grown from the museum's initial gift of a Roman sarcophagus. Holdings include majestic sculpture and busts, tombs, wall paintings, vases, glass, and silver. The department claims that its "archaic Attic sculpture is second only to that in Athens."

Myriad Roman paintings survived the eruption of Mount Vesuvius in 79 A.D., and the museum owns the largest group outside of Italy. A villa near Pompeii yielded especially well-preserved examples, such as a complete bedroom with murals depicting rustic scenes and architectural views.

ASIAN ART

SECOND FLOOR

The Department of Asian Art, established in 1915, covers many countries, a long time span, and a rambling area at the northeast corner of the second floor. It winds around the

balcony of the Great Hall to the northeast corner and back toward the American Wing.

Art from China, Japan, Korea, India, and Southeast Asia ranges backward in time from this century to the third millennium B.C. The centerpiece of the area is the charming Astor Court, a re-creation of a traditional Chinese garden. Built by Chinese craftsmen, using materials from China, the garden marks the first permanent cultural exchange between the United States and the People's Republic of China.

The Asian collection began in 1879 with the purchase of a group of Chinese porcelains. Then came the first Han bronze, donated in 1887, and, in 1902, the gift of a thousand jades.

Between 1902 and 1960, further gifts, fleshing out the collections to major proportions, made possible special galleries for Chinese paintings and Japanese art works.

Highlights of the collections include superb Chinese Buddhist sculptures, ceramics, jades, and furniture; Japanese prints, screens, and lacquered objects, and stone and bronze sculptures from India and Southeast Asia.

Also notable is the textile collection, which was established in 1888 when John Jacob Astor donated his wife's lace collection after her death.

MUSICAL INSTRUMENTS

On the second floor, north side center, is a music lover's paradise, stemming from Anne Crosby Brown's gift of the Crosby Brown Collection. Mrs. Brown, the wife of a partner in the investment banking firm of Brown Brothers who was also a trustee and treasurer of the museum, donated two hundred and seventy musical instruments in 1889. She continued to add to the collection for the next eighteen years. By 1906, the collection included thirty-five hundred instruments from all parts of the world, ranging from prehistoric bone flutes to rare pianofortes to modern saxophones. The André Mertens Galleries housing the collections were opened in 1971.

The oldest existing piano, made by Bartolommeo Cristofori in Florence, Italy, in 1720, is here. Among the eight hundred instruments displayed are precious violins and stringed instruments, a small pipe organ, horns, spinets, drums, and even a nineteenth-century carved rattle from British Columbia, as well as a replica of a violin maker's fully equipped workshop. With earphones, visitors can hear recordings of music performed on the various instruments.

EUROPEAN PAINTINGS

Nearly three thousand works from the twelfth through the nineteenth centuries are housed here, ranging from Old Masters to Impressionists and Post-Impressionists.

There are masterpieces from virtually every country: from Italy, Bronzino's *Portrait of a Young Man*; from Holland, Rembrandt's *Aristotle With a Bust of Homer*, and five paintings by Jan Vermeer, more than are owned by any other museum in the world; Flemish paintings, such as Hieronymous Bosch's *The Adoration of the Magi* and Peter Paul Rubens's self portrait with his wife and son; Spanish works, including Velázquez's portrait of Juan de Pareja and El Greco's *View of Toledo*, and French masterworks by Nicholas Poussin, Claude Lorrain, Jean Antoine Watteau, and Jean-Baptiste Chardin, among others.

You will find nineteenth- and early twentieth-century

Aristotle With a Bust of Homer *by Rembrandt; the Metropolitan Museum of Art, purchased with special funds and gifts of friends of the museum, 1961*

European paintings in the André Meyer Galleries on the second floor of the Michael C. Rockefeller Wing. The Metropolitan owns thirty paintings by Claude Monet and seventeen by Paul Cézanne, including his famous view of Mont Sainte-Victoire, *The Card Players*, and *Still Life: Apples and a Pot of Primroses*, which was once owned by Monet. Also here are Paul Gauguin's *la Orana Maria*, and several important works by Vincent van Gogh, including his *Cypresses*, *L'Arlésienne*, and *Self-Portrait With a Straw Hat*, and Rosa Bonheur's *The Horse Fair*, donated by Cornelius Vanderbilt and one of the most widely reproduced images of the late nineteenth century.

ISLAMIC ART

An outstanding collection of Islamic art is on view at the southeast corner of the second floor, adjacent to Ancient Near Eastern Art. The glass, metalwork, carpets, wall hangings, miniatures, and pottery cover approximately twelve centuries, beginning with the founding of the Muslim religion in the seventh century.

The collection had its origin in 1891, with a bequest of metalwork, pottery, and enameled mosque lamps from Edward C. Moore, the president of Tiffany & Company. Additional pottery and wall decorations came from the museum's own excavations at Mihapur.

The objects on view represent the art and culture of Morocco, Egypt, Syria, Mesopotamia, Persia, and India. Of special interest are a magnificent Turkish prayer rug, woven in the late sixteenth century and a room whose marble floors, wood-panelled walls, and stained glass windows originally graced an eighteenth-century house in Syria.

ANCIENT NEAR EASTERN ART

This department, located on the second floor toward the south end of the building, also benefited from the museum's Egyptian excavations.

Established in 1956 and housed in a comparatively small space, the scope of the collections is enormous, spanning the sixth millennium B.C. to the seventh century A.D. There are separate galleries for Achaemenian, Anatolian, Assyrian, Iranian, Mesopotamian, Parthian, Sasanian, and Syrian art.

Particularly noteworthy are statues that came from the palace of Ashurnasirpal II in Iraq.

DRAWINGS, PRINTS, AND PHOTOGRAPHS

Because works on paper deteriorate if exposed to light over long periods of time, this collection, located near the south end of the second floor, is shown in rotating exhibitions.

DRAWINGS

The collection began with a gift of seventeenth- and eighteenth-century Italian works. In 1880, Cornelius Vanderbilt donated nearly seven hundred drawings from the collection of art critic James Jackson Jarves. The museum purchased other works by Michelangelo, Goya, Rubens, Degas, and Matisse.

Important Fauve and Cubist drawings were added when Georgia O'Keefe donated the collection of her husband, Alfred Stieglitz. The museum now owns nearly four thousand drawings. The department, established in 1960, is especially noted for its fifteenth- through nineteenth-century works by French and Italian masters.

PRINTS

The print department was established in 1916, when publisher Harris Brisbane Dick bequeathed a large collection of etchings. The museum's holdings were expanded by bequests from J.P. Morgan's father, banker Junius Spencer Morgan; Mrs. Havemeyer, and financier Felix M. Warburg of such artists as Dürer and Rembrandt.

All major artists who included printmaking in their work are now represented. Special emphasis is placed on collections of fifteenth-century German, eighteenth-century Italian, and nineteenth-century French prints. Highlights include a rare design for wallpaper, *Satyr Family in a Vine*, by Albrecht Dürer, Rembrandt's *The Three Crosses*, and Mary Cassatt's *Woman Bathing*.

In addition, the library contains over twelve thousand books with prints as illustrations. The subject matter includes such subjects as architecture, calligraphy, costumes, and gardening.

The Print Study Room is open to scholars by appointment.

PHOTOGRAPHY

The photography collection includes many works assembled by noted photographer Alfred Stieglitz and donated to the museum between 1928 and 1949.

It has recently been supplemented by a gift from the Ford Motor Company of John Waddell's collection of five hundred photographs taken from the 1920s to the 1940s.

GROUND FLOOR

COSTUME INSTITUTE

The Costume Institute is unique in this country as the repository of more than forty-five thousand items of dress. In fact, it is one of the most comprehensive collections in the world, ranging from the seventeenth century to the present.

Many of the costumes in the collection came from the former Museum of Costume Art, which was founded in 1936 by Irene Lewisohn, Aline Bernstein, Lee Simonson, and other theatrical and fashion personalities interested in the history and design of costumes. The Museum of Costume Art changed its name to the Costume Institute in 1946, when it became part of the Metropolitan Museum of Art.

The institute includes facilities for research and study, as well as the Dorothy Shaver Design Rooms, named in honor of the former president of Lord & Taylor who was instrumental in bringing the Costume Institute to the Metropolitan. Beautifully arranged thematic exhibitions are mounted periodically, such as "La Belle Époque" or "The Age of Napoleon: Costume From Revolution to Empire."

The library of costumes and photographs is open by appointment to scholars and fashion professionals.

EL MUSEO DEL BARRIO

**1230 Fifth Avenue at 104th Street
New York, N.Y. 10128
Mailing address: Post Office Box 816
Gracie Station, N.Y. 10028
212/831–7272**

SUBWAY	6.
BUS	M1, M2, M3, and M4.
HOURS	11 A.M. to 5 P.M. Wednesday through Sunday. Closed Monday and Tuesday.
TOURS	By appointment only.
ADMISSION	$2, adults; $1, senior citizens and students with I.D.; children under 12, free when accompanied by an adult.
HANDICAPPED FACILITIES	Ramp access to building lobby. Galleries accessible to the disabled.
SALES DESK	Exhibition catalogs.
SPECIAL EVENTS	Bilingual public education programs, including gallery talks, workshops, films, concerts, poetry readings, and panel discussions.
SPECIAL FACILITIES	Artists' File, information about Hispanic artists available to scholars and researchers by appointment.
MEMBERSHIP	From $25.
AUTHOR'S CHOICE	Santos de Palo, hand-carved religious statues

El Museo del Barrio is a distinguished Latin American cultural institution located at the northern end of the Museum Mile. In addition to art exhibits and cultural events, the museum mounts shows that celebrate life in El Barrio, which has been one of New York's Hispanic communities since the 1930s.

HISTORY

Founded in 1969, El Museo del Barrio is the only museum in the continental United States devoted to the arts and culture of Puerto Rico. It is noted for its contemporary and historical exhibitions of paintings, prints, and sculpture, in addition to film screenings, concerts, workshops, lectures, performances, and festivals.

The museum also sponsors educational programs for families and children, and, as a major cultural force in the community, encourages the use of its facilities by local and city-wide groups.

The building is owned by the City of New York and its operation is supported in part with public funds from the New York City Department of Cultural Affairs and the Office of the Manhattan Borough President.

Virgen del Carmen,
Puerto Rico, circa
1920

THE COLLECTION

A highlight of the museum's permanent collection of more than six thousand sculptural works is its collection of Santos de Palo. Numbering approximately 240, these wooden figures of saints were carved by artisans from various countries, including Puerto Rico, Spain, the Philippines, Mexico, and Guatemala, for devotion at home.

Bearing witness to early achievements are the pre-Columbian artifacts from the Taino culture of Puerto Rico and the Dominican Republic. Other objects are works on paper, including silkscreens and lithography; contemporary paintings; folkloric pieces, such as masks; textiles, handcrafted tools, photographs, films, and videos.

A selection of the museum's *santos* is on permanent display, while other works are shown as integral parts of temporary exhibits.

EXHIBITIONS

The spacious white-walled museum is the site of many changing exhibitions. One such exhibition was "Folklore! Traditional Crafts from Cuba, Dominican Republic, and Puerto Rico Made in New York," a show that introduced viewers to artisans who continue to work in traditional folkloric ways in an urban setting. "Mira! The Canadian Club Hispanic Art Tour III," called special attention to twenty-nine artists of Latin origin working in the United States, while "The Seventeen Saints of José Rosa" presented silkscreen prints by José Rosa in a satirical view of traditional *santos*.

MUSEUM OF THE CITY OF NEW YORK

Fifth Avenue at 103rd Street
New York, N.Y. 10029
212/534–1672
212/534–1034 recorded information

SUBWAY	6.
BUS	M1, M2, M3, and M4.
HOURS	10 A.M. to 5 P.M. Tuesday through Saturday; 1 to 5 P.M. Sunday and legal holidays. Closed Monday.
TOURS	By arrangement with the Education Department.
ADMISSION	Free.
HANDICAPPED FACILITIES	Ramp access at 104th Street, elevators accessible, and wheelchair available.
MUSEUM SHOP	Books, New York City souvenirs, toys, Christmas cards and ornaments, and museum-related merchandise.
SPECIAL EVENTS	Concerts, lectures, walking tours, and receptions.
SPECIAL FACILITIES	Auditorium.
MEMBERSHIP	From $25.
AUTHOR'S CHOICE	The Big Apple, first floor Toy Gallery, third floor John D. Rockefeller Rooms, fifth floor

The Museum of the City of New York focuses on the city's history and culture, from its exploration and settlement to the present day. The museum's collection in decorative arts, paintings, sculpture, prints, photographs, and assorted bibelots holds something to fascinate anyone interested in New York City. And its highly imaginative sight and sound exhibitions are of particular interest to children.

HISTORY

The Museum of the City of New York, founded in 1923, was originally housed in Gracie Mansion. It was the first American museum dedicated to the history of a major city. Construction of the present Georgian Colonial building began in 1929. Funds were raised by popular subscription and the museum opened to the public in 1932.

The museum's collection spans three centuries, from New York's early years as a forest hunting ground to the vibrant metropolis of today. Recalling New York through the years are collections of costumes, decorative arts, paintings and sculpture, prints and photographs, toys, and theater memorabilia. Among the imaginative aspects of the gallery-by-gallery experience are the sound and musical tracks that serve to transport the visitor to other times and places.

Special exhibitions highlight aspects of the collection that

are not on permanent display. There have been "City Play," a lively survey of urban amusements through photographs, toys, paintings, and video; "American Lines: Manuscripts of Eugene O'Neill," a centennial tribute to the Nobel-prize winning playwright, and "Celebrating George," part of a city-wide tribute to the first president on the bicentennial of his inauguration, which took place in New York in 1789. The latter exhibition, as well as other exhibits, also included lectures and a day-long conference.

In 1959, the museum started Sunday Walking Tours, which have become as much of a sign of New York spring as budding trees. The tours focus on various aspects of New York through history and architecture. "Made in New York" tours, started in 1988, take participants behind the scenes of some of New York's best-known manufacturers and producers, and include a discussion of their contributions to the city.

In addition, the museum presents many educational programs in schools and day camps throughout the area.

A program to renovate and expand the museum building is underway. As a result, the collections on view may differ somewhat from the descriptions given.

The Museum of the City of New York

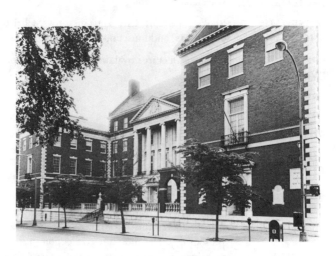

FIRST FLOOR

ITT GALLERY—THE BIG APPLE
A good place to start is this multimedia presentation of the city's history from 1524 to the present. Shows are scheduled every hour on the half hour.

DUTCH GALLERY
Displays and dioramas in this fort-like gallery bring to life virtually every aspect of the city's Dutch origins. You can survey the entire scene from the turret of the life-size replica of Fort Amsterdam, complete with cannon poised to shoot. And you can study the fort's history in exhibits around its base.

A nearby scale model depicts New Amsterdam in 1660 as a neat, orderly place, with fences around the houses and boats tied at moorings. Grouped around the room are dioramas and displays relating to such topics as religion, education, recreation, company's business, farming, transportation, Indian war, and Indian life. Groups of blue-and-white Delft tiles are coordinated with each display. These utilitarian tiles, which

commonly lined walls near kitchen stoves, depict laborers, sports, the military, and all manner of Dutch life.

A most interesting diorama (with its complementary tile grouping) is "Stone Street," a three-dimensional miniature display of the first paved street in Manhattan. In another display case outside the Dutch gallery, a diorama depicts an even earlier moment in time when Manhattan was inhabited by Native Americans.

VOLUNTEER FIRE GALLERY

GROUND FLOOR

The history of fire fighting in New York, from the 1640s to the 1890s, is shown here. Peter Stuyvesant started New York's first fire department by appointing wardens to inspect wooden chimneys on the thatched roof cottages. His deputies imposed a fine of three guilders for every dirty chimney. This money was used to buy the buckets, hooks, and ladders that were needed to fight fires. Lithographs throughout the exhibit portray some of the city's most famous early fires. Especially fine are the Currier and Ives lithographs, including *The Night Alarm* (1854), and the vividly colored *The Burning of New York's Crystal Palace* (1854).

In addition to many scale models, the exhibition's main attractions are two life-size pumpers. Firefighting's early days are recalled through a wooden figure typical of those that once marked firehouses, huge ceremonial trumpets, fire buckets, and leather helmets.

SILVER GALLERY

SECOND FLOOR

Gleaming marble floors and long windows overlooking Central Park form a stately setting for a glittering array of silver objects, from 1678 to 1910. They mark such milestones as births, marriages, deaths, and other important occasions. Early silver was simple and unadorned, echoing the taste of the day. As home furnishings became more ornate, however, silver became heavily ornamented. This trend can be seen in an elaborate, grape-trimmed silver teapot that was manufactured during the same era as the heavily carved, grape-trimmed table nearby.

Some of the most beautiful silver pieces are those sold by Tiffany & Company, assembled in a case to the southeast of the corridor. The famed jeweler sold other makers' silver until 1859, when the firm began to create its own distinctive pieces, and by 1897, Tiffany & Company was also manufacturing silver. The case contains part of a gold Tiffany tea service, crafted in 1897.

A few pieces of furniture punctuate the silver gallery. Among these, opposite the elevator, is a cabinet-bookcase, presented to the famous "song bird," Jenny Lind, in 1850 by members of New York City's fire department. Its shelves are appropriately stocked with seven volumes of John James Audubon's *Birds of America*.

ALEXANDER HAMILTON GALLERY

The handsome furniture and paintings here once belonged to Alexander Hamilton, Federalist politician and first secretary of the U.S. Treasury. These items came from his residence in lower Manhattan and his country estate, "The Grange," on

Convent Avenue. In a small display case is a well executed ivory miniature of Hamilton painted by Edmund Chartres. Portraits of Hamilton and his wife, Elizabeth Schuyler, by John Trumbull and Ralph Earl hang on either side of the handsome mahogany and satinwood desk.

MRS. GILES WHITING GALLERY

Mrs. Giles Whiting of New York City and Westchester County was an avid collector, who died in 1971. She donated her extensive possessions to a number of museums and ordered the remainder sold at auction to benefit charity.

Handsome Federal furniture, silver, and other appointments from her collection have been arranged in a living room setting reminiscent of an 1820s New York parlor. Mrs. Whiting was fond of English transfer printed china, and her tea set, appropriately decorated with a tea party scene, is displayed in a case near the gallery.

J. CLARENCE DAVIES GALLERY

This gallery has prints, maps, paintings, and documents relating to New York City's history, but visitors will also be drawn to such objects as filigree silver buckles, a delicate colonial tea set, and period furnishings. The two handsome pier tables seen here are attributed to the noted French-born New York cabinetmaker, Charles Honoré Lannuier.

Among the paintings are Winslow Homer's *Union Pond, Williamsburg, Long Island*, a skating scene by J. M. Culverhouse, and Francis Guy's intricate *View of Brooklyn*.

Outside the Davies Gallery are portraits of prominent New Yorkers Margaret Beekman Livingston and Rufus King by Gilbert Stuart. City surveys, maps, and views of New York from the Battery provide additional information about the early history of New York.

PERIOD ROOMS

These six rooms re-create the interiors and costumes of New York houses from the late seventeenth to the early twentieth century. A focal point is the exceptionally fine stained glass window designed by Richard Morris Hunt. (Other Hunt windows are in the Metropolitan Museum's American wing.)

The room settings include

• A New York interior whose seventeenth-century Dutch furnishings illustrate the city's earliest period;

• An English Colonial parlor, re-creating the period between 1760 and 1780, with Chinese hand-painted wallpaper and a mahogany gaming table, lit by Sheffield candlesticks;

• Bertha King Benkard Memorial Bedroom, ca. 1740–60. Crewel embroidery embellishes the canopy and coverlet on the four-poster bed. Mrs. Benkerd's English transfer printed china is displayed on the tiered-top chest.

• Stephen Whitney Drawing Room, ca. 1830. For his drawing room at 7 Bowling Green, Whitney, a financier and merchant, chose classically styled pieces that were adorned with allegorical motifs and such decorative elements as the lion paw and cornucopia mounts on the pier table.

• Drawing Room, 1 Pierrepont Place, Brooklyn, 1856–57. Aubusson rugs, nineteenth-century Sèvres china, ebonized wood chairs with ormolu mounts and a black papier-mâché table inlaid with mother-of-pearl are featured here.

• Mr. and Mrs. Harry Harkness Flagler Drawing Room,

1906. Designed by Willard Parker Little for the Flaglers' home at 32 Park Avenue, this room was inspired by the Sala Della Zodiaco in the Ducal Palace at Mantua. The ceiling was copied from Venetian ecclesiastical decor and the doors are decorated with the legend of Cupid and Psyche. *The Elysian Fields*, a painting by Bryson Burroughs, hangs above the mantel. A collection of small boxes is also here.

MARINE GALLERY PORT OF THE NEW WORLD

Sea chanteys and an occasional blast from a fog horn set the scene in this wharf-inspired gallery devoted to New York's maritime tradition. Dioramas dramatically re-create Giovanni di Verrazano's discovery of New York in 1524, Henry Hudson's arrival on the *Half-Moon*, and South Street during its Victorian heyday of ship building. Carved figureheads, paintings, prints, and ship models lend additional nautical touches.

GENERAL MILLS TOY GALLERY · THIRD FLOOR

Among the dolls and dolls' houses seen here are:
• Ann Anthony's Pavilion, 1769. The earliest dolls' house in the collection, it was made by its fourteen-year-old owner from cardboard and paper embellished with shells and mica. She also made the splendid brocade and gilt-edged outfits for the small wax dolls standing in the wax-tree shaded flower garden with its glass fountain. The mirror-accented arcades and cupolas, and the twenty-four-paned windows with blue satin curtains add further elegance to the setting.
• The Brett House, 1838. This house, made by Reverend Philip Brett, remained in the family until 1960, when it was given to the museum. Its outstanding architecture, garden setting, eighteenth-century silver and books, and rare Waltershausen chairs with sabre legs make this an exceptional dolls' house.
• The Goelet House, 1845. The real version of this stylized miniature brownstone stood at the corner of Nineteenth Street and Broadway. It is furnished with objects from the museum's vast collection of miniatures.
• Altadena's House, 1895. Donated by Mrs. Gardner Whitman, the house reflects two generations of dolls' house owners—Mrs. Whitman and her mother, Altadena. It looks especially festive during the Christmas holidays.
• The Stettheimer House, 1925. Carrie Stettheimer, one of three sisters, made this house, which was later donated to the museum by her sister, Ettie. The Stettheimers were friendly with avant-garde artists Marcel Duchamp, Gaston Lachaise, William Zorach, and Alexander Archipenko, who created miniature works of art for the house.
• Mr. Briggs's Dream House, 1930. A talented museum craftsman, Briggs spent his lunch hours building this Colonial Revival house for his own amusement and gave it to the museum. True to its period, the house combines Spanish Renaissance and Art Deco styles. It is a very personal dwelling. Chests of drawers hold tiny versions of Briggs's shirts and socks; his pipe tobacco is in a jar, and sketches and tools are in the attic, together with the blueprints for the house.
• Palace for Wednesday, 1981. This is a fantasy structure, rather than a dolls' house. Created by Alice Hudson from wood and twigs, its airy nooks are inhabited by fairy tale creatures, including the Swan Prince, the Babes in the Wood, Rapunzel, and others.

The Stettheimer dolls' house with Mother and Child *by William Zorach and* Female Nude *by Gaston Lachaise*

When not devoted to a particular exhibit, the display cases in the room house toy treasuries culled from the museum's six-thousand-item collection, of which one thousand are dolls. They contain such memorabilia as valentines, books, banks, tiny theaters and zoos, articulated paper dolls, trolley cars, miniature tea sets, teddy bears, puzzles, and, of course, dolls.

BENKARD MEMORIAL DRAWING ROOM

The early nineteenth-century Benkard drawing room is serene and rather simply furnished. A special treasure is the trictrac table for backgammon and checkers which bears the stamp of Charles Honoré Lannuier. A Madeira decanter and punch bowl stand ready to serve guests. Some of the furniture in this room was once thought to be by Duncan Phyfe but the pieces are now known to be late nineteenth-century objects crafted in the Phyfe manner.

The third floor also includes a changing exhibition space and the permanent portrait installation, *New York Faces 1820–1920*.

FIFTH FLOOR

Master bedroom from the residence of John D. Rockefeller, Sr.

JOHN D. ROCKEFELLER ROOMS

Here are the opulent bedroom and dressing room from the John D. Rockefeller house at 4 West Fifty-fourth Street. Echoing the work of the English architect Charles L. Eastlake, they are the epitome of ornate Victorian taste, with a stained glass arch, red damask chairs and chaise, and a fall front desk that conceals a safe. The 1860s house, which Rockefeller bought in 1884, was torn down in 1938 to make room for the garden of the Museum of Modern Art.

Other exhibitions on the fifth floor include selections from the eighteen different sets of tableware manufactured by Minton, Doulton, and others that were owned by Harry Harkness Flagler, and room settings from the William H. Vanderbilt mansion at Fifty-first Street and Fifth Avenue, as pictured in the book, *Artistic Houses*, by Earl Shinn and Edward Strathan. Vanderbilt lived in the mansion from 1879 to 1881. During 1913–14, the building was home to Henry Clay Frick, who hung his collection in the gallery pictured here.

Before leaving the fifth floor, be sure to see the two evocative Childe Hassam paintings, *Snow Storm* and *Union Square*. They hang near the ebonized boulle inlaid Steinway piano that was formerly in the Waldorf-Astoria Hotel.

NATIONAL ACADEMY OF DESIGN

1083 Fifth Avenue
New York, N.Y. 10128
212/369–4880

SUBWAY	4, 5, and 6.
BUS	M1, M2, M3, M4, and M18.
HOURS	Noon to 8 P.M. Tuesday; Noon to 5 P.M. Wednesday through Sunday. Closed Monday.
TOURS	6 P.M. Tuesday and at other times with advance reservations. Group tours available by advance arrangement with the Office of Public Affairs.
ADMISSION	$2.50, adults; $2, students and seniors; Academy Friends, free. Free to the public 5 P.M. to 8 P.M. Tuesday; free Tuesday to art students with valid identification.
HANDICAPPED FACILITIES	Accessible to the disabled.
BOOK SHOP	Art books, exhibition catalogs, posters, and notecards.
SPECIAL EVENTS	Lectures, symposia, walking tours of historic homes, afternoon teas, and musical performances.
SPECIAL FACILITIES	National Academy School of Fine Arts, art reference library, and historical archives.
MEMBERSHIP	From $50.
AUTHOR'S CHOICE	*Samuel F. B. Morse* by Launt Thompson, ground floor *Diana* by Anna Hyatt Huntington, ground floor

The National Academy of Design

The National Academy of Design occupies a unique place in the annals of American art. Founded by artists early in the nineteenth century, its handsome quarters house both an art school and an outstanding small museum that hosts a series of temporary exhibitions. Its permanent collection of American art is considered to be one of the best in the country.

HISTORY

In the first quarter of the nineteenth century, there were no schools in New York City where aspiring artists could learn their craft and few galleries where artists could exhibit their works. To remedy the situation, in November 1825, a group of thirty artists, including Samuel F. B. Morse, Asher B. Durand, and Thomas Cole, formed the New-York Drawing Association, whose chief goal was to provide a place for young artists to study. An earlier organization, the American Academy of Fine Arts, composed mainly of businessmen and art collectors, was not regularly accessible to artists. The founders of the Drawing Association wanted an organization run by artists, for artists.

Two months later, the association became the National Academy of the Arts of Design, and, in 1828—inspired by Academies of Art in London, Paris, and Rome—it incorporated as the National Academy of Design. Its mission

was to promote the arts in America by training artists, providing a place for them to exhibit and create, and serving as an honorary society. The founding members represented each of the four arts of design—painting, sculpture, architecture, and engraving. The roster included portrait painter Rembrandt Peale, architect Ithiel Town, and sculptor John Frazee, among others. Morse, the first president, was known as a leading portrait and history painter, as well as the inventor of the telegraph. He was also a prominent exponent of traditional European methods for training artists and played an important role during the academy's early years.

Originally, academy members volunteered to teach young artists, who drew from casts. During the first few years, lectures on anatomy, perspective, architecture, ancient history, and mythology were also given. In 1837, advanced male students were permitted to draw live models. Although a School of the Antique had been opened in 1831 "for a class of ladies on Tuesday, Thursday, and Saturday from 12 to 3 o'clock," not until forty years later were women permitted to enroll in a life class.

The academy supported the school by charging admission to annual exhibitions of members' works. In 1875, classes were discontinued, rather than charge tuition. At that time, Lemuel Wilmarth, the first full-time instructor, and some of his students left to form the Art Students League.

Two years later, the academy began to charge a fee for classes, but, whenever the budget permitted, tuition was waived. Through the years, the curriculum has been expanded to include other artistic disciplines in addition to painting and drawing. Sculpture classes were inaugurated in 1886, the design and modeling of coins in 1893, and etching in 1894. In 1901, a course in illustration was introduced, and mural painting was added in 1915.

Today the school's faculty includes both academy members and nonmembers. Three-year programs in painting and sculpture and two-year courses in watercolor painting and the graphic arts are offered, in addition to anatomy classes and instruction in the drawing of buildings.

Originally, the academy met in a building occupied by its predecessor, the American Academy of Fine Arts. For the next forty years, however, it was housed in a number of different locations, beginning with a room above the American Museum in the Alms House at 237 Broadway. At various times, the academy was located on Chambers Street, in the Mercantile Library at Nassau and Beekman Streets, and in the Society Library on Broadway, near Leonard Street. During the 1850s and 1860s, academy exhibitions were held at various locations on and near Broadway.

Finally, despite the Civil War and resulting economic difficulties, academy members were able to build a permanent home for the organization on Twenty-third Street and Fourth Avenue. In 1863, architect Peter Bonnet Wight designed a building with a Venetian Gothic façade inspired by the Doge's Palace in Venice. The building, demolished in 1899, was replaced by the Metropolitan Life Insurance Company building which is still standing.

A temporary building was then constructed on property owned by the academy between Hundred and Ninth Street and Cathedral Parkway. Carrère and Hastings won a design competition to replace it, but World War I intervened and the

plans were never carried out. For the next forty-two years, the academy occupied this "temporary" building.

Through the generosity of art patron and philanthropist Archer M. Huntington, the academy has been established in his former town house on Fifth Avenue at Eighty-ninth Street since 1940.

THE BUILDING

Archer M. Huntington purchased 1083 Fifth Avenue in 1902. It was one of a row of three houses, designed by the architectural firm of Turner & Killian, built on speculation by George Edgar.

In 1913, Huntington commissioned architect Ogden Codman, Jr., to redecorate the building and add a wing at 3 East Eighty-ninth Street. Codman, who had co-authored *The Decoration of Houses* with Edith Wharton, was renowned as an architect and interior designer.

Codman replaced the original brick and limestone façade with Indiana limestone. He also added fluted brackets and a wrought iron railing to the second-floor balcony in the style of eighteenth-century France.

The entrance foyer and the dramatic, sweeping staircase are good examples of Codman's work. He used black-and-white marble from Namur, Belgium, and beige marble from Ain, France, for the floor. The stairwell boasts a geometrically patterned floor of Belgian marble and the marble staircase—also from Belgium—has an elaborately designed wrought iron railing with bronze finials.

Huntington, who founded the Hispanic Society of America in 1904, gave the academy his New York town house, together with the site of the school, in 1940. This was extremely fortuitous, since the academy's Hundred and Ninth Street building had been destroyed in a fire.

THE COLLECTION

As an honorary organization, artists are required to submit a portrait of themselves for election to membership as an Associate of the National Academy (A.N.A.) and, later, a representative work of art—a "diploma" work—which, if accepted, enables them to add the coveted initials "N.A." (National Academy) after their name.

As a result of this procedure, as well as gifts and bequests, the academy has acquired an art collection that mirrors the taste of the nineteenth and twentieth centuries. Nearly two thousand paintings, more than two hundred sculptures, and approximately a thousand drawings, prints, photographs, and architectural renderings are included. Artists range from Frederic E. Church, Thomas Eakins, Winslow Homer, and John Singer Sargent to Isabel Bishop, Richard Estes, Reginald Marsh, N.C. Wyeth, Philip Pearlstein, and Raphael Soyer.

EXHIBITIONS

The academy mounts a series of temporary exhibitions each year, most of which focus on some aspect of the academic tradition.

In addition, annual exhibitions of contemporary art have been held since the academy was founded in 1825. In odd-numbered years, the works of academicians and associates of the National Academy are shown. In even-numbered years, it is an open, juried competition.

ABIGAIL ADAMS SMITH MUSEUM

421 East 61st Street
New York, N.Y. 10021
212/838–6878

SUBWAY	4, 5, 6, B, N, and R.
BUS	M15, M31, and M103.
HOURS	Noon to 4 P.M. Monday through Friday; 1 P.M. to 5 P.M. Sunday, September to May. 5:30 P.M. to 8 P.M. Tuesday in June and July. Closed in August.
TOURS	Sunday afternoons on the half hour. Groups by appointment.
ADMISSION	$2, adults; $1, senior citizens and students, children under 12, free.
MUSEUM SHOP	Books, postcards, notecards, museum tote bags, and gift items.
SPECIAL EVENTS	Lectures, concerts, walking tours, candlelight tours, and workshops for children.
SPECIAL FACILITIES	Garden and auditorium in adjacent building available for private functions.
MEMBERSHIP	From $15.
AUTHOR'S CHOICE	Eighteenth-century Chippendale desk, entrance hall *Sixtieth Street at the East River*, upper hall

Although now largely commercial, this area in the shadow of the busy Fifty-ninth Street Bridge was the site of fashionable country estates during the eighteenth century. The Federal-style structure named for the daughter of John Adams, second president of the United States, is one of only eight eighteenth-century buildings still standing in New York City. And it is the only historic house in midtown New York.

HISTORY

In London in 1786, Abigail Adams met and married Colonel William Stephens Smith, who was secretary to the American Legation while her father was serving as minister to the Court of St. James.

When they returned to America, the Smiths purchased a twenty-three-acre parcel of land on the East River, where they planned an elaborate estate with a grand frame mansion, stable, gardens, and orchards. Smith had served under George Washington during the Revolutionary War and had chosen the name Mount Vernon for his new home.

But construction had barely begun before Smith suffered financial reverses as a result of land speculation. The estate, by then cynically called "Smith's Folly," was sold to William T. Robinson, a merchant who had made his fortune in the China trade. Robinson completed the estate around 1799, named it Mount Vernon as the original owner intended, and made it a great showplace of the city. Decorative furnishings and

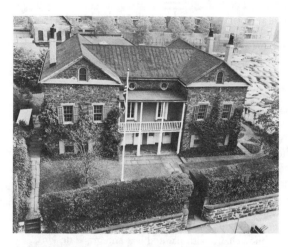

*The Abigail Adams
Smith Museum*

appointments from China displayed in the house today are not
Robinson's, but show the era's fascination with that country.
The patrician frame mansion was next converted into the
Mount Vernon Hotel and, later, a girls' school. After the
building was destroyed by fire in 1826, the property was
divided and sold.

This building, formerly a stone stable, survived. Historians
believe that the ground floor had low arched doors to the
south and housed farm animals. A ramp joined the second
floor to a stone outcropping next to the building, providing an
entry through another set of arched doors for carriages and
horses. The third floor served as a dove cote and hayloft.

The stable and several acres along the river were purchased
by Joseph Coleman Hart, Rodman Browne, and Ephras
Holmes. The building was then remodeled by Hart, who
revived the Mount Vernon Hotel from 1826 to 1833. During
this period, stable doors were bricked up and two porticoes,
six Greek Revival-style fireplaces, cornices, mantels, and a new
staircase were added, while the open area was divided into
smaller rooms.

In 1833, Jeremiah Towle, an assistant alderman, bought the
property and his descendants occupied it until 1905, when his
daughters sold the building to the Standard Gas Light
Company. The company installed huge gas storage tanks on
the grounds, and the house was badly neglected. At the same
time, the neighborhood along the river also declined, as
breweries and warehouses replaced the great estates and the
bottom of East Sixty-first Street became a dumping station for
the New York Sanitation Department.

In 1919, Jane Teller, president of the Society of American
Antiquarians, leased the building and converted it into a shop
for colonial crafts and antiques. She taught a group of
neighborhood women how to spin and weave wool in the
house. The textiles they produced were sold exclusively by the
prestigious retailer Abercrombie & Fitch.

The Colonial Dames of America purchased the property in
1924 and restored the house and garden, focusing on the
period from 1826–33 when it was a hotel. The museum
opened in 1939.

THE HOUSE
Set back from the street, the neat gray stone house with its
cream-colored shutters and door was constructed in 1799 as a

coach house. It is surrounded by well-tended lawns and an eighteenth-century-style garden with brick paths, herbs, espaliered ivy, boxwood, and seasonal plantings.

Nine Federal-period rooms and the garden are open to visitors.

MAIN FLOOR

ENTRANCE HALL

Tours begin in the entrance hall, where photographs and exhibits describe the house's history. Notice the wide arches over the doorway, which recall the building's origins as a carriage house.

Jeremiah Towle's desk, a handsome mahogany, fall-front Chippendale piece made in England in 1770, is the only object known to have been in the house originally. In this hall also are a Sheraton-style sofa dating from about 1820–25 and four Sheraton fancy chairs with painted leaf and grape designs.

MUSIC ROOM

Corn-and-wheat-patterned wallpaper, made in France for the American market, forms the backdrop for the music room. You can imagine guests seated on the graceful sleigh-shaped Récamier sofa while enjoying a concert on the harp and pianoforte that were imported from England. Among the other pieces in this room are a handsome Sheraton secretary, made in Boston or Portsmouth, New Hampshire, around 1810, which is characteristic of the Federal period. The Aubusson carpet is one of three Aubussons in the house.

DINING ROOM

The American-made table is surrounded by six decorative fancy chairs and is perpetually set for the fruit course with Swansea fruit-decorated earthenware dishes. The wine glasses are tipped into glass rinsing bowls. In those days, most glasses were imported and were, therefore, expensive. So, when guests were offered more than one wine, they rinsed their glasses between courses, instead of replacing them.

Three paintings of major Chinese ports, executed by Chinese artists in the European style, decorate the walls. Scenic works of this type were created for export and were widely used to show scenes, much as photographs do today.

A mirror with gold wire work in classical Hepplewhite style hangs above the fireplace. The pint-size Zanzibar chairs near the fireplace became children's high chairs when placed on blocks, which are now missing. The room also has reversible, mosaic-patterned Scottish ingrained carpeting; it is a reproduction, based on an original fragment which is in the collection of the Metropolitan Museum of Art.

KITCHEN

Adjoining the entrance hall, this cozy room is dominated by a fireplace hung with various long-handled cooking implements and kettles to hold green turtle soup, among many other colonial favorites. Nearby are an unusual reflector oven, an 1826 rotisserie, and a metal rack for toasting bread.

Blue-and-white dishes from Canton and Nanking line the shelves of an adjacent cabinet. The kitchen table topped with bowls and baskets converts into a chair which, clever as it may seem today, was considered commonplace in an earlier period.

A view of the garden

Windsor chairs, another kitchen staple, are seen here. The shelves of the wooden hutch, stained with oxblood and buttermilk, display speckled stoneware bowls, among other traditional kitchen vessels. Near the door, the pie safe with perforated tin doors was used for storage.

UPPER HALL

The staircase opens on to the upper hall, a spacious area with long windows overlooking the neatly trimmed front lawn. Here is a splendid Empire settee with claw feet in the neoclassical style, which may have been made by New York cabinetmaker Duncan Phyfe. It is covered with gold medallion-patterned blue satin. Nearby is a pair of serving tables with lion head drawer pulls and gilt bronze hairy claw feet. An 1846 posthumous portrait of George Washington graces the east wall, and the beige, rust, and green Brussels carpet, based on an English design, incorporates colors that were popular in the early days of the republic. The amber-colored glass lantern, which would have cast a soft candlelight, dates from the early nineteenth century.

An 1850 painting over the settee recalls the area's pastoral days, with sailboats on the nearby East River, a dock, and other houses, including one of the country mansions owned by the Beekman family.

SOUTH PARLOR

In the elegant but homey upstairs parlor, the era's interest in oriental furnishings is seen once more in the lacquered desk lavishly covered with gold landscapes, made in China for export; the tall English case clock with japanned designs, and the Chinese tea set once owned by Abigail Smith's mother.

Notice the shield near the candlesticks on the small table. Called a "pox screen," it was designed to protect a lady's face from the heat of nearby candles. (Eighteenth-century ladies wore make-up—which had a wax base—to hide their smallpox scars.)

An 1810 sewing table with its raspberry silk compartment for needles, threads, and other necessities stands in front of the window.

GAME ROOM

Portraits of Smith and his wife, Abigail, gaze down on New York card tables set with wine decanters, board games, and clay pipes nearby. While the scene seems set for men only, games of this type were also enjoyed by women. Of note in this room are the painted fancy chairs (1810) and the French mantel clock (1800) flanked by rare cut-glass Argand lamps which, fueled by whale oil, glowed brighter than electric lights. (Electricity did not enter most homes until the end of the nineteenth century.) Overhead, the six-branch chandelier (1840)—then candlelit—could have been made either in Europe or the United States.

New York cabinetmaker Michael Allison made the mahogany chest of drawers with an eagle inlaid in satinwood and eagle-decorated brass pulls.

LIBRARY

This Colonial Revival room, built in 1924 as the Colonial Dames of America's Board Room, is a rich repository of

historic documents and artifacts. The paneling dates from the 1920s and 1930s but most of the furniture is eighteenth-century Queen Anne style. One chair in the corner is a particularly fine Philadelphia example of this design.

On the walls are historic Smith and Adams documents. In enclosed cabinets are memorabilia of the period, including a set of Chinese export porcelain. The Eli Terry pillar-and-scroll mantel clock was made in Connecticut in the 1820s and boasts a unique wooden mechanism that enabled it to run for eight days.

BEDROOM

Because this room has no fireplace, it may have been a bedroom originally. A white-on-white embroidered spread tops a bed which is a period reproduction. An English corner washstand and a wing back chair stand nearby. A gown that belonged to Abigail Adams Smith can be seen in an open drawer of an antique English wardrobe. A baby's cradle, a toy cradle, and other children's toys stand on the floor, as if awaiting a young visitor.

WHITNEY MUSEUM OF AMERICAN ART

945 Madison Avenue at 75th Street
New York, N.Y. 10021
212/570–3600

SUBWAY	6.
BUS	M4.
HOURS	1 to 8 P.M. Tuesday; 11 A.M. to 5 P.M. Wednesday through Saturday; Noon to 6 P.M. Sunday. Closed Monday.
TOURS	2 P.M. and 3:30 P.M. Saturday and Sunday.
ADMISSION	Adults, $5; senior citizens 62 and over, $3; children under 12, high school and college students with valid I.D., and members, free.
HANDICAPPED FACILITIES	Accessible to the disabled.
FOOD SERVICE	Café on lower level.
SALES DESK AND STORE	Books, posters, notecards, household objects, and jewelry available next door.
SPECIAL EVENTS	Films and lectures. Monthly schedule available at information desk in lobby.
MEMBERSHIP	From $50.
AUTHOR'S CHOICE	*Circus* by Alexander Calder, first floor *Early Sunday Morning* by Edward Hopper, third floor *Three Flags* by Jasper Johns, third floor

BRANCHES OF THE MUSEUM AT THE FOLLOWING LOCATIONS:
Federal Reserve Plaza
33 Maiden Lane at Nassau Street
212/943–5655

HOURS	11 A.M. to 6 P.M. Monday through Friday.
TOURS	12:30 P.M. Monday, Wednesday, and Friday
ADMISSION	Free. Accessible to the disabled. Temporary exhibitions of American art.

Equitable Center
787 Seventh Avenue between 51st and 52nd Street
212/554–1113

HOURS	11 A.M. to 6 P.M. Monday through Friday; 11 A.M. to 7:30 P.M. Thursday; Noon to 5 P.M. Saturday.
TOURS	12:30 P.M. Monday through Friday.
ADMISSION	Free. Accessible to the disabled. Two galleries: one for works from the permanent collection and the other for temporary exhibitions.

Philip Morris Building
120 Park Avenue at 42nd Street
212/878–2550

HOURS 11 A.M. to 6 P.M. Monday through Saturday; 11 A.M. to 7:30
 P.M. Thursday.

TOURS 12:30 P.M. Monday, Wednesday, and Friday.

ADMISSION Free.
 Accessible to the disabled.
 Sculpture court with works of art in a garden setting and an
 adjacent gallery for temporary exhibitions.

*The Whitney Museum
of American Art*

The Whitney Museum of American Art, founded in 1930 by
Gertrude Vanderbilt Whitney, has pioneered in showing the
works of living American artists. It is an impressive showcase
for American art of the twentieth century.

Three Whitney branches in Manhattan and a fourth in
Stamford, Connecticut, bring art to a broad audience.

HISTORY

Gertrude Vanderbilt Whitney, the granddaughter of Cornelius
Vanderbilt and the wife of Harry Payne Whitney, was a
sculptor and art collector. In 1907, she had a studio in
Greenwich Village, then a center for avant-garde artists. In
1914–15, Mrs. Whitney and her close associate, Juliana Force,
operated art galleries in the Village where they showed the
works of fledgling American artists.

For ten years, from 1918 to 1928, they promoted new
artists through the Whitney Studio Club, which functioned
also as a social meeting place for artists. Edward Hopper began
his long association with the Whitney by staging his first one-
man show at the Studio Club.

Club members met regularly and campaigned vigorously
and successfully for the purchase of living American artists'
works. By the mid-twenties, the group had become highly
influential in gaining acceptance for contemporary American
artists. The club's importance grew through annual exhibits
circulated to museums throughout the country.

The Studio Club was replaced by the Whitney Studio
Galleries, which flourished until 1930. Some of the nation's
leading artists, such as George Bellows, Stuart Davis, Edward
Hopper, Walt Kuhn, Reginald Marsh, and Charles Demuth
were featured in Whitney Studio Galleries exhibitions. Mrs.
Whitney bought objects from nearly every exhibition. When
the Metropolitan Museum of Art declined her offer of the
Whitney collection, she decided to establish her own museum.

With Mrs. Whitney's donation of six hundred works of art
from her own collection as its nucleus, the Whitney Museum
of American Art opened at 10 West Eighth Street in
November 1931. The museum was housed in three
brownstone buildings remodeled by the architectural firm of
Noel and Miller. In 1954, the museum moved to a building
designed by Auguste L. Noel on West Fifty-fourth Street on
land donated by the trustees of the Museum of Modern Art.

As the collection grew, more space was required, and, in
1966, the museum moved to its present location in a
distinctive Marcel Breuer-designed building on Madison
Avenue at Seventy-fifth Street.

Before her death in 1942, Mrs. Whitney established certain policies which are still followed: to mount exhibitions frequently, to acquire works by living artists for the permanent collection, and to publish books and other educational materials devoted to American art.

Approximately fifteen exhibitions are on the Whitney schedule each year, including some that travel to other institutions. Film and video programs have been featured since 1970.

The museum remains dedicated to twentieth-century American painting, sculpture, and graphic arts. So rigid was this commitment that, in 1949, all works created before 1900 were sold. This policy remained in effect until 1966. In recent years, the museum has continued to acquire works by contemporary artists, as well as quality works by major artists historically associated with the Whitney Museum.

Since 1932, the Whitney has sponsored a series of invitational exhibitions of works by living American artists. Although no awards or prizes are given at the Whitney Biennials, the museum often buys works of art from the exhibitions for the permanent collection.

In 1973, the museum opened its first branch downtown in the financial district at 55 Water Street. The downtown branch moved in 1988 to Federal Reserve Plaza. Since then, branches have opened at the Philip Morris Building and the Equitable Center in New York City, as well as at One Champion Plaza in Stamford, Connecticut.

THE BUILDING

Internationally renowned architect Marcel Breuer and Hamilton Smith designed the Whitney Museum, with Michael Irving as consulting architect. The three-story gray granite structure resembles an abstract fortress, with an entrance ramp above a sunken sculpture garden. The naturalism of the exterior continues indoors with stone floors, terrazzo stairs, polished granite counters, teak banisters, and brush-hammered concrete walls.

Highlights of the permanent collection can be seen on the first and third floors. Temporary exhibits are mounted on the second and fourth floors. The sculpture garden adjoins the restaurant on the lower level.

A new wing, designed by architect Michael Graves, is planned to provide expanded exhibition, office, and library facilities.

THE COLLECTION

The museum owns approximately 8,500 paintings, drawings, prints, and sculptures, making this the world's most comprehensive collection of twentieth-century American art.

Gertrude Whitney's friends included the anti-establishment members of The Eight or Ash Can School, so artists from that group, such as William J. Glackens, Robert Henri, and John Sloan, are well represented. The museum's holdings include a hundred and thirty-one etchings and twelve paintings by Sloan. Of this number, a hundred and five were in the original Whitney donation. In 1970, Edward Hopper's widow bequeathed Hopper's entire artistic estate to the museum. The gift of approximately two thousand oils, watercolors, drawings, and prints covers the period from Hopper's student days to his

later years, and is the largest donation ever received by the museum.

A 1979 bequest by Reginald Marsh's widow of more than eight hundred and fifty paintings, oil studies, drawings, and sketches made the museum the owner of the most significant collection of Marsh's work in the world.

Among the Whitney's five oils by Robert Henri, leader of the Eight, is a portrait of Gertrude Vanderbilt Whitney that she commissioned in 1916.

The roster of artists whose works are in the permanent collection reads like a history of twentieth-century American art: Thomas Hart Benton, Ben Shahn, Yasuo Kuniyoshi, William Gropper, and Arshile Gorky. There are modernists Georgia O'Keeffe and Arthur G. Dove; cubist painters Marsden Hartley, Max Weber, and John Marin; precisionists Charles Sheeler, Charles Demuth, and Ralston Crawford, and synchromists Stanton McDonald Wright and Morgan Russell.

In the extensive Abstract Expressionist collection are works by Willem de Kooning, Jackson Pollock, Mark Rothko, and Barnett Newman, as well as a number of paintings by Adolph Gottlieb and Ad Reinhardt. Franz Kline, Jack Tworkov, Theodoros Stamos, and others are here, as are the next wave of Abstract Expressionists, such as Helen Frankenthaler and Joan Mitchell.

Abstract works from the sixties and seventies by such familiar names as Richard Diebenkorn, Larry Poons, and Jules Olitski are in the museum's collection, as are works by Ellsworth Kelly, Frank Stella, Robert Rauschenberg, and Jasper Johns.

Pop Art painters Rube Goldberg, Larry Rivers, and Andy Warhol, and modern realists Will Barnet, Jack Beal, Alex Katz, and Alice Neal are also represented.

In addition, the museum's holdings include works by artists who are associated with other careers. There are sketches by poet e.e. cummings, an oil painting by photographer Edward Steichen, and works by art dealer Betty Parsons.

The sculpture collection ranges from works by Gaston Lachaise and Elie Nadleman to George Segal and Richard Serra. Artists represented include Louise Nevelson, David Smith, Isamu Noguchi, and Alexander Calder. Five sculptures by Gertrude Vanderbilt Whitney are also here.

GROUND FLOOR

THE GALLERIES

One of the museum's best known works, Alexander Calder's *Circus*, can be seen on the ground floor. The creator of the mobile and the stabile, Calder began this miniature circus in Paris during the 1920s. Like many artists of the period, he was fascinated by the circus and spent many years creating this intricate assemblage of wire, cloth, cork, wood, and paint. The suspense, surprise, spontaneity, and humor of the circus were important elements in all of Calder's work. A video, presented several times a day, supplements the exhibit.

Calder placed *Circus* on deposit at the museum in 1970, and it was purchased from the artist's estate in 1982 for $1.25 million.

A small gallery to the left primarily showcases new artists.

THIRD FLOOR

Approximately seventy paintings and sculptures from the permanent collection are displayed on the third floor. The

works are presented both chronologically and by style to give an overview of the range of styles and developments in American art during the twentieth century.

Three Flags by Jasper Johns, 1958; collection of Whitney Museum of American Art

Among the art works to be seen here are Charles Demuth's *My Egypt*; Georgia O'Keeffe's *Flower Abstraction*, a fiftieth anniversary gift to the museum, and Edward Hopper's *Early Sunday Morning*. The latter was the first work by Hopper to enter the permanent collection.

Don't miss Arshile Gorky's *The Artist and His Mother*. Nearby are Jackson Pollock's 1950 painting, *Number 27*, Willem de Kooning's *Woman and Bicycle*, painted in 1952–53, and his *Door to the River*, a 1960 abstract landscape.

One of the museum's best known works is *Three Flags* by Jasper Johns, in which three American flags of different sizes are placed on top of each other. The artist used encaustic on canvas to create this powerful image in 1958. It was a fiftieth anniversary gift to the museum twenty-two years later.

More recent works include Andy Warhol's silkscreen on canvas, *Ethel Scull, 36 Times*, Ellsworth Kelly's *Green, Blue, Red*, and Richard Diebenkorn's 1980 oil painting, *Ocean Park #125*.

Sculpture on view includes David Smith's stainless steel *Lectern Sentinel*, Louise Nevelson's *Black Cord* (the Whitney owns sixteen works by Nevelson), and George Segal's plaster of Paris pedestrians in *Walk Don't Walk*.

UPPER WEST SIDE

AMERICAN MUSEUM OF NATURAL HISTORY

Central Park West at 79th Street
New York, N.Y. 10024
212/769–5000
212/769–5100 recorded information
212/769–5650 Naturemax Theater
212/769–5920 Planetarium Sky Shows
212/769–5921 Laser Shows

SUBWAY 1, B, C, and K.

BUS M7, M10, M11, and M79

HOURS 10 A.M. to 5:45 P.M. Monday, Tuesday, Thursday, and Sunday; 10 A.M. to 9 P.M. Wednesday, Friday, and Saturday. *Planetarium showtimes* October through June: 1:30 P.M. and 3:30 P.M. Monday through Friday; 11 A.M., 1 P.M., 2:15 P.M., 3:30 P.M., and 4:45 P.M. Saturday; 1 P.M., 2:15 P.M., 3:30 P.M., and 4:45 P.M. Sunday. July through September: 1:30 P.M., 2:30 P.M., and 3:30 P.M. Monday through Friday; 1 P.M., 2 P.M., 3 P.M., and 4 P.M. Saturday and Sunday. Special holiday schedules. Closed Thanksgiving and Christmas.

TOURS From 10:30 A.M. to 3:30 P.M. daily. Check at first floor information desk for schedule.

ADMISSION Pay as you wish. Suggested contribution $5, adults; $2.50, children. Planetarium: $4, adults (13 and older); $3, students and senior citizens with I.D., and museum members (participating and higher); $2, children ages 2 through 12.

HANDICAPPED FACILITIES. Wheelchairs available. Accessible to the disabled.

FOOD SERVICE American Museum Restaurant and Food Express on lower level.

MUSEUM SHOPS Books, posters, notecards, jewelry, reproductions, educational toys, mineral specimens, dinosaurs, and T-shirts. Junior shop on lower level.
Planetarium shop: books, postcards, posters, astronaut ice cream, space-related games, prisms, holograms, and T-shirts.

SPECIAL EVENTS Lectures, films, concerts, and dance performances. Call 212/769–5606 and 212/769–5315 for information.

SPECIAL FACILITIES Naturemax Theater, Discovery Room, and Natural Science Center.

MEMBERSHIP From $22.

AUTHOR'S CHOICE Halls of Meteorites, Minerals, and Gems, first floor
Hall of African Mammals, second floor
Halls of Early and Late Dinosaurs, fourth floor

This is the largest museum in the world and, as such, may seem a bit overwhelming at first. More than thirty-six million

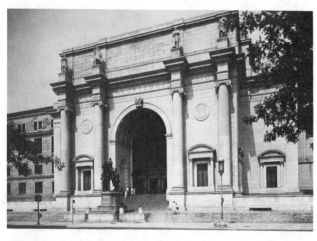

The American Museum of Natural History

artifacts and specimens—not all of which are on view—are housed in twenty-two interconnected buildings, comprising 1.5 million square feet. The gem collection is outstanding. And there are more dinosaurs, fossil mammals, birds, spiders, and whale skeletons here than in any other museum.

The collections are displayed on four floors. Dinosaurs, meteorites, minerals, and gems are the most popular permanent exhibits. Museum entrances are located on Central Park West and West Seventy-seventh Street. The Naturemax Theater ticket desk is on the first floor in the Seventy-seventh Street foyer.

The entrance to the American Museum-Hayden Planetarium is on West Eighty-first Street.

HISTORY

During the nineteenth century, interest in the natural sciences was widespread. In the early 1800s, for example, the natural history collections of the New-York Historical Society grew so large that they virtually overshadowed the society's historical collections. In many middle- and upper-class homes, collections of minerals, seashells, and fossils were displayed alongside paintings and prints.

Aware of the public's curiosity about natural science, Albert S. Bickmore, a professor of zoology and geology at Madison (now Colgate) University in Hamilton, New York, conceived the idea of a museum that would advance the study and teaching of the natural sciences and anthropology. With the support of many prominent New Yorkers, he founded the American Museum of Natural History in 1869 as an independent corporation governed by a board of trustees.

The following year, the museum moved into its first permanent home, a building known as the Arsenal in Central Park. It soon became apparent, however, that a larger building would be needed, and the City of New York appropriated $700,000 for construction in 1871. Calvert Vaux, one of the designers of Central Park, designed the first section of the present museum building on a swampy tract of farmland, inhabited by herds of goats.

President Ulysses S. Grant laid the cornerstone in 1874, and the first section, which now houses Gallery 77 and exhibitions devoted to Northwest Coast Indians, opened three years later. At that time, the scientific staff consisted of just two people, Bickmore and his assistant. Today, it numbers

approximately two hundred scientists and their assistants, and includes nine departments ranging from anthropology to vertebrate paleontology.

Between 1887 and 1905, the city provided funding for eight more sections of the building. Additional appropriations were received during the 1920s for the African Wing and the Whitney Wing, as well as the block-long Romanesque Revival building on Seventy-seventh Street. The American Museum-Hayden Planetarium opened in 1935, and the Theodore Roosevelt Memorial was dedicated the following year.

Throughout the years, research has played an important role. The museum has sponsored more than a thousand expeditions, including trips to the Congo, the South Seas, and Central Asia. More recently, field stations have been established in Lake Placid, Florida; St. Catherines Island, Georgia; Portal, Arizona, and Great Gull Island, New York.

The museum publishes *Natural History* magazine, which was founded in 1899 as the American Museum Journal.

FIRST FLOOR

THEODORE ROOSEVELT MEMORIAL
The recently restored Theodore Roosevelt Memorial Wing pays homage to the twenty-sixth U.S. President, who was an explorer and conservationist, as well as a politician. In the impressive, high-ceilinged rotunda, some of his thoughts about nature, youth, manhood, and the state are inscribed on the walls. A skeleton of *Barosaurus*, one of the largest dinosaurs known to have existed, dominates the center of the rotunda.

A bronze equestrian statue of Roosevelt by James Earle Fraser stands outside the Central Park West entrance.

THE BIOLOGY OF INVERTEBRATES
With a giant squid hanging from the ceiling, exhibits depict modern invertebrates and fishes. To demonstrate the structure and classification of species, one of the cases contains models of microscopic organisms and other invertebrates crafted from hand-blown colored glass by the late master-craftsman Hermann O. Mueller. These replicas are enlarged up to a thousand times.

Other displays are devoted to fire beetles and marine specimens, such as horseshoe crabs.

Blue whale, Hall of Ocean Life

OCEAN LIFE AND THE BIOLOGY OF FISHES
The focal point here is a ninety-four-foot model of a blue whale, suspended from the ceiling. Another feature is the spectacular Bahamian Coral Reef Group diorama. The forty-ton coral formation was found at the bottom of the ocean in the Bahamas. It was shipped to the museum, and the exhibit was carefully reconstructed around it during a twelve-year period.

DISCOVERY ROOM
In the Discovery Room, children aged five and older are encouraged to learn about natural science and anthropology through "discovery boxes" and touchable specimens that stimulate the imagination. The Discovery Room is open from Noon to 4:30 P.M. Saturday and Sunday, and is closed most holidays.

NORTH AMERICAN FORESTS

Dioramas of forests from twelve states include life-size replicas of plant, bird, insect, and animal life, including sections from a 4,500-year-old bristlecone pine and a giant sequoia.

AGRICULTURE

The relationship of plant and animal life to geology and soil is depicted here. By showing a cross-section of the soil, one of the most interesting exhibits reveals the variety of animals and insects that are able to live underground, including chipmunks, moles, ants, and yellow jackets.

SEVENTY-SEVENTH STREET FOYER

As you pass through the foyer, you can't miss the realistic, life-size figures paddling a Haida canoe near the entrance. This eight-foot-wide, ocean-going craft, made from the trunk of a cedar tree, can hold more than thirty people. The Haida Indians in the Queen Charlotte Islands used the canoe for ceremonial visits and to transport war parties before the museum purchased it in 1883.

MOLLUSKS AND OUR WORLD

In 1874, just five years after the museum was founded, a collection of approximately fifty thousand shells was acquired. This marked the beginning of the museum's interest in malacology, the scientific study of shells, and formed the core of its holdings, which now number over two million specimens.

In the Hall of Mollusks and Our World, you can see the importance of shells in clothing, decoration, food, medicines, and jewelry. Don't miss the wall-size photograph of the interior of the Shell House in Goodwood, Chichester, England, built in the 1740s. Elaborate shell decorations such as these were popular during the eighteenth century.

HUMAN BIOLOGY AND EVOLUTION

The relationship of humans with other organisms, the transmission of hereditary information, and facts about human anatomy are explored in this hall, which is scheduled to open in late 1992. Highlights include a five-foot-long hologram of a DNA molecule and a computerized "tour" of the human body.

In one of several dioramas, visitors will be able to see a reconstructed, fifteen-thousand-year-old hut made from the bones of a wooly mammoth. The original hut, excavated in the Ukraine in the early 1980s, incorporated the remains of ninety-five mammoths and is the earliest known example of true architecture. Experts estimate that it took ten people five days to build the original structure.

As proof of the unusual creativity that marked the arrival of modern man in Europe near the end of the Ice Age, the exhibit also includes reproductions of prehistoric works of art. You can see replicas of the fourteen-thousand-year-old decorated ceiling of the cave of Altamira in northern Spain, and an animal frieze from the cave of Lascaux in France.

METEORITES

The thirty-four ton Ahnighito, the largest meteorite ever retrieved from the surface of the earth, is the focal point of

the Arthur Ross Hall of Meteorites, which opened in 1981. Ahnighito was found by Admiral Robert E. Peary, with the help of an Eskimo guide, in 1894 near Cape York, Greenland. Peary spent four Arctic summers—several weeks in August—digging it out of the frozen ground. The massive chunk of iron and nickel was loaded aboard ship and carried to New York in 1897. The meteorite remained in the Brooklyn Naval Ship Yard until 1906, when the museum purchased it for $40,000, and sent it up the East River on a barge. A team of thirty horses then carried it to the museum.

Three moon rocks are also exhibited here.

MINERALS AND GEMS

"Star of India,"
Morgan Hall of Gems

Among the spectacular objects artfully displayed in the Morgan Memorial Hall of Gems are the five-hundred-and-sixty-three-carat Star of India Sapphire, found in Sri Lanka and donated by J.P. Morgan in 1901; the hundred-and-three-tenths-carat DeLong Star Ruby from Burma; the Schettler Emerald, which weighs eighty-seven-and-six-tenths carats, and the Patricia Emerald, at sixty-three-and-two-tenths carats considered to be the finest emerald crystal in the world.

Approximately a hundred and twenty-five thousand rocks, minerals, gems, and meteorites are included in the museum's collections.

NORTHWEST COAST INDIANS AND ESKIMOS

Exhibits depict Northwest Coast Indians, and Eskimos, who came to North America across the land bridge between Siberia and Alaska about twenty thousand years ago. Displays include the tools, clothing, weapons, and household goods they used in adapting to environments that ranged from plains and forests to the arctic.

NORTH AMERICAN MAMMALS

The specimens for this hall were found on more than twenty-five museum-sponsored expeditions. Realistic dioramas show jaguars, bighorn sheep, bears, mountain lions, and bison, as well as other North American mammals, in their native habitats.

Exhibits in an adjoining hall feature such small mammals as the rare black-footed ferret, a weasel, a marten, a badger, a nine-banded armadillo, a kit fox, and a flying squirrel.

BIOLOGY OF BIRDS

The museum owns a million specimens of birds, representing ninety-six percent of all known species, the largest collection in existence. They are housed in their own eight-story wing, a joint gift of Harry Payne Whitney and the City of New York, which opened in 1933.

The Hall of the Biology of Birds traces the hundred-and-fifty-million-year development of birds from the early *Archaeopteryx* to the nine thousand species known today. Exhibits show the similarity in appearance and behavior among various species, including starlings and birds of paradise, and gulls, puffins, and plovers.

SECOND FLOOR

AFRICAN PEOPLES

On the continent of Africa the environment ranges from deserts to tropical rain forests and woodlands, grasslands, and

fertile river valleys. Exhibits depict the diversity of the continent and its inhabitants.

Highlights include a display of masks, and a case filled with delicately wrought Ashanti brass weights, created by the "lost wax" casting process and used for weighing gold.

Elephants, Akeley Hall of African Mammals

AFRICAN MAMMALS

The highlight of the Akeley Memorial Hall of African Mammals is a stunning group of elephants, realistically mounted by Carl Akeley. Using artists' sketches and photographs to re-create authentic habitats, Akeley planned, designed, and collected for this hall.

A museum sculptor who revolutionized the art of taxidermy, Akeley devised a technique that produced extremely realistic mounted animals. First, he reinforced an animal's skeleton with wood and wire. Clay was then placed over the framework, and the veins, tendons, muscles, and flesh were sculpted. After a plaster cast was made of the clay figure, and a hollow mannequin was cast from the mold, the animal's original skin was fitted over the maninequin. The elephants seen here look so real that you can almost hear them trumpeting in alarm.

Among the other African animals depicted in their natural settings are giraffes, lions, gorillas, and zebras. Exhibits continue on the third floor.

ASIATIC MAMMALS

In the Vernay-Faunthrope Hall of South Asiatic Mammals, you can see exhibits featuring some of the area's most threatened species, such as the tiger, the Asiatic lion and leopard, and the rhinoceros of India and Sumatra.

ASIAN PEOPLES

The Gardner D. Stout Hall of Asian Peoples contains about five percent of the museum's sixty thousand Asian artifacts. Clothing, rugs, furniture, paintings, musical instruments, and beautiful carvings reveal the cultures of Tibet, Japan, China, India, Arabia, and central Asia.

Especially noteworthy are several displays featuring miniature models of important trading cities of the past, including Ur in the late third millennium B.C.; Alexandria in the first century A.D.; Isfahan in the seventeenth century; late fifteenth-century Peking, and late eighteenth-century Calcutta.

BIRDS OF THE WORLD
Some of the birds that are indigenous to various parts of the world, including the high Andes of Chile, the plains of Kenya, and the Swiss Alps, can be seen here. As in other bird exhibits in the museum, the diversity of species is striking.

MEXICO AND CENTRAL AMERICA
The Hall of Mexico and Central America is devoted to the great accomplishments of the Olmec, Toltec, Aztec, and Maya peoples. A focal point of the hall is the twenty-ton Aztec Stone of the Sun, with its intricately carved symbols. Olmec jade carvings, Toltec ceramics, and gold objects from Mexico and Costa Rica, crafted thousands of years ago, are highlights among the many beautiful artifacts on view.

SOUTH AMERICAN PEOPLES
Exhibits focus on the way of life of Indians of the Amazon Basin, showing their arts and crafts, social life, warfare, and religious ceremonies.

Other displays are devoted to the Inca and pre-Inca cultures of Peru. Don't miss the Copper Man, an Indian killed in a copper mine about 800 A.D., whose body was preserved naturally by copper salts. In 1899, discovery of the body led to a dispute between the American owner of the mine and the Frenchman who was renting it. The Frenchman, claiming the mummy assayed at nearly one percent copper, said it belonged to him. The American asserted that he had rented the mine, not the miners. The two finally reached an agreement, and J.P. Morgan eventually acquired the mummy for the museum.

PEOPLE CENTER
An educational center for multi-cultural performances, the People Center is open Saturday and Sunday afternoons from 1 P.M. to 4:30 P.M. from October through June. It is closed most holidays. Performances are designed to appeal to all ages.

NATURAL SCIENCE CENTER
Designed especially for children, the Natural Science Center is open from 2 P.M. to 4:30 P.M. Tuesday through Friday, and from 1 P.M. to 4:30 P.M. Sunday. It is closed most holidays.

THIRD FLOOR

NORTH AMERICAN BIRDS
When the Hall of North American Birds opened in 1912, it marked the first time that dioramas filled an entire hall. Frank M. Chapman, the first head of the museum's ornithology department and the author of the *Handbook of Birds of Eastern North America*, collected most of the materials and designed the hall. It was refurbished and reopened in 1964, on the hundredth anniversary of Chapman's birth.

Birds exhibited here include wood storks, terns, geese, pelicans, and the wild turkey, which Benjamin Franklin believed should be America's national bird, instead of the bald eagle.

REPTILES AND AMPHIBIANS
Opened in 1977, this hall shows the habits and behavior of reptiles and amphibians, realistically displayed in their native habitats. Highlights include an exhibit about snake bite and its treatment, and a group of ten-foot Komodo dragons that were

collected in Indonesia during one of the museum's expeditions in the 1920s.

A giant Galápagos turtle guards the entrance to this hall, while a twelve-foot alligator and a crocodile of similar size stand near the exit.

PRIMATES

Primates, a subdivision of mammals, includes monkeys and apes, as well as humans. Exhibits are devoted to various species of monkeys, apes, chimpanzees, and gorillas.

EASTERN WOODLANDS AND PLAINS INDIANS

Indians settled in the woodlands east of the Mississippi River about twelve thousand years ago. You can see the fluted stone spearpoints these Paleo-Indians used to hunt the woolly mammoth, mastodon, and big-horned bison. The Archaic Indians and Burial Mound People who came later hunted with bows and arrows, fished with spears and nets, and grew maize, squash, and tobacco, among other crops.

Don't miss the display featuring models of houses used by various tribes. Interesting similarities, as well as differences, are revealed in a nineteenth-century Seminole house; a Creek Council house; an Iroquois long house; a Natchez Indian house, and an Ojibwa dome-shaped wigwam.

PACIFIC PEOPLES

Noted anthropologist Margaret Mead spent fifty-three years at the museum and collected many of the artifacts exhibited in this hall dedicated to her. The cultures of Polynesia, Micronesia, Melanesia, Australia, and Indonesia are represented. Highlights of the exhibit include the façade of a Maori storehouse from New Zealand, and a reproduction of a stone head from Easter Island.

Portions of this floor may be closed at times during renovation.

FOURTH FLOOR

EARLY DINOSAURS

Three 170-million-year-old skeletons—the plant-eating *Apatosaurus* (formerly called *Brontosaurus*), the plated *Stegosaurus*, and the meat-eating *Allosaurus*—are the main attraction here.

FOSSIL FISHES

The museum's collection and study of fossils began during the administration of Henry Fairfield Osborn, its fourth president, in the first quarter of this century. Holdings now include 330,000 vertebrate fossils, which are shown in four exhibition halls, and are stored and studied in an adjacent ten-story building. The specimens were found in all parts of the world, but the majority came from the western United States and Canada.

LATE DINOSAURS

Three late Cretaceous dinosaurs are featured. They include *Tyrannosaurus rex*, the largest carnivorous animal that ever lived on land; *Triceratops*, an enormous horned dinosaur, and a pair of trachodonts, duck-billed, herbivorous dinosaurs. There are also armored dinosaurs, horned dinosaurs, and aquatic dinosaurs. Scientists hold different theories as to the reason these creatures became extinct at the end of the Cretaceous period.

EARLY MAMMALS

Mammals succeeded dinosaurs on earth, and exhibits trace their development from small animals, similar to opossums, to wolflike, hoofed creatures.

LATE MAMMALS

Here, in the final hall devoted to fossils, you can see four huge skeletons of mounted mastodons and mammoths. One of the most fascinating displays traces the development of the horse from the early *Eohippus* (now known as *Hyracotherium*) to *Equus*, the modern horse, ass, and zebra. Early rhinoceroses, camels, wolves, and saber-toothed cats are also on view.

AMERICAN MUSEUM–
HAYDEN PLANETARIUM

The Hayden Planetarium, which opened in 1935, is noted for its presentations on astronomy and space science.

FIRST FLOOR

A moving, forty-eight-foot model of the solar system is suspended from the ceiling, and an Aztec calendar is mounted at the center of the Guggenheim Space Theater. There are also audiovisual presentations on the planets and space explorations. Comets, star clusters, and a moon landscape are among the wonders to be seen in the nearby Astronomical Black Light Gallery.

Also on this floor is the fourteen-ton Willamette meteorite, the largest such object ever found in the United States.

SECOND FLOOR

Spectacular images from a Zeiss VI star machine are projected onto the dome of the Sky Theater in forty-five minute shows that reveal the night sky, alien worlds, and exploding stars. The perforated, white, stainless steel dome soars forty-eight feet above the floor of the theater, and measures seventy-five feet in diameter.

The Billy Rose Hall of the Sun contains one of the largest exhibits in the world devoted to the sun. Displays center around the sun as a star, its place in the universe, and its influence on human beings.

Astronomia, the planetarium's IBM wing, focuses on astronomical lore from the medieval era to the present time. Other exhibits explain how distances to the stars are measured, and how a planet's distance affects its motion around the sun.

Don't miss the wall of scales where you can find out how much you would weigh on the moon, Venus, Mars, Jupiter, and the sun.

CHILDREN'S MUSEUM OF MANHATTAN

**212 West 83rd Street
New York, N.Y. 10024
212/721–1221**

SUBWAY	1, C, E, and K.
BUS	M10, M11, M27, M28, and M104.
HOURS	2 P.M. to 5 P.M. Tuesday through Friday; 10 A.M. to 5 P.M. Saturday and Sunday. Closed Monday, Thanksgiving, Christmas, and New Year's Day.
ADMISSION	$4, children and adults.
HANDICAPPED FACILITIES	Accessible to the disabled.
MUSEUM SHOP	Books, games, art supplies, cross-cultural toys and objects.
SPECIAL EVENTS	Weekend and holiday performances of children's theater, music, dance, and storytelling.
SPECIAL FACILITIES	Two hundred-seat theater.
MEMBERSHIP	From $40 for families.
AUTHOR'S CHOICE	Magical Patterns Warner Communications Center

The Children's Museum of Manhattan

The Children's Museum of Manhattan is a "participatory" museum where children can interact with exhibits that range from a "body spark" to a multimedia center.

HISTORY
The Children's Museum of Manhattan was founded in 1973. Originally located on the edge of the theater district, the museum's move to its present location in October 1989 was underwritten by a grant from the Tisch family. The new space enabled the museum to quadruple its size, and the site, a former school, was innovatively transformed by a team of architects, museum designers, scientists, and educators.

MAIN FLOOR

BRAINATARIUM
Directly to the right upon entering the museum is the "Brainatarium," a domed, thirty-seat amphitheater that is the focal point of the museum's exhibits. Here visitors view a four-minute, multimedia show about how the brain works.

Upon leaving the Brainatarium, children are photographed and given what looks like a bank automated teller card. This card may be used at seven computerized "self-portrait" stations, where children can enter information about themselves and their activities at the museum. Before leaving

the museum, this information is synthesized into a personalized "newspaper" printout, with the child's picture and details about the day's activities.

MEZZANINE

TROPICANA PRODUCTS, INC., GALLERY

A special stairway, illustrated with climbing and crawling animals, leads from the Brainatarium to this gallery on the mezzanine which houses the Brain Games exhibit. The "Brain Bar" contains various work stations showing how the brain works. Of particular interest is the "Enchanted Loom." Its picture of nerve highways illustrates how messages are transmitted and organized into information. Visitors may also place their heads between giant elephant ears or look through hawk eyes to understand the differences in the sensory makeup of various animals. At the far end of the gallery, an animated film explains the working of the brain.

MAIN FLOOR

MAGICAL PATTERNS

Leaving the mezzanine and returning to the main floor, visitors are in the conceptual heart of the museum. The world of nature, culture, and art is filled with patterns of five basic types, and there is an exhibit devoted to each type: branch, geometric, rhythmic, spiral, and random. Children become "pattern finders."

In the area detailing rhythmic patterns, the young visitor can navigate a sailboat through the "wavy water world," listen to a giant multilingual radio, or play with a huge pin sculpture. The "Snowflake Crystal Palace" and "tensegrity" illustrate geometric shapes. In "Cactus Canyon," visitors explore branch patterns.

Children particularly enjoy the "Body Spark" in which they place their finger on a screen and watch the electric current attracted to the warmth and moisture of their body. The "whirling swirling zone" with its spiral patterns and the random patterns in the "Land of Pitter Patter" all contain interactive exhibits that can be touched, felt, and played with.

SECOND FLOOR

WARNER COMMUNICATIONS CENTER FOR THE MEDIA, PERFORMING ARTS, AND EARLY CHILDHOOD EDUCATION

This media center is a highlight for visitors. In the state-of-the-art television newsroom, a stage is set against a backdrop of the New York skyline. Here children can become camera operators, newscasters, and sound technicians. They can also experiment with animation techniques and bring their drawings to life.

Toddlers have their own play space on this floor, where they can dress up and play with age-appropriate toys. A two-hundred-seat performing arts space is nearby.

THIRD FLOOR

SCHOLASTIC GALLERY

This gallery gives children an understanding of the art of book illustration. The exhibits, which change periodically, contain original art from recently published children's books.

BASEMENT

On this level is a gallery that displays children's art. In workshops here, children can become "pattern makers," which is an enjoyable outgrowth of their having been "pattern finders" on the main floor.

THE CLOISTERS

Fort Tryon Park
New York, N. Y. 10040
212/923–3700

SUBWAY	A.
BUS	M4.
HOURS	9:30 A.M. to 4:45 P.M. Tuesday through Sunday, November through February; 9:30 A.M. to 5:15 P.M. Tuesday through Sunday, March through October.
TOURS	3 P.M. Tuesday through Friday; Noon Sunday.
ADMISSION	$5, adults; $2.50, students and senior citizens.
MUSEUM SHOP	Books, notecards, calendars, jewelry, scarves, and three-dimensional representations.
SPECIAL EVENTS	Concerts, gallery talks, and Saturday lectures.
MEMBERSHIP	From $25.
AUTHOR'S CHOICE	Unicorn tapestries Campin altarpiece *Belles Heures* manuscript Bury St. Edmunds cross

The Metropolitan Museum of Art, the Cloisters Collection

Four medieval cloisters—and part of a fifth—have been reconstructed here on a hilltop, sheltered from the bustle of New York. As you stroll through the rooms and gardens, studying art and architecture dating from the eleventh to the sixteenth centuries, the world of the Middle Ages comes alive.

Few museums re-create a specific time and place as dramatically as the Cloisters.

HISTORY

George Grey Barnard, an American sculptor who lived in France before World War I, collected medieval architectural fragments, such as the columns and capitals of the Saint-Guilhem, Cuxa, Bonnefont, and Trie cloisters. Some of the objects in his collection came from buildings that had been destroyed during the French Revolution. Others had fallen victim to the weather and years of neglect.

When Barnard returned to the United States, he exhibited his collection in a building on Fort Washington Avenue, not far from the present location of the museum. During the 1920s, the collection was advertised for sale, and, in 1925, John D. Rockefeller, Jr., gave the Metropolitan Museum of Art funds for its purchase and continued exhibition. Rockefeller also donated approximately forty medieval sculptures from his own collection.

Later, when Rockefeller gave New York City the land for Fort Tryon Park, he reserved a hilltop site overlooking the Hudson River for a museum of medieval art. Charles Collens, the architect of New York's Riverside Church, was selected to design the museum. Joseph Breck, assistant director of the Metropolitan Museum, worked with Collens until his death in

1933, when curator James J. Rorimer, later director of the Cloisters and director of the Metropolitan Museum, assumed Breck's responsibilities. The goal was to create a building whose style would evoke the Middle Ages by incorporating key structural elements into the design.

Construction began in 1934, and the museum opened to the public four years later.

THE COLLECTIONS

A cloister is a covered walkway surrounding a large open courtyard that generally leads to other monastic buildings. Portions of the arcades of five medieval cloisters can be seen here. In addition, the collection includes an unparalleled assemblage of sculpture, tapestries, stained glass, metalwork, manuscripts, panel paintings, and other precious objects from the Middle Ages.

The museum's holdings span more than fifteen hundred years—from the Romanesque period, dating from about 1,000 A.D. to between 1150 and 1200, through the Gothic era, which lasted from about 1150 to approximately 1520.

THE ROMANESQUE HALL

To the right of the entrance, this hall showcases three doors that represent different architectural periods. The entrance to the church, often called the "gate of heaven," the "portal of glory," or the "triumphal gate" was one of the most important elements of early church design.

The Entrance Door, dating from about 1150, has a rounded arch supported by limestone blocks which is characteristic of the Romanesque style. It bears certain resemblances to other portals and church windows around Poitou in west-central France.

The Reugny Door nearby represents a transitional style between the Romanesque and the Gothic, with a Gothic pointed arch and stylized drapery folds on a carved figure in the Romanesque manner. The door once graced a late-twelfth-century church in Reugny in the upper Loire Valley.

Opposite the Entrance Door is a mid-thirteenth-century portal from the Burgundian monastery of Moutiers-Saint-Jean, with the pointed arch and naturalistic carving that mark it as a late Gothic example. Moutiers-Saint-Jean suffered greatly during periods of religious and political upheaval. It was sacked in 1567, 1595, and 1629, and was virtually destroyed during the French Revolution. The figures carved on the door, thought to represent King Clovis, the first Christian king of France, and his son Clothar, were found in a private garden in Moutiers in 1909 and replaced on the portal in 1940.

FUENTIDUEÑA CHAPEL

Wrought iron mountings from the eleventh or twelfth century are displayed on the modern oak doors that lead from the Romanesque Hall into the adjoining Fuentidueña Chapel.

The apse, which contained the altar where Mass was celebrated, came from the church of San Martín in Fuentidueña, a village about seventy-five miles north of Madrid. Except for this apse, the church was in ruins by the mid-nineteenth century and villagers used it as a cemetery. The apse, which is on permanent loan from the Spanish government, was carefully dismantled and reconstructed here.

A fresco painting of the Madonna and Child that originally graced the church of San Juan de Tredós in Spain dominates the dome of the apse. Like the frescoes in the Romanesque Hall, it was painted on wet plaster around the middle of the twelfth century.

THE SAINT-GUILHEM CLOISTER

The first cloister that visitors generally see is this rather small, skylit garden area enclosed by columns that are notable for their varied carvings. The Benedictine abbey of Saint-Guilhem-le-Désert was founded in 804 by Guilhem, count of Toulouse and duke of Aquitaine, near Montpellier in southern France.

Legends abounded about Guilhem. In a variation of the Trojan horse story, he was said to have captured Nîmes by smuggling his troops into the town in wine casks. Another story claimed that, when a Saracen king imprisoned him, he escaped with the aid of the queen whom he later married. Guilhem, who took holy vows in the monastery that he founded, later became a saint.

The monastery was on the route followed by many medieval pilgrims traveling through France to Santiago de Compostela in Spain. A new monastery was built early in the thirteenth century, incorporating many of the columns and pilasters seen here. They are mainly adaptations of the classical Corinthian column—many of which were still standing in southern France at that time.

As you stroll through the cloister, notice the carvings on the capitals. They range from medieval versions of the acanthus leaf and palm tree to representations of Biblical stories, including Daniel in the lions' den, the presentation of Christ in the temple, and the devil and sinners.

During the French Revolution, the Saint-Guilhem monastery was sold to a stonemason. No record was kept of the original size of the cloister or the placement of its columns. During the nineteenth century, the columns supported a grape arbor and served to decorate the garden of a justice of the peace nearby in Aniane.

The fountain in the center of the courtyard is made from a late-eleventh-century capital from the Auvergne or Guyenne region of southern France.

Seasonal flowers and plants can be seen here throughout the year.

LANGON CHAPEL

Heavy oak doors connect the Romanesque Hall to the Langon Chapel. The chapel's stonework comes from the church of Notre-Dame-du-Bourg in Langon, near Bordeaux. Benedictine monks were ordered to construct a church in Langon in 1126, to be dedicated to the Virgin. The church prospered for a while, but, during the Hundred Years War in the late-fourteenth century, Langon, then held by the English, was raided by the French. It is believed that the church's original Romanesque transept was rebuilt in the Gothic style sometime after 1374. Huguenots sacked Langon in 1566. Jacobins met in the nave during the French Revolution, and, in recent years, a dance hall, tobacco warehouse, film theater, and garage have occupied various parts of the church.

It is interesting to compare the two statues of the Virgin and Child enthroned in this chapel. The sculpture to the right

of the entrance, carved in the Auvergne region in the late twelfth century, is crafted of walnut. The Christ Child is shown as a diminutive man, rather than a baby. Traces of paint reveal that the Virgin once wore a red gown with a blue cloak and the Christ Child was dressed in green with a red mantle.

The other sculpture, which stands under the marble *ciborium* or altar canopy, came from Autun in northwest Burgundy. Except for the Christ Child's head, which is now missing and was originally attached with a dowel, the statue, which was also painted, was carved from a single piece of birch around 1130 or 1140. Although both statues have the same stylized frontal pose, the Autun Virgin's expressions seem more realistic.

PONTAUT CHAPTER HOUSE

In a starkly simple room such as this, the monks, seated on the stone benches that line the walls, would discuss the daily routine of the monastery.

This chapter house came originally from the abbey of Notre-Dame-de-Pontaut in Gascony, south of Bordeaux. Established by the Benedictines around 1115, it was given to the Cistercians in 1151. Architecturally, it is a good example of a transitional style, combining rounded Romanesque arches with a Gothic rib-vaulted ceiling.

Notice the iron tethering rings on the two center columns. They may date from the period during the nineteenth century when the chapter house was used as a stable.

CUXA CLOISTER

This cloister, from the Benedictine monastery of Saint-Michel-de-Cuxa in the northeast Pyrenees, was built in the twelfth century as part of a monastery that was founded around 878. It was originally nearly twice the size you see here.

The monastery was sacked in the seventeenth century and abandoned in the eighteenth century after the French Revolution. In the mid-nineteenth century, the roof of the church and the bell tower collapsed and local families acquired much of the stonework. Some of the Cuxa columns were found in a private garden near Montpellier, together with those in the Saint-Guilhem Cloister.

The carved capitals on the marble columns show a wide diversity of design. Some are fairly simple but others include elaborate designs of lions, apes, eagles, human figures, and animals with two bodies and a common head.

The octagonal fountain in the center of the courtyard, surrounded by plants and flowers, came from the nearby monastery of Saint-Genis-des-Fontaines, where it may have been used as a baptismal font.

NINE HEROES TAPESTRIES ROOM

The door leading from the Cuxa Cloister to this room typifies the flamboyant Gothic style of the fifteenth century. By that time, curves, stylized leaves, and other design elements frequently embellished the pointed Gothic arches.

Medieval tapestries, generally hung on castle walls to keep out the cold, served also as indications of the wealth of their owners. These tapestries were probably commissioned around 1385 by Jean, duke of Berry, the brother of Charles V of France. You can see the duke's royal *fleur-de-lis* emblem on the banners near the top of the Hebrews tapestry.

The heroes represented include three pagans, Hector, Alexander, and Julius Caesar; three Hebrews, David, Joshua, and Judas Maccabeus, and three Christians, Arthur, Charlemagne, and Godfrey of Bouillon. All are dressed magnificently in fourteenth-century clothing, rather than in the garments that would have been appropriate to their periods in history.

UNICORN TAPESTRIES ROOM

The Unicorn in Captivity; *the Metropolitan Museum of Art, the Cloisters Collection, gift of John D. Rockefeller, Jr., 1937*

The door leading to this room dates from the early sixteenth century and features, appropriately, a carving of unicorns supporting a shield.

The seven spectacular tapestries that comprise the Hunt of the Unicorn set are among the best known and rarest objects in the Cloisters collection. Although experts have determined that they were woven in Brussels around 1500, other questions remain unanswered. Who commissioned the set and for whom was it made? Who was "AE", whose initials figure so prominently in the design? Whose coat of arms is on the dog's collar in the first tapestry? What is the meaning of the various inscriptions on the dogs' collars and the hunters' horns?

The earliest reference to the tapestries is an inventory of the possessions of Francois VI de la Rochefoucauld in 1680. At that time, they were listed as hanging in the bedchamber of La Rochefoucauld, the author of the famous *Maxims*, in Paris. During the French Revolution, in 1793, they were removed from the La Rochefoucaulds' château at Verteuil, near Paris, and were used by peasants to protect vegetables and fruits from freezing. Not surprisingly, some of the tapestries were severely damaged during this period. In the mid-nineteenth century, Count Hippolyte de La Rochefoucauld heard about some "old curtains" that had once belonged to his family. He rescued them from the barn in which they were stored and rehung them in his château.

In 1922, six of the tapestries were exhibited in New York, where John D. Rockefeller, Jr., purchased them for his collection. It was said that Count Gabriel de La Rochefoucauld was more interested in having a private golf course on his estate than tapestries on his walls. In 1937, Rockefeller donated the six tapestries to the Cloisters. The following year, the seventh tapestry was added. (It is the fifth one in the series, showing the unicorn tamed by a virgin.)

Woven of fine wool, silk, and metallic threads, the narrative can be read on three levels: as the hunt and capture of the unicorn, as a tale of courtly love, or as symbolic of Christ's suffering, crucifixion, and resurrection.

Experts believe that the first and seventh tapestries, *The Start of the Hunt* and *The Unicorn in Captivity*, may not have been part of the original set. Their *millefleurs* style, with figures placed against a background of hundreds of carefully delineated flowers, differs dramatically from the landscape backgrounds in the other tapestries.

Each tapestry provides a wealth of detail about medieval life. The costumes of the hunters, their ladies, and attendants provide accurate information about the styles of dress in the sixteenth century. And the plants are depicted so precisely that most of them have been identified. Many of these plants grow in the Trie Cloister garden.

BOPPARD ROOM

The highlights of this room are an elaborately carved alabaster retable that once stood above the altar in the archbishop's palace in Saragossa, Spain, and six magnificent stained glass panels from the Carmelite church at Boppard-am-Rhein.

By the end of the Middle Ages, popular taste called for the addition of fancy canopies, such as those over the stained glass panels, as a decorative and unifying element in sculpture, paintings, and stained glass.

CAMPIN ROOM

A three-paneled altarpiece painted by the Flemish artist Robert Campin around 1425 is the focal point of this room. In the central panel of the triptych, the Archangel Gabriel announces the Virgin Mary's selection as the mother of Christ. Campin has portrayed her against the background of a typical, middle-class Flemish home.

One of the side panels shows Ingelbrecht of Mechelen and his wife, who commissioned the altarpiece for their home, while the third panel depicts Joseph making a mousetrap in his carpenter's shop. The houses of a town can be seen through the open window in Joseph's workshop.

Annunciation Altarpiece by Robert Campin; the Metropolitan Museum of Art, the Cloisters Collection

Fifteenth-century furniture is placed in the Campin Room, together with objects that mirror those in the altarpiece, such as a majolica vase, a brass candlestick, and a bench with lion and dog finials. During the Middle Ages, a dog symbolized fidelity and the lion was a symbol for Christ.

LATE GOTHIC HALL

Notable here are a retable with scenes from the life of Saint Andrew and a Spanish *Lamentation for Christ* dating from the late-fifteenth or early-sixteenth century.

LOWER LEVEL TREASURY

Reached through the Boppard Room, the Treasury—like its medieval counterpart—contains finely crafted works of art, including reliquaries, illuminated manuscripts, and religious objects used both privately and in church services.

In the first room, you can see a magnificent triptych of silver, silver-gilt, enamel, and mother-of-pearl made in Austria in 1494. Thirty-five carved oak panels line the room. In the early sixteenth century, they may have been part of the choir stalls in the royal abbey church of Jumièges in Normandy.

Don't miss the *Belles Heures* of Jean, duke of Berry, the royal art patron who originally owned the Nine Heroes Tapestries. Books of hours contained daily devotional prayers and were often works of art as well as religion. The *Belles Heures* manuscript was illuminated by Pol de Limbourg and his brothers Janequin and Hermann. The colors are as fresh as if they were painted today, rather than in the early fifteenth century. This may be the only virtually complete commissioned prayer book that has survived from the Duke of Berry's library.

A charming set of playing cards—the only complete, illuminated set that has survived from the fifteenth century— is on view here. Probably made in Flanders between 1470 and 1485, the cards are marked with symbols associated with the hunt, including hunting horns, dog collars, hound tethers, and game nooses. The figures, based on Franco-Flemish models, show the fashions of the day.

In the next room, display cases are filled with liturgical objects crafted of silver, ivory, silver gilt, and enamel. One of the most outstanding pieces is an intricately carved, mid-twelfth-century altar cross probably made at the abbey of Bury Saint Edmunds in eastern England. Five pieces of walrus-tusk ivory have been fitted together and embellished with over a hundred miniature three-dimensional figures.

Notice the boxwood rosary bead, carved in Brabant in the early sixteenth century. A gift from financier J. P. Morgan to the museum, it contains a series of miniature religious scenes. Many pieces of boxwood were fitted together with the aid of a magnifying glass to create this unusual devotional object.

GLASS GALLERY

Throughout history, works of art have reflected the social and political mores of the times. With the growth of cities and increased trade in the late Middle Ages came the rise of a prosperous middle class. Many became art patrons, commissioning works of art to adorn their homes and private chapels. This gallery is filled with the stained glass, sculpture, tapestries, and other precious objects that were popular during the fifteenth and sixteenth centuries.

Especially notable is the Nativity of the Virgin, a lindenwood and polychrome sculpture dating from about 1480, to the right of the entrance. This reclining Saint Anne with the infant Virgin may have been part of a large altarpiece in Germany.

The workshop of Roger van der Weyden, the great mid-fifteenth-century Flemish artist, produced the polyptych with scenes of the Nativity that reportedly came from a nunnery in Segovia, Spain. Roger van der Weyden was a pupil of Robert Campin in Tournai, whose triptych of the Annunciation can be seen in the Campin Room.

GOTHIC CHAPEL

Large sculptured figures, tomb effigies, and magnificent fourteenth-century stained glass windows combine to create a somber mood in this re-creation of a Gothic chapel.

Highlights include a limestone and polychrome statue of Saint Margaret, carved around 1330, from the chapel of the Montcada family in Lérida, Spain; the tombs of the counts of Urgel, and the tomb slab of a thirteenth-century lady, thought to be Margaret of Gloucester, the wife of Robert II, baron of

Neubourg. Also note the beautifully carved thirteenth-century tomb slab of Jean d'Alluye, founder of the abbey La Clarté-Dieu, near Le Mans. During the French Revolution, the abbey was vandalized, and the slab, placed face down, was reportedly used as part of a bridge over a stream.

BONNEFONT CLOISTER

This late-thirteenth- or early-fourteenth-century cloister was originally part of a Cistercian abbey, founded in 1136, at Bonnefont-en-Comminges near Toulouse in southern France. It managed to survive the turbulent years of the French Revolution and was still standing in 1807. Little more than a generation later, however, most of the abbey had been destroyed and its architectural elements had been incorporated into various public buildings and private gardens.

Two arcades have been reconstructed here. Notice the simplicity of the carved designs on the capitals. In keeping with the Cistercians' disapproval of decorative sculpture, the gray marble columns are embellished with leaf designs or coats of arms, rather than the elaborate carvings of people, animals, and mythical creatures found elsewhere in the Cloisters.

An Italian wellhead stands in the center of the garden, surrounded by plants and trees that date from the Middle Ages. Many of them were on Charlemagne's list of plants for the royal gardens at Aachen. An herb garden flourishes in front of the north arcade.

TRIE CLOISTER

Adjoining the Bonnefont Cloister are three arcades composed of late-fifteenth-century marble capitals and bases from the Carmelite convent at Trie-en-Bigorre and the monastery at Larreule in southwestern France. Some of these architectural artifacts may also have come from the abbey of Saint-Sever-de-Rustan in the same region. Although the marble columns in the south, east, and west arcades are old, they were not originally part of the cloister. Several capitals were originally part of the Bonnefont Cloister, including one with carvings of grape clusters. Most of the carvings are more elaborate, however, featuring Biblical scenes, saints' legends, fanciful creatures, and coats of arms.

The fountain in the center of the garden is a combination of two late-fifteenth- or early-sixteenth-century limestone elements from the area of Vosges in northeastern France. Seven apostles and John the Baptist stand in niches in the lower portion. The figures of Christ, Mary, and John can be seen on one side of the upper part, while Saint Anne with the Virgin and Child and two saints are visible on the reverse.

Flowers depicted in the Unicorn Tapestries are planted in the garden.

FROVILLE ARCADE

As you leave the Cloisters, walk through this arcade of fifteenth-century arches from the Benedictine priory of Froville in Lorraine. This late Gothic wall of pointed arches is the sole surviving element of a small, square, French cloister. The rest of the building either succumbed to the elements or was torn down to make room for a stable sometime before 1904.

DYCKMAN HOUSE

4881 Broadway
New York, N.Y. 10034
212/304–9422

SUBWAY	A.
BUS	M100.
HOURS	11 A.M. to Noon, 1 P.M. to 4 P.M. Tuesday through Sunday. Closed Monday and legal holidays.
ADMISSION	$1 donation requested.
AUTHOR'S CHOICE	Military hut, rear of park

Once surrounded by three hundred acres of orchards and lush farmland, Dyckman House, at the corner of Two Hundred and Fourth Street and Broadway, is New York City's only remaining eighteenth-century farmhouse.

Dyckman House

HISTORY
William Dyckman (1725–87), builder of the house, was a grandson of Jan Dyckman, who came to New Amsterdam from Westphalia around 1660. The elder Dyckman was one of the most prominent landowners in New Haarlem.

William Dyckman, who inherited some of his grandfather's land, built a house near Two Hundred and Eighth Street, east of Tenth Avenue. During the Revolutionary War, Dyckman and his family moved to Peekskill. His sons served in the Continental Army, and one was killed.

At various times during the war, British and Hessian soldiers were stationed at Dyckman Farm. After the British left New York on November 25, 1783, the Dyckmans returned to find their home and orchards destroyed. William Dyckman built another house, around 1785, which is now the museum.

About a hundred and twenty huts had been erected near the new house for the troops who were stationed there during the occupation. After the British destroyed the huts, William turned the remnants of the former army camp into an apple orchard. The stone and wood hut in the garden is similar to those originally on the grounds of Dyckman Farm.

The Dyckmans lived in the small wing to the south side of the house while they rebuilt their home. The wing later became a summer kitchen. An old smoke house and a well are in back of the main building.

The house descended in the family until 1871, when it was sold. In 1915, with its existence threatened by the northward expansion of the city, two members of the Dyckman family, Mrs. Bashford Dean and Mrs. Alexander McMillan Welch, purchased the property and gave it to the city in memory of their parents, Isaac Michael and Fannie Blackwell Dyckman. The house opened to the public in 1916. Some of the furnishings were originally at Boscobel, which was built farther north on the Hudson by Staats Morris Dyckman, a nephew of William.

THE BUILDING
In typical Dutch colonial style, the exterior has a wide low-sloping, ridged gambrel roof covering the porches; a high

basement, with Manhattan schist and brick walls on the lower part of the façade, and clapboard above. Originally, two long porches extended along the front and rear of the house. Although the rear porch had disappeared by 1916, it was possible to reconstruct it on the original foundation. A north wing, added about 1830, was removed, and the hall and dining room, which had been modernized about 1850, were restored to their eighteenth-century appearance.

The simple interior plan includes a cellar, two floors of living space, attic, and winter kitchen. In this unpretentious house, snug rooms have low ceilings, and simple mantels grace fireplaces on the first and second floors.

A small exhibit shows how houses were built in the eighteenth century, with hand-sewn studs, river lathes, homemade nails, and fillings of mud and marsh grass.

THE INTERIORS

The house is divided by a narrow hall with Dutch doors at either end. Photographs of the farm in the 1890s, family portraits, and the Dyckman coat of arms hang in the hall. The house is furnished as it might have appeared in the early nineteenth century.

In the parlor, to the right of the hall, the mantelpiece, corner cupboard, and dado rail are original. (Except in the dining room and hall, all of the woodwork in the house is original.) The Chippendale side chairs and Queen Anne wing chair are believed to be New York pieces. Staats Morris Dyckman purchased the "deep blue and white jasper cameo" ware in the cupboard from Josiah Wedgwood & Byerley in England in 1803.

The ladder-back chairs in the dining room belonged to the father of painter-inventor Samuel F. B. Morse, a close friend of the Dyckman family. The Empire sideboard is another Dyckman family heirloom, and the nineteenth-century cut glass fruit bowl and decanters were originally used at Boscobel.

Behind the parlor is a small room that was the farm office; off the dining room is the museum, with relics found in the neighborhood. Most of the objects here relate to the Revolutionary War camp on the property and were excavated by Reginald Pelham Bolton, author of *Relics of the Revolution*. There are bullets, bone buttons, and belt buckles; a uniform and sword worn in the War of Independence, and domestic objects such as fragments of pottery. In sharp contrast to the military objects on view are beaded purses, dainty wedding slippers, and a delicate, gauzy dress with cut-work border and hem, worn by a member of the Dyckman family.

Two furnished bedrooms are on the second floor. A Sheraton field bed and the Dyckman family cradle are in the south bedroom. Other Dyckman pieces, including some dating to 1790, are in the north bedroom.

The winter kitchen in the cellar boasts a spinning wheel, a large fireplace, and a fine array of copper caldrons, skillets, and long-handled cooking implements, including a wooden shovel, or peel, which was used to remove bread from the oven. There are slipware and pewter dishes on the table, and the furnishings include an eighteenth-century slat-back armchair and several country Sheraton chairs.

HISPANIC SOCIETY
OF AMERICA

Audubon Terrace, Broadway at 155th Street
New York, N.Y. 10032
212/926–2234

SUBWAY	1, B, and K.
BUS	M4, M5, M100, and M101.
HOURS	*Museum*: 10 A.M. to 4:30 P.M. Tuesday through Saturday; 1 to 4 P.M. Sunday. *Reading Room*: 1 to 4:30 P.M. Tuesday through Friday; 10 A.M. to 4:30 P.M. Saturday. Closed Monday and February 12, 22, Good Friday, Easter Sunday, May 30, July 4, Thanksgiving Day, December 24, 25, 31, and January 1. Reading Room also closed the month of August, October 12, Thanksgiving weekend, and two weeks during the Christmas season.
TOURS	Group tours by appointment only. No more than fifty persons permitted inside the building at one time.
ADMISSION	Free. School children must be accompanied by one adult for every ten children.
SALES DESK	Postcards, notecards, color prints, color slides, posters, books, and articles relating to the collections, and catalogs of museum and library collections.
SPECIAL FACILITIES	Research library with thousands of manuscripts and over 100,000 books relating to Spanish and Portugese art, history, and literature.
MEMBERSHIP	Membership in the Hispanic Society of America is limited to one hundred persons of recognized achievement in Hispanic arts and letters. Members are selected from the ranks of Corresponding Members, a group whose size is limited to three hundred.
AUTHOR'S CHOICE	Renaissance tombs *Portrait of a Little Girl* by Velázquez *The Duchess of Alba* by Goya *Provinces of Spain* by Sorolla

Once the site of naturalist John James Audubon's country home, Audubon Terrace on Broadway between 155th and 156th Streets now houses a complex of several small museums and cultural institutions grouped around a central courtyard. A visit to the Hispanic Society of America, the first Spanish museum in the United States and one of New York's lesser known institutions, provides an overview of Hispanic culture from prehistoric times to the present.

HISTORY

The Hispanic Society of America

As a young man, Archer Milton Huntington, the son of railroad magnate Collis P. Huntington, was fascinated by the culture of Spain and Portugal. He traveled extensively throughout the Iberian peninsula and collected books, manuscripts, paintings, and decorative arts outside Spain with

the eventual aim of establishing a center for the study of Hispanic arts and civilization.

Soon after founding the Hispanic Society of America in 1904, Huntington built this museum and reference library to house his collections of books and works of art. The building was formally opened in 1908. An eight-story building with additional exhibition and storage space was constructed opposite the main building in 1930.

In addition to his collections, Huntington provided an endowment to support the society.

THE BUILDING

The building was designed by Charles Pratt Huntington in Renaissance style. A bronze equestrian statue of El Cid Campeador and four seated warriors by Anna Hyatt Huntington, the wife of Archer M. Huntington, dominates the terrace between the main and north buildings. Mrs. Huntington also sculpted other pieces on the terrace, including the two limestone lions that stand guard at the entrance to the main building.

The walls of the two-story exhibition hall on the first floor of the main building are crafted of terra-cotta in Spanish Renaissance style. Arcades encircling the room contain cases filled with some of the museum's treasures. Paintings by Old Masters line the gallery above the main court.

THE COLLECTIONS

According to the bylaws of the society, the museum is not permitted to lend objects from the permanent collection or to borrow from other institutions. However, such restrictions do not apply to the more recently established loan collection.

Temporary exhibitions display objects from the museum, iconography, and library collections.

PAINTINGS

Works of art from the Catalan, Aragonese, Valencian, and Castillian schools of the fourteenth and fifteenth centuries are among the earliest paintings in the collection. Seven paintings and two miniatures by El Greco (Domenikos Theotocopoulos) and three paintings by Luis Morales are representative of the sixteenth century. The museum's seventeenth-century holdings include two paintings by Juan Carreño de Miranda, two by José Ribera, three by Diego Rodriguez de Silva Velázquez, and two by Francisco de Zurbarán. Eighteenth-century art is represented by five paintings and ten drawings by Francisco de Goya.

Among the museum's modern painters are works by José López Mezquita, Martín Rico, Joaquín Sorolla y Bastida, Daniel Urrabieta Vierge, and Ignacio Zuloaga. The society owns 104 paintings by Sorolla, in addition to the fourteen large canvases of his *Provinces of Spain* that line the walls of the west exhibition room.

SCULPTURE

Engraved Phoenician style ivories from the seventh century B.C. are among the rarest items in the collection. Other early pieces include Iberian, Greek, and Roman bronzes, jet statuettes and amulets, a tenth-century Hispano-Moresque ivory box, and Roman marble sculptures.

A thirteenth-century polychrome wood carving of a *Mater Dolorosa* and two early sixteenth-century marble-and-alabaster tombs from Cuellar are particularly noteworthy.

TEXTILES

The textile collection includes Hispano-Moresque silks woven in the thirteenth and fourteenth centuries, as well as gold brocaded velvets, silks, laces, and embroideries dating from the fifteenth through the twentieth centuries.

Rugs from Alcaraz, Cuenca, and Salamanca are typical of the craftsmanship of those centers of weaving.

METALWORK

Included in the metalwork collection are examples from the pre-Roman era through the eighteenth century. There are Gothic iron knockers, iron grillwork bands, and locks, as well as crucifixes, paxes, and censers from the Gothic and Renaissance periods. One of the most important objects is a silver, architecturally formed monstrance made by Cristobal Becerril of Cuenca in 1585.

GLASS AND CERAMICS

The oldest pieces in the collection, which date from the prehistoric era through the Roman period, were unearthed in archaeological finds in the region of Carmona and Seville.

The museum owns an outstanding collection of Hispano-Moresque and Spanish lusterware. The colors of the bowls and platters are as brilliant today as when they were painted in the fifteenth century.

Also here are ceramics from Talavera de la Reina, Toledo, and Seville; porcelains from the royal factories of Capodimonte and Buen Retiro, and pottery from Mexico.

Among the rarest objects in the glass collection are three pieces of Renaissance glass produced in the area around Barcelona.

FURNITURE

Highlights include seventeenth-century tables, chairs, cabinets, benches, and braziers, as well as sixteenth- and seventeenth-century *varguenos*, or writing desks, embellished with iron mountings, inlay, carving, and gilding.

Choir stalls from the Monastery of San Francisco in Lima, Peru, are typical of seventeenth-century colonial furniture.

A view of the main exhibition room

FIRST FLOOR **MAIN EXHIBITION ROOM**

The atmosphere of the museum is serene, despite the fact that hundreds of objects are on view at all times, in the side galleries and upstairs, as well as in the main hall. In this lofty exhibition space, you can see such diverse objects as Paleolithic tools dating from circa 19,000 to 15,000 B.C.; thirteenth-, fourteenth-, and fifteenth-century polychrome wooden religious figures; a charming polychrome statue of Saint Martin on horseback, ca. 1500; an eighteenth-century altar frontal appliquéd with gold threads on lace; a brilliantly colored *Assumption of the Virgin* from fifteenth-century Spain, and early chalices, bowls, crosses, and candlesticks.

A Goya painting of the Duchess of Alba, dressed in black lace with a black lace mantilla on her head, is the focal point of the room.

SOUTH EXHIBITION ROOM

An altarpiece signed by Pere Espalargues in 1490 dominates one corner of the room. Works of art from the fifteenth to the seventeenth centuries are displayed here in a chapel-like setting.

WEST EXHIBITION ROOM (READING ROOM)

Provinces of Spain, murals by Joaquín Sorolla y Bastida commissioned by the society, depict the fiestas and regional costumes of Spain. A bronze sculpture of Sorolla by Paul Troubetzkoy and a portrait of the artist by Mariano Benlliure can also be seen here.

SECOND FLOOR

Galleries lined with paintings and display cases filled with treasures overlook the main exhibition room below.

Highlights of the collection on view here include Roman glass vessels and silver ritual bowls from the first century A.D. and a large collection of ceramics dating from the fifteenth to the eighteenth century, including glazed earthenware, blue-and-white bowls, chargers, basins, and spectacular pink luster pottery.

Many of the museum's finest Old Master paintings line the walls. Displays are changed periodically, but you might see, for example, Goya's portrait of Alberto Foraster, Zurbarán's richly dressed *Saint Lucy* and *Saint Rufina*, Ribera's *The Ecstasy of Mary Magdalene*, or El Greco's *Pietà*.

JEWISH MUSEUM

at the New-York Historical Society
170 Central Park West
New York, N.Y. 10024
212/399–3344

Until late 1992:
Mailing address
1865 Broadway, fourth floor
New York, N.Y. 10023

After 1992:
1109 Fifth Avenue
New York, N.Y. 10128
212/860–1888

SUBWAY	1, 2, 3, 9, B, and C.
BUS	M10 and M79.
HOURS	10 A.M. to 5 P.M. Sunday, Tuesday, Wednesday, and Thursday; 10 A.M. to 3 P.M. Friday. Closed Monday, Saturday, and major legal and Jewish holidays.
ADMISSION	$3, adults; $2, senior citizens over 65; $1, children under 12.
HANDICAPPED FACILITIES	Limited; special access by appointment.
MUSEUM SHOP	Books, jewelry, posters, wedding gifts, toys, and Judaica.
SPECIAL EVENTS	Films, concerts, lectures, family and school programs, live performances.
MEMBERSHIP	From $40.
AUTHOR'S CHOICE	*The Holocaust* by George Segal

The Jewish Museum—the largest institution of its kind in the Western hemisphere—presents fascinating exhibitions that explore various facets of Jewish life and culture.

While its own home on Fifth Avenue undergoes a major remodeling, the museum's exhibitions, educational programs, and shop are located at the New-York Historical Society on Central Park West between Seventy-sixth and Seventy-seventh Streets.

HISTORY

The Jewish Museum was founded in 1904 when Judge Mayer Sulzberger donated a group of objects associated with Jewish rituals. As a branch of the Jewish Theological Seminary of America, the museum's collection was originally displayed in the seminary library.

In 1944, Frieda Schiff Warburg, the widow of financier Felix Warburg, gave their former home to the seminary. Three years later, the museum opened in the former Warburg mansion. The six-story building, constructed in 1908 in the style of a French Gothic château, is a fitting tribute to the Warburgs, who were avid art collectors.

A modern wing, added in 1963, is to be replaced by a new extension in the style of the Warburg mansion, designed by

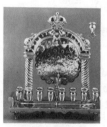

Hanukkah lamp,
Vienna, circa 1900

Kevin Roche of the architectural firm of Kevin Roche John Dinkeloo & Associates. The new addition will double the existing space.

During the mid–1960s, the museum—although founded as a repository and showcase for Judaica—shifted its focus and presented avant-garde art exhibitions, including early works by Robert Rauschenberg, Jasper Johns, and others.

In 1971, the museum closed for a few months to mount an exhibition on Masada, which proved quite popular. When it reopened, there was a renewed emphasis on using art to illuminate Jewish life and experience. Currently, the museum mounts shows that dramatize provocative themes of wide appeal, such as "The Dreyfus Affair: Art, Truth, and Justice," and "Golem! Danger, Deliverance, and Art." Other exhibitions have explored Jewish life in Italy; the role of Jews in India, China, and Ethiopia, and the work of Jewish artists, such as the recent "Jacques Lipchitz: A Life in Sculpture."

THE COLLECTION

Selections from the permanent collection, as well as temporary exhibitions, are displayed on the first and second floors of the New-York Historical Society during 1991 and 1992. After that time, the collection will return to its newly enlarged home on Fifth Avenue near Ninety-second Street.

The permanent collection includes more than fourteen thousand objects, ranging from biblical artifacts to radio and television programs. Among the Judaica objects are rare and beautiful Hanukkah lamps, spice boxes, kiddush goblets, Torah pointers, and seder plates. Many of the ceremonial objects entered the museum collection as a result of the Holocaust.

Other highlights are a rare book of biblical illustrations, dating from 1626; silver- and velvet-bound prayer books; gravestone rubbings, and early Zionist memorabilia.

The textile collection—one of the finest and most comprehensive in the world—includes an unusual nineteenth-century American folk art quilt that combines Jewish imagery with early American history. Other choice items include a nineteenth-century silver-embroidered velvet Torah curtain, a silk-embroidered, glass-beaded wedding blouse, wedding shawls, and such priceless relics as ancient oil lamps, flints, and glass jars.

The collection of the National Jewish Archive of Broadcasting adds another dimension to the museum's storehouse of Jewish information. It documents the contributions made by Jewish writers, producers, actors, and comedians to broadcasting.

Paintings, sculpture, and graphics inspired by the Jewish experience are frequently on view. Works range from Rembrandt's etching, *The Triumph of Mordecai*, to contemporary images by William Gropper, Abraham Rattner, Max Weber, Larry Rivers, and noted Israeli artists.

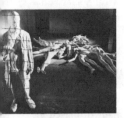

The Holocaust *by George Segal, 1982*

Probably the most striking object in the entire collection is George Segal's *The Holocaust*, which was acquired in 1985. The sculpture is a plaster, wire, and wood version of Segal's moving bronze memorial in San Francisco, showing ten life-size figures crumpled on the ground and one anguished survivor standing behind barbed wire. Segal worked with live models and consulted documentary photographs to find images that conveyed the horrors of the Holocaust.

MORRIS-JUMEL MANSION

1765 Jumel Terrace
Between 160th and 162nd Streets
New York, N. Y. 10032
212/923–8008

SUBWAY	1, A, B, and K.
BUS	M2 and M3.
HOURS	10 A.M. to 4 P.M. Tuesday through Sunday.
TOURS	Guided tours by special arrangement; group tours by reservation.
ADMISSION	$3, adults; $1, senior citizens and students with ID. Children under 12, free when accompanied by an adult.
SALES DESK	Postcards and miscellaneous items relating to the house.
MEMBER CONTRIBUTION	From $25.
AUTHOR'S CHOICE	Octagonal drawing room, first floor Madame Jumel's bedroom, second floor

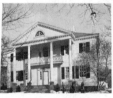

The Morris-Jumel Mansion

Seeing the Morris-Jumel Mansion for the first time is a bit like finding a pot of gold at the end of a rainbow. This handsome, white pillared building is an unexpected delight in the midst of the rather somber apartment houses and brownstones of Washington Heights. It is located at the center of the Jumel Terrace Historic District, half a block from St. Nicholas Avenue and across the street from the wood-framed 1882 houses of Sylvan Terrace.

HISTORY

In 1765, British Colonel Roger Morris and his American wife Mary Philipse built a summer "villa" in the country. Colonel Morris, an acquaintance of George Washington, had been an aide-de-camp to General John Braddock during the French and Indian War. And it was rumored that Washington was romantically interested in Mary Philipse before her marriage.

Originally, the Morrises' 130-acre Mount Morris estate was twelve miles from New York City and extended from the Harlem to the Hudson Rivers. Because the house was built on one of the highest parcels of land in Manhattan, it was possible to see Connecticut and New Jersey, as well as the New York harbor and Staten Island.

Colonel Morris, a Tory and a member of the New York Provincial Executive Council, left for England when the American Revolution began in 1775. Mrs. Morris and their four children moved to a family estate in Westchester County.

After the Battle of Long Island and the Battle of Kip's Bay, General Washington requisitioned the Morrises' house and used it as his temporary headquarters from September 14 to October 18, 1776. Washington planned the successful Battle of Haarlem Heights here and watched the fire, set by American forces, that laid waste to much of New York City on the night of September 28.

Recognizing the strategic importance of the house, British General Sir Henry Clinton chose it as his headquarters in November 1776. He was followed by Baron Wilhelm von Knyphausen, commander of the Hessian forces. Prince William Henry, later the British King William IV, reportedly visited as a young midshipman in 1781.

The house remained a military establishment throughout the Revolutionary War. When the war ended, the American government confiscated the estate and leased the land to a farmer. The house became Calumet Hall, a tavern that was the first stop on the Albany Post Road. On July 10, 1790, President Washington hosted a dinner for his cabinet members and their wives at Calumet Hall. The guests included Vice-President John Adams, Secretary of State Thomas Jefferson, Secretary of the Treasury Alexander Hamilton, and Secretary of War Henry Knox.

Stephen Jumel, a wealthy, French-born merchant and ship owner, bought the property in 1810 for $10,000. Six years earlier, he had married his mistress, Eliza Bowen, of Providence, Rhode Island. Although she was generally considered to be both beautiful and brilliant, Eliza, the daughter of a sailor and a prostitute, was shunned by New York society because of her background.

As a young woman, Eliza—then called Betsy Bowen— decided that New York offered greater opportunities for advancement than Providence. Some accounts say that she gave birth to an illegitimate child, went to New York with a ship captain, William Brown, and changed her name to Eliza Brown. Soon afterward she met Jacques de la Croix, a French shipmaster, and accompanied him on transatlantic voyages to France. Eventually, Eliza and de la Croix parted and she settled again in New York City.

The socially ambitious Eliza met Aaron Burr, then a prominent lawyer and politician, and Stephen Jumel, who introduced her to a world she had never known before.

Jumel's New York friends found Eliza more raffish than refined, so the couple went to Paris, where Eliza's charm and beauty captivated French society. By the time they returned to New York, Eliza had acquired a veneer of elegance and sophistication, together with a wardrobe of fashionable Parisian gowns. In spite of these new attributes, Eliza found that she was still not accepted in the best circles.

It is said that, while Jumel was away on a business trip, Eliza persuaded her doctor that she was seriously ill. Jumel was summoned to her bedside and she whispered that she wanted to marry him before she died. The wedding was performed immediately, and a few days later the new Madame Jumel made a remarkable recovery.

The Jumels left for France in 1815, where they became favorites of Napoleon and his court. After Napoleon's defeat at Waterloo, they offered to bring him to America on their ship, The Eliza. Napoleon refused, but, according to legend, he gave the Jumels his trunk and a carriage. His brother, Joseph Bonaparte reportedly visited the Jumels' home in 1820.

Madame Jumel spent much of her time in France between 1815 and 1826 and was once exiled by Louis XVIII for her Napoleonic sympathies. During this period, the Jumels acquired a number of furnishings associated with the French Emperor that are on view at the Morris-Jumel Mansion.

Madame Jumel's extravagance, coupled with several financial disasters, brought Jumel close to bankruptcy. He remained in France for several years to rebuild his fortune, while Eliza returned to New York.

When Stephen Jumel returned to America in 1828, he found that his wife had redecorated their colonial house in the then-fashionable high French Empire style, using many of the Napoleonic pieces she had acquired in Paris. With Jumel's power of attorney, she had also managed to increase the value of the family's assets considerably. And everything was in Eliza's name—not her husband's.

Jumel was injured in a carriage accident and died in 1832, leaving Eliza "the richest widow in the country." After her husband's death, Eliza resumed her friendship with former Vice-President Burr, and they were married July 1, 1833, in the front parlor of her mansion. Gossip swirled around the couple. Although Eliza's birth date is unknown, she was rumored to be about fifty-nine years old at the time. According to the rumors, the seventy-seven-year-old Burr married Eliza for her money and she married him for the prestige of his name. They separated six months later and were divorced in 1836.

Eliza traveled extensively and occasionally found that her reputation had preceded her. She bought a large Greek Revival house in Saratoga Springs, New York—then one of the country's most fashionable spas—and spent summers there until she grew tired of the ill-concealed hostility of the dowagers who controlled Saratoga's social life. Sometimes, it is said, when traveling around Europe, Eliza called herself "Madam Burr, ex vice-Queen of America." Otherwise, she continued to be known as Madame Jumel. She became increasingly eccentric and finally died in July 1865, when some accounts gave her age as ninety-one years.

In the early 1890s, L. A. LePrince rented the house, planning to use it to show his newly invented motion picture process. LePrince disappeared in France after Thomas Alva Edison filed a lawsuit against him.

General and Mrs. Ferdinand Pinney Earle purchased the house in 1894. In 1903, after the general died, Mrs. Earle, acting to preserve the mansion, persuaded the City of New York to purchase the property and preserve it.

Members of four chapters of the Daughters of the American Revolution formed the Washington Headquarter Association when both the D.A.R. and the Colonial Dames of America vied for control of the property. The Washington Headquarter Association is responsible for maintaining and furnishing the interior of the house, while the City of New York owns and maintains the building and its grounds. New York City and New York State are currently financing the restoration of the mansion's interior and exterior and the landscaping of the surrounding one-and-a-half-acre park.

The Morris-Jumel Mansion, a New York City Landmark, is the oldest remaining residential structure in Manhattan. It is listed in the National Register of Historic Places.

THE BUILDING

Colonel Roger Morris, the original owner of the mansion, was the son of another Roger Morris, a leading eighteenth-century English architect and builder. Both Colonel Morris and his

father were influenced by the designs of the great sixteenth-century Italian architect, Andrea Palladio.

The Morris-Jumel Mansion was one of the first houses in America built in the Palladian style. Its two-story portico with large columns supporting a triangular pediment is a much-copied Palladian design. The octagonal room on the first floor was also a "first" in the colonies.

Wide wooden boards with wooden corner quoins cover the brick shell of the house. The two-story colonnade and the portico are original, dating back to 1765.

Two theories exist about the mansion's design. One is that John Edward Pryor is the architect. Pryor also designed the Kennedy House near Bowling Green in New York City and the Proprietary House in Perth Amboy, New Jersey. The other theory is that Morris himself, influenced by the Palladian revival designs of his father, played a major role in the design of his summer "villa."

FIRST FLOOR

ENTRANCE HALL

Keystoned arches and a recessed staircase in the wide entrance hall suggest a Palladian influence. When the Jumels bought the house in 1810, they changed the entrance door and balcony door above it to the Federal style and added fashionable wallpaper in the hall. The current hall paper with its *trompe l'oeil* design of columns and a stone bas-relief has not been documented as an original design. Unfortunately, stripping of the walls through the years has left little evidence of the original wallpaper.

Furnishings include a signed Duncan Phyfe sofa, its legs carved with an elaborate giltwood wing motif; Madame Jumel's marble-topped pier table, and four chairs, made in 1804, that are attributed to Phyfe.

FRONT PARLOR

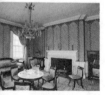

The front parlor

Eliza Jumel and Aaron Burr were married in this room in 1833.

The nineteenth-century French ormolu chandelier which belonged to the Jumels has brass candle holders and crystal drops. It was a gift from Napoleon to French General Moreau. The green wallpaper with small stylized morning glory flowers and bands of trumpet vine is a reproduction of the paper the Jumels purchased in France around 1815. (Original panels of the morning glory paper are on display in the second floor hall galleries.) The Wilton carpet is based on an 1887 photograph of the Jumels' octagonal drawing room in which the chandelier, the Empire parlor suite, and the morning glory wallpaper are shown.

The nineteenth-century American Empire parlor suite with its black-and-gold chairs was commissioned by Madame Jumel in 1826. The drop-lid desk of mahogany and satinwood, made in New York around 1820, belonged to Aaron Burr.

DINING ROOM

This elegant room was used for formal dinner parties. Family meals would have been taken either in the back parlor or the bedrooms.

The twelve Duncan Phyfe chairs and settee with reeded legs and carved back rails were made for William Bayard, a friend and business associate of Stephen Jumel, in 1808. The table is

set with Madame Jumel's nineteenth-century Chinese export porcelain. Guests used the wine rinsers at each place to rinse their glasses between courses.

The *strié* or streaked effect of the Prussian blue woodwork is in keeping with today's decor, but it was also popular during the Federal period. Research has revealed that this blue-green shade is the original dining room color.

The yellow and blue-green wallpaper is a reproduction of Federal wallpaper. Painted floor cloths, such as this one with its black, brown, and beige marbleized design, were popular during the early nineteenth century.

A 1790 portrait of Colonel John Chester by Joseph Steward hangs over the sideboard. Chester, an aide-de-camp to George Washington, was a hero of the Battle of Bunker Hill in 1775. A companion portrait of Chester's wife, Elizabeth, hangs nearby. The window frames and interior shutters in the background of her portrait are similar to those in this room.

BACK PARLOR

This family sitting room would have been a cozy place for the Morrises or Jumels to play the pianoforte or have a game of cards.

Cotton slipcovers in a *toile de Jouy* fabric called "The Apotheosis of Benjamin Franklin" cover the furniture. Most of the furnishings, including Madame Jumel's shield-back New York chair, date from the last quarter of the eighteenth century.

The walls are painted a pumpkin color that was fashionable at that time.

DRAWING ROOM

In addition to being perhaps the first octagonal room in America, this is undoubtedly one of the most beautiful drawing rooms in the country, restored to its 1765 appearance.

The hand-painted Chinese wallpaper depicting landscape scenes against a rich blue background is a perfect foil for the eighteenth-century Chippendale furniture. Chairs are lined up against the walls to allow room for dancing and games, as was customary during the Morris era. An eighteenth-century harpsichord and card table stand ready for use, as well as a large Chinese export porcelain punch bowl dating from that period.

The ivory-colored woodwork is similar to the shade selected by the Morrises. While the house was occupied by General Washington, this room served as a Council Chamber and was the scene of meetings and courts martial.

When the house was advertised for sale after the Revolutionary War, the advertisement noted that this room was appropriate for "turtle parties," a reference to the then-popular and expensive turtle soup.

HALL

SECOND FLOOR

The focal point of the wide hall is a large portrait of Eliza Jumel and her two grandchildren, painted in Rome in 1854 by Alcide Ercole. The Jumels, who were childless, adopted Eliza's stepniece Mary. Mary, the wife of Nelson Chase, was the mother of William and Eliza Jumel Chase, who are shown here with Eliza, then in her eighties.

Glass-enclosed display cases contain memorabilia connected with the house and its occupants. Among the most interesting items is a silhouette of Eliza made by Auguste Edouart, one of the most noted practitioners of that art, in 1843. Also on view are Madame Jumel's nineteenth-century French toilet set, her Nast pottery that was a copy of a set made for Napoleon, and the mahogany desk Aaron Burr used in his office on Reade Street in New York City.

DRESSING ROOM

The Morris family may have used this small room as a nursery. However, it was Madame Jumel's dressing room after 1826 when she decided to have the sort of "boudoir" that she had seen in Paris.

The room is simply furnished, with a day bed, an 1820 French sewing table, and an eighteenth-century French commode chair. In keeping with the Jumels' Napoleonic sympathies, a pair of nineteenth-century colored engravings depict the *Battle of Austerlitz* and the *Coronation of Josephine Bonaparte*.

MADAME JUMEL'S BEDROOM

This room contains some of the most important Napoleonic relics in the house, including several pieces that Eliza Jumel brought back from Paris in 1826 when she redecorated in French Empire style.

Notice particularly the mahogany sleigh bed with ormolu trim that Napoleon is said to have used when he was First Consul and his "dolphin" chair near the entrance to the room (so called because of the dolphin carvings on the arms). The slipper chairs near the fireplace originally belonged to Queen Hortense of the Netherlands, the daughter of Josephine Bonaparte and the mother of Napoleon III.

The brilliant blue of the bedspread and walls was a favorite color of Percier and Fontaine, decorators to Napoleon and his court. The carpet is a reproduction of a classic Empire design, as are the swags at the windows.

AARON BURR'S BEDROOM

While other rooms typify the decorative styles of the late eighteenth or early nineteenth centuries, Aaron Burr's bedroom illustrates the taste of the 1830s, the period of his marriage to Eliza Jumel.

The chest of drawers bears the date of 1830 on the label of Michael Allison, a competitor of cabinetmaker Duncan Phyfe. The walnut shaving stand belonged to Madame Jumel. The two rushseated Hitchcock chairs are typical of the sort of mass-produced chairs found in nearly every American home in the first half of the nineteenth century.

The fourposter bed covered in red damask was a gift to the museum from the late statesman Bernard Baruch.

GEORGE WASHINGTON'S OFFICE

General Washington may have used this room at the end of the hall as his office while the Morris mansion served as the Continental Army's military headquarters in 1776. During that time, the Americans won their first victory against the British at the Battle of Haarlem Heights.

Handsome pieces of eighteenth-century English and

American furniture can be found here, including a 1760 mahogany architect's table from England, a 1780 American Windsor chair, an American 1770 chestnut candlestand, and a mahogany blockfront desk.

Notice the fossilized marble fireplace, which is original to the house.

GARDENS

Before leaving, take a few minutes to stroll through the gardens and imagine the scene as it was over two hundred years ago when George Washington lived here.

NEW-YORK HISTORICAL SOCIETY

**170 Central Park West
New York, N.Y. 10024
212/873–3400**

SUBWAY	1, 2, 3, 9, B, and C.
BUS	M10 and M79.
HOURS	10 A.M. to 5 P.M. Tuesday through Sunday. Closed Monday and national holidays.
TOURS	By appointment.
ADMISSION	$3, adults; $2, senior citizens over 65; $1, children under 12.
HANDICAPPED FACILITIES	Limited; special access by appointment.
MUSEUM SHOP	Books, notecards, jewelry, antique reproductions, children's toys, and posters.
SPECIAL EVENTS	Lectures, films, concerts, and symposia.
SPECIAL FACILITIES	Research library.
MEMBERSHIP	From $35.
AUTHOR'S CHOICE	*Birds of America* by John James Audubon, second floor *The Course of Empire* by Thomas Cole, second floor Tiffany lamps, second floor

Original watercolors of John James Audubon's *Birds of America*, a spectacular collection of Tiffany lamps, silver, and important works of American art are some of the treasures to be found at the New-York Historical Society. Located on Central Park West between Seventy-sixth and Seventy-seventh Streets, this library and museum of American history, founded in 1804, is the oldest museum in New York and one of the oldest historical societies in the nation.

From January 1991 through December 1992, the Jewish Museum will also be housed here while its building at Fifth Avenue and Ninety-second Street is closed for renovation and expansion.

The New-York Historical Society

HISTORY
In November 1804, eleven of New York's most prominent citizens met in the picture room of City Hall to organize "a Society, the principal design of which should be to collect and preserve whatever may relate to the natural, civil, or ecclesiastical History of the United States in general and of this State in particular."

The founders understood the importance of preserving an accurate record of contemporary events while the men who played major roles were still alive. At that time, the name New-York was always hyphenated and the society has continued that tradition.

The society's roster of members has included important figures from the worlds of business, the arts, and public service. They range from John Adams, Thomas Jefferson, John Jay, and James Monroe to Charles Willson Peale, Washington Irving, James Fenimore Cooper, and J.P. Morgan.

For the first five years of its existence, the society was housed in the old City Hall, also known as Federal Hall. In 1809, the organization moved into a room at Government House in Bowling Green. With a rapidly growing library of books, manuscripts, maps, documents, newspapers, and prints, the society soon outgrew its quarters and, in 1816, relocated to the New York Institution in City Hall Park.

When the society's emphasis on natural history—a popular subject in the early nineteenth century—threatened to overshadow its original purposes, the group decided to present its entire natural history collection to the recently established Lyceum of Natural History.

In 1841, after occupying several different buildings and coping with severe financial problems, the society found a new home at New York University in Washington Square. Its library was combined temporarily with that of the university. Soon afterward, a campaign was launched to raise funds for a new building to be erected at Second Avenue and Eleventh Street, then the city's most fashionable area. The society moved into the new building in 1857 and remained there for the next fifty-one years.

By the end of the nineteenth century, space was again a problem and funds were raised to construct the present building in 1908.

Recently, the society has been updating its image and widening its focus. Instead of concentrating on the past, the emphasis, in research and education, is frequently on the present social, political, and cultural history of the City and State of New York. Through films, lectures, concerts, and symposia, contemporary issues are studied in the context of America's multicultural history. An innovative series entitled "Why History?" provides new perspectives about the contributions of all racial, ethnic, social, and economic groups in America.

THE BUILDING

The central portion of the building, designed in neo-classical style by the architectural firm of York and Sawyer, was completed in 1908. The two wings, designed by Walker and Gillette, were opened in 1939.

Through the years, various improvements have been made, including renovation of the auditorium, enlargement of the galleries, and the purchase of additional property on Seventy-sixth Street.

A master plan, developed by the architectural firm of Skidmore Owings and Merrill, and a five-year plan for the installation and conservation of the collections, are currently being implemented.

The restoration work will provide new galleries and public areas, improved handicapped access, an education center, and secure, environmentally controlled study and storage areas.

The permanent collection and temporary exhibitions are displayed on four floors. The library is on the second floor. The Department of Prints, Photographs, and Architecture, on

the third floor, is open by appointment only from 10 A.M. to 5 P.M. Thursday through Saturday.

THE COLLECTIONS

The society's holdings in paintings, prints, sculpture, books, furniture, silver, and decorative arts have been growing steadily since its inception.

In 1858, the entire collection of the New-York Gallery of the Fine Arts—which included Luman Reed's art collection, one of the finest in the country—was acquired. The Abbott collection of Egyptian antiquities and the Lenox collection of Assyrian marbles were secured in 1859–60 and the Edwin Smith Surgical Papyrus, the oldest scientific medical document in the world, was added in 1907.

The society transferred all of its Egyptian holdings to the Brooklyn Museum in 1936 on an indefinite loan, and they were later purchased by the Brooklyn Museum. The Surgical Papyrus was donated to the New York Academy of Medicine by the society and the Brooklyn Museum jointly in 1948.

The society's galleries house one of the best collections in the city of both fine and decorative arts from the seventeenth century to the twentieth. Virtually all major American artists of the seventeenth, eighteenth, and nineteenth centuries are represented in paintings and drawings of landscapes, portraits, and genre scenes.

The collections of American silver and Art Nouveau decorative arts, especially the works of Louis Comfort Tiffany, are equally outstanding. In addition, the society's library is a great resource for information about New York.

SECOND FLOOR

Selections from the Neustadt Collection of Tiffany lamps

THE WORLD OF TIFFANY: THE EGON NEUSTADT COLLECTION OF TIFFANY LAMPS

More than 150 lamps, stained glass windows, and other works of art from the workshop of Louis Comfort Tiffany can be seen here in the largest and most comprehensive exhibition of Tiffany lamps ever assembled.

The collection, begun by the late Dr. Egon Neustadt and his wife Hildegard in 1935, was donated to the society in 1984.

The exhibition includes examples of every type of Tiffany shade and base discussed in Dr. Neustadt's book, *The Lamps of Tiffany*. One of the earliest styles was the blown favrile shade, which was decorated before and during the blowing process by applying different colored materials to a hot surface.

There are simple leaded glass shades with geometric designs; shades with flowers added to the geometric design; flowered cones; flowered globes, and shades with irregular lower borders. Shades with irregular upper and lower borders, which are almost like sculptures, are the most advanced in coloration and execution.

Louis Comfort Tiffany was born in 1848 into the family that founded the New York jewelry firm of Tiffany & Company. He drew much of his inspiration from nature— from plants, flowers, trees, and even insects, such as spiders and dragonflies. His multicolored glass, produced at a factory in Corona, Queens, was noted for its strong colors and easy transmission of light.

With its emphasis on the decorative imitation of nature, Tiffany's work was especially popular during the Art Nouveau

period, from approximately 1890 to 1920. It lost favor when Art Deco was in fashion but began to attract a following again by 1950 and today is much sought after by collectors.

BIRDS OF AMERICA BY JOHN JAMES AUDUBON

During the 1820s, when he was about thirty-five years old, John James Audubon decided to paint every species of North American bird, life size and in appropriate habitats. Although he had little formal training as an artist or as a naturalist, Audubon devoted nearly twenty years to the project. Living in the wilds to observe his subjects, he painted 435 watercolors, including a few in which the species were misidentified. The watercolors were later copied for engravings.

In 1863, the society paid Audubon's widow four thousand dollars for all but two of the 435 original watercolors. Selections from the collection, which are rotated seasonally, are on display.

Wild Turkey *by John James Audubon, circa 1825*

THE LUMAN REED GALLERY

Luman Reed was a distinguished nineteenth-century New York collector and art patron whose taste influenced other collectors, particularly in the first quarter of the nineteenth century.

Born on a farm in upstate New York in 1785, Reed moved to New York City in 1815, where he operated a highly successful Front Street drygoods store, Reed and Sturges. Like most American collectors of the period, he began by acquiring European paintings attributed to Old Masters. In the early 1830s, however, he began to concentrate on the works of contemporary American artists, in an effort to encourage the development of the arts. With little formal education, Reed developed an interest in cultural pursuits and an eye for quality. He believed that art was important in the development of the nation.

Recognized as one of the earliest and most important patrons of American landscape, history, and genre painters, Reed encouraged and supported such artists as Thomas Cole, the founder of the Hudson River School of landscape painting, Asher B. Durand, William Sidney Mount, and George W. Flagg.

Reed was so pleased with his purchase of Cole's *Italian Scene, Composition*, that he commissioned the artist's five-part allegory, *The Course of Empire*, which is a focal point of the gallery. He purchased two paintings by Mount, *Bargaining for a*

The Course of Empire: The Consummation of Empire *by Thomas Cole, 1836*

Horse and *The Truant Gamblers*, that are considered among the best works of that genre painter.

Spurred by patriotism after meeting President Andrew Jackson, Reed paid Durand to paint the portraits of the first seven U.S. presidents—a commission which enabled Durand, an engraver, to become a full-time painter. And in an unusual seven-year contract, Reed subsidized Flagg, sending the eighteen-year-old artist to Europe to study, paying him an annual salary, and providing funds for his studio rent and art supplies, in exchange for Flagg's entire output of history and genre paintings.

In 1832, Reed built a handsome town house for his family at 13 Greenwich Street in lower Manhattan. Two rooms on the third floor were set aside as a gallery, filled with paintings and prints, minerals and seashells. Reed also commissioned his friends, Cole and Durand, to paint genre scenes as decorations on the gallery doors. The gallery, which was like a European collector's "cabinet" in its combination of art and science, was opened to the public once a week—an innovative and generous gesture on Reed's part.

The Luman Reed Gallery captures the ambiance of the 1830s by re-creating the arrangement of pictures in Reed's Greenwich Street home. Before he died in 1836, Reed acquired thirty-four American and eighteen European paintings, which have been reunited here for the first time in more than a hundred years.

Eight years after Reed's death, a group of friends purchased his collection to found the New-York Gallery of the Fine Arts. With the Luman Reed collection as its core and with many American artists' donations of paintings, this was to be the first permanent art collection in New York and the nucleus of a national art gallery. Eventually, the gallery closed, however, and its entire collection was given to the New-York Historical Society in 1858.

Although especially strong in American images, the Reed collection also includes Dutch, English, Flemish, German, and Italian paintings and engravings. Exhibits in an introductory gallery provide background information on economic, cultural, and social life in New York in the 1830s.

LIBRARY

The society's library shelves are filled with volumes dealing with the history of New York, as well as reference works on American history. The holdings in pre-twentieth-century Americana rank with those of the New York Public Library and the Library of Congress.

Two million manuscripts, more than six hundred and fifty thousand books, and thousands of letters, maps, prints, and photographs are stored here. The collection includes John Jay's manuscript for one of the Federalist papers, Napoleon's signed authorization for negotiations which culminated in the Louisiana Purchase, a copy of the 1787 New York directory, diaries of former slaves, and the correspondence between Alexander Hamilton and Aaron Burr which led to their duel in 1804. A large number of newspapers, published before 1820, provide firsthand information about events during the Colonial and Federal periods.

The library is open from 10 A.M. to 5 P.M. Tuesday through Saturday.

A TREASURY OF TOYS

More than 150 toys, dolls, and other playthings that delighted children from the early nineteenth to the early twentieth century are here.

Highlights include cast-iron and painted tin mechanical banks, horse pull-toys, and elegantly dressed bisque dolls. A group of transportation toys includes miniature horse-and-carriage sets, fire engines, a milk wagon, and trains. The doll furniture ranges from a William and Mary style chest on frame to an inlaid game table and a painted parlor suite with silk upholstery.

PAPERWEIGHTS

Examples of virtually every type of American and European paperweight are displayed here, including floral, *millefiori*, sulphide, and animal designs.

A Clichy five-pointed star with a rose in the center, *millefiori* mushrooms crafted by Baccarat and Clichy, and sulphide portraits of Lafayette, Napoleon, and George Washington are a few of the subjects depicted.

Among the more unusual objects are shot glasses with paperweight bases and hand coolers, which were made to cool ladies' hands.

PORTRAITS

The styles of American portraiture and the taste of eighteenth- and early nineteenth-century American collectors are reflected in over forty portraits in oil, pastel, paint, glass, and ceramic.

Don't miss the portrait of Edward Hyde, Viscount Cornbury, which hangs next to the elevator. Hyde was the governor of New York and New Jersey from 1702 to 1708. He is reputed to have been a transvestite who wore women's clothing when he received guests, as portrayed here, because he "represented the person of a female sovereign, his cousin German Queen Anne."

Other noteworthy paintings include John Durand's *Beekman Children* and *Rapalje Children*, John Trumbull's portrait of artist Asher B. Durand, and Rembrandt Peale's *Stephen Decatur*.

AMERICAN PAINTINGS, DECORATIVE ARTS, AND MANUSCRIPTS

A selection of mid-eighteenth- to late-nineteenth-century paintings from the society's collection of portraits, landscapes, and genre scenes is on display.

Included are Gilbert Stuart's *George Washington*, after his 1796 original; Rembrandt Peale's 1805 portrait of Thomas Jefferson; *Alexander Hamilton* by John Trumbull, and Charles Willson Peale's portrait of artist Benjamin West.

Peale himself is represented by paintings of George Washington, Gilbert Stuart, the Peale family, and a self-portrait with mastodon bone, painted in 1824, just three years before his death.

Other paintings include a view of the White Mountains by Asher B. Durand and a somber portrait of Abraham Lincoln and his family by Francis B. Carpenter.

In addition to the works of art, the gallery contains important period furniture from the society's collection, including the Federal armchair, dating from 1785, that George Washington used on the balcony of Federal Hall during his

inauguration. Presidents Grant and Garfield also used the chair at their inaugurations.

Pierre L'Enfant is said to have designed both the mahogany pedestal desk seen here and the unusual two-part desk which was used in Federal Hall by members of the first Congress in 1789.

You can also see an unusual Renaissance Revival armchair, made in 1865 from oak timbers rescued from the house on Cherry Street that George Washington occupied when New York was the capital of the United States. A portrait bust of Washington, an eagle, and the arms of the City and State of New York are carved on the chair back.

Various objects from the society's outstanding collection of American silver are also displayed here. Silver tea and coffee services, salvers, tankards, porringers, sauce boats, and punch bowls dating from the Colonial period through the nineteenth century are on view.

A rare pair of wine coasters bearing the Schuyler family coat of arms was made by the noted New York silversmith Myer Myers around 1765. Myers worked in Philadelphia and Norwalk, Connecticut, during the Revolutionary War and returned to New York in 1783.

Included in the collection of nineteenth-century silver are several pieces made by Baldwin Gardiner, who worked in Boston, Philadelphia, and New York. Gardiner crafted the pair of pitchers that were presented to Commodore Isaac Chauncey upon his retirement as head of the Brooklyn Navy Yard in 1833. Another pair of Gardiner pitchers was presented to Samuel Ruggles in 1832 for his efforts in establishing Gramercy Park.

Souvenir spoons marking visits to Niagara Falls, the Columbian Exposition, and Albany, New York, among others, attest to the nineteenth-century interest in travel, as well as collecting.

Often, objects in museums hint at mysterious, untold stories. One such intriguing item is here—a silver trinket box made by the Gorham Manufacturing Company whose lid is graced by a tiny, beautifully crafted bird holding a page of music in its beak. The box was presented to Emma Thursby, an internationally renowned American singer, by the members of Gilman's Band as a reminder of her "great triumphs in a series of grand concerts." George P. A. Healy's portrait of Miss Thursby is on view in the portrait gallery on this floor.

THOMAS JEFFERSON BRYAN GALLERY

Thomas Jefferson Bryan, the son of a prominent Philadelphia family, assembled one of the first important collections of European paintings in New York. Although trained as a lawyer, his wealth enabled him to devote his life to art, rather than the law.

In 1823, soon after graduating from Harvard, Bryan went to Europe, where he lived for the next nineteen years. From his base in Paris, he traveled throughout Europe, buying works of art at auctions and directly from artists. Many of his purchases also were made when distinguished collections were sold, including those of Louis-Philippe, the former King of France, the Peale Museum in Philadelphia in 1854, and the American Museum in New York in 1863.

Bryan returned to New York in 1852, and opened the Bryan

Gallery of Christian Art in the New York Society Library building at 348 Broadway, in space formerly occupied by the National Academy of Design. The following year, he relocated to 839 Broadway.

The title of the gallery was designed to reflect the fact that it contained a number of Old Master paintings, although portraits, genre paintings, and mythologicial subjects were represented, as well as religious art. Bryan's collection was viewed by many observers as the nucleus of a permanent city or national museum. An admission fee of twenty-five cents was charged, although artists were admitted free. Every inch of wall space was covered with paintings, hung from floor to ceiling in typical nineteenth-century fashion.

Dwindling admission fees, and concerns about insurance, fire, and theft prompted Bryan to move his collection to the Cooper Union for the Advancement of Science and Art when that institution opened in 1859. Five years later, after a series of disagreements with Cooper, Bryan's collection was installed at the New-York Historical Society. It was formally presented to the society in April 1867, and Bryan spent the next three years in Europe. He died aboard ship en route to New York from Europe in 1870. The works of art he purchased on his last trip were included in Bryan's bequest, bringing his gift to the society to more than three hundred and seventy-five paintings.

In amassing his collection, Bryan's goal was to provide a survey of the history of European art from the thirteenth through the early nineteenth century. He wanted the collection to be available to the general public and to artists, for, like Luman Reed, he believed that would encourage the development of the fine arts in America. Unlike the society's Luman Reed Collection, however, Bryan's collection is no longer completely intact.

The thirty-odd paintings on view provide insights into the tastes of an astute collector during the first sixty years of the nineteenth century. An interesting sidelight of this exhibit is the changing attributions that have resulted from recent scholarly studies. Although Bryan had an excellent eye for quality, some of the works he acquired were not painted by the artists to whom they were attributed. The labels indicate the original attribution, together with information gleaned from recent historical research.

Works of art ranging from the fourteenth to the nineteenth century by—or attributed to—such artists as Lucas Cranach, Jean Baptiste Greuze, Gerard Ter Borch, and David Teniers the Younger, among others are on display. Although European works predominate, Bryan also collected the paintings of American artists Rembrandt Peale and Benjamin West, and had his portrait painted by American Thomas Sully in 1831.

SCHOMBURG CENTER FOR RESEARCH IN BLACK CULTURE

New York Public Library
515 Malcolm X Boulevard
New York, N.Y. 10037
212/862–4000

SUBWAY	2 and 3.
BUS	M1, M2, M7, and M102.
HOURS	Noon to 8 P.M. Tuesday and Wednesday; 10 A.M. to 6 P.M. Thursday, Friday, and Saturday. Closed Sunday, Monday, and holidays, June to mid-September. Noon to 8 P.M. Monday, Tuesday, and Wednesday; 10 A.M. to 6 P.M. Friday and Saturday. Closed Thursday, Sunday, and holidays, mid-September to June.
TOURS	By appointment.
ADMISSION	Free.
HANDICAPPED FACILITIES	Accessible to the disabled.
GIFT SHOP	Books, posters, notecards, jewelry, T-shirts, and African memorabilia.
SPECIAL EVENTS	Seminars, forums, film screenings, performing arts presentations, traveling exhibition program, exhibition openings.
SPECIAL FACILITIES	Langston Hughes Theatre; research library with documents relating to black history and culture.
MEMBERSHIP	From $35.

Chances are, if you have a question concerning black history or culture, you will find the answer here. This is more than simply a research division of the New York Public Library. Ever since the Schomburg Center was established more than sixty years ago, it has played an important role in the cultural development of black writers, artists, and performers.

HISTORY

Arthur A. Schomburg, for whom the center is named, was born in Puerto Rico in 1874, the son of a black laundress and a German-born merchant. He came to New York City in his teens, and, after starting as a messenger, he eventually became head of the Bankers Trust Company's foreign mail division.

Believing that "the American Negro must remake his past in order to make his future," Schomburg wanted to disprove the popular myth that African-Americans had little or no cultural heritage. He assembled a collection of five thousand books, three thousand manuscripts, two thousand prints and paintings, and several thousand pamphlets by and about

Arthur A. Schomburg

blacks. The scope of Schomburg's library ranged from eighteenth-century anti-slavery works to contemporary novels.

During the Harlem Renaissance of the 1920s, Schomburg lectured frequently and arranged exhibitions of his collection. He was friendly with Langston Hughes and other leaders.

In 1924, Schomburg suggested that his collection be housed at the offices of the Urban League. Because their facilities were inadequate, Urban League officials arranged for a ten-thousand-dollar grant from the Carnegie Corporation in 1926 to purchase the Schomburg collection and donate it to the 135th Street Branch Library. The Schomburg holdings became part of the library's Division of Negro Literature, History, and Prints.

Schomburg retired from the Bankers Trust Company because of ill health in 1929. During 1930 and 1931, however, he was curator of Fisk University's Negro Collection. The Carnegie Corporation awarded another grant to the New York Public Library in 1932, and Schomburg was hired as curator of the Negro Division, a post he held until his death in 1938. In 1940, the Negro Division was renamed the Schomburg Collection of Negro Literature, History, and Prints.

It was here that James Baldwin discovered literature, Kenneth Clark studied, and Alex Haley researched *Roots*. In the 1940s, the American Negro Theatre, housed in the basement of the library building at 103 West 135th Street, served as a training ground for such entertainers as Harry Belafonte, Ruby Dee, and Ossie Davis.

THE BUILDING

Originally, the Schomburg collection was housed in a white limestone four-story building designed by McKim, Mead, and White in 1905. In 1972, the Schomburg Collection was transferred from the branch libraries to the research libraries and its name was changed to the Schomburg Center for Research in Black Culture. In 1980, the original building was closed and the Schomburg Center was relocated to a red brick postmodern building designed by Bond Ryder Associates at 515 Lenox Avenue, now Malcolm X Boulevard.

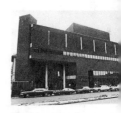

The Schomburg Center for Research in Black Culture

A recent $8.8 million construction and renovation project has resulted in a fifty percent expansion of the Schomburg Center, with state-of-the-art storage and conservation facilities housed in the 1905 building—an official city landmark since 1978; a 1,700-square-foot exhibition hall and a gift shop on the first floor, and room for seminars, film screenings, meetings, and receptions in the former American Negro Theatre space in the basement. In addition, three divisions have moved from the main building into new quarters in the 1905 building. The Prints and Photographs Division is on the first floor, Art and Artifacts is on the second floor, and Moving Image and Recorded Sound on the third. There is also a new 360-seat theater named for poet Langston Hughes. The theater lobby connects the complex of buildings.

GENERAL RESEARCH AND REFERENCE

THE COLLECTIONS

If you are searching for information, you have access to more than ten thousand volumes and eighty thousand microforms in the General Research and Reference Collections. These collections are open to anyone eighteen years and older upon presentation of identification listing a permanent address.

If you are interested in journalism, you can read selections from more than four hundred black newspapers and over a thousand periodicals gathered throughout the world. The Schomburg Center's Vertical File contains approximately seven thousand subject headings referring to information contained in newspapers and magazines, flyers, and pamphlets. The Ernest D. Kaiser Index to Black Resources lists more than 250,000 references to articles in black magazines and newspapers, including many which are no longer published.

RARE BOOKS, MANUSCRIPTS, AND ARCHIVES

Arthur Schomburg's personal library forms the core of this collection. It includes such rare volumes as a book of poetry by Juan Latino, a full-blooded African who occupied the chair of poetry at the University of Granada in the eighteenth century, and the autobiography of Gustavus Vassa, which formed the basis for an attack on slavery in the British colonies by Granville Sharpe in 1796.

Among the more recent works are the original manuscript of Richard Wright's *Native Son*; the papers of Dr. Robert Weaver, the first black U.S. Cabinet officer; the Harry A. Williamson Collection devoted to the history of blacks in Freemasonry, and records of the Civil Rights Congress, the New York Urban League, and the Phelps-Stokes Fund.

More than three thousand rare books and pamphlets, 250 manuscript collections, thirteen thousand pieces of sheet music, and many other valuable documents comprise this collection.

ART AND ARTIFACTS

Black Americans represented range from nineteenth-century artists, such as Edward Mitchell Bannister and Henry Ossawa Tanner to twentieth-century artists Lois Mailou Jones, Romare Bearden, and William T. Williams. The strongest elements in the collection are works produced during the Harlem Renaissance of the 1920s and the WPA period of the 1930s.

African and Caribbean art is also well represented. Included in the African holdings are the Melville Herskovits Collection of nearly six hundred objects, including many from West Africa, and one of the oldest collections in the United States of objects gathered by Belgian diplomat Raoul Blondiau in Zaire.

PHOTOGRAPHS AND PRINTS

Over 250,000 images are preserved here, ranging from eighteenth-century slavery graphics to contemporary photographs.

Among the rarest items in the collection is an 1842 daguerreotype. There are also ambrotypes, tintypes, albumen prints, stereographic views, and cartes-de-visite with scenes from the slave period through the Civil War era.

The collection documents major historical events, showing black life throughout the world. Portraits of many of the world's most important black actors, artists, musicians, athletes, and political leaders are included in the photographic archives. The works of photographers James VanDerZee, Edward Steichen, and Gordon Parks are among those represented.

MOVING IMAGE AND RECORDED SOUND

The audiovisual collection ranges from oral history recordings and musical documentation to motion pictures and videotapes. The voices of noted black leaders, such as Marcus Garvey, Booker T. Washington, and George Washington Carver, can be heard in early radio broadcasts and recordings.

Early black film classics and documentaries are included in the files of more than two thousand motion pictures and videotapes. In addition, over five thousand hours of interviews, lectures, and conference proceedings have been preserved in oral history recordings. The collection continues to grow, as a special Oral History/Video Documentation Project videotapes interviews with people who are culturally or historically significant.

Edgar Allan Poe Cottage

THE BRONX
BROOKLYN
QUEENS AND
STATEN ISLAND

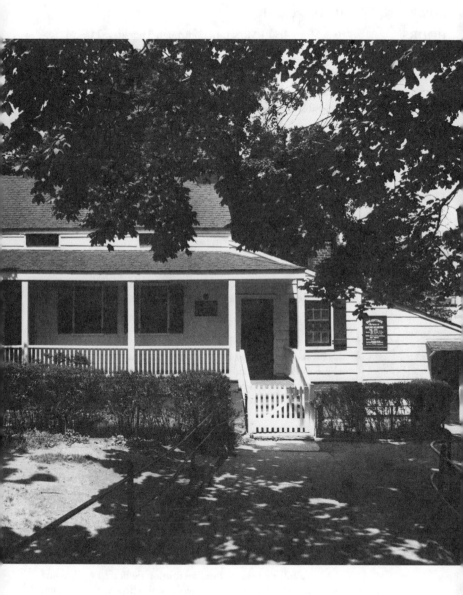

BRONX MUSEUM OF THE ARTS

1040 Grand Concourse
Bronx, N.Y. 10456
212/681–6000

SUBWAY	4 and D.
BUS	B1, B2, B4, and B6.
HOURS	10 A.M. to 4:30 P.M. Saturday through Thursday; 11 A.M. to 4:30 P.M. Sunday. Closed Friday.
ADMISSION	Suggested contribution $2, adults; $1, students and senior citizens.
HANDICAPPED FACILITIES	Accessible to the disabled.
MUSEUM SHOP	Catalogs, posters, jewelry, tote bags, and T-shirts.
SPECIAL EVENTS	Concerts, film series, weekend performances, educational programs.
MEMBERSHIP	From $35.
AUTHOR'S CHOICE	*Tidings* by Romare Bearden, first floor

The Bronx Museum of the Arts is more than simply a showcase for art. As a community institution, it is a symbol of hope for the revitalization of the borough.

The Bronx Museum of the Arts

HISTORY
The museum was founded in 1971 to bring art and culture to the Bronx. Assisted by the Metropolitan Museum of Art, whose directors agreed on the importance of decentralizing cultural activities in certain neighborhoods, the museum was originally located in the rotunda of the Bronx County Courthouse.

In 1982, the museum moved to its present site at the corner of Hundred and Sixty-fifth Street and the Grand Concourse, near Yankee Stadium. The building was formerly a synagogue that had been sold to the city by its dwindling congregation.

A six-year, $5.8 million renovation program began in 1982, with funds contributed by New York City, the National Endowment for the Arts, and the Kresge and Vincent Astor foundations. By the fall of 1988, the former house of worship had been transformed into a well-designed showcase for art.

Now a full-fledged cultural institution dedicated to bringing the arts to the 1.5 million residents of the Bronx, the museum also provides art education workshops and outreach programs for children, adults, and emerging artists.

THE BUILDING
Designed by architect Simon B. Zelnick, the beige brick building was constructed in 1961 for the Young Israel of the Concourse Synagogue.

The former main sanctuary is now a spacious gallery; offices and classrooms have been renovated to serve the educational needs of the community, and a sophisticated heating and ventilation system has been installed. The centerpiece of the new design is a spacious three-thousand-square-foot, three-story, glass-walled atrium-style lobby that houses the museum shop and a reception lounge. The open, modern design complements the museum's philosophy that art is accessible.

THE COLLECTION

The museum's permanent collection, begun in 1986, focuses on twentieth-century works on paper from Africa, Latin America, and southern Asia, as well as art produced by American descendants of those geographical areas.

The collection, which is displayed on the first floor, has been growing with gifts and a small but impressive number of acquisitions. Highlights include Romare Bearden's *Tidings* and *Quiet Cone*, a fiber and wire sculpture by Douglas Fuchs.

Tidings by Romare Bearden

EXHIBITIONS

Three types of exhibitions are presented, all of which are sensitive to the ethnic diversity of the Bronx: works by local and emerging artists; by artists who are nationally and internationally renowned, and exhibitions devoted to the history and culture of the Bronx.

Typical of the shows presented by the museum was "The Latin American Spirit: Arts and Artists in the United States, 1920–70," which featured rarely exhibited works by Mexican artists Diego Rivera and Frida Kahlo, in addition to more than 130 other Latin American artists, and "Traditions and Transformations: Contemporary Afro-American Sculpture." The latter show focused on works created by ten black artists between 1973 and 1988.

The museum has also established satellite galleries in various public spaces in the Bronx.

THE GRAND CONCOURSE

The museum has initiated "The Committee to Make the Concourse Grand Again." Revitalizing the four-and-a-half-mile, 138-foot-wide avenue is believed to be a key to the rehabilitation of the Bronx.

The broad boulevard, designed in the 1890s by Louis Risse, a civil engineer, was modeled after the Champs-Elysées in Paris. Lined with fine examples of Art Deco architecture, it extends from Hundred and Thirty-Eighth Street to Moshulu Parkway.

Originally one of the most prestigious addresses in the Bronx, the Concourse maintained its upscale image throughout the 1950s and early 1960s, but declined in the late 1960s as suburban housing and Coop City attracted people away from the Concourse. By the late 1970s, signs of decline could be seen adjacent to the Grand Concourse, especially south of Fordham Road.

Along the Concourse today, newly renovated buildings, including many in the characteristic streamlined Art Deco designs of the 1930s, have restored some of the broad boulevard's former beauty. The gleaming museum is now seen as a symbol of the Grand Concourse's future.

EDGAR ALLAN POE COTTAGE

**East Kingsbridge Road and Grand Concourse
Bronx, N.Y. 10458
212/881–8900 (Bronx County Historical Society)**

SUBWAY	4 and D.
BUS	M4A and M4B; B1, B2, B9, B12, B15, B17, B22, B24, B26, B28, B32, B34, B41, and B55; Westchester Liberty Lines 60.
HOURS	9 A.M. to 5 P.M. Wednesday through Friday; 10 A.M. to 4 P.M. Saturday; 1 to 5 P.M. Sunday.
TOURS	Group tours by appointment. Tour scripts in French, Japanese, and Spanish.
ADMISSION	$1 per person.
MUSEUM SHOP	Books, notecards, posters, postcards, and miscellaneous items.
SPECIAL EVENTS	Edgar Allan Poe Week each April.
MEMBERSHIP	From $10.
AUTHOR'S CHOICE	Two-piece desk in parlor that folds into a box for traveling

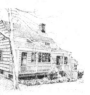

The Edgar Allan Poe Cottage

In 1846, Edgar Allan Poe, poet, critic, editor, and writer of mystery stories and mystical poems, moved from New York City to this tiny Bronx cottage with his wife, Virginia, and her mother, Maria Clemm. He hoped that his tubercular wife would benefit from the pure air in rural New York. Today, Poe's simple cottage—the only house remaining from the village of Fordham—is an international attraction. Forty percent of its visitors come from overseas.

HISTORY

Edgar Allan Poe was already an established author when he moved to Fordham. Born in Boston on January 19, 1809, he was the son of the English-born actress Elizabeth Arnold Poe and David Poe, Jr., an actor and former army officer. Poe was only two-and-a-half years old when his mother died in Richmond, Virginia, in 1811. Historians are not certain what happened to his father, except that the elder Poe's name disappeared from acting records. Poe lived with his foster parents, John Allan and his wife, Frances, a childless couple who never adopted him.

Allan wanted his ward to become a lawyer but Poe had a literary career in mind. In 1827, the two quarreled over his future, and Poe joined the army under the pseudonym, Edgar A. Perry. He rose to the rank of sergeant-major—a cut below that of an officer—and received an honorable discharge. Moving to Baltimore, Poe lived with his aunt, Maria Clemm, and her daughter, Virginia, who later became his wife.

Poe's poems were published, beginning in 1827. Six years later, he won a fifty-dollar award from a Baltimore weekly for

his "Manuscript Found in a Bottle," and became editor of a
literary magazine in Richmond.

He married his thirteen-year-old cousin, Virginia Clemm,
May 16, 1836; resigned from the magazine, and moved to New
York where financial opportunities were thought to be better.
A few years later, he moved to Philadelphia, where he
continued to write and edit magazines. In 1843, he became
more widely known when "The Gold Bug" won a hundred-
dollar literary prize awarded by a Philadelphia newspaper.

Returning to New York in 1844, Poe became sub-editor of
the *Evening Mirror*. The following year, as editor of the *Broadway
Journal*, he reprinted many of his earlier stories, and published
"The Raven," perhaps his most famous poem, in the *American
Review*.

Although Poe had had many of his works published, he was
still a struggling writer when he moved to the little cottage in
the idyllic village of Fordham in 1846.

THE COTTAGE

Poe paid John Valentine an annual rental of a hundred dollars.
The neat one-and-a-half story white frame cottage, built by an
itinerant carpenter about 1812, combines Dutch and English
colonial styles, and was typical of local workmen's homes in
the nineteenth century. An 1884 photograph on the parlor
wall shows the cottage's rural setting, surrounded by trees and
expansive grounds.

Originally, Poe used the little attic room near the couple's
bedroom as his study. Too poor to provide fuel for the attic
during the severe winter of 1846, he moved his wife to the
small, warmer bedroom downstairs and worked in the parlor.
Virginia Poe died January 30, 1847.

Mrs. Clemm stayed on to take care of Poe. She was often
seen by the side of the road, digging for greens to provide
food for their table. She also called on editors, urging them to
print her son-in-law's works.

By all accounts, Poe adored his wife and mourned her loss
until he fell ill and was unable to work. He fled into the
woods for solace, where vistas from rock ledges and twisted
paths inspired such works as "Ulalume" and "Eureka." Both
were written at the little cottage, as were the tender "Annabel
Lee" and "The Bells."

The troubled Poe sometimes visited with the students and
teachers at St. John's College, now Fordham University, and
drank at the nearby taverns to ease his sorrow.

In 1849, Poe hoped to start a cultural magazine, *Stylus*, with
the promise of financial backing from E.H. Patterson of St.
Louis. Embarking on a lecture tour, he traveled by steamboat
to Philadelphia, where some biographers say he drank too
much before going on to Richmond. There he became engaged
to his former boyhood sweetheart, Sarah Elmira Royster, and
was reunited with other old friends.

What happened next is a mystery. In late September, he set
sail for Baltimore. Arriving on election day, some historians
think that Poe was plied with liquor and was used by corrupt
politicians as a "repeater," casting his ballot at several polling
places. At any rate, Poe was found unconscious, wearing
someone else's clothing, and with no identification in front of
a polling place. He died in a hospital a few days later, on
October 7, 1849. Another version of his death is that Poe's

heavy drinking at a party brought on a heart attack. The true story lies buried with the poet in Westminster Presbyterian churchyard in Baltimore.

Meanwhile, in the Bronx, Maria Clemm had been packing to move South and join Poe and his future wife. After receiving news of his death, she continued to live in the cottage for a short time before returning to Baltimore.

Poe's cottage was home to several other tenants after his death. By 1895, the rural village of Fordham had become part of New York City. Apartment buildings replaced the meadows and fruit trees that had once been visible from Poe's porch. As land values increased, the charming little cottage was in danger of being torn down.

The New York Shakespeare Society lobbied to save the building. In 1902, New York City created Poe Park across the street from the cottage which, by this time, was sandwiched between two large houses on the east side of Kingsbridge Road, near Hundred and Ninety-second Street.

The cottage was moved to its present site at the northern edge of Poe Park and opened as a museum in 1917. A national historic landmark, the cottage was restored and refurbished by the Bronx County Historical Society, which has been responsible for it since 1975. The interiors have been carefully re-created to recall the period from 1846 to 1849, when Poe lived here. This is said to be the most authentic of the four Poe museums in America; the others are located in Baltimore, Philadelphia, and Richmond.

FIRST FLOOR

The kitchen

THE KITCHEN

The iron stove, made by a Bronx foundry in the mid-nineteenth century, was used in Poe's time, as was the clock. The fireplace, which was boarded up when the stove was installed, still has a crane that once held pots for open hearth cooking.

THE PARLOR

In this cozy room, light blue trimmed walls form a backdrop for a gilt-edged mirror and a rocking chair which are said to date from Poe's time. The two-piece desk is identical to the one at which Poe wrote his poetry and on which his wife's coffin was placed. The top folds into a box for traveling and the stand is a separate piece.

A gold and white tea set, typical of the 1840s, stands on a small table.

BEDROOM

This snug room with its wooden bedstead is believed to have been used by Virginia when she was moved from the upstairs bedroom.

THE ATTIC

POE'S STUDY

Reached by a narrow staircase, this is the room where Poe wrote when he first moved into the cottage. It later became Maria Clemm's bedroom.

BEDROOM

Originally Virginia and Edgar Allan Poe's bedroom, this room now houses video equipment for the story of Poe's life in this cottage.

BROOKLYN CHILDREN'S MUSEUM

**145 Brooklyn Avenue, at St. Mark's Avenue
Brooklyn, N.Y. 11213
718/735–4400
718/735–4432 recorded information**

SUBWAY	3.
BUS	B7, B44, B47, and B65.
HOURS	2 P.M. to 5 P.M. Monday, Wednesday through Friday; 10 A.M. to 5 P.M. Saturday, Sunday, and most school holidays. 10 A.M. to 5 P.M. daily in summer. Closed Tuesday.
ADMISSION	Suggested contribution, $2, adults, $1, children.
HANDICAPPED FACILITIES	Accessible to the disabled.
SPECIAL EVENTS	Storytelling, films, and lectures.
AUTHOR'S CHOICE	Plant of the Week Night Journeys: Home Is Where I Sleep

The Brooklyn Children's Museum

The first museum in the world designed expressly for children, this is a place where little ones need not stand on tip-toe to see exhibitions, the warning "Don't touch" is never heard, and adults do not hush gleeful, young voices. At the Brooklyn Children's Museum, everyone from toddlers on up is encouraged to question and learn through interactive, hands-on installations. The brightly colored building, installations designed at child's eye level, and helpful assistants all serve to welcome both young people and adults.

HISTORY

Founded in 1899, the Brooklyn Children's Museum is a pioneer in its field. From the start, the museum has been a role model and was the originator of interactive, hands-on exhibitions.

Initially, the museum, together with the Brooklyn Botanic Garden, was part of the Brooklyn Institute of Arts and Sciences, later renamed the Brooklyn Museum. The Children's Museum became an autonomous institution in 1948.

Originally housed in the Adams Building, a Victorian mansion in Bedford Park (later renamed Brower Park), the building had deteriorated so badly by 1967 that the museum had to be closed. The following year, MUSE, a temporary facility, opened in a renovated Crown Heights pool hall and auto dealership. MUSE, the first community museum in New York State, moved to its present location in 1977.

The museum attempts to meet the needs of its ethnically diverse urban audience by presenting relevant and innovative programs and exhibitions. It continues to function as a role model, advising other institutions on opening museums.

THE BUILDING

The award-winning building, designed by the architectural firm of Hardy Holzman and Pfeiffer, opened in 1977. The museum is a playful assemblage of elements from both urban and rural America. For example, a renovated oil tank serves as an auditorium and a turn-of-the-century subway kiosk is now the museum's entrance. Composed of four levels with an exterior courtyard, the museum is painted with bright colors, bold neon decorations, and whimsical touches at every turn. The four levels of the building flow into each other, so little ones are not challenged by large flights of stairs.

THE COLLECTIONS

The museum's collection includes more than twenty thousand artifacts of both cultural and natural history. The natural history collection began in 1899 and includes plants, crystals, insects, and shells, as well as birds native to Brooklyn.

A wooden headrest from Zaire

Central to the ethnological holdings is the Zim African Art collection, donated by Dr. Herbert S. Zim, who wanted children to have an opportunity to handle art objects. In addition to the collections displayed in the museum, portable collections, with such treasures as masks, skeletons, and musical instruments, travel to area schools.

EXHIBITION HIGHLIGHTS

As you enter the building, you will find the Early Learners Area to your right. This is a small-scaled exhibition designed for the youngest museum visitors. Little ones can mimic and explore facial expressions in mirrors, marvel at small specimens that they can enlarge with a magnifying glass, and learn how to fasten locks and bolts.

The exhibition directly after the Early Learners Area on the right of the building is the Music Studio, which displays musical instruments from Africa, Europe, Asia, and the Americas. As in the recent movie, *Big*, children can make music by skipping across a walking piano. In addition to synthesized and electronic instruments, children can pluck a thumb piano, beat a slit drum, and blow a melodica.

Continue along on the right-hand side, stepping down a level to Under Your Feet, which presents the natural wonders of the universe, displaying plants, insects, and geological specimens. Each week, two different plants are displayed in Plant of the Week, with labels describing the greenery. Children are encouraged to place their votes in the appropriate ballot box to select the Plant of the Week.

Now loop around to the exhibitions on your left, and visit Night Journeys: Home Is Where I Sleep, which uses cross-cultural comparisons and imaginative play to explain the phenomena of dreams and sleep. A display showing the different ways animals and plants sleep includes a flamingo sleeping on one leg, a butterfly resting with its head down and wings folded, and a bean plant's leaves drooping at night and opening in the daylight.

Life-size re-creations of beds from other cultures give children an opportunity to try out headrests from Egypt, Indonesia, and Zaire. The "Sleep Laboratory" provides scientific information about how bodies behave during sleep. And in "Souvenirs of Sleep," youngsters share their dreams with others and learn how dreams can contribute to creativity.

BROOKLYN HISTORICAL SOCIETY

128 Pierrepont Street
Brooklyn, N.Y. 11201
718/624–0890

SUBWAY	2, 3, 4, 5, A, F, N, and R.
BUS	B41, B51, B67, and B75.
HOURS	Noon to 5 P.M. Tuesday through Sunday.
TOURS	Various walking tours of Brooklyn throughout the Spring, Summer, and Fall.
ADMISSION	$2.50, adults; $1, children; free on Tuesdays.
HANDICAPPED FACILITIES	Accessible to the disabled.
FOOD SERVICE	No food allowed in the building; many cafés nearby.
SPECIAL EVENTS	Weekly family programs, lectures, and reminiscences.
SPECIAL FACILITIES	Research library.
MEMBERSHIP	From $25.
AUTHOR'S CHOICE	Stage set from "The Honeymooners" "Focus on Weeksville: A Nineteenth-Century Black Settlement"

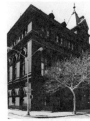

The Brooklyn Historical Society

Although the words "historical society" often conjure up an image of a quiet, dark museum filled with portraits of prominent, deceased individuals, that is not the case here. At the Brooklyn Historical Society, history is lively, engaging, and current.

Surprisingly, it is said that one out of every seven Americans traces his roots to the borough of Brooklyn. The community has been either the birthplace or the home of such varied notables as Walt Whitman, Woody Allen, W.E.B. DuBois, Al Capone, Danny Kaye, Spike Lee, Gypsy Rose Lee, and Lena Horne. It is also the home of perhaps the grandest bridge and the liveliest West Indian Carnival this side of the islands. And it is the place where history was made when Jackie Robinson became the first African-American to join a major league baseball team. These people, their diverse ethnic heritages, and the sights and events of Brooklyn are all celebrated at the Brooklyn Historical Society.

HISTORY

Established in 1863 as the Long Island Historical Society, the focus originally was on exhibitions devoted to world and natural history. In 1926, economic problems led officials to convert the gallery into commercial space, and the society became primarily a research institution.

In 1985, the name was changed to the Brooklyn Historical Society, because of its focus on Brooklyn artifacts, history, and

collections, and ambitious plans were developed for a $1.8 million history museum. Four years later, with a $400,000 gift from the estate of Brooklyn businesswoman and real estate investor Ruth Ann Shellens, the society opened the Shellens Gallery, a permanent exhibition devoted to Brooklyn history.

In addition to the exhibition, the society's staff tries to keep current with events in Brooklyn, a challenge in this multi-racial, multi-ethnic community. So that the lives of all Brooklynites are preserved, both for the present and the future, the society actively interviews residents of the borough, photographing people and events, and acquiring objects. In so doing, it has redefined the notion of a history museum, making it a more inclusive, diverse experience.

THE BUILDING
Surrounded by the brownstone buildings of Brooklyn Heights, the society is not far from the promenade which affords a spectacular view of the Manhattan skyline. The landmark building, designed by George B. Post, opened in 1881. As is typical of the period, the building is a synthesis of numerous styles, including Neo-Grec, Queen Anne, and Renaissance. The first structure in the metropolitan area to use terra-cotta extensively, its exterior is elaborately embellished with figures, scrolls, and other decorative details.

The society's library, housed on the second floor, received recognition as an interior landmark. This beautiful two-story space is paneled with rich wood, festooned with stained glass, and decorated with long wooden tables and antique green reading lamps. It is perhaps one of New York's most beautiful libraries, and a setting that invites scholarly thought and research. Visitors are allowed to peek into this handsome room. However, there is a separate fee of $2.50 per day to use its resources.

THE COLLECTIONS
More than five hundred Brooklyn-related manuscripts, over a hundred thousand books, numerous newspapers, periodicals, and extensive genealogical resources are housed here. Visual material includes thousands of historic photographs and several hundred paintings. Visitors can arrange to view copies of *The Brooklyn Eagle*, which once employed a young Walt Whitman; photographs celebrating the completion of the Brooklyn Bridge, and memorabilia from Coney Island.

EXHIBITIONS
The first floor Shellens Gallery presents the society's first permanent exhibition on Brooklyn history. The gallery is organized according to five themes: the Brooklyn Bridge, the Brooklyn Navy Yard, Coney Island, Brooklynites, and the Brooklyn Dodgers. Within these five categories, special "focus-on" installations highlight particular people and events.

The Brooklyn Bridge was completed in 1883, and this exhibition includes souvenir plates, newsclippings, and postcards from opening day. Artists' renditions and poets' odes to the grand, gothic-inspired structure are also displayed. The bridge has had an impact on popular culture, and visitors can see packs of "Brooklyn Bubble Gum" (made in Italy) with its logo of the bridge.

The Navy Yard, established in 1801, flourished during

World War II, and was closed in 1966. Photographs and artifacts, such as goggles, tools, identification badges, and lunch boxes, are reminders of the patriotic duties performed by the men and women of Brooklyn. Didactic panels detail concerns over "Hazards of the Job" and "Loose Lips Sink Ships."

Brooklynites celebrates the immigrant inhabitants of the borough, whose ethnic heritages range from the Dutch, the seventeenth-century founders of Brooklyn, to the Arabs, Asians, African-Americans, Jews, Eastern Europeans, Hispanics, and Scandinavians who came later.

In "Focus on Weeksville: A Nineteenth-Century Black Settlement," visitors learn about this unique black community, established in the 1830s, and its four surviving houses. Tribute is also paid to celebrities who hail from Brooklyn, including Zero Mostel, Thomas Wolfe, and Mary Tyler Moore, to name just a few.

Another subject is fictionalized Brooklynites and the image of Brooklyn presented by films and television. The original stage set of Alice and Ralph Cramden's kitchen, as seen on "The Honeymooners," recalls the popular television program that was set in Bensonhurst, Brooklyn. *Saturday Night Fever* and *Moonstruck*, both represented by posters and photographs, are two recent films that capture life in Brooklyn.

Coney Island evokes images and smells: a Nathan's hot dog, the salt of the ocean, the whirl of lights on the amusement rides, and the barkers inviting visitors to take a chance at a game of skill or luck. Visitors to the Brooklyn Historical Society can learn about this famous amusement center, and such past glories as the Cyclone, the Steeplechase, and Dreamland. One Coney Island tradition that continues, and is captured through photographs, is the Polar Bear Club. Its members plunge into the icy waters each New Year's Day.

The Brooklyn Dodgers broke many local hearts when they moved to Los Angeles in 1957. Before then, "Dem bums," as they were affectionately called, made history in 1947 when Branch Rickey signed Jackie Robinson to be the first African-American major leaguer, and in 1955, when they won the World Series. Players' memorabilia includes uniforms worn by Roy Campanella and Casey Stengel, bats used by Gil Hodges and Jackie Robinson, and Pee Wee Reese's baseball card. But the Dodgers were as much about the fans as the players. On display are "crying towels," thrown to the opposing team when being beaten, T-shirts worn and saved by fans, and photos of the Brooklyn Sym-phony, known to serenade "erroneous" umpires with "Three Blind Mice" played on kazoos.

BROOKLYN MUSEUM

200 Eastern Parkway
Brooklyn, N.Y. 11238
718/638–5000

SUBWAY 2 and 3.

BUS B41, B69, and B75.

HOURS 10 A.M. to 5 P.M. Wednesday through Sunday. Closed Monday and Tuesday.

TOURS Gallery talks at 3 P.M. every weekday.

ADMISSION Suggested contribution $4, adults; $2, students with valid I.D.; $1.50, senior citizens.

HANDICAPPED FACILITIES Full wheelchair access and handicapped parking.

FOOD SERVICE Available.

MUSEUM SHOP Museum publications, folk arts, crafts, postcards, and art books. Separate children's shop with art supplies, crafts, toys, books, and games.

SPECIAL EVENTS Lectures, concerts, and films.

SPECIAL FACILITIES On-site parking available, $5.

MEMBERSHIP From $45.

AUTHOR'S CHOICE Egyptian collection, third floor
Twenty-eight period rooms, fourth floor
Rodin sculpture collection, fifth floor

The collections of the Brooklyn Museum—one of America's oldest institutions—include approximately one-and-a-half million objects, ranging from Egyptian figures crafted between 3500 and 3400 B.C. to superb antique Chinese porcelains, rare African art, period furniture, and thousands of paintings, prints, drawings, and sculptures. Housed in a handsome nineteenth-century landmark building, the museum is near the borough's historic brownstone houses and the Brooklyn Botanic Garden.

HISTORY
The Brooklyn Museum traces its origins to 1823, when civic-minded citizens established the Brooklyn Apprentices' Library Association. An educational institution, the library was meant to keep young Brooklyn men on a virtuous path by shielding them "from evil associations, and to encourage improvement during leisure hours by reading and conversation."

During the nineteenth century, the collections, donated by the citizens of the village of Brooklyn, continued to grow. In 1843, the public demand for broader educational programs resulted in a reorganization of the library into the Brooklyn Institute of Arts and Sciences. The institute was later renamed the Brooklyn Museum and became exclusively an art museum.

Through the years, the Brooklyn Museum has pioneered in various fields. In 1923, Curator Stewart Culin, appreciating the elegance of African objects, mounted the world's first exhibition of African pieces as art, rather than as ethnological artifacts. Culin placed similar emphasis on collecting American Indian, Pre-Columbian, and Oceanic art.

In the decorative arts field, the museum opened its seventeenth- and eighteenth-century period rooms in 1929. Nearly twenty-five years later, in 1953, the museum became the first in the nation to install nineteenth-century period rooms, and it is currently collecting and displaying twentieth-century rooms and objects as well.

In the 1930s, Curator John I.H. Baur began acquiring paintings by then unknown or forgotten American artists. During his tenure at the museum, Baur produced major exhibitions of American Impressionists and nineteenth-century American still-life and genre painters, among others.

The museum's collection of German Expressionist prints is particularly strong, thanks to the foresight of Curator Una Johnson. She began collecting these works in the 1940s, a time when German art and culture were not popular in America.

The museum continues its long tradition of presenting challenging installations of contemporary art, special exhibitions of American, European, African, and Asian art, and innovative educational programs.

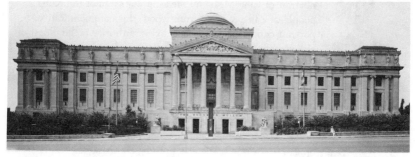

The Brooklyn Museum

THE BUILDING

Housed in a spectacular Beaux-Arts building designed by McKim, Mead & White, the museum's home is one of New York's finest landmark buildings. A grand structure festooned with allegorical statuary and classical architectural elements, the building is actually less than one-sixth its intended size.

In 1895, construction began on what was to have been an enormous square covering a million-and-a-half square feet. Two years later, the first section of the museum was opened. The central portion of the façade was added in 1904, and in 1906 the east wing and a grand staircase were completed. In 1909, thirty statues designed under the direction of Daniel Chester French were mounted on the exterior. Because of the First World War, the next sections were not completed until 1927. These sections were the last parts of the building to be constructed according to McKim, Mead & White plans.

In 1934, the grand staircase—a major classical feature of the building—was removed under the banner of functionalism and modernism. The firm of McKim, Mead & White canceled its contract, and its grand scheme was never realized.

Recently, museum officials have embarked on a master plan designed to improve the preservation and installation of the collections. Architects Arata Isozaki and James Stewart Polshek, winners of an architectural competition held in 1986, produced a design that the competition jury called "inspired" because it respects the intention of the original architects and translates it into a twentieth-century vocabulary.

FIRST FLOOR

THE COLLECTIONS

Since 1984 the Grand Lobby has been used as a showcase for contemporary art. Several times a year, artists representing diverse trends in contemporary art are invited to install large-scale works in the lobby.

Behind the Grand Lobby, in the Lobby Gallery, are the Curator's Choice exhibitions. Short-term installations (usually three months), these exhibitions draw from the museum's permanent collections. Past exhibitions have featured American watercolors, Spanish colonial art, nineteenth-century French painting, and costume sketches for Hollywood films.

AFRICAN, OCEANIC, AND NEW WORLD ART

Female Figure With Child, *19th century; The Brooklyn Museum, Frank Sherman Benson Fund*

Much of the first floor is devoted to African, Oceanic, and New World art. The African Gallery was refurbished in 1989 and features architectural elements, ceremonial and household objects, figurative sculpture, jewelry, masks, and textiles. Among the collection's highlights is the seventeenth-century portrait of King Mishe mi Shyaang Ma Mbul of the Kuba people of Zaire. Carved from wood, this commemorative portrait expressing the king's divine authority is the oldest of eleven such figures known to exist.

The pioneering Stewart Culin also amassed a collection of American Indian objects on expeditions to the Southwest, California, and the Northwest Coast. Towering high in the galleries are magnificent totem poles carved by the Haida Indians of the Northwest Coast in the late nineteenth century. Other collection highlights include buckskin clothing, Kachina dolls, rare examples of early pottery, and baskets.

A Paracas textile dating from 100 B.C. is perhaps the most famous piece in the museum's notable pre-Columbian collection. Lining the border of the textile are ninety male figures, dressed in ceremonial costumes and ornaments, who represent leaders of a ritualistic society.

Ancient American artistic traditions are well represented by Peruvian pottery, Central American gold, and Mexican stone statuary.

Completing the holdings of this department is the Oceanic collection, which includes a handsome canoe breakwater from Papua, New Guinea. The breakwater, or rajim, is finely carved in low relief with curvilinear forms and zoomorphic designs. Artworks from the Solomon Islands and New Zealand are also included.

SECOND FLOOR

ASIAN ART

A comprehensive selection of Chinese, Korean, Japanese, Indian, Southeast Asian, and Islamic art is exhibited on the museum's second floor. Rotating exhibitions of such objects from the permanent collection as *ukiyo-e* prints, Japanese and Chinese paintings, Indian miniature paintings, and Islamic calligraphy complement sculpture, textiles, and ceramics from

all of Asia. The museum is known for its *mingei* (Japanese folk art), its Avery collection of Chinese cloisonné and enamel vessels, and its Oriental carpets.

Among the masterpieces of the Asian Department is a fourteenth-century Chinese blue-and-white porcelain jar from the Yuan dynasty. Painted in tones of intense cobalt blue against a stark white background are fish and water plants whose flowing lines suggest undersea motion. A twelfth-century porcelain celadon ewer from Korea's Koryo dynasty is painted in a rich "kingfisher blue," the color of only the best twelfth-century porcelain. One final ceramic that should not be missed is an elegant Nishapur bowl from ninth- to- tenth-century northeastern Iran. Its interior rim is decorated with Arabic script in metallic black.

PRINTS AND DRAWINGS
Some forty thousand prints, drawings, and photographs are included in the collection of this department. Rotating exhibitions feature selections from these vast holdings. Although the strength of the collections lies in twentieth-century American art, the extraordinary print collection, begun in 1913, includes a superb group of works by Dürer, Rembrandt, and Goya, as well as German Expressionist prints, and late nineteenth- and early twentieth-century French prints.

EGYPTIAN, CLASSICAL, AND ANCIENT MIDDLE EASTERN ART THIRD FLOOR
Egyptian, classical, and ancient Middle Eastern artworks fill the museum's third floor. Displayed to emphasize aesthetic concerns and stylistic developments, the collection encompasses five millennia of art, from the Predynastic to the Coptic, and includes the West's largest collection of Aramaic papyri, which documents the life of a Jewish colony in Egypt during the fifth century B.C.

An early female figure from the Predynastic period, circa 3500–3400 B.C., is a surprisingly elegant and spiritual work. While the body is of a human female, the beaklike face and sweeping winglike arms are reminiscent of a bird. Found in a tomb, the statuette is an acknowledged masterpiece of ancient art.

The galleries also include Greek and Roman art and a notable selection of ancient Middle Eastern art.

COSTUMES AND TEXTILES FOURTH FLOOR
Changing exhibitions of costumes and textiles are on the fourth floor. Begun around the turn of the century with examples of lace and ecclesiastical garments, the costumes and textiles collections rapidly expanded with the addition of a rich variety of Eastern European costumes. Today, the holdings include spectacular Russian costumes, eighteenth-century European silks, a large collection of quilts, and important examples from European and American designers.

DECORATIVE ARTS AND PERIOD ROOMS
The focus of the Decorative Arts Department is a collection of twenty-eight period rooms that range from a 1676 Dutch house from the Flatlands section of Brooklyn to a 1920s Art Deco library from a Park Avenue apartment. In many instances, the entire first floor of a house has been installed, providing an accurate view of domestic life.

One of the most opulent displays is an 1883 Moorish Smoking Room from the John D. Rockefeller house in New York. Every inch of the room, from the Oriental rug on the floor to the Islamic motifs painted on the ceiling, swims with rich colors and swirling patterns. Stained glass, a polished bronze hookah, and elaborate candleholders reflect and add color and light, accentuating the sumptuous, mysterious ambience.

Exhibited along with the period rooms are selections from the museum's holdings of ceramics, glass, silver, pewter, metalware, and furniture.

While on the fourth floor, take a moment to peer down at the spectacular Beaux-Arts court on the third floor, with its classical elements and decorative lanterns designed by McKim, Mead & White.

FIFTH FLOOR

AMERICAN PAINTINGS

The Brooklyn Museum's noteworthy collection of American paintings includes fine examples of colonial portraiture, landscapes by artists of the Hudson River School, urban scenes by the American Impressionists, and works by early twentieth-century modernists and realists.

A favorite with visitors is Albert Bierstadt's *Storm in the Rocky Mountains, Mt. Rosalie* of 1866, a tremendous canvas that conveys all the drama and power of the Rockies. A very different view of nature is presented by John Singer Sargent's *Paul Helleu Sketching With His Wife* of 1889. In bright impressionistic colors and with a quick, loose brush, Sargent renders an artist working outdoors as he himself did during summer sojourns.

Orpheus *by Auguste Rodin, 1890; The Brooklyn Museum, gift of the B. Gerald Cantor Art Foundation*

EUROPEAN PAINTING AND SCULPTURE

Although the collection includes work of the early Italian Renaissance to the early twentieth century, the strength of these holdings lies in nineteenth-century French painting. Don't miss Claude Monet's *The Ducal Palace at Venice*, painted in 1908. The façade of the Doge's Palace dissolves into thickly applied blues, pinks, and purples that blend into the Venetian waters.

Complementing the French paintings is a collection of bronzes by Auguste Rodin. Numerous studies and figures from Rodin's *The Burghers of Calais* are installed in the Iris and B. Gerald Cantor Galleries in the museum's rotunda. The twisted and tormented figure of Pierre de Wiessant from the *Burghers* group is installed so that visitors can walk around the statue, observing it from every angle and marveling at Rodin's skillful manipulation of surface and reflection.

OUTDOOR SCULPTURE GARDEN

The museum's shady, tranquil Frieda Schiff Warburg Memorial Sculpture Garden contains one of the nation's earliest collections of architectural ornaments and stonework. These salvaged elements from old New York include decorative statuary from McKim, Mead & White's Penn Station, ornamental elements from Louis Sullivan's only New York building, and a mechanical roaring lion from Coney Island's Steeplechase amusement park.

During the summer, museum-sponsored jazz concerts are held in the sculpture garden.

LEFFERTS HOMESTEAD

95 Prospect Park West
Brooklyn, N.Y. 11215
718/965–6505

SUBWAY	D and Q.
BUS	B41 and B48.
HOURS	Noon to 4 P.M. Wednesday through Sunday, April and October through December; Noon to 4 P.M. Wednesday through Saturday, Noon to 5 P.M. Sundays and holidays, May through September; Noon to 4 P.M. Saturday and Sunday, January through March.
ADMISSION	Free.
SPECIAL EVENTS	Craft demonstrations, family workshops, adult courses, and seasonal special events.
AUTHOR'S CHOICE	Period rooms, first floor

A visit to the Lefferts Homestead gives you a chance to explore a historic farm house, enjoy hands-on museum exhibitions, pick herbs from a kitchen garden, watch crafts demonstrations and sheep shearing, and participate in family workshops and St. Nicholas Day celebrations. One of the few remaining Dutch-American farm houses in Brooklyn, it is located in Prospect Park on Flatbush Avenue, near the corner of Empire Boulevard.

HISTORY

During the Revolutionary War, American troops burned Lefferts Homestead to the ground to prevent British soldiers from occupying it. The homestead seen today was rebuilt from the charred ruins between 1777 and 1783 by Peter Lefferts, the son of Judge John Lefferts, a descendant of Pieter Janse Hagewout of Holland, who settled in Flatbush in 1660.

Peter Lefferts, a lieutenant in the Continental Army, became one of the wealthiest men in Kings County. The patriarch of a large family, he owned two hundred and fifty

Lefferts Homestead

acres of land and about a dozen slaves. He was a judge on the County Court of Sessions and Common Pleas, a trustee of the Dutch Reformed Protestant Church of Flatbush, and a delegate to the New York convention in Poughkeepsie in 1788, where the state ratified the U.S. Constitution. Upon his death in 1791, Lefferts left his homestead and farmland to his six-year-old son, John, who later became a state senator.

John Lefferts died in his forties, leaving his wife, Maria, and two young children, Gertrude, five, and John, Jr., three. Gertrude, who moved from the homestead when she married Judge John Vanderbilt, wrote a social history of Flatbush that included memoirs of the homestead. John, Jr., owned and lived at the homestead, as did successive generations of the Lefferts family.

In 1918, the family gave the homestead to the City of New York. The house was moved four blocks north, from 563 Flatbush Avenue to its present location in Prospect Park.

The homestead, which is operated by the Prospect Park Administrator's office, is currently undergoing phased restorations, including major repairs to the roof.

THE BUILDING

Like Dyckman House in upper Manhattan, this is a handsome example of Dutch-American architecture. Outstanding features are a center-split front door, and high, sloping gambrel roof with three dormers and deep eaves over a porch supported by slender columns. Bell-shaped roofs such as this allowed for tall, wide attic spaces. The Lefferts' attic houses a large, plastered smoke room.

The front door with circle and diamond-patterned glass windows and the elegant interior woodwork were added by successive generations of Lefferts, as were other architectural details typical of the Federal style. The rooms are symmetrically arranged off a central hall.

The interiors are furnished as they might have been in the early 1800s with period furniture, including a few Lefferts family heirlooms.

THE INTERIORS

The interiors are undergoing changes to reflect the Federal period, when the house was still a significant landmark in the tiny town of Flatbush. Pieces are moved or changed periodically, so furnishings mentioned may or may not be on view as described. Colors are authentic for the period covered. A tour guide points out the highlights.

FIRST FLOOR

PARLOR

This is an elegant room, typical of a "society family" that would have had the most fashionable furnishings in the 1820s. Important pieces are the handsome Empire sofa and the Federal period gilt-edged mirror above it; the tall clock that belonged to the Lefferts, and the fancy painted parlor chairs and side table.

FAMILY HALL

This is where the family ate their meals and gathered together to socialize around the hearth. Meals were taken in the alcove (the kitchen, now a caretaker's apartment, is adjacent) around a table similar to the eighteenth-century one seen here, which

is now accented by Sheraton chairs. Among the other furnishings are an Empire period sideboard, two Chippendale side chairs, and Hepplewhite wingback chairs in front of the hearth.

BEDROOM

The downstairs bedroom was meant to be seen by visitors and was, therefore, more elegantly appointed than those upstairs. (Today, the rooms upstairs are used for exhibitions and school visits.) Here, the four-poster bed is covered with a handsome, handloomed bed covering. The highboy is believed to date from the eighteenth century. A fireplace, angled in the corner, is one of three on the first floor of the house. On the second floor, only one of the four bedrooms was warmed by fireplace heat—a luxury in which even a family as wealthy as the Lefferts did not indulge in excess.

HALL

A fine Dutch *kas* (cupboard), made in New York in the early eighteenth century, stands in the second floor hall.

DISCOVERY ROOM

This aptly named room is the site of many activities, including regularly scheduled crafts demonstrations and "Weave-It-Yourself" workshops, that enable youngsters to enjoy accomplishments while discovering the past.

An eighteenth-century spinning wheel, which is still used regularly, is a focal point of the room.

MUSEUM

Changing exhibitions cover subjects in creative ways. For example, "A New Hat for the Homestead" focused attention on the restoration of the building's gambrel roof, making an analogy between hats and roofs. The Lefferts were among the largest slave holders in Kings County, and another exhibition, "Black Roots on a Brooklyn Farm," explored the lives and roles of their African-American slaves.

SECOND FLOOR

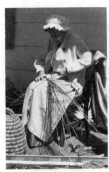

Craft demonstrations include basket making

AMERICAN MUSEUM OF THE MOVING IMAGE

35th Avenue at 36th Street
Astoria, N.Y. 11106
718/784–4520

SUBWAY	R.
BUS	Q101.
HOURS	Noon to 5 P.M. Tuesday through Friday; 11 A.M. to 6 P.M. Saturday and Sunday.
TOURS	Highlight tours for adults Wednesday through Saturday afternoons by appointment only.
ADMISSION	$5, adults; $4, senior citizens; $2.50, children and students with I.D.; members free.
HANDICAPPED FACILITIES	Accessible to the disabled. Handicapped entrance at side of building.
MUSEUM SHOP	Books, posters, notecards, toys, games, and jewelry related to the movies.
SPECIAL EVENTS	Lectures, symposia, demonstrations, and conferences.
MEMBERSHIP	From $35.
AUTHOR'S CHOICE	"Behind the Screen: Producing, Promoting, and Exhibiting Motion Pictures"

The American Museum of the Moving Image

Located far from the glamour and glitz of Hollywood, on the site of an early movie studio, the American Museum of the Moving Image (AMMI) offers an informative and entertaining look behind the scenes at producing, promoting, and exhibiting motion pictures, television, and video.

Interactive displays make learning about the complicated technology fun, and the delightful collection of tie-in merchandise—from a Gomer Pyle lunch box to Star Trek curtains—will appeal to anyone who has ever enjoyed a television show or fantasized about a movie star.

HISTORY

The museum is located across the East River from Manhattan on the site of the Astoria Studios, once the East Coast facility of Paramount Pictures. The studio opened in 1920, and was used for filming such legendary figures as Rudolph Valentino, W.C. Fields, the Marx Brothers, and Gloria Swanson.

From 1941 until 1971, the Army Signal Corps produced military training films here. The studios, which remained empty during most of the seventies, suffered the usual damage and vandalism inflicted upon abandoned buildings.

In 1977, the Astoria Motion Picture and Television Foundation, whose members included Queens Borough officials and members of motion picture labor unions, was

established to preserve the complex, and the studio was included in the National Register of Historic Places. Filming Sidney Lumet's $24 million musical *The Wiz* here helped to provide some of the funds for restoration.

Foundation members passed a resolution in 1981 to create a museum of the moving image on this site. A director was hired and ownership of the buildings was transferred from the federal to the city government. New York has leased the facility to George S. Kaufman, a developer who helped raise funds to refurbish what are now called Kaufman Astoria Studios.

The complex is a multimedia center for the production of feature films, television programs, and commercials. Movies produced on the site since restoration include *All That Jazz* and *Arthur*.

The museum opened September 10, 1988, to the kind of media attention usually reserved for the stars and films featured within.

THE BUILDING

The architectural firm of Gwathmey Siegel & Associates transformed one of the studio buildings into a museum. The white, reinforced concrete industrial-style building is now complemented by an airy concrete and glass staircase, visible at the back of the building, which sets it apart from the rest of the complex. Currently, three floors of the museum are open to the public, with a fourth floor and a courtyard planned.

RIKLIS THEATER FIRST FLOOR

The 195-seat Riklis Theater contains state-of-the-art projection and Dolby soundtrack equipment.

Rather than collecting and preserving television films, the museum offers ambitious film and video programs. They range from early silents to contemporary avant-garde films and are often organized according to theme, director, or actor. Recent examples include a John Ford retrospective and films about the New York woman in the postwar period. Visitors are urged to call for schedule information.

WARNER COMMUNICATIONS SCREENING ROOM

This fifty-seat screening room is used primarily for video programs, in addition to occasional video art installations.

GALLERIES

Changing exhibitions are housed in the first and third floor galleries. In the small first floor gallery, exhibitions are devoted to a specific theme, such as the work of famed set designer Tony Walton or an exhibition of early motion picture technology.

GALLERY SECOND

The museum's core exhibition, which is drawn from its FLOOR
permanent collection of over sixty thousand artifacts, is displayed on the second floor. The collection was amassed mainly through donations.

Walking into the core exhibition, "Behind the Screen: Producing, Promoting, and Exhibiting Motion Pictures," is like entering a theater. The lights are dimmed and light flickers from screens around the room. Although many of the exhibits

focus on world-famous Hollywood stars, a special effort is made to introduce visitors to the lesser known people and processes behind the finished products of movies and television.

Nam June Paik's *Get-Away Car* of 1988, an arresting commissioned piece, stands at the entrance to the gallery. Brightly colored video images flash across a bank of TV monitors arranged in the shape of a car, punning on the "moving" image. Nearby, the *Rolling Credits* video ceaselessly lists the types of professions that are detailed in the gallery displays.

Fantasy comes to life in the Magic Mirror. When you step in front of the mirror you see your head reflected on the body of movie icons, including Sylvester Stallone's *Rocky*, Marilyn Monroe in *The Seven Year Itch*, and Eddie Murphy in *Beverly Hills Cop*. In another exhibit, the viewer can match—or mismatch—sound effects with actions occurring onscreen in a television commercial.

A Mickey Mouse Club Mousegetar, Jr., 1955; American Museum of the Moving Image Collection

The promotional tie-ins on display offer something of interest to every generation, including movie star spoons from the 1920s, a *Gone With the Wind* cookbook, a Grace Kelly coloring book, a Mickey Mousegetar, and a Fonzie paper doll set. Costumes, such as Annie Hall's vest, hat, and tie, and Don Johnson's "Miami Vice" suit are also on view.

The set for Paul Newman's 1988 film, *The Glass Menagerie*, offers a chance to be in the scene, as well as behind it. Museum guides demonstrate lighting techniques on this simulated sound stage, which features sketches and scale models, as well as excerpts from the movie.

The various forms of exhibiting motion pictures are also explored. Tut's Fever, a forty-seat movie theater commissioned from Red Grooms and Lysiane Luong, was inspired by such classics as Grauman's Chinese Theater. It combines orientalist elements with famous Hollywood faces in cartoon fashion. A picture of Rita Hayworth decorates the seat covers, an ample Mae West presides over the concession stand, and James Dean makes an appearance as a mummy. Movie serials and short films are shown in Tut's Fever.

Jim Isserman's re-creation of an Op Art early sixties TV lounge features a plastic-covered, black-and-white cowhide sofa and a television set that replays vintage clips.

THIRD FLOOR GALLERY
The large third floor gallery hosts changing exhibitions. A popular recent exhibition was "Hot Circuits: A Video Arcade," the first museum retrospective of video games.

ISAMU NOGUCHI GARDEN MUSEUM

**32–37 Vernon Boulevard
Long Island City, N.Y. 11106
718/204–7088
718/721–7088 shuttle bus and tour information**

SUBWAY	N.
BUS	Q103 and Q104. Shuttle bus Saturdays from the Asia Society in Manhattan.
HOURS	11 A.M. to 6 P.M. Wednesdays and Saturdays, April through November.
TOURS	Call for information.
ADMISSION	Suggested contribution, $2 per person.
MUSEUM SHOP	Books, posters, postcards, and Noguchi's "Akari" lamps.
SPECIAL EVENTS	Films, including biographical films about Noguchi.
AUTHOR'S CHOICE	Garden fountain

*The Isamu Noguchi
Garden Museum*

A warehouse district in Queens seems an unlikely place for a sculpture garden. Yet it is the site of the tranquil Isamu Noguchi Garden Museum, one of the first museums of its kind dedicated to the work of a single artist. Noguchi, a trailblazer in art, was attracted to Long Island City by the easy availability of raw materials and space in which to work. Since then, other artists have moved here, making the area one of New York's most interesting new art centers.

BACKGROUND

Sculptor Isamu Noguchi, whose works melded East with West, was born in Los Angeles, November 17, 1904, the son of American and Japanese parents. Soon after his birth, the family moved to Japan, where he learned to use carpenter's tools and to make wood carvings.

Noguchi enrolled in Columbia University in New York in 1923 as a pre-medical student, working part-time and taking sculpture classes at the Leonardo Da Vinci School on the Lower East Side. His copies of classical casts earned praise from the school's director, who encouraged him to become a sculptor. By 1925, he had established a studio on University Place in Greenwich Village and was showing his work in academic exhibitions.

In 1927, the twenty-two-year-old Noguchi spent six months in Paris on a John Simon Guggenheim Fellowship as an apprentice to Constantin Brancusi. Brancusi's abstract sculptures had a profound influence on him. The wood, stone, and sheet metal abstractions he created in Paris were exhibited in New York in 1929 in Noguchi's first one-man show.

The following year, he traveled to China to study brush drawing and calligraphy, and spent six months in Japan,

studying Zen gardens and working with a noted potter. This experience led him to consider how earth could be sculpted and how sculpture might fit a natural environment.

After a stint in Hollywood as a portrait artist during the 1930s, Noguchi's art became socially conscious. He created a seventy-two-foot-long brightly colored mural in Mexico about Mexican history. In New York, in 1935, Noguchi built the first of approximately twenty stage sets for Martha Graham in a collaboration that lasted until his death. He also fabricated sets for dancer Merce Cunningham and the late choreographer George Balanchine.

Noguchi's ten-ton steel bas relief sculpture, *News*, installed over the entrance to the Associated Press headquarters in Rockefeller Center in New York in 1940, was his first large commission. During World War II, he voluntarily spent seven months in a Japanese-American relocation camp in Arizona, hoping to create landscape environments.

Noguchi returned to Japan in 1949, and, during the next three years, he created his first garden; began designing his first paper light sculptures, the famed Akari lamps; established a studio in Kamakura, and exhibited ceramics.

During the fifties, he became increasingly concerned with environmental art. As his international reputation grew, he was commissioned to design the UNESCO gardens in Paris, France, and to execute his first plaza in Fort Worth, Texas. He also exhibited his environmental designs and sculptures in iron, marble, balsa wood, and aluminum. In 1961, he began to work in Long Island City, in a building across the street from the present museum.

Red Cube, created in 1968, is probably the best known Noguchi work in New York. It is a twenty-four-foot-high steel sculpture balanced on a point in front of the Marine Midland Bank on Lower Broadway. Another outdoor Noguchi work in New York is a seventeen-foot-high basalt sculpture, installed south of the Metropolitan Museum of Art in 1979.

The prolific artist also designed playgrounds in Atlanta and Tokyo and fountains in Chicago, Detroit, Palm Beach, and Tokyo. In 1984, his *Bolt of Lightning*, a soaring stainless steel sculpture, initially proposed in 1933 as a memorial to Benjamin Franklin, was installed in Philadelphia.

In 1985, the Isamu Noguchi Garden Museum, designed and financed by the artist, opened in Queens. The following year, he exhibited his lamps, bronze playground models, and three large stone sculptures at the Venice Biennale.

Originally, Noguchi bought stones and sculpted them in Long Island. In later years, he used his Long Island studio for landscape and architectural projects. He traveled extensively throughout Europe and the Orient, selecting marble in Italy and sculpting in Japan. Noguchi's gardens, plazas, and sculptures can be seen in France, Germany, Israel, Italy, and Japan, besides the United States.

A fifty-minute biographical film at the museum shows the artist in action.

Noguchi died in New York City in 1988 at the age of eighty-four.

THE GARDEN MUSEUM
Twelve galleries and an outdoor garden bring together the many facets of Noguchi's lengthy career and show his artistic

development. More than two hundred and fifty sculptures of wood, stone, metal, and paper, as well as models, drawings, and photographs of his many gardens and plazas, are exhibited in twenty-four thousand square feet of display space. The works on view span a period of sixty years.

In explaining his reasons for the museum project, Noguchi wrote, "The museum shows in particular my own part in the widening ideas of environment starting in 1933; my experimental approach to structure and theatre during the 1940s, and my search for a sculpture outside the confines of the studio since then."

A view of one of the galleries

A map at the garden entrance identifies individual sculptures, and details of the artist's philosophy are explained on the informative museum tour.

A tranquil retreat from the workaday world, the garden soothes the spirit and delights the eyes. Among the cherry trees, ivy, birches, bamboo, pines, and trailing vines are many of the artist's late, rough-hewn, stipple-chiseled stone pieces, interspersed with an occasional sleek, sinuous marble shape.

A focal point is one of the artist's famous fountains, designed so that the water spreads over the surface before trickling down the sides. Nearby is a long stone spiral offered as a tribute to both the double helix (the molecule which is the basis of all life) and his early teacher, Brancusi.

The elegant, two-story museum, formerly a photo-engraving plant, occupies a triangular lot across the street from Noguchi's old studio. The artist purchased it in 1974 to use both as an office and as a warehouse for his sculpture. He enlarged the building before converting it into a studio and museum, investing approximately a million dollars of his own money, in addition to financial support from the New York Department of Cultural Affairs.

Among early Noguchi treasures to be found in the museum are his realistic sculpture, *Lynching*, of 1935; a photograph of the Mexican mural for which he received eighty-eight dollars; Chinese-inspired brush drawings, and the brass dress the sculptor designed for "Medea," a Martha Graham ballet.

A scale model of *Slide Mantra*, a ten-and-a-half-foot-tall spiral of white Carrara marble created for the 1986 Venice Biennale, combines humor and mysticism. It was designed so that viewers could climb up the stairs in back and slide down the front, which resembled an Eastern religious symbol.

Sketches and models for projects that were never realized are also displayed on the second floor.

QUEENS MUSEUM

New York City Building
Flushing Meadows-Corona Park
Flushing, N.Y. 11368
718/592–2405
718/592–5555 recorded information

SUBWAY	7.
BUS	Q48, Q58, and Q88.
HOURS	10 A.M. to 5 P.M. Tuesday through Friday; Noon to 5:30 P.M. Saturday and Sunday. Closed Monday. Call for summer hours.
TOURS	By reservation only. Call 718/592–9700.
ADMISSION	Suggested contribution $2, adults; $1, senior citizens and students. Members and children under 5, free.
HANDICAPPED FACILITIES	Accessible to the disabled.
MUSEUM SHOP	Exhibition catalogs, books related to museum exhibits, toys, and City Safari board game.
SPECIAL EVENTS	Films, videos, lectures, and other special events scheduled throughout the year.
SPECIAL FACILITIES	Theater.
MEMBERSHIP	From $25.
AUTHOR'S CHOICE	The Panorama of New York City

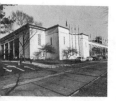

The Queens Museum

The centerpiece of the Queens Museum is the spectacular Panorama of New York City, a precise scale model of all five boroughs. At 9,335 square feet, it is the world's largest architectural scale model. Housed in the New York City Building, which served as the New York City Pavilion for both the 1939 and 1964 New York World's Fairs, the museum remains committed to exploring the impact of those international events, in addition to providing a variety of other fine art and cultural exhibitions.

The museum is dedicated to presenting visual arts and educational programming to the people of the New York metropolitan area—especially the ethnically and culturally diverse residents of Queens.

HISTORY
Although the Queens Museum did not open until 1972, its origins can be traced to the 1939 World's Fair. That fair provided a glimpse into a more prosperous and fantastic future for the United States as it was emerging from the Depression. Robert Moses, the New York City Parks Commissioner, shaped the fair and utilized its development to augment his greater urban planning schemes. The fair site was created from an expanse of burned garbage located at the geographic center of New York City, which is now known as Flushing Meadows-Corona Park.

Unlike the majority of temporary exhibition halls at the

1939 Fair, the New York City Building was designed as a permanent recreation facility. Skaters enjoyed the ice and roller rinks inside the building until 1946.

Then, in keeping with the international nature of the fair, but in a more serious spirit, the New York City Building hosted the United Nations from 1946 to 1950, before the peace-keeping organization's Manhattan headquarters opened. The ice and roller rinks were covered up during this time, but the building served again as a recreational facility from 1950 to 1961.

After three years of renovations, the New York City Building welcomed visitors during the 1964 World's Fair. The roller rink was covered with the Panorama, but the ice rink was still used. Between the close of the Fair in 1965 and the opening of the Queens Museum in 1972, the structure was open to the public under the auspices of the Triborough Bridge and Tunnel Authority for viewing the Panorama and for ice skating.

The idea of establishing a major Queens museum was initiated in early 1971 by the planning boards of the borough, who recognized the need for a cultural institution to call their own. The project was unique in its community-based genesis, as opposed to most museums, which are established through private endowments. August Hecksher, New York City's Parks, Recreation, and Cultural Affairs Administrator, gathered funds from the city budget to renovate the space and open the museum.

The inaugural exhibition of the Queens County Art and Cultural Center, as it was then known, took place on November 10, 1972.

THE UNISPHERE

Although not officially linked with the Queens Museum, the Unisphere is inseparable from the facility and its ties to the World's Fairs, and it certainly cannot be missed by any museum visitor. The Unisphere is a 140-foot tall globe comprised of hoops of steel, with representations of the continents applied upon them. It is circled by rings illustrating the orbits of three man-made satellites.

Designed by Gilmore Clarke for the 1964 Fair and funded by U.S. Steel, the Unisphere was the fair's theme center and logo, and has come to represent the borough of Queens, in general.

THE BUILDING

The New York City Building was designed for the 1939 Fair by Aymar Embury II, a parks department architect, and redesigned by Daniel Chait for the 1964 Fair. When approached from the Unisphere, the entrance to the museum is located at the right section of this U-shaped building. An immense indoor skating rink occupies the left section.

Unlike the whimsical designs of the 1939 Fair's temporary exhibition halls—like the trademark polka dots of the Wonder Bread wrapper on the Continental Baking Company building—the New York City Building alludes to the neo-classical style in architecture, while employing such modern materials as exterior glass brick walls.

The museum has two floors. The first floor houses a theater for lectures and films, a gift shop, and the Lobby Gallery

where changing exhibitions are displayed. These exhibitions continue into the East, West, Middle, and Panorama Galleries on the second floor. The Panorama, although laid out on the first floor, is visible only from the second floor balcony in the Panorama Gallery. Renovations planned for the early 1990s will significantly enlarge and change the present configuration of the galleries. The Panorama will be surrounded with a rising, clear staircase that will allow even greater visibility of its features.

THE COLLECTION

The Queens Museum has a constantly expanding permanent collection of over fourteen hundred works. Exhibitions are often based on objects owned by the museum, and the Panorama is supplemented by materials drawn from the collection. Items related to the New York World's Fairs, ranging from souvenirs to guidebooks and photographs are a primary concern. The museum also has a number of smaller scale models associated with the fairs, and art items related to New York City history and culture.

On long-term loan from the Metropolitan Museum of Art are 283 plaster casts of significant Classical and Renaissance sculptures. These pieces have been cared for by the museum's Cast Restoration Workshop since 1975, and are displayed at other Queens sites, such as the Bulova Corporate Center in Jackson Heights.

The permanent collection also includes works by twentieth-century New York artists and other contemporary artists and photographers, including Henry Moore, Robert Indiana, and Berenice Abbott.

EXHIBITIONS

The galleries on both floors are devoted to shows created by curators of the Queens Museum and traveling exhibitions sponsored by other institutions. In-house shows have included "Television's Impact on Contemporary Art" and "Remembering the Future: The New York World's Fairs from 1939 to 1964." "Art of the Fantastic: Latin America 1920–87" and "The New British Painting" are typical of shows organized by other museums and seen at the Queens Museum.

From its inception, the Queens Museum has been dedicated to enhancing the arts experience for visitors with mental and physical disabilities. As a result, the building is completely accessible to handicapped individuals. The "Please Touch" program opens the museum to the blind and the visually impaired through tactile objects like casts of sculptures and scale models of special exhibits.

Museum educators, assisted by specially trained docents, present many tours, lectures, films, and art workshops for school children. A special audiovisual "City Safari" program was developed for use with the Panorama, and on weekends the museum's educational staff presents special events, lectures, and films for both adults and children.

THE PANORAMA OF NEW YORK CITY

The 9,335-square-foot Panorama of New York City is a marvel of architectural models and an object of sentimental affection for both tourists and New York City residents. Robert Moses, the man who made New York City a smaller place by

The Panorama of New York City

constructing numerous bridges, expressways and parkways to connect the five boroughs and their surrounding communities, had the city reduced to a scale of one inch for every hundred feet for the delectation of fair visitors in 1964. Raymond Lester Associates was commissioned to undertake the project, which took over three years to complete. Queens Borough funds have been allocated to update the Panorama for its first major restoration since 1974. Private donations by developers and architects, of models of significant buildings they have designed, keep the city's skyline looking vibrant.

This model, known as the world's largest architectural scale model of an urban area, is constructed of wood, plastic, and foam. Special attention was devoted to the bridges, so important to Moses, which are constructed in brass. Over 865,000 buildings are represented on the Panorama. The lights conform to an elaborate system for pinpointing certain municipal facilities, such as police stations and fire headquarters. From time to time, the lights illuminating the Panorama dim, then darken and then become bright again, simulating New York City from dusk to night to day. Airplanes arrive and depart at LaGuardia Airport intermittently.

Maps labeling some areas are located around the balcony viewing area. None of the maps indicates "You are here," but Flushing Meadows-Corona Park is easily spotted to the southeast of LaGuardia Airport, near Shea Stadium.

The 1939 World's Fair featured a forerunner of the Panorama known as "The City of Light." This diorama (a two-dimensional representation, as opposed to a panorama, which is three-dimensional) sponsored by the Consolidated Edison Company of New York, Inc., depicted the day and night skylines of New York City and part of Westchester County.

The 1964 Panorama was created in celebration of the 300th anniversary of the British assuming control of New York City from the Dutch in 1664. It was originally paired at the 1964 Fair with a model created in 1931 by Charles S. Capehart and refurbished for the fair by Lester, representing New Amsterdam, as the city was known in the early seventeenth century. That model is now at the Museum of the City of New York.

ALICE AUSTEN HOUSE

2 Hylan Boulevard
Staten Island, N.Y. 10305
718/816–4506
716/727–2500 ferry information

SUBWAY	1, 4, 5, 9, N, and R; then Staten Island ferry.
BUS	M1, M6, and M15; then Staten Island Ferry; S51 from ferry terminal.
FERRY	Round-trip tickets from Battery Park, 50 cents, adults; free, children 5 and under.
HOURS	Noon to 5 P.M. Thursday through Sunday.
TOURS	Adult and school group tours by appointment. Other tours during public hours.
ADMISSION	Suggested donation $2.
MUSEUM SHOP	Books, Alice Austen photo postcards, and reproduction Victorian holiday ornaments and picture frames.
SPECIAL EVENTS	Concerts featuring turn-of-the-century music, nautical festivals, lectures on 19th-century life and the history of photography.
MEMBERSHIP	From $25.
AUTHOR'S CHOICE	Video on Alice Austen narrated by Helen Hayes Furnished Victorian parlor Landscaped grounds and garden

This historic house evokes the turn-of-the-century world of one of America's most remarkable photographers. Alice Austen pioneered, both as a woman and as a photographer who worked outside the confines of a studio, in producing realistic documentary photographs. Determined to capture all levels of society, she photographed a bucolic Staten Island and the bustling world beyond. Today, those scenes complement striking views of an urban skyline, the Statue of Liberty, and the graceful Verrazano-Narrows Bridge.

HISTORY
Originally a one-and-a-half-story farm house built around 1700, the cottage was purchased by Austen's grandfather, John Haggerty Austen, in 1844. He enlarged it and added the Gothic Revival gingerbread trim and gabled dormer windows. Alice's grandmother, Elizabeth Alice Townsend Austen named the property "Clear Comfort," signaling that all the joys of pleasure-loving Victorian life could be found here.

Austen's photographs make it easy to turn back the clock and recall the days when the rooms were filled with her family's flamboyant Victorian furnishings and bric-a-brac.

Austen lived here for seventy-nine years, from shortly after her birth in March 1866, until 1945. She and her mother, Alice Connell Austen (who kept her maiden name) moved into

The Alice Austen House, photographed by Alice Austen

the house after her father, Edward Stopford Munn of Great Britain, abandoned the family.

Besides Austen and her mother, the little cottage was also home to her mother's younger brother, Peter, and sister, Mary ("Aunt Minn") and Mary's second husband, Oswald Muller, a sea captain. As the only child, Alice, affectionately called "Lala," "Loll," or "Brat," was showered with attention. Uncle Oswald let the ten-year-old girl use a camera, and her entire family encouraged her interest by supplying costly equipment and becoming her favorite subjects.

By the 1880s, Austen was an accomplished photographer, producing beautifully composed pictures with clumsy cameras and glass plate negatives, in a complicated and time-consuming process. After composing her subjects and photographing them, she developed the pictures in a closet darkroom on the second floor. She also kept detailed notes on exposure, time of day, weather, light, and other conditions.

With more portable cameras available by the 1890s, Alice traveled outside Staten Island, around New York State and to Illinois and Massachusetts, photographing wherever she went. Her focus shifted to landscapes and her portraiture became more naturalistic. She traveled to Europe and took many pictures, but few photographs remain of these journeys. (Collectors who find glass plates with "EAA" scratched on them are urged to alert the Friends of Alice Austen House to any lost works.)

Through the years, Austen took more than seven thousand pictures, covering the entire social spectrum. She recorded the leisurely activities of what she called the "larky life" of Staten Island—the lawn tennis, bicycling, and fun and games of the well-to-do—as well as the dismal daily grind of shoeshine boys and news vendors in Manhattan.

Some of her most moving photographs concern the lives of newly arrived immigrants, a subject that fascinated her long before other photographers focused on the new arrivals. Her portrayal of women is interesting, too. Instead of being typically docile Victorian women, they appear to be eager participants enjoying life to the hilt. Another of her specialties was portraits of dogs, a subject that she particularly enjoyed.

Austen, who never married, lived on the income from her inheritance most of her life. After losing her savings in the stock market crash of 1929, when she was in her sixties, she—together with Gertrude Tate, her intimate friend for fifty-five years—struggled to save her life and her home. She tried to operate a restaurant at "Clear Comfort." When it

failed, she mortgaged and remortgaged her family home and was finally forced to sell it in 1945. She moved to a small apartment, then to several homes, and, finally, crippled with arthritis, entered the New York City Farm Colony on Staten Island, a pauper.

Remarkably, her glass negatives survived in the basement of the Staten Island Historical Society, where they were taken in 1945. The plates were discovered toward the end of her life and the sale of a few pictures provided payment for a nursing home where she spent her last years.

About two years before her death in 1952, *Life* published some of Austen's photographs. In 1976, she achieved belated recognition when a book, *Alice's World*, was written by the late Ann Novotny. This was followed by an exhibition at the South Street Seaport Museum that included Austen photographs of the thriving seaport at the turn of the century. In recent years, Alice Austen's reputation has been growing as one of the most gifted photographers of her time.

New York City restored the Austen house and grounds in 1985, at a cost of a million dollars. Austen's photographs served as a guide to landscaping the authentic Victorian garden visitors see today, planted with weeping mulberry, flowering quince, and other old-fashioned shrubbery. The photographs also provide useful details that aid the Friends of the Alice Austen House in their restoration of the rooms. The Staten Island Historical Society owns the Austen negatives and cooperates in exhibiting her works at the house.

In her desperate effort to survive, Austen sold her remaining furnishings for six hundred dollars. As a result, today's interiors have only remnants of their former glory. However, some surviving Austen pieces have been restored and placed in the house, along with other furnishings that reproduce settings during her "larky life."

EXHIBITIONS

Alice Austen's photographs mirror her life and times. Exhibitions, such as "Clear Comfort, Alice Austen's House as Seen Through the Eye of Her Camera," show the interiors of the house in its Victorian heyday; the "larky life" enjoyed by Austen and her friends, and views of her bedroom, the garden, and the harbor. In other exhibitions, the work of other photographers, such as Gertrude Kasebier and Frank Eugene, is shown, in addition to Austen images.

The site is also the scene of antiques fairs to benefit the restoration work, and special events in keeping with the Victorian atmosphere. These include special mother-daughter and fathers' events, and a "Pug Dog Day" that recalls Austen's beloved, much-photographed pug dog, "Punch."

GARIBALDI MEUCCI MUSEUM

Order of Sons of Italy in America
420 Tompkins Avenue
Staten Island, N.Y. 10305
718/442–1608
718/727–2500 ferry information

SUBWAY 1, 4, 5, 9, N, and R; then Staten Island ferry.

BUS S103 or S104 from M1, M6, and M15; then Staten Island ferry; Ferry terminal.

FERRY Round trip tickets from Battery Park, 50 cents, adults; free, children 5 and under.

HOURS 9 A.M. to 5 P.M. Tuesday through Friday; 1 P.M. to 5 P.M. Saturday and Sunday. Closed Monday and major holidays.

ADMISSION Free.

HANDICAPPED FACILITIES Ramp access to the building from the sidewalk.

SPECIAL EVENTS Videotape screenings, concerts, and lectures.

SPECIAL FACILITIES Reference library and archives open by appointment.

AUTHOR'S CHOICE Garibaldi's red shirt and wire frame glasses, ground floor.

This modest Gothic Revival house pays tribute to two great men of Italian heritage. It was the home of the inventor Antonio Meucci, from 1850 to 1889, and of the patriot, Giuseppe Garibaldi, from 1850 to 1854.

The Garibaldi Meucci Museum

HISTORY

One of the earliest occupants of this house was Max Maretzek, an Austrian opera director and impresario, who lived here when his company was performing in New York.

For fifteen years, the Florentine-born Meucci and his wife, Esterre, were employed by the Tacon Opera in Havana, Cuba, as superintendent of mechanics and wardrobe mistress. When they moved to New York in 1850, Maretzek told them that the house was available. Lorenzo Salvi, leading Italian operatic tenor of that period, also made his home with the Meuccis for several years.

Meucci bought a candle factory on Staten Island and continued his earlier experiments on new uses for electricity, especially in transmitting the human voice over electrical wires. In his spare time, he was active in groups supporting Italian patriotic causes.

Meanwhile, the great Italian patriot Garibaldi, following his family tradition, went to sea and became a sea captain in 1832. (Garibaldi had been born in Nice, which was then part of France, but later became part of the Kingdom of Sardinia.)

In 1836, Garibaldi joined the revolutionary leader Giuseppe

Mazzini in the unsuccessful insurrection of Genoa. Condemned to death, Garibaldi fled to South America, where he lived in exile until 1848 and fought against Brazil as a guerilla leader for the state of Rio Grande do Sul. He also commanded the Italian legion for the republican Uruguayans against Argentina. In South America, Garibaldi married the first of his three wives, Anita Ribeira de Silva.

With the spirit of nationalism sweeping across Europe in the 1840s, Garibaldi returned to Italy to join revolutionary forces in 1848. He helped the Milanese fight the Austrian government in Lombardy and continued to wage war against Austria with a small group of friends. In Rome in 1849, he supported Mazzini's Roman Republic forces, which were defeated.

Forced to flee again, he came to New York in 1850, in poor health and mourning his wife, who had died in the retreat from Rome. Meucci befriended him and helped him to recuperate. The two men worked in Meucci's candle factory and enjoyed a close friendship.

Garibaldi planned to become an American citizen, but, restored to health, he sailed on voyages to South America, China, and Australia as a merchant sea captain. In 1854, he returned to Italy, in charge of the red shirt volunteers whose victories led eventually to Italy's unification and establishment as a nation.

After declining an offer from President Abraham Lincoln to take a command in the American Civil War, Garibaldi continued to fight for Italian independence and for various patriotic causes. He made his home on Caprera, a barren island near Sardinia, where he wrote novels before his death in June 1882.

At home in Staten Island, in 1858, Meucci's experiments produced a working model of a telephone. He received a *caveat,* or preliminary patent, in 1871. Meucci had experienced great setbacks—his business partner defrauded him, his wife became ill, and he was severely burned during a ferry explosion. He no longer had funds to finance further development of his telephone or to renew the costly patents. When Alexander Graham Bell secured his telephone patent in 1876, Meucci and his friends tried to prove prior claim through court proceedings. Despite their efforts, however, Meucci died in poverty in 1889, unrecognized as the inventor of the telephone.

THE MUSEUM

A city, state, and national landmark, this frame house was constructed in Gothic Revival style during the 1840s.

Garibaldi's death in 1882 prompted a group of Italian Americans to organize a tribute to him. In a ceremony attended by Meucci, they installed a marble plaque over the front door of the house in 1884. After Meucci's death five years later, his landlord and friend, Frederick Bachmann, donated the house to the Italian community to be preserved as a memorial to Garibaldi.

In 1907, with funds raised by the Garibaldi Society, the house was moved from the nearby countryside to its present site and a pantheon was built over it. The Order of Sons of Italy in America, which acquired the property in 1919,

maintains it with the help of city, state, and local governmental funding.

The pantheon was removed in 1952, and the building was restored. It was dedicated in 1956 as the Garibaldi Meucci Museum.

THE EXHIBITIONS

The history of Garibaldi and Meucci is well documented through exhibits here. A display to the left of the entrance is devoted to Garibaldi, with prints and old newspaper clippings describing the patriot's life and career as a military leader. You can see his eyeglasses and the type of red shirt worn by Garibaldi and his followers.

Meucci's artifacts are displayed to the right of the entrance. Here are his death mask and his rocker made of vines and twigs, as well as photographs of the museum in various stages of development. One photograph, showing the house with the pantheon around it, is particularly interesting.

A changing photographic exhibit in the center hall occasionally deals with an aspect of immigrant life.

Upstairs is a faithful re-creation of Garibaldi's bedroom. All of the furniture and the potbelly stove—although not here originally—would have been found on Staten Island around 1850 to 1860. The shotgun on the wall was used by Garibaldi when he went hunting with Meucci. The two men also sailed and fished together. Because Garibaldi had a large number of visitors, there are a great many chairs in this otherwise sparsely furnished room.

The library on this floor houses a large collection of English and Italian books about Garibaldi, as well as volumes on music, the arts, and travel.

JACQUES MARCHAIS CENTER OF TIBETAN ART

338 Lighthouse Avenue
Staten Island, N.Y. 10306
718/987–3500
718/987–3478 recorded information
718/727–2500 ferry information

SUBWAY	1, 4, 5, 9, N, and R; then Staten Island ferry.
BUS	M1, M6, and M15; then Staten Island ferry; S113 from ferry terminal.
FERRY	Round-trip tickets from Battery Park, 50 cents, adults; free, children 5 and under.
HOURS	1 P.M. to 5 P.M. Wednesday through Sunday, April through November; by appointment all year.
TOURS	Guided group tours for children and adults available by appointment all year.
ADMISSION	$2.50, adults; $2, senior citizens; $1, children.
MUSEUM SHOP	Books, jewelry, posters, tapes, and gift items from the Far East.
SPECIAL EVENTS	Music and dance programs, 2 P.M. Sundays, April through November.
MEMBERSHIP	From $20.
AUTHOR'S CHOICE	Eleven-headed statue of Chenrezig, Bodhisattva of Compassion

The Jacques Marchais Center of Tibetan Art presents its treasures in a religious setting that enlightens the visitor about an endlessly fascinating, centuries-old culture. A terraced meditation garden adds to the museum's otherworldly charms.

HISTORY

The museum was built in 1947 by Mrs. Harry Klauber, the former Edna Coblentz, to house her collection. A Midwesterner, Mrs. Klauber developed an interest in Oriental art as a child when she discovered thirteen Tibetan figurines in the attic of her home. The pieces, on view today, belonged to her great-grandfather, who had brought them from Darjeeling, India.

By the 1930s and 1940s, Mrs. Klauber had an Oriental art gallery on Madison Avenue in New York City and a new name, Jacques Marchais. Interestingly, she managed to build her Tibetan art collection without ever leaving this country.

The Tibetan lamas had been counselors to the Chinese emperors from the thirteenth century to the C'hing dynasty (1644–1912), and there were many Lamaist temples and monasteries in Beijing. Their contents were sold when the temples were shut down in the 1920s and 1930s. Mrs. Klauber also purchased major pieces from other dealers and collectors

in the United States, as well as from the collection of Sven Hedin, a Swedish explorer and Orientalist who had displayed his works in the "Century of Progress Exposition" in Chicago in 1932.

As Mrs. Klauber sold her Oriental objects, she kept her Tibetan works for herself and built a showcase for them in Staten Island—two compact Tibetan-style gray stone buildings with high windows, cedar canopies and posts. (In mountainous Tibet, high windows allow light to enter when snowdrifts cover much of the lower portion of a building.) Her home was next door. The museum opened on October 5, 1947, and *Life* Magazine wrote about its dedication. Mrs. Klauber died early in 1948, having been ill for some time.

The serene garden is a lovely place to pause, enhanced with the flowing lines of *Meditation Arbor* by Elizabeth Egbert, a contemporary sculptor. Her aesthetically pleasing weathered piece is a bench, as well as a work of art. Metal and stone animals and statues of Buddha are tucked among the greenery and near the tree-shaded lotus pool.

THE MUSEUM AND COLLECTION

In this largely residential area, a discreet sign on Lighthouse Hill marks the museum, which is entered through the gift shop and former library with its red-lacquered, intricately carved table and chairs. Nearby, in contrast, stands a handsome rosewood desk with delicate inlays. The library is now used as an office.

Beyond is the museum, which duplicates a Tibetan mountain temple, layered with colorful religious paintings and bronze images. The setting is an appropriate background for the Eastern religious art on view.

The Jacques Marchais Center of Tibetan Art

Approximately two hundred objects from Mrs. Klauber's collection are displayed here. A mélange of Tibetan, Sino-Tibetan, Chinese, Mongolian, and Nepalese pieces, they date mainly from the seventeenth to the nineteenth century. The Shi Khro Shinje painted wood figures, however, may have been crafted as early as the fourth to eighth centuries.

The centerpiece is an authentic, consecrated three-tier altar

filled with religious objects. Three-foot high, gilded deities crown the tiers that are filled with statues, offering bowls, conch shells, cloisonné urns, incense holders, and handsomely inlaid chests. A chart nearby contains a sketch and simple descriptions of the pieces, and a docent is on hand to provide more details.

Here are a few of the altar highlights:

The three largest statues on top are: to the left, Maitreya (the Buddha of the future); right, Avalokitesvara Padmapani (Bodhisattva of compassion, of whom the Dalai Lama is believed to be a manifestation); and in the center, Tsong Khapa (fourteenth-century monk and founder of the yellow hat sect to which the Dalai Lama belongs). The white scarf on the statue is a traditional gift to show respect to dignitaries or high religious figures.

To the far left of the altar is an elaborate bejewelled prayer table and bench. The vivid paintings above the altar and elsewhere are *tankas*, depicting deities, their helpers, and various religious symbols. They are used as an aid in meditation.

Pema Wangyal, a Tibetan *tanka* painter and conservator, works with traditional natural paints and herbal solutions to keep the *tankas* continually in top condition, repairing other objects as well.

Displayed in glass cases are Buddhas and multi-armed, multi-headed deities in brass, bronze, and copper, including the eleven-headed Chenrezig (in a case to the left of the altar), another rendition of the Buddha of compassion. The cloth fragments on the deity indicate that, originally, the figure was lavishly dressed. Elsewhere, the wrathful deity, Hayagriva, with six arms and three heads, protects against serious illnesses, perhaps by frightening away the deities that cause them.

Hayagriva, *Jacques Marchais Center of Tibetan Art Collection*

The thirteen original figurines that inspired the collection are seen in their own glass case as you enter. A display case to the right of the entrance is filled with children's clothing and toys. In another corner is an elaborate dragon-gilded Japanese Buddhist home shrine.

The eighteenth-century Nepalese wall plaque in a case to the left of the main altar, near the entrance, is a prize crafted of copper, silver, and semi-precious stones on wood. Nearby, are a handsome wooden crown and hair ornaments. Among the enameled cloisonné pieces, brightly colored ceremonial masks, and silver-edged ritual objects displayed around the room are handsome silver ceremonial implements that were the property of a previous Panchen Lama. The Panchen Lamas were considered to be the second highest ranking lama in Tibet after the Dalai Lama.

An informative video offers an explanation of the Tibetan people and their culture, which suffered greatly when Tibet was annexed by China, especially during the Cultural Revolution. Religious objects were destroyed, as well as thousands of temples and monasteries. As a result, this small museum in suburban Staten Island has become one of the most important resources in the world for Tibetan culture, which is in danger of disappearing in its own land.

RICHMONDTOWN RESTORATION

441 Clarke Avenue
Staten Island, N.Y. 10306
718/351–1611
718/727–2508 ferry information

SUBWAY	1, 4, 5, 9, N, and R; then Staten Island ferry.
BUS	M1, M6, and M15; then Staten Island ferry; S4 and S113 from ferry terminal.
FERRY	Round-trip tickets from Battery Park, 50 cents, adults; free, children 5 and under.
HOURS	10 A.M. to 5 P.M. Monday through Friday; 1 P.M. to 5 P.M. Saturday and Sunday.
ADMISSION	$4, adults; $2.50, senior citizens, students with I.D., and children aged 6 to 18; free, children under 6.
HANDICAPPED FACILITIES	Accessible to the disabled.
FOOD SERVICE	Available.
MUSEUM SHOP	Maps, books, handcrafted leather, tin, pottery, baskets, jewelry, and gift items.
SPECIAL EVENTS	County fair Labor Day weekend; harvest festival third Sunday in October.
MEMBERSHIP	From $20.
AUTHOR'S CHOICE	Voorlezer's House

New York's only restored village and outdoor museum complex, set on a hundred-and-three wooded acres, features twenty-nine buildings dating to the 1600s. Period exhibits of Dutch furnishings, antique toys, vehicles, costumes, and memorabilia bring the buildings to life, as costumed interpreters reenact the daily tasks of Staten Island farmers, merchants, and tradesmen. Eventually, thirty-five buildings and sites will be restored; fifteen buildings are now open to the public.

HISTORY

The original settlement, established in the 1690s, was known as Cocclestown because of the oysters and clam shells, or cockles, found here. By the 1730s and throughout the eighteenth century, the centrally located Richmondtown, as it had become known, was the principal village, political center, and seat of government of Staten Island.

The village was partially destroyed when the British occupied Staten Island during the Revolutionary War. In later years, as New York City grew, and Staten Island's north and east shores were developed, there was little growth in Richmondtown. When Staten Island became part of New York City in 1898, Richmondtown—no longer a county seat—became a quiet, residential enclave. Since there had been few

changes through the years, the property was ideal for restoration.

The restoration project is jointly sponsored by the Staten Island Historical Society and New York City, which owns the land and buildings. The Historical Society's museum, located in the former County Clerk's and Surrogate's Office, presents continuing exhibitions, including "Made on Staten Island," a large exhibit about the economic history of the island. The society also maintains its Museum of Childhood in the Bennett House.

THE TOUR

Stop first at the Visitors Center, to pick up a map and other information about Richmondtown. Formerly the third County Courthouse, this 1837 structure is a fine example of Greek Revival architecture. Its halls are filled with exhibits highlighting local history.

Allow about one-and-a-half hours to visit the main attractions. The sites listed here are not in chronological order but follow a typical visitor's route, depending upon the scheduled days. The numbers correspond to those on the visitors' map.

An interpreter working on needlepoint in the Stephens-Black House

STEPHENS-BLACK HOUSE AND GENERAL STORE (30)

Located in back of the Visitors Center, the modified Greek Revival-style house, originally built between 1838 and 1840, was part of a residential area planned to blend with the neighboring site. The original occupants, the Stephen D. Stephens family, lived here and operated a general store until 1870. They were succeeded by the Joseph and Mary Black family, who occupied the house until 1915. The building is a 1964 reconstruction of a mid-nineteenth-century structure.

In the sewing room, visitors can see demonstrations of artistic stitching, and can also admire intricately patterned, century-old framed needlework on the walls. The sewing machine was manufactured in 1863.

The interiors of both the parlor, with its tiny tea set accenting the marble mantel, and the dignified dining room, are typical of the 1860s. From the latter, there was access to the General Store and Post Office. Entry now is through the main door to the side of the house.

The store's wide variety of merchandise—buttons, bows, laces, hurricane lamps and candles, foot warmers, hardware, yard goods, and food—is typical of items sold around 1910. Proximity to the Court House, and one of the first telephones in the area added to the store's popularity.

COLON STORE (31)

Built between 1840 and 1850, this was originally a general store on Woodrow Road, operated by James and Mary Colon. In 1913, the building was moved to a farm in Pleasant Plains, where it was used as a storage shed. Brought back to Richmondtown in 1969, it was converted into a tinsmith's shop of the 1860s. It is staffed by a tinsmith who demonstrates his craft and explains the history of various tin objects in the shop, including "his and her" tin bonnets.

ELTINGVILLE STORE (29)

Behind the Stephens-Black House, visitors can see a typical print shop of the mid-nineteenth-century. Originally built around 1860 as a one-room grocery store, it was later a woodworking shop on Amboy Road in Eltingville and was moved here in the early 1960s.

CARPENTER'S SHOP (28)

This 1966 re-creation of an 1835 building reproduces a rural carpentry shop. It was created from the kitchen wing of the Decker-Bender farmhouse, which was originally located in New Springfield.

BENNETT HOUSE (27)

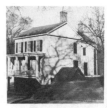

This Greek Revival house, dating from around 1839, and its 1854 addition, was owned by a wealthy shipping merchant, John H. Bennett, and his family from the late 1840s to the early twentieth century. During part of that period, the house had a bakery in the cellar. The cellar is now the Richmondtown Snack Bar, specializing in fresh baked goods.

The Bennett House

The Staten Island Historical Society's Museum of Childhood is housed here, with antique toys displayed on two floors. In the parlor, fashionably dressed dolls are placed on chairs and in carriages. Upstairs, dolls share space in glass-enclosed cases with some of the oldest objects in the collection—trains and games, educational toys, a replica of "The Old Woman Who Lived In a Shoe," miniature tea sets, slates, and other school supplies. Children's clothing is also on view. In the adults' bedroom on the second floor, the furniture includes a cradle and a bed covered with a knitted spread.

GUYON-LAKE-TYSEN HOUSE (24)

This four-bedroom Dutch Colonial house—an excellent example of its genre—is Richmondtown's showcase for domestic arts. The oldest portion was built around 1740. The kitchen was added in 1820 and the dormers date from around 1840.

Moved to this site from Staten Island's New Dorp-Oakwood neighborhood, the interiors are noted for their elegant paneling. The rooms echo the styles of the mid-eighteenth to late-nineteenth centuries, and include a formal parlor, a bedroom, and a fully equipped kitchen, which is sometimes the source of delicious aromas from hearth- or brick-oven baked goods.

Delft tiles embellish the parlor fireplace, and the pagoda-shaped desk shows the era's fascination with Oriental decor. Bristol tiles are seen in the bedroom. The bed, a reproduction, is covered with a spread that was spun and woven on the huge wheel used here for home textiles.

REDWARE POTTERY (24A)

Another craft, making red earthenware pottery, is demonstrated in the cellar of the Guyon-Lake-Tysen House.

KRUSER-FINLEY HOUSE (21)

Built around 1790, with an 1820 addition and an 1850–60 shop, this building now houses a saddlemaker, trunk, and harnessmaker's shop of the 1830s. Among the items made

here are shoes which have no right and left shapes. They adapted to fit the feet as the wearers walked in them. Costumed staff members who wear these shoes claim they are both comfortable and long-lasting.

The adjoining rural, Dutch-influenced house, which was moved here from Egbertville in 1965, is closed for restoration.

BASKETMAKER'S HOUSE (23)

This typical Dutch farm house near the mill pond was built between 1810 and 1820. Moved from New Springfield in 1965, it re-creates a typical nineteenth-century Methodist household in which basketmaking was an important means of acquiring additional income. Various other family activities and household chores can also be seen here.

VOORLEZER'S HOUSE (10)

One of the earliest and most important buildings in Richmondtown, this house, built around 1695, boasts notable Dutch-style windows of multi-paned, tinted glass. Angled to admit maximum light, they are reminiscent of the windows in a Vermeer painting.

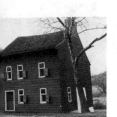

The Voorlezer's House, the oldest surviving elementary school in the United States

The *voorlezer*, or lay minister and teacher, lived, taught, and preached in this simple home until 1701. Built by the Dutch Reformed Church, it is said to be the oldest surviving school house in the United States, and is a National Historic Landmark.

An eighteenth-century kitchen, a root cellar, and a sanctuary are additional attractions.

DUTCH REFORMED CHURCH (8)

The church that played such an important role in the lives of early settlers is now only a shape on the visitors' map. Built around 1769, the church was destroyed as a rebel site by the British in 1776. It was rebuilt in 1808 and served as a house of worship until 1880, when it was abandoned. It was later moved and demolished.

BOEHM HOUSE (11)

An exhibit, "Discovering Boehm House," shows traditional building methods, together with modern restoration, conservation, and historic preservation techniques. The house was built around 1750 and has an addition that dates from around 1840.

TRANSPORTATION MUSEUM (32)

Designed to resemble a nineteenth-century carriage house, this building, erected in 1967–68, houses the Richmondtown gift shop.

SNUG HARBOR CULTURAL CENTER

1000 Richmond Terrace
Staten Island, N.Y. 10301
718/448–2500
718/727–2500 ferry information

SUBWAY	1, 4, 5, 9, N, and R; then Staten Island ferry.
BUS	M1, M6, and M15; then Staten Island ferry; S40 from ferry terminal. Snug Harbor Trolley runs from Staten Island Ferry Ramp F. Adults, $1; children under 12, free when accompanied by adult.
FERRY	Round-trip tickets from Battery Park, 50 cents, adults; free, children 5 and under.
HOURS	*Grounds* open daily dawn to dusk. *Newhouse Center for Contemporary Art* galleries open Noon to 5 P.M. Wednesday through Sunday. *Art Lab* open 10 A.M. to 5 P.M. Monday through Friday; 1 P.M. to 5 P.M. Saturday and Sunday. *Staten Island Botanical Garden* open daily 1 P.M. to 5 P.M. *Staten Island Children's Museum* open 2 P.M. to 5 P.M. Wednesday through Friday; 11 A.M. to 5 P.M. Saturday, Sunday, and holidays. Summer hours: 1 P.M. to 4 P.M. Tuesday through Friday; 11 A.M. to 5 P.M. Saturday, Sunday, and holidays.
TOURS	2 P.M. Saturday and Sunday.
ADMISSION	Grounds, free; galleries, $1 suggested donation.
HANDICAPPED FACILITIES	Most buildings accessible to the disabled. Occasional sign-interpreted gallery talks and events.
FOOD SERVICE	Melville's Café open Wednesday through Sunday.
MUSEUM SHOP	Jewelry, scarves, books, catalogs, posters, and objets d'art.
SPECIAL EVENTS	Films, concerts, lectures, ethnic festivals, and free outdoor concerts.
MEMBERSHIP	From $20.
AUTHOR'S CHOICE	Greek Revival architecture Newhouse Center for Contemporary Art

A former refuge for retired sailors is now a haven for the arts. This unusual cultural center offers a full schedule of visual and performing arts programs, including concerts, recitals, and contemporary art exhibitions. Temple-like nineteenth-century Greek Revival buildings set in an eighty-acre park, botanical gardens, museums, and outdoor sculpture are additional attractions.

A stained glass window in the main hall, a memorial to the founder of Sailors' Snug Harbor

HISTORIC HARBOR PARK

Snug Harbor is part of New York City's Harbor Park, formed by the New York State Office of Parks, Recreation, and Historic Preservation. Harbor Park encompasses six waterfront sites that played an important role in the city's development—

Snug Harbor, Battery Park, Ellis Island, Liberty Island, South Street Seaport, and Fulton Ferry/Empire Stores. Eventually, they may be served by a special Harbor Park ferry. Currently, each Harbor Park site offers activities that make New York's waterfront an important recreational resource.

HISTORY

Sailor's Snug Harbor, founded in 1801 by Robert Richard Randall, was the first maritime hospital and home for retired seamen in the United States. After spending their lives at sea, when they retired, seamen often found themselves adrift without family, pensions, or home. Among Snug Harbor's governors was Thomas Melville, the brother of author Herman Melville. The author, who was a frequent visitor, may have drawn inspiration from sailors' tales for his own stories.

Overlooking New York Bay, Snug Harbor includes twenty-eight historic buildings. The current restoration project is designed to make the structures suitable for a variety of cultural and artistic presentations, including contemporary art, sculpture, concerts, and theatrical productions. Buildings not designated as museums or performance spaces will become studios and temporary housing for artists.

The first building was erected in 1831. Centrally placed in the first row of landmark structures, it is considered to be one of the finest examples of Greek Revival architecture today. Other examples of Italianate Revival, Beaux Arts, and Gothic Revival are scattered over the tree-shaded grounds. Architectural and ornamental details have been carefully preserved.

The historic buildings were nearly demolished in the 1960s by the Sailor's Snug Harbor trustees, in an effort to create more efficient space for the geriatric home and hospital. The city designated the site a landmark, but the trustees continued to plead their case in court for several years. Finally, the city purchased the property as a park and cultural center for Staten Island.

Since 1976, when the center was established, some of the buildings have been reopened. However, other badly deteriorated structures are still not ready.

ART LAB

Staten Island's leading independent art school offers classes for adults, teens, and children in fine arts, crafts, and photography. The Community Gallery mounts nine exhibitions annually. Call 718/447–8667 for information on exhibitions and class registration.

NEWHOUSE CENTER FOR CONTEMPORARY ART

The oldest of the Greek Revival buildings, this was originally the main hall of Sailor's Snug Harbor. It is now the site of changing contemporary art exhibitions and summer outdoor sculpture shows.

The building was the seamen's first stop at Snug Harbor. Two glowing stained glass panels symbolically mark the passage to their new life. Over the front entrance, a panel depicts storm tossed ships at sea. Above the rear door, which led to their quarters, the stained glass scene shows sailing on calm seas—the life seafaring men would enjoy at Snug Harbor.

Storm tossed ships at sea depicted in a stained glass window in the main hall

THE GREAT HALL
One hundred and fourteen feet long, with thirty-five-foot-high vaulted ceilings, this impressive space, restored for use as a formal hall, is available for private functions. The built-in benches were part of the original seating when this was the sailors' reading room, and many nautical ornamental touches remain from those days.

VETERANS MEMORIAL HALL
A small Italianate chapel is now an intimate recital hall. Musical performances here range from jazz to choral groups and opera.

MUSIC HALL
Behind the first group of buildings, the structure with Ionic capitals is the old music hall. A contemporary of Carnegie Hall, it is a rare example of an intact music hall from the 1890s. Opened in 1892, it was a vaudeville house with a shallow stage, a small orchestra pit, and seating for six hundred sailor-residents. A film booth was added in 1911 for screening silent films and, later, talking motion pictures.

The building is now undergoing a $12 million restoration and transformation. When completed, it will have expanded stage and backstage areas, as well as a terrace, glass-enclosed lobby, and rehearsal room.

Photographic displays show the old hall decorated with the classical details typical of nineteenth-century music halls. A distinctive plaster frieze of Orpheus and the Muses sets off the proscenium. Painted green with buff and gilt accents, the hall must have been a handsome sight under flickering gas lights. In 1902, the interiors were redecorated in quasi-Art Nouveau style to blend with the classical themes. Now greatly deteriorated, the task is to retain the classicism of the elegant landmark while making needed additions.

STATEN ISLAND BOTANICAL GARDEN
The Staten Island Botanical Garden is a separate showcase within Snug Harbor Park. An English perennial garden and formal annual displays are outdoors, while greenhouses are abloom with tropicals and orchids, specimen trees, and shrubs.

STATEN ISLAND CHILDREN'S MUSEUM
STATEN ISLAND INSTITUTE
OF ARTS AND SCIENCES
Both of these museums are described elsewhere in this book.

STATEN ISLAND CHILDREN'S MUSEUM

1000 Richmond Terrace
Staten Island, N.Y. 10301
718/273–2060
718/727–2500 ferry information

SUBWAY	1, 4, 5, 9, N, and R; then Staten Island ferry.
BUS	M1, M6, and M15; then Staten Island ferry; S40 or Snug Harbor Trolley from ferry terminal.
FERRY	Round-trip tickets from Battery Park, 50 cents, adults; free, children 5 and under.
HOURS	1 P.M. to 5 P.M. Wednesday through Friday; 11 A.M. to 5 P.M. Saturday and Sunday. Closed Monday and Tuesday.
ADMISSION	$2.
HANDICAPPED FACILITIES	Accessible to the disabled.
MUSEUM SHOP	Toys, books, art materials, and science kits.
SPECIAL EVENTS	Workshops every week and performances three times each month.
MEMBERSHIP	From $35.
AUTHOR'S CHOICE	Storytelling gallery

On the grounds of the eighty-acre Snug Harbor Cultural Center, an old, Italianate building has been transformed into a high-tech setting for imaginative, interactive exhibits that help youngsters and their parents discover the world around them.

HISTORY

The Staten Island Children's Museum, which was founded in 1974, opened in Snug Harbor in 1986. The museum's home was originally the maintenance building, dating from the period when Snug Harbor was a haven for aged sailors. It was the first structure to be restored when the cultural center was established.

About half of its eighty thousand visitors each year are school children, who usually make something to take home as a souvenir of their visit.

Four galleries feature interactive exhibitions on topics ranging from News and the Media, to Insects, to Storytelling. Museum interpreters explain hands-on exhibits, and guest artists perform in puppet shows, mime, dance, drama, concerts, and storytelling sessions. Family workshops give children and their parents an opportunity to learn while working together.

The museum's imaginative installations and programs have led to awards from the American Graphics Institute, the New York Alliance for the Arts, the American Association of

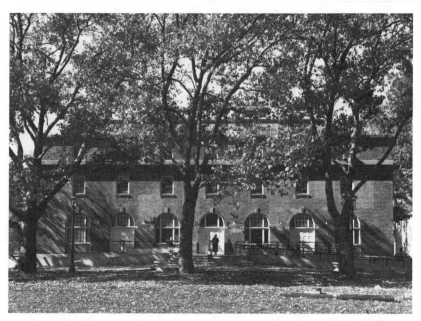

The Staten Island Children's Museum

Museums, the New York State Council on the Arts, and the Governor's Arts Award.

EXHIBITIONS

Changing exhibitions increase children's knowledge of everyday events. In "It's News To Me—What and Who Makes News," youngsters learn how information is transformed from an event to the printed page, with interactive displays devoted to gathering news, editing, and transmitting information.

A stylized forest of seven-foot-high trees forms the background for "Tales in Tall Trees," an exhibit that examines every aspect of storytelling. Children see how seeds of discovery, planted among the tree stumps and in the forest's nooks and crannies, can sprout ideas about imaginary experiences.

In another project, children designed, constructed, and decorated a ferry. They reproduced a harbor crossing with sounds of fog horns, birds' cries, waves, and a moving panel that simulated the boat's passage.

Special events sponsored by the museum include "The Joke Jamboree," a day-long festival, and the young magicians convention. In the latter event, conjurers, aged seven to twelve, had an opportunity to learn new tricks and perform feats of magic.

STATEN ISLAND INSTITUTE OF ARTS AND SCIENCES

75 Stuyvesant Place
Staten Island, N.Y. 10301
718/727–1135
718/727–2500 ferry information

SUBWAY	1, 4, 5, 9, N, and R; then Staten Island ferry.
BUS	M1, M6, and M15; then Staten Island ferry; S1, S102, and S104 from ferry terminal; or turn right on Richmond Terrace and walk to signal; walk up Wall Street one block to Stuyvesant Place.
FERRY	Round-trip tickets from Battery Park, 50 cents, adults; free, children 5 and under.
HOURS	9 A.M. to 5 P.M. Tuesday through Saturday; 1 P.M. to 5 P.M. Sunday.
TOURS	By appointment.
ADMISSION	$2.50, adults; $1.50, senior citizens and children under 12; members free.
MUSEUM SHOP	Craft items, jewelry, books, miscellaneous souvenirs selected for aesthetic or educational value.
SPECIAL EVENTS	Concerts, lectures, films, study groups and clubs, children's and members' events.
SPECIAL FACILITIES	William T. Davis Education Center, one block from the museum, houses classrooms, Manteo Sicilian Marionette Theatre and offices.
AUTHOR'S CHOICE	"Beyond the Bridge" exhibition

Within easy walking distance of the Staten Island ferry, this is one of the country's few general museums, with collections that encompass art, history, and natural science. It is the island's oldest cultural institution, and a prime source of information about local heritage and history. A move to the Snug Harbor Cultural Center in late 1992 will provide significantly enlarged space to display the museum's art and artifacts.

The Staten Island Institute of Arts and Sciences in snow

HISTORY

Founded in 1881 by William T. Davis and other Staten Island residents, this was the first cultural institution on the island. It is housed in a 1918 neo-Georgian building designed by a local architect, Robert Gardner. In 1928, the second floor gallery and attic were added to increase exhibit space.

At first, the museum existed on donations from Staten Islanders. Its first art purchase, *Looking Oceanward from Todt Hill* by Hudson River School artist Jasper Francis Cropsey, was made in 1946 with funds contributed by thirty friends of the

museum. Since then, collections have grown to include objects ranging from ancient to contemporary.

The William T. Davis Education Center, one block from the museum, caters to youngsters, with nature trips, environmental studies, and other special programs.

The noted Manteo Family Sicilian Marionette Theatre has operated under the auspices of the museum since 1985. This is one of the few remaining examples of a theatrical tradition dating back to the Middle Ages. The Manteos have been renowned puppeteers in Sicily since the 1800s. They emigrated to Manhattan and established the Manteo Theatre there in 1923 before moving to Staten Island.

The Manteo Family Sicilian Marionettes

The family operates its workshop in St. George, one block from the museum. The four-foot-high, 100- to 150-pound Manteo marionettes, dressed in satins, silks, and full armor, and surrounded by other sword- and shield-wielding puppets, perform swashbuckling dramas at various times during the year. In addition, tours of the workshop, where the puppets are created and groomed, can be arranged through the museum.

THE COLLECTIONS

The archives and the library contain more than twelve thousand books, in addition to thousands of photographs, maps, and prints dating from the 1700s. A unique special collection documents the history of blacks on Staten Island.

In the natural science collection, the history of Staten Island is traced through several thousand mineral specimens, mounted birds and insects, seashells, skulls, and bird and mammal skins.

The art collection spans thirty-five hundred years with hundreds of paintings, prints, drawings, watercolors, and sculpture, in addition to antiquities, costumes, textiles, furniture and decorative art objects.

EXHIBITS

"Beyond the Bridge: A Celebration and Exploration of Recent Staten Island History," occupied the entire museum until July 1991. When new exhibition and interpretation facilities open at Snug Harbor Cultural Center in late 1992, "Beyond the Bridge" will become part of a continuing exhibition devoted to twentieth-century Staten Island.

Displays include life-size replicas of portions of the bridge, and ferries at either end serve as an entrance to past and present worlds. Visitors can also experience "Contemporary Visions," an innovative presentation of the concerns of the present and the implications for the future. Interactive displays featuring video, sound and light effects, music, and games that teach as well as entertain, explore the past and look toward the future.

Before the exhibit opened, Staten Islanders were asked to contribute or loan photographs, family and business papers, and other memorabilia from the previous sixty years. These are incorporated into a time capsule, and a large family album display provides additional information.

ART GALLERIES

TRIBECA

Artists Space, Inc.
223 West Broadway (10013)
212/226–3970
11 A.M. to 6 P.M. Tuesday through
Saturday.
Nonprofit contemporary arts
organization committed to assisting
artists professionally and financially.

Bennett & Siegel, Ltd.
140 West Broadway, 4th floor (10013)
212/385–4434
1 P.M. to 6 P.M. Tuesday and by
appointment.
Contemporary paintings, sculpture,
and photography; estate work.

Hal Bromm Gallery
90 West Broadway (10007)
212/732–6196
11 A.M. to 5 P.M. Monday through
Friday and by appointment.
Contemporary American, European,
and Soviet art.

Ceres Gallery
91 Franklin Street (10013)
212/226–4725
Noon to 6 P.M. Tuesday through
Saturday.
Contemporary women artists.

Fred Dorfman
123 Watts (10013)
212/966–4611
11 A.M. to 5 P.M. Monday through
Friday.
Specializing in artists from the "pop"
period and internationally recognized
contemporary painters and
printmakers.

Franklin Furnace Archive
112 Franklin Street (10013)
212/925–4671
Noon to 6 P.M. Tuesday through
Saturday.
Large archive of artist-created books
and written materials. Gallery space
with weekend performances.

Pelavin Editions
13 Jay Street (10013)
212/925–9424
10 A.M. to 6 P.M. Monday through
Friday and by appointment.
Showing works on paper published by
Pelavin Editions. Monotype and
etching suites, and unique editions by
gallery artists.

SOHO

A.I.R.
63 Crosby Street (10012)
212/966–0799
11 A.M. to 6 P.M. Tuesday through
Saturday
Contemporary art.

Salvatore Ala
560 Broadway, 3rd floor (10012)
212/941–1990
10 A.M. to 6 P.M. Tuesday through
Saturday.
Contemporary art.

Brooke Alexander
59 Wooster Street (10012)
212/925–4338
10 A.M. to 6 P.M. Tuesday through
Saturday
Contemporary American and European
paintings, drawings, and sculpture.

Brooke Alexander Editions
476 Broome Street (10013)
212/925–2070
10 A.M. to 6 P.M. Tuesday through
Saturday.
Contemporary American and European
prints and multiples.

Josh Baer Gallery
476 Broome Street (10013)
212/431–4774
10 A.M. to 6 P.M. Tuesday through
Saturday.
Contemporary art.

David Beitzel Gallery
102 Prince Street, 2nd floor (10012)
212/219–2863
10 A.M. to 6 P.M. Tuesday through
Saturday.
Contemporary painting and sculpture
by young American and European
artists.

Nathan Berman-E.N. Gallery
138 Greene Street (10012)
212/431–1010
10 A.M. to 6 P.M. Monday through
Saturday; Noon to 4 P.M. Sunday.
Soviet Russian contemporary art.

Frank Bernaducci Gallery
560 Broadway, 5th floor (10012)
212/334–0982
10 A.M. to 6 P.M. Tuesday through
Saturday.

Mary Boone Gallery
417 West Broadway (10012)
212/431–1818
10 A.M. to 6 P.M. Tuesday through
Saturday.
Contemporay paintings, drawings, and
sculpture.

Damon Brandt Gallery
568 Broadway (10012)
212/431–1444
10 A.M. to 6 P.M. Tuesday through
Saturday.
Contemporary, African, and pre-
Columbian art.

Diane Brown Gallery
560 Broadway, 2nd floor (10012)
212/219–1060
10 A.M. to 6 P.M. Tuesday through
Saturday
Contemporary art with an emphasis on
sculpture.

Leo Castelli Gallery
420 West Broadway (10012)
212/431–5160
10 A.M. to 6 P.M. Tuesday through
Saturday.
Contemporary American and European
painting and sculpture, representing
over 30 artists, including the major
Pop, Minimalist, and Conceptual
artists.

Leo Castelli Gallery
578 Broadway (10012)
212/431–6279
10 A.M. to 6 P.M. Tuesday through
Saturday.
Representing major 20th century
artists, including Johns, Kelly,
Lichtenstein, Newman, Oldenburg, and
Rosenquist.

Castelli Graphics
578 Broadway (10012)
212/941–9855
10 A.M. to 6 P.M. Tuesday through
Saturday.
Prints by leading contemporary, pop,
and minimalist artists.

Paula Cooper
155 Wooster Street (10012)
212/674–0766
10 A.M. to 6 P.M. Tuesday through
Saturday.
Contemporary paintings and sculpture.

Charles Cowles Gallery
420 West Broadway (10012)
212/925–3500
10 A.M. to 6 P.M. Tuesday through
Saturday.
Contemporary and modern art in
various media.

Bess Cutler Gallery
593 Broadway (10012)
212/219–1577
10 A.M. to 6 P.M. Tuesday through
Saturday.
Contemporary American and European
artists.

Dia Center for the Arts
77 Wooster Street (10012)
212/925–0325
10 A.M. to 6 P.M. Tuesday through
Saturday.
and
393 West Broadway
and
141 Wooster Street
Noon to 6 P.M. Wednesday through
Saturday.
Nonprofit group, specializing in
contemporary art.

The Drawing Center
35 Wooster Street (10013)
212/219–2166
10 A.M. to 6 P.M. Tuesday through
Friday; 10 A.M. to 8 P.M. Wednesday;
11 A.M. to 6 P.M. Saturday.
Nonprofit gallery devoted to the
exhibition and study of unique works
on paper.

Rosa Esman Gallery
575 Broadway (10012)
212/219–3044
10 A.M. to 6 P.M. Tuesday through
Saturday.
Contemporary sculpture and painting;
Russian avant-garde and contemporary
conceptual works; European Bauhaus
and dada art.

Ronald Feldman
31 Mercer Street (10013)
212/226–3232
10 A.M. to 6 P.M. Tuesday through
Saturday; by appointment Monday.
Contemporary art.

Barbara Fendrick
568 Broadway (10012)
212/966–2820
10 A.M. to 6 P.M. Tuesday through
Saturday.
Contemporary paintings, prints, and
photography.

Gemini G.E.L. at Joni Weyl
375 West Broadway, 2nd floor (10012)
212/219–1446
Daily by appointment.
Fine art limited edition prints and
sculpture by important contemporary
artists.

John Gibson
568 Broadway, 2nd floor (10012)
212/925–1192
10 A.M. to 6 P.M. Tuesday through
Saturday.
Contemporary American and European
conceptual art.

Barbara Gladstone Gallery
99 Greene Street (10012)
212/431–3334
10 A.M. to 6 P.M. Tuesday through
Saturday.
Contemporary and modern art.

John Good Gallery
532 Broadway, 2nd floor (10012)
212/941–8066
10 A.M. to 6 P.M. Tuesday through
Saturday.
Contemporary abstract painting.

Jay Gorney Modern Art
100 Greene Street (10012)
212/966–4480
10 A.M. to 6 P.M. Tuesday through
Saturday.
Contemporary art.

O.K. Harris Works of Art
383 West Broadway (10012)
212/431–3600
10 A.M. to 6 P.M. Tuesday through
Saturday.
Innovative contemporary art.

Pat Hearn Gallery
39 Wooster Street (10012)
212/941–7055
10 A.M. to 6 P.M. Tuesday through
Saturday.
Contemporary American and European
painting, sculpture, and photography.

Helander Gallery
415 West Broadway (10012)
212/966–9797
10 A.M. to 6 P.M. Tuesday through
Saturday.
Contemporary American art.

Helio Galleries, Inc.
588 Broadway, 4th floor (10012)
212/966–5156
10 A.M. to 6 P.M. Tuesday through
Saturday.
Fine contemporary paintings,
sculpture, and photography.

Nancy Hoffman Gallery
429 West Broadway (10012)
212/966–6676
September through June: 10 A.M. to 6
P.M. Tuesday through Saturday; July
and August: 10 A.M. to 5 P.M. Monday
through Friday.
Contemporary paintings, sculpture,
drawings, and prints by gallery artists.
Represents 15 artists living in the U.S.,
France, England, and Australia.

Phyllis Kind Gallery
136 Greene Street (10012)
212/925–1200
10 A.M. to 6 P.M. Tuesday through
Saturday.
American, Soviet, and European
contemporary paintings, sculpture, and
drawings.

Koury-Wingate
578 Broadway, Suite 106 (10012)
212/966–5777
10 A.M. to 6 P.M. Tuesday through
Saturday.
Contemporary art.

Lieberman & Saul Gallery
155 Spring Street, 5th floor (10012)
212/431–0747
10 A.M. to 6 P.M. Tuesday through
Friday. Contemporary photography.
Also vintage photographs, paintings,
and works on paper.

Lorence-Monk Gallery
568 and 578 Broadway (10012)
212/431–3555
10 A.M. to 6 P.M. Tuesday through
Saturday.
Two galleries: one devoted to prints of
1960s to the present; the other shows
paintings, drawings, and sculpture of
artists represented by the gallery.

Luhring Augustine

130 Prince Street, 2nd floor (10012)
212/925–9372
10 A.M. to 6 P.M. Tuesday through
Saturday.
Contemporary painting and sculpture.

M–13 Gallery, Ltd.

72 Greene Street (10012)
212/925–3007
10 A.M. to 6 P.M. Tuesday through
Saturday.
Contemporary art.

Curt Marcus Gallery

578 Broadway, 10th floor (10012)
212/226–3200
10 A.M. to 6 P.M. Tuesday through
Saturday.
Contemporary art.

Metro Pictures

150 Greene Street (10012)
212/925–8335
10 A.M. to 6 P.M. Tuesday through
Saturday.
Contemporary art.

Multiple Impressions, Ltd.

128 Spring Street (10012)
212/925–1313
Noon to 7 P.M. Monday through
Sunday.
20th century prints and paintings. A
printmaking gallery since 1972, with
an international array of printmakers.

David Nolan Gallery

560 Broadway, #604 (10012)
212/925–6190
10:30 A.M. to 5:30 P.M. Tuesday
through Saturday.
Works on paper by European and
American artists.

Annina Nosei

100 Prince Street (10012)
212/431–9253
10 A.M. to 6 P.M. Tuesday through
Saturday.
Contemporary art.

Petersburg Galleries

130 Prince Street (10012)
212/966–4099
10 A.M. to 6 P.M. Tuesday through
Saturday; by appointment Monday.
Contemporary paintings.

Pindar Gallery

127 Greene Street (10012)
212/353–2040
11:30 A.M. to 6 P.M. Tuesday through
Saturday.
Artist-run gallery, featuring various
styles of contemporary art in all media.

Max Protetch

560 Broadway at Prince Street (10012)
212/966–5454
10 A.M. to 6 P.M. Tuesday through
Saturday.
Contemporary art.

Tony Shafrazi Gallery

130 Prince Street, 5th floor (10012)
212/274–9300
10 A.M. to 6 P.M. Tuesday through
Saturday. Summer hours: 10 A.M. to 6
P.M. Monday through Friday.
Contemporary art.

Jack Shainman Gallery

560 Broadway, 2nd floor (10012)
212/966–3866
10 A.M. to 6 P.M. Tuesday through
Saturday.
Contemporary European and American
paintings, sculpture, and photography.

Anita Shapolsky

99 Spring Street (10012)
212/334–9755
11 A.M. to 6 P.M. Tuesday through
Saturday.
Contemporary art.

Sonnabend

420 West Broadway (10012)
212/966–6160
10 A.M. to 6 P.M. Tuesday through
Saturday.
Contemporary art.

Sperone Westwater

121 Greene Street (10012)
212/431–3685
10 A.M. to 6 P.M. Tuesday through
Saturday.
Contemporary art.

Staley-Wise

560 Broadway (10012)
212/966–6223
11 A.M. to 5 P.M. Tuesday through
Saturday.
Contemporary art and photography.

Stux Gallery
155 Spring Street (10012)
212/219-0010
10 A.M. to 6 P.M. Tuesday through Saturday.
Contemporary painting, sculpture, and photography.

Edward Thorp Gallery
103 Prince Street, 2nd floor (10012)
212/431-6880
10 A.M. to 6 P.M. Tuesday through Saturday.
Emerging American and European contemporary artists.

Barbara Toll Fine Arts
146 Greene Street (10012)
212/431-1788
10 A.M. to 6 P.M. Tuesday through Saturday.
Contemporary art.

GREENWICH VILLAGE, CHELSEA, AND EAST VILLAGE

Dia Center for the Arts
548 West 22nd Street (10011)
212/989-5912
Noon to 6 P.M. Thursday through Sunday.
Nonprofit exhibition space featuring contemporary paintings, sculpture, and photography.

Marcella Halpert
111 East 19th Street (10003)
212/228-3423
By appointment only.
Contemporary Mexican paintings, sculpture, and works on paper.

The Illustration Gallery
330 East 11th Street (10003)
212/979-1014
1 P.M. to 6 P.M. Tuesday through Sunday.
Devoted exclusively to contemporary original illustration.

Kenkeleba Gallery
214 East Second Street (10009)
212/674-3939
1 P.M. to 6 P.M. Wednesday through Sunday.
A nonprofit alternative art space presenting art by African American and Third World artists; artists working in innovative media, and little-known emerging and mature artists.

Limner
216 East Tenth Street (10003)
212/353-0473
Noon to 6 P.M. Wednesday through Sunday.
Exclusively representing new art movements, including modern Medievalism and pop-surrealism.

White Columns
Alternative Arts Space
142-54 Christopher Street
212/924-4212
Noon to 6 P.M. Wednesday through Sunday.
Nonprofit exhibition space, specializing in "cutting edge" art by emerging or little known artists.

FORTIES AND FIFTIES

Arras Gallery
24 West 57th Street (10019)
and
725 Fifth Avenue
Trump Tower (10022)
212/265-2222
10 A.M. to 5:30 P.M. Tuesday through Saturday. Trump Tower open on Monday.
Contemporary paintings, sculpture, and tapestries.

Associated American Artists
20 West 57th Street (10019)
212/399-5510
10 A.M. to 6 P.M. Tuesday through Saturday.
Long-established gallery specializing in modern and contemporary American prints and other works on paper.

Babcock Galleries
724 Fifth Avenue (10019)
212/535-9355
10 A.M. to 5:30 P.M. Tuesday through Saturday.
Established 1852. Fine quality American 19th and early 20th century works. Also some contemporary artists.

Blum Helman Gallery
20 West 57th Street (10019)
212/245-2888
10 A.M. to 6 P.M. Tuesday through Saturday.
20th century and contemporary American and European painting and sculpture.

Grace Borgenicht Gallery
724 Fifth Avenue (10019)
212/247–2111
10 A.M. to 5:30 P.M. Tuesday through
Friday; 11 A.M. to 5:30 P.M. Saturday.
Modern and contemporary paintings
and sculpture.

Brewster Gallery
41 West 57th Street (10019)
212/980–1975
10:30 A.M. to 5 P.M. Monday through
Saturday. July and August: 10:30 A.M.
to 5 P.M. Monday through Friday.
Paintings, sculpture, drawings, and
graphics by Latin American masters,
including Cuevas, Rivera, Tamayo, and
Zuñiga, and graphics by 20th century
masters Calder, Chagall, Mirò, and
Picasso.

Frank Caro
41 East 57th Street (10022)
212/753–2166
10 A.M. to 5:30 P.M. Tuesday through
Saturday.
Ancient art of China, India, and
Southeast Asia.

Sylvan Cole
200 West 57th Street (10019)
212/333–7760
10 A.M. to 6 P.M. Tuesday through
Saturday.
Graphics by American masters.

Tibor de Nagy Gallery
41 West 57th Street (10019)
212/421–3780
10 A.M. to 5:30 P.M. Tuesday through
Saturday.
Small, eclectic gallery celebrated its
40th anniversary in 1990.

Andre Emmerich Gallery
41 East 57th Street, 5th and 6th
floors(10022)
212/752–0124
10 A.M. to 5:30 P.M. Tuesday through
Saturday.
Contemporary American and European
art; classical antiquities.

David Findlay, Jr.
41 East 57th Street, 3rd floor (10022)
212/486–7660
9:30 A.M. to 5:30 P.M. Tuesday
through Saturday.
American 19th and early 20th century
paintings and sculpture, including
Avery, Cassatt, Chase, Duveneck,
Hassam, Moran, Sargent, Twachtman,
Weir, and others.

Wally Findlay
17 E. 57th Street (10022)
212/421–5390
9:30 A.M. to 5:30 P.M. Monday
through Saturday.
Contemporary and 20th century
paintings.

Fischbach Gallery
24 West 57th Street (10019)
212/759–2345
10 A.M. to 5:30 P.M. Tuesday through
Saturday.
Contemporary American
representational painting, drawing, and
sculpture.

Frumkin/Adams
50 West 57th Street (10019)
212/757–6655
September to June: 10 A.M. to 6 P.M.
Tuesday through Friday; 10 A.M. to
5:30 P.M. Saturday. June: 10 A.M. to 6
P.M. Monday through Friday. July and
August: 10 A.M. to 5 P.M. Monday
through Friday.
Contemporary painting, sculpture, and
drawings; European modern master
drawings.

Galerie Lelong
20 West 57th Street (10019)
212/315–0470
10 A.M. to 5:30 P.M. Tuesday through
Saturday.
Modern and contemporary art.

Marian Goodman Gallery
24 West 57th Street (10019)
212/977–7160
10 A.M. to 6 P.M. Monday through
Saturday.
Contemporary European and American
art.

Hammer Galleries
33 West 57th Street (10019)
212/644–4400
9:30 A.M. to 5:30 P.M. Monday
through Friday; 10 A.M. to 5 P.M.
Saturday.
19th and 20th century European and
American paintings.

Intar Gallery
420 West 42nd Street, 2nd floor
(10036)
212/695–6135
Noon to 6 P.M. Monday through
Friday.
Multicultural art center, exhibiting
artists of diverse racial and cultural
backgrounds.

Sidney Janis Gallery
110 West 57th Street (10019)
212/586–0110
10 A.M. to 5:30 P.M. Monday through Saturday.
Nine decades of 20th century masters.

Kennedy Galleries
40 West 57th Street (10019)
212/541–9600
9:30 A.M. to 5:30 P.M. Tuesday through Saturday.
A leading dealer in American art of the 18th, 19th, and 20th centuries. Fine quality paintings, drawings, sculpture, and prints.

Kent Fine Art
41 East 57th Street (10022)
212/980–9696
10 A.M. to 5:30 P.M. Tuesday through Saturday; by appointment Monday.
Modern and contemporary paintings and sculpture.

Kraushaar Galleries
724 Fifth Avenue (10019)
212/307–5730
9:30 A.M. to 5:30 P.M. Tuesday through Friday; 10 A.M. to 5 P.M. Saturday.
20th century American paintings, drawings, prints, and sculpture.

Marisa del Re
41 East 57th Street (10022)
212/688–1843
10 A.M. to 5:30 P.M. Tuesday through Saturday.
Contemporary painting and sculpture.

Marlborough
40 West 57th Street (10019)
212/541–4900
10 A.M. to 5:30 P.M. Monday through Saturday.
Contemporary painting, sculpture, and drawing. Impressionist and post-Impressionist 20th century European masters and postwar American artists.

Jason McCoy
41 East 57th Street (10022)
212/319–1996
10 A.M. to 5:30 P.M. Tuesday through Saturday.
Work by artists of the New York School, including Pollock, Hofmann, Kelly, and Gorky. Also, works by Impressionist masters, and contemporary artists.

McKee Gallery
41 East 57th Street (10022)
212/688–5951
10 A.M. to 5:30 P.M. Tuesday through Saturday.
Contemporary art.

Robert Miller
41 East 57th Street (10022)
212/980–5454
10 A.M. to 5:30 P.M. Tuesday through Saturday.
Modern and contemporary art.

Multiples
24 West 57th Street (10019)
212/977–7160
10 A.M. to 6 P.M. Monday through Saturday.
20th century graphics.

Pace Prints
32 East 57th Street, 3rd floor (10022)
212/421–3237
9:30 A.M. to 5:30 P.M. Tuesday through Friday; 10 A.M. to 6 P.M. Saturday.
Comprehensive selection of prints by American and European artists.

Pace Prints/Pace Primitive
32 East 57th Street, 10th floor (10022)
212/421–3688
9:30 A.M. to 5:30 P.M. Tuesday through Friday; 10 A.M. to 6 P.M. Saturday.
Master prints and drawings by leading 19th and 20th century artists, including Braque, Degas, Klee, Matisse, Picasso, and Whistler. Old Master prints and drawings from 15th to 18th century.

Schmidt Bingham
41 W. 57th Street (10019)
212/888–1122
10 A.M. to 6 P.M. Monday through Saturday.
Contemporary art.

Robert Schoelkopf
50 West 57th Street (10019)
212/765–3540
10 A.M. to 5 P.M. Tuesday through Saturday.
Contemporary art.

Holly Solomon Gallery
724 Fifth Avenue (10019)
212/757–7777
10 A.M. to 6 P.M. Monday through
Saturday.
Contemporary painting, sculpture, and
photography.

Studio 53, Ltd.
424 Park Avenue (10022)
212/755–6650
10 A.M. to 6 P.M. Monday through
Friday; 11 A.M. to 6 P.M. Saturday.
Original oils and limited edition
graphics of major European and
American artists.

Washburn Gallery
41 East 57th Street, 8th floor (10022)
212/753–0546
10 A.M. to 6 P.M. Tuesday through
Saturday.
Contemporary art.

Gerold Wunderlich & Co.
50 West 57th Street (10019)
212/974–8444
10 A.M. to 5:30 P.M. Tuesday through
Saturday.
19th and early 20th century American
art; 19th century American prints, and
contemporary realism.

Zabriskie Gallery
724 Fifth Avenue (10019)
212/307–7430
10 A.M. to 5:30 P.M. Monday through
Saturday.
Early 20th century American paintings
and sculpture; contemporary paintings,
sculpture, and photography.

SIXTIES, SEVENTIES, AND EIGHTIES

Blumka II Gallery
23 East 67th Street (10021)
212/879–5611
10:30 A.M. to 5:30 P.M. Monday
through Friday; by appointment
Saturday.
Medieval and Renaissance sculpture,
works of art, jewelry, and objets d'art.

Bruton
40 East 61st Street (10021)
212/980–1640
By appointment.
19th and 20th century sculpture.

Coe Kerr
49 East 82nd Street (10028)
212/628–1340
9 A.M. to 5 P.M. Monday through
Friday.
19th and 20th century American
painting.

Colnaghi USA, Ltd.
21 East 67th Street (10021)
212/772–2266
9:30 A.M. to 5:30 P.M. Monday
through Friday; 11 A.M. to 4 P.M.
Saturday during special exhibitions.
Founded in London 1760, opened in
New York 1982. Specializing in Old
Master paintings, drawings, and prints.

David Findlay Galleries
984 Madison Avenue (10021)
212/249–2909
10 A.M. to 5 P.M. Tuesday through
Saturday.
19th and 20th century European art.

Galerie Felix Vercel, Inc.
17 East 64th Street (10021)
212/744–3131
10 A.M. to 6 P.M. Tuesday through
Saturday.
Contemporary painting and sculpture;
Old Masters.

Hirschl & Adler Galleries
21 East 70th Street (10021)
212/535–8810
October through May: 9:30 A.M. to
5:15 P.M. Tuesday through Friday; 9:30
A.M. to 4:45 P.M. Saturday. June
through September: 9:30 A.M. to 4:45
P.M. Monday through Friday.
American and European paintings,
watercolors, drawings, sculpture, and
prints from the 18th century to the
present. American decorative arts,
1810–1910.

Hirschl & Adler Folk

851 Madison Avenue (10021)
212/988–3655
9:30 A.M. to 5:30 P.M. Tuesday
through Friday; 10 A.M. to 4:45 P.M.
Saturday.
Broad range of American folk art,
including paintings, furniture,
weathervanes, wood carvings, quilts,
coverlets, and various other 19th
century decorative arts.

Hirschl & Adler Modern

851 Madison Avenue (10021)
212/744–6700
9:30 A.M. to 5:30 P.M. Monday
through Friday; 9:30 A.M. to 5 P.M.
Saturday.
Important contemporary European and
American painting and sculpture.

Vivian Horan Fine Art

35 East 67th Street (10021)
212/517–9410
10 A.M. to 6 P.M. Monday through
Saturday.
Paintings, drawings, and sculpture by
20th century European and American
masters, from cubism and futurism to
major contemporary artists.

Knoedler & Company

19 East 70th Street (10021)
212/794–0550
9:30 A.M. to 5:30 P.M. Tuesday
through Friday; 10 A.M. to 5:30 P.M.
Saturday.
Contemporary American and European
art. Representing major artists,
including Diebenkorn, Motherwell,
Rauschenberg, and Stella.

La Boetie, Inc.

9 East 82nd Street (10028)
212/535–4865
October through May: 10 A.M. to 5:30
P.M. Tuesday through Saturday. June,
July and September: 10 A.M. to 5:30
P.M. Tuesday through Friday. Closed
August.
Early 20th century European works on
paper, including drawings, watercolors,
gouaches, and collages, which survey
German and Austrian Expressionism,
Russian Constructivism, and artists of
the Paris School, dada and the
Bauhaus.

Helene and Philippe Leloup

1080 Madison Avenue (10028)
212/772–3410
10 A.M. to 6 P.M. Tuesday through
Saturday, and by appointment.
African and pre-Columbian art.

Spanierman Gallery

50 E. 78th Street (10021)
212/879–7085
9:30 A.M. to 5:30 P.M. Tuesday
through Saturday. Summer hours: 9
A.M. to 5:30 P.M. Monday through
Thursday; 9 A.M. to 3 P.M. Friday.
American 19th and 20th century
painting, sculpture, and works on
paper, featuring works by Hudson
River School, American Impressionist,
ash can, and Modernist artists.

Tambaran

The Surrey Hotel
20 East 76th Street (10021)
212/570–0655
11 A.M. to 6 P.M. Monday through
Saturday.
Fine African, Indonesian, and
Oceanic art.

SPECIAL PLACES FOR PRIVATE FUNCTIONS

Sponsorship by a member and/or a large fee to the organization is often required. Certain restrictions concerning smoking or the serving of alcoholic beverages may also apply.

American Craft Museum
40 West 53rd Street
212/956–3535
Corporate sponsors only

**American Museum
of the Moving Image**
35th Avenue at 36th Street
Astoria
718–784–4520

**American Museum of
Natural History**
Central Park West at 79th Street
Office of Guest Services
212/769–5350
Civic and corporate groups only

Asia Society Galleries
725 Park Avenue
212/288–6400
Auditorium available

Bronx Museum of the Arts
1040 Grand Concourse
Bronx
212/681–6000

Brooklyn Children's Museum
145 Brooklyn Avenue
Brooklyn
718/735–4400

Brooklyn Museum
200 Eastern Parkway
Brooklyn
718/638–5000
Corporate members and community
groups for non-fundraising events

Center for African Art
54 East 68th Street
212/861–1200

Children's Museum of Manhattan
212 West 83rd Street
212/721–1221

China House Gallery
China Institute in America
125 East 65th Street
212/744–8181

The Cloisters
Fort Tryon Park
Special Events Office
212/879–5500
Limited availability

Cooper-Hewitt Museum
National Museum of Design
Smithsonian Institution
Two East 91st Street
212/860–6868
Corporate members and
exhibition sponsors only

Federal Hall
26 Wall Street
212/264–8711

Fraunces Tavern Museum
54 Pearl Street
212/425–1778

Frick Collection
Office of the Administrator
One East 70th Street
212/288–0700
Limited availability

Garibaldi Meucci Museum
Order of Sons of Italy in America
420 Tompkins Avenue
Staten Island
718/442–1608

Hispanic Society of America
Audubon Terrace
Broadway at 155th Street
212/926–2234

**International Center of
Photography**
1130 Fifth Avenue
212/860–1777
Corporate members only

International Center of Photography Midtown
1133 Avenue of the Americas at 43rd Street
212/768–4680
Corporate members only

Metropolitan Museum of Art
Special Events Office
Fifth Avenue at 82nd Street
212/570–3773
Corporate groups only

Pierpont Morgan Library
Development Office
29 East 36th Street
212/685–0008
Corporate and nonprofit groups only

Morris-Jumel Mansion
1765 Jumel Terrace
Between 160th and 162nd Streets
212/923–8008

Museum of the City of New York
Fifth Avenue at 103rd Street
212/534–1672
Organizations only

Museum of Modern Art
11 West 53rd Street
212/708–9480
Corporate members only

Museum of Television and Radio
25 West 52nd Street
212/752–4690

National Academy of Design
1083 Fifth Avenue
212/369–4880

New Museum of Contemporary Art
583 Broadway
212/219–1222

Old Merchant's House
29 East 4th Street
212/777–1089
Limited availability
for civic functions

Queens Museum
New York City Building
Flushing Meadows-Corona Park
Flushing
718/592–2405
Civic and corporate groups only

Richmondtown Restoration
441 Clarke Avenue
Staten Island
718/351–1611
Courthouse available for small meetings

Schombur Center for Research in Black Culture
New York Public Library
515 Malcolm X Boulevard
212/862–4000
Civic and corporate groups only

Abigail Adams Smith Museum
421 East 61st Street
212/838–6878
Auditorium and garden available

Snug Harbor Cultural Center
1000 Richmond Terrace
Staten Island
718/448–2500

South Street Seaport Museum
16 Fulton Street
212/669–9430
A.A. Low Building, *Peking*, *Wavertree*, Museum Gallery, Seaport Line vessels, and *Pioneer* available for private and corporate functions

Staten Island Children's Museum
1000 Richmond Terrace
Staten Island
718/273–2060

Staten Island Institute of Arts and Sciences
75 Stuyvesant Place
Staten Island
718/717–1135

Whitney Museum of American Art
945 Madison Avenue
212/570–3600
Corporate members only

CHECKLIST OF SPECIAL COLLECTIONS

AFRO-AMERICAN
American Museum of Immigration
Brooklyn Historical Society
Bronx Museum of the Arts
Center for African Art
Ellis Island Immigration Museum
Schomburg Center for Research in
 Black Culture
Staten Island Institute of Arts and
 Sciences

AMERICANA
American Museum of Immigration
Bronx Museum of the Arts
Dyckman House
Edgar Allan Poe Cottage
Ellis Island Immigration Museum
Federal Hall
Gracie Mansion
Lefferts Homestead
Lower East Side Tenement Museum
Metropolitan Museum of Art
Museum of American Folk Art
Museum of the City of New York
Museum of Staten Island
New-York Historical Society
Theodore Roosevelt Birthplace
Richmondtown Restoration
Abigail Adams Smith Museum
Snug Harbor Cultural Center
South Street Seaport Museum

ART
Medieval and Renaissance
The Cloisters
Frick Collection
Metropolitan Museum of Art
Pierpont Morgan Library

ART
17th and 18th Centuries
Dyckman House
Frick Collection
Metropolitan Museum of Art
Pierpont Morgan Library
Museum of the City of New York
New-York Historical Society

ART
19th and 20th Centuries
American Craft Museum
Brooklyn Museum
Bronx Museum of the Arts
City Hall Governor's Room
Federal Hall
Forbes Magazine Galleries
Frick Collection
Gracie Mansion
Solomon R. Guggenheim Museum
Jewish Museum
Metropolitan Museum of Art
Morris-Jumel Mansion
Museum of American Folk Art
Museum of the City of New York
Museum of Modern Art
New Museum of Contemporary Art
New-York Historical Society
Isamu Noguchi Garden Museum
Queens Museum
Schomburg Center for Research in
 Black Culture
Snug Harbor Cultural Center
Staten Island Institute of Arts and
 Sciences
Whitney Museum of American Art

CERAMICS AND PORCELAIN
(See also, Decorative Arts)
American Craft Museum
Asia Society
Brooklyn Museum
Cooper-Hewitt Museum
Dyckman House
Frick Collection
Hispanic Society of America
Metropolitan Museum of Art
Pierpont Morgan Library
Morris-Jumel Mansion
Museum of American Folk Art
Museum of the City of New York
New-York Historical Society
Richmondtown Restoration
Abigail Adams Smith Museum

CHILDREN
American Museum of Natural History
American Museum of the Moving
 Image
Brooklyn Children's Museum
Brooklyn Museum
Bronx Museum of the Arts
Center for African Art
Children's Museum of Manhattan
Forbes Magazine Galleries
Solomon R. Guggenheim Museum
Museum of the City of New York
New-York Historical Society
Queens Museum
Richmondtown Restoration
South Street Seaport Museum
Staten Island Children's Museum
Staten Island Institute of Arts and
 Sciences
Statue of Liberty

CRAFTS
American Craft Museum
El Museo del Barrio
Brooklyn Museum
Museum of American Folk Art
Richmondtown Restoration

DECORATIVE ARTS
 (Furniture, Silver, Porcelain,
 Glass, Objets d'Art)
American Craft Museum
Asia Society
Brooklyn Museum
City Hall Governor's Room
The Cloisters
Cooper-Hewitt Museum
Dyckman House
Federal Hall
Forbes Magazine Galleries
Fraunces Tavern Museum
Frick Collection
Gracie Mansion
Hispanic Society of America
Lefferts Homestead
Metropolitan Museum of Art
Pierpont Morgan Library
Morris-Jumel Mansion
Museum of American Folk Art
Museum of the City of New York
New-York Historical Society
Old Merchant's House
Edgar Allan Poe Cottage
Richmondtown Restoration
Theodore Roosevelt Birthplace
Abigail Adams Smith Museum
Staten Island Institute of Arts and
 Sciences

GARDENS
Alice Austen House
Brooklyn Museum
The Cloisters
Dyckman House
Gracie Mansion
Jacques Marchais Center of Tibetan
 Art
Morris-Jumel Mansion
Museum of Modern Art
Pierpont Morgan Library
Isamu Noguchi Garden Museum
Richmondtown Restoration
Abigail Adams Smith Museum
Snug Harbor Cultural Center

HISTORIC HOUSES
Alice Austen House
Cooper-Hewitt Museum
Dyckman House
Federal Hall
Fraunces Tavern Museum
Frick Collection
Garibaldi Meucci Museum
Gracie Mansion
Lefferts Homestead
Old Merchant's House
Pierpont Morgan Library
Morris-Jumel Mansion
Edgar Allan Poe Cottage
Richmondtown Restoration
Theodore Roosevelt Birthplace
Abigail Adams Smith Museum

JUDAICA
American Museum of Natural History
Ellis Island Immigration Museum
Jewish Museum

LIBRARIES
Brooklyn Historical Society
Frick Collection
International Center of Photography
Metropolitan Museum of Art
Pierpont Morgan Library
Museum of Broadcasting
New-York Historical Society
Schomburg Center for Research in
 Black Culture

MARITIME HISTORY
Museum of the City of New York
Museum of Staten Island
Snug Harbor Cultural Center
South Street Seaport Museum

MEDIEVAL ART, ARCHITECTURE, AND MANUSCRIPTS
The Cloisters
Metropolitan Museum of Art
Pierpont Morgan Library

NATURAL HISTORY
American Museum of Natural History
Staten Island Institute of Arts and
 Sciences

ORIENTAL ART
Asia Society
Brooklyn Museum
China House Gallery
Frick Collection
Jacques Marchais Center of Tibetan Art
Metropolitan Museum of Art
Pierpont Morgan Library

PHOTOGRAPHY
Alice Austen House
American Museum of Immigration
American Museum of the Moving Image
Ellis Island Immigration Museum
El Museo del Barrio
Brooklyn Museum
Forbes Magazine Galleries
Garibaldi Meucci Museum
Gracie Mansion
Solomon R. Guggenheim Museum
Lower East Side Tenement Museum
Metropolitan Museum of Art
Museum of Modern Art
New-York Historical Society
International Center of Photography
International Center of Photography
 Midtown
Queens Museum
Schomburg Center for Research in
 Black Culture
Whitney Museum of American Art

PRINTS AND DRAWINGS
Brooklyn Historical Society
Brooklyn Museum
Cooper-Hewitt Museum
Frick Collection
Solomon R. Guggenheim Museum
Hispanic Society of America
Jewish Museum
Metropolitan Museum of Art
Museum of Modern Art
Pierpont Morgan Library
Museum of the City of New York
Museum of Modern Art
New-York Historical Society
Staten Island Institute of Arts and
 Sciences
Whitney Museum of American Art

RELIGIOUS ART
Asia Society
El Museo del Barrio
The Cloisters
Hispanic Society of America
Jewish Museum
Jacques Marchais Center of Tibetan Art
Metropolitan Museum of Art

SCIENCE
American Museum-Hayden Planetarium
American Museum of the Moving Image
American Museum of Natural History
IBM Gallery of Science and Art

SCULPTURE
Asia Society
El Museo del Barrio
Brooklyn Museum
Center for African Art
The Cloisters
Frick Collection
Solomon R. Guggenheim Museum
Hispanic Society of America
Metropolitan Museum of Art
Museum of American Folk Art
Museum of the City of New York
Museum of Modern Art
New-York Historical Society
Isamu Noguchi Garden Museum
Snug Harbor Cultural Center
Statue of Liberty
Whitney Museum of American Art

SPANISH ART
El Museo del Barrio
Hispanic Society of America
Metropolitan Museum of Art

TEXTILES
American Craft Museum
Brooklyn Museum
Cooper-Hewitt Museum
Frick Collection
Hispanic Society of America
Jewish Museum
Metropolitan Museum of Art
Museum of American Folk Art
Richmondtown Restoration

VICTORIANA
Alice Austen House
Forbes Magazine Galleries
Museum of the City of New York
New-York Historical Society
Old Merchant's House
Edgar Allan Poe Cottage
Theodore Roosevelt Birthplace

PHOTO CREDITS

SELECTED BIBLIOGRAPHY

Betts, Mary Beth. *The Governor's Room, City Hall, New York*. New York: The Art Commission of the City of New York, November 1983.

Black, Mary. *New York City's Gracie Mansion: A History of the Mayor's House 1646–1942*. New York: The Gracie Mansion Conservancy, 1984.

Blaugrund, Annette and Olson, Roberta J.M. "The History of the Thomas Jefferson Bryan Collection." New York: New-York Historical Society, n.d.

Bliven, Bruce, Jr. *Federal Hall National Memorial*. Washington, D.C.: National Park Service, U.S. Department of the Interior, 1988.

Bridges, Hudson. "Along the Avenues: The Center for African Art and the San Francisco Ship Model Gallery." *Gourmet*, March 1990.

Brouwer, Norman. "The Port of New York, 1860–1985: Improving Conditions for Sailors, Ashore and Afloat." *Seaport*, Volume XXIII, Number 2, Fall 1989.

Buckley, William F., Jr. "A Family Tree's Trimmings." *Art and Antiques*, December 1987.

Comstock, Helen. "History in Houses: the Dyckman House in New York." *Antiques*, October 1961.

Fisher, Leonard Everett. *Ellis Island Gateway to the New World*. New York: Holiday House, 1986.

Foshay, Ella M. *Mr. Luman Reed's Picture Gallery: A Pioneer Collection of American Art*. New York: Harry N. Abrams, Inc. 1990.

The Frick Collection Guide to the Galleries. New York: The Frick Collection, 1979.

The Frick Collection: A Guide to Works of Art on Exhibition. New York: The Frick Collection, 1989.

"The Fund For the Future." New York: The Museum of Broadcasting, 1988.

Goldberger, Paul. "Architecture/1990: The Important Things Were What Didn't Happen." *New York Times*, 30 December 1990.

Goler, Robert I. *Capital City: New York After the Revolution*. New York: Fraunces Tavern Museum, 1987.

Golightly, Bill. "U.S. Arts Strategies for the 80s." *Horizon*, July/August 1986.

Grimes, William. "Kirk Varnedoe Is In the Hot Seat as MOMA's Boy." *New York Times Magazine*, 11 March 1990.

Harvey, George. *Henry Clay Frick the Man*. New York: The Frick Collection, 1936.

The Hispanic Society of America: A Brief Description. New York: The Hispanic Society of America, n.d.

Howard, Kathleen, ed. *The Metropolitan Museum of Art Guide*. New York: Metropolitan Museum of Art, 1989.

Huxtable, Ada Louise. "A Landmark Survives the Odds." *New York Times*, 28 February 1980.

James, Henry. *Washington Square*. New York: New American Library, 1964.

Kelly, Margaret. *Highlights From the Forbes Magazine Galleries*. New York: Forbes, Inc., 1985.

Kimmelman, Michael. "A New Spirit at the New-York Historical Society." *New York Times*, 5 September 1990.

Klein, Marilyn W. and Fogle, David P. *Clues to American Architecture*. Washington, D.C.: Starrhill Press, 1986.

Krens, Thomas. "The Guggenheim: An American Museum With a European Face." *Masterpieces from the Guggenheim Museum* exhibition catalog. New York: Solomon R. Guggenheim Museum, 1990.

Levi, Peta. "A Family Album." *House and Garden*, British Edition, January 1988.

McDarrah, Fred W. *Museums in New York*. New York: A Frommer book published by Simon and Schuster, Fourth edition, 1983.

Metropolitan Museum of Art Curatorial Staff. *The Cloisters*. New York: The Metropolitan Museum of Art, n.d.

Metropolitan Museum of Art Curatorial Staff. *The Metropolitan Museum of Art Guide*. New York: Harry N. Abrams, Inc., 1983.

Mondadori, Arnoldo and LaFarge, Henry A. *Great Museums of the World, The Metropolitan Museum of Art*. New York: Newsweek, 1978.

"The Morris-Jumel Mansion." New York: Washington Headquarters Association, n.d.

Murray, Peter and Linda. *A Dictionary of Art and Artists*. England: Penguin Books, Fourth Edition, 1976.

The Museum of Modern Art, New York: The History and the Collection, Introduction by Sam Hunter. New York: Harry N. Abrams, Inc., 1984.

The National Academy of Design: A Brief History. New York: National Academy of Design, n.d.

Packer, William. "The Guggenheim Comes to Europe." *Financial Times*, 11 September 1990.

Palmer, Sara and Henry, Steven, editors. *The New Museum of Contemporary Art, New York, 1989 Twelfth Anniversary*. New York: New Museum of Contemporary Art, 1989.

Ratcliff, Carter. "A Tour of the Modern." *Travel & Leisure*, January, 1985.

"Recalling the Early Days at the Schomburg Center." *New York Times*, 29 August 1987.

Mr. and Mrs. John D. Rockefeller 3rd Collection, Handbook of, New York: The Asia Society, 1981.

Santoro, Gene. "An Open Window on Black Culture." *New York Post*, 28 May 1989.

The Schomburg Center for Research in Black Culture. 60th Anniversary Tribute. New York: The New York Public Library, Astor, Lenox, and Tilden Foundations, 1986.

"The Story of the New-York Historical Society." New York: New-York Historical Society, n.d.

Stuart, James. *Three Years in North America. Volume I*. Edinburgh: Robert Cadell, 1833.

Svendsen, Dr. Louise Averill. *Guggenheim Museum: The Building, The Collection, General Information*. New York: Solomon R. Guggenheim Museum, n.d.

Tomkins, Calvin. *Merchants and Masterpieces: The Story of the Metropolitan Museum of Art*. New York: E.P. Dutton & Co., Inc., 1970.

Tourist Guide New York City. New York: Michelin Tire Corporation, 1989.

Tucker, Alan, general editor. *The Penguin Guide to New York City 1989*. New York: Penguin Books, 1989.

Turan, Kenneth. "Through the Doors of Ellis Island." *Washington Post*, 30 December 1990.

Waller, George. *Saratoga, Saga of an Impious Era*. Gansevoort, N.Y.: George Waller, 1966.

Whelan, Richard. "Cornell Capa's 'lighthouse of photography'." *Artnews*, April, 1979.

Whitmore, George. "The Old Merchant's House." *Seaport*, Winter 1985.

Williams, Roger M. "Old Merchant's House Landmark on East Fourth Street." *Americana*, n.d.

Yarrow, Andrew L. "A Home for a Bustling Borough's Memorabilia." *New York Times*, 23 March 1990.

Young, Bonnie. *A Walk Through the Cloisters*. New York: The Metropolitan Museum of Art, fifth printing (revised), 1988.

Zappler, Georg. *Official Guide to the American Museum of Natural History*. New York: American Museum of Natural History, 1984.

INDEX

Another Ross Guide . . .

A MUSEUM GUIDE TO WASHINGTON, D.C.

Ideal for gifts or reference, it includes

- over 60 Washington area museums, historic houses and libraries

- 80 art galleries

- 46 clubs and historic houses available for private functions

- a checklist of special collections

- nearly 150 illustrations

- 7 maps

This carefully researched guide is *the only book of its kind* featuring in-depth descriptions of Washington's very special attractions. Included are biographies and historical backgrounds, comprehensive reports on museum collections, anecdotes, and information on hours, admission fees, museum shops, restaurants, libraries, handicapped facilities, and public transportation.

Order today and receive the book *Vogue* has called "a must for capital-bound travelers."

--

ORDER FORM

To: AMERICANA PRESS
5610 Wisconsin Avenue, Suite 306
Chevy Chase, MD 20815
301-718-9808

Please send me _____ copies of A MUSEUM GUIDE TO WASHINGTON, D.C. by Betty Ross at $12.95 each, plus postage and handling. (In Maryland, add 5% sales tax.)

Postage and Handling: $2.50 for the first book and $.50 for each additional book.

Enclosed is $ _____

Name _____

Address _____

_____ Zip _____